Women Television Producers

Women Television Producers: Transformation of the Male Medium

ROBERT S. ALLEY * IRBY B. BROWN

 UNIVERSITY OF ROCHESTER PRESS

✦ AN ADDRESS BY NORA EPHRON TO GRADUATES OF WELLESLEY COLLEGE ✦

When I graduated from Wellesley in 1962, those were the days when you got an M.A. in teaching because it was something to fall back on in the worst-case scenario: no one married you and you actually had to go to work. . . . At my 1987 reunion one classmate said, "Our education was a dress rehearsal for a life we never led." Isn't that the saddest line? We weren't meant to have futures, we were meant to marry them. . . . We were to spend our lives making nice. But then the Women's Movement came along. The rules changed and many of my contemporaries were caught in some kind of strange time warp. They never intended to be the heroines of their own lives, they were intended to be first ladies in the lives of big men.

Things have changed. The Women's Movement made a huge difference and you are the lucky beneficiaries of it. Nevertheless, the pay differential between men and women has barely changed. Don't forget this. In my own business there are many more of us who are directors but it's just as hard to get a movie made about women as it was thirty years ago, and it's much, much harder than it was sixty years ago. Look at the parts the Oscar-nominated actresses played this year—hooker, hooker, hooker, hooker, nun.

Don't be fooled, there is still a glass ceiling. And don't underestimate how much antagonism there is toward women and how many people wish we could turn the clock back. People always say to you, when you get upset, "Don't take it personally." But listen hard to what's going on in the world and I beg you to take it personally. Every attack on Hillary Clinton for not knowing her place is an attack on you. . . .

Above all, whatever you do, be the heroine of your life, not the victim. . . . In case you are wondering whether you can "have it all," of course you can have it all. . . . It will be a little messy, but embrace the mess. . . . Whatever you choose, I hope you choose not to be a lady. I hope you find some way to break the rules and make a little trouble out there, and I hope you will choose to make some of that trouble on behalf of women.

Nora Ephron kindly edited this 1996 address for use in this volume. She is a distinguished author and film director. She has written screenplays for several popular films, including Silkwood, Cookie, When Harry Met Sally, *and wrote and directed* Sleepless in Seattle.

THIS VOLUME IS DEDICATED, WITH DEEP APPRECIATION,
TO
JEAN FIRSTENBERG
COLLEAGUE, MENTOR, FRIEND

University of Rochester Press
668 Mt. Hope Avenue
Rochester, New York, 14620, USA
and at P.O. Box 9, Woodbridge, Suffolk 1IP12 3DF, UK

Library of congress cataloging-in-publication data
Brown, Irby B.
Women television producers : transformation of the male medium / Irby B. Brown
and Robert S. Alley.
p. cm.
Includes bibliographical references.
ISBN 1-58046-045-3 (alk. paper)
1. Women television producers and directors—United States—Interviews. 2.
Television—Production and direction—congresses. I. Alley, Robert S., 1932– II. Title.

‿ PN1992.4.A2 B77 2001
791.45'0232'0820973—dc21 00-066305

British Library Cataloguing-in-Publication Data

A catalogue record for this book is available from the British Library

This publication is printed on acid-free paper
Printed in the United States of America
Designed and typeset by Straight Creek Bookmakers

✦ Contents ✦

Contents

❖ Acknowledgments ❖

THIS PROJECT HAS INVOLVED TWENTY YEARS OF PREPARATION AND THE LIST OF those persons who aided us extends far beyond the limits reasonably imposed by any editor or reader. Therefore, we cite here the names of those who have been particularly generous with their time as we sought advice and counsel.

Jean Firstenberg, to whom we dedicate this volume, when serving as Program Officer for the Markle Foundation, provided generous funding for our research. As Director of the American Film Institute she has been unstinting in her support, encouragement, and advice as this book took shape. To Earl Hamner we owe a special thanks, for it was he who facilitated the first contacts we made in the television industry in 1975. It goes without saying that we are particularly indebted to all of the women who gave of their time and freely discussed their experiences, hopes, and thoughts for inclusion in this volume. They were enthusiastic participants, welcoming questions and promptly returning our numerous calls. A few were with us from the beginning; their filmed and taped interviews are reminders of the distance women have moved in the television industry in the past twenty-five years. To those friends and to the women with whom we met in the 1980s who remember when this book became a goal, and to the women with whom we first became acquainted as late as 1996, we thank you for being the backbone of this book.

Beyond the persons whom readers meet in these pages, we owe special thanks to Roz Wyman for so generously opening her home for the discussion to be found in Part 3. While the chapters devoted to the women most directly responsible for making this book possible highlight their contributions, particular thanks as well for invaluable assistance are due Jane Alexander, Blue Andre, Candice Bergen, Kathy Bonk, Elinor Donahue, Nora Ephron, Fern Field, Lillian Gallo, Lisa Goldberg, Bar-

bara Hall, Karen Hall, Marsha Hunt, Carol Isaacs, Irma Kalish, P. K. Knelman, Emily Laskin, Rosanna Levinson, Margery Link, the late Shelly List, Lynn Littman, Diana Meehan, Beshetta Merritt, Marsha Mitchell, Marge Mullen, Laura Oaksmith, Linda Seger, Lail Stegal, Sally Steenland, Susan Sullivan, and Jane Wyatt. A very special word of appreciation is due our friends Fay Kanin and Lynn Roth who were always available to listen and suggest. Several men, many of whom are mentioned in the pages to follow, provided introductions, information, and insight: the late Harry Ackerman, Alan Alda, James Brooks, Allan Burns, Jonathan Estrin, Rick Gitter, Gary David Goldberg, Bob Jeffords, Norman Lear, the late Dick Levinson, Bill Link, Delbert Mann, Garry Marshall, the late Frank McCarthy, Horace Newcomb, Bill Persky, the late Gene Roddenberry, Barney Rosenzweig, Jay Sandrich, Van Gordon Sauter, Ron Simon, Harry Thomason, Paul Witt, and Russ Woody.

Organizational support has come from the National Organization for Women, the National Commission on Working Women, the American Broadcasting Company, the Markle Foundation, the Virginia Foundation for the Humanities and Public Policy, the University of Richmond, and WCVE-TV in Richmond.

Very special and personal appreciation goes to Carol and Marcus Weinstein and Gilbert and Fannie Rosenthal of Richmond. We are grateful as well for the constant support of the University of Richmond Library staff. Further, we have been helped in defining the feminine perspective by University of Richmond Professors Holly Blake, Elisabeth Gruner, Suzanne Jones, Carol Oakey, Miranda Shaw, Barbara Sholley, and Ladelle McWhorter. Wendy Levy in the English Department has always made time in her busy day for typing, mailing, telephoning, and a hundred other tasks that move far beyond routine secretarial tasks. She has been a true colleague in this endeavor.

In California the assistants in the offices of *Murphy Brown,* the American Film Institute, and Marian Rees Associates have always been willing to stop for a moment, and often longer, to furnish us with a name, a phone number, or some other valuable piece of information.

Our wives, Ilia and Norma, have amassed more frequent-flyer miles and telephone conversations than they care to remember. Without their support and critiques all this would have been impossible.

Special thanks also for those dozens of persons of good will who attended one or more of the six national conferences that we planned and executed from 1978 to 1992. And finally, and most particularly, to our colleague and friend, Jane Hopkins, a full partner in two of those gatherings, a very sincere thank you.

Unless otherwise noted in the text, the quotations from the principals in this study are taken from interviews the authors conducted.

✦ Introduction ✦

We begin by exploring stories from network television's first twenty-five years in order to create a backdrop for the examination of women in television production over the last twenty-five years. Our research confirms that a defining moment for the changing role for women in the television business came with the decision by the Equal Employment Opportunity Commission, in the early 1970s, to apply its regulatory power to the employment of women. Much of the testimony from the producers we have interviewed harks back to the early 1970s, and the evidence is overwhelming that television network hiring policies concerning women began to shift in that time period. But change did not occur quickly or without massive resistance from the male establishment.

In all candor, we did not recognize that fact as we began our content analysis of prime-time network television in 1975. But in the course of conducting a series of six conferences in the 1970s and 1980s on the subject of broadcast television, we became more and more focused on the subject of women in the medium—both the image of women on screen and their participation in the industry.

Our investigation has always been driven by the women in the business who have become our colleagues and friends and who have spoken fully and frankly with us. Readers will hear their voices. Sadly, space restrictions have caused us to make choices from a much larger contingent of highly successful careers in television production.

We are satisfied that our selection of subjects for this inquiry has not been random, but it certainly has been influenced by networking with a growing number of women producers. In the process, choices had to be made. A reader may find an omission egregious. We understand this as the challenge every recorder of events faces. We have attempted to offer exposure to some of the best professionals and some of the variety the

medium has to offer. That said, other persons with equal stature might have been chosen for inclusion. We leave that task in the hands of others, hoping that what we have begun will bring to light the growing cadre of talented female producers in numerous other studies to follow. One person in particular is missing from our inquiry because she declined to be interviewed. We accept, with regret, that decision by Linda Bloodworth-Thomason, since *Designing Women* was such a significant event in the portrayal of women on television.

We know that there remain significant vestiges of a white male system firmly in place. Some barriers have crumbled; others continue to resist change: in many ways the glass ceiling seems still in place. In November 1986, Women in Film, through its first Annual Luminas Awards, directed attention to the steps already taken by commercial television in reflecting positive images of women. At that ceremony a goal was stated: strive for a time when the awards will be obsolete. That time has not come, as witnessed in the presentation of the second annual Lucille Ball Award by Women in Film in 1995, an award described by Bonny Dore as being "created because we felt that Women in Film needed to sponsor something totally for women in television." The heartening news is that there appears now to be a critical mass of powerful female producers affecting the look of television. Our primary caveat in 2001 is the growing evidence of harm to independent women television producers wrought by the ill-conceived decision of the 1995 Congress to abolish "FinSyn," often mentioned in this volume. The Financial Interest Syndication Rule (FISR), known in the trade as FinSyn, was abolished after successful lobbying by the networks. The effect of that decision is widely acknowledged among our interviewees and has contributed to the growing power of the networks to the detriment of independent producers. The modifications to the Communications Act of 1934 were similarly motivated, with similar unfortunate results. This new insult to entrepreneurial producers in favor of megabusiness began as a strong trend during the Reagan administration, and continues with such recent mergers as Disney/ABC and the Time-Warner/AOL.

Our focus is narrow, concentrating on female television producers. "Producer" is a very slippery title, with numerous manifestations over the past quarter century. All of the women interviewed or otherwise quoted bear that title, but each will tell the reader what being a producer means to her.

As two men seeking to present this perspective on women in the medium of television, we hope to construct a foundation upon which others may build. For us the focus is upon the words we have heard and recorded against the backdrop of a series of critical events in our nation since 1972. This is a first serious look at a representative group of women

producers working in that era from their point of view. It rests with others to interpret, if they choose, these ideas in terms of feminist theory. That is not our task. We work as historical and literary critics within the frame of our disciplines, History and English.

In the thoughtful and provocative words of over two dozen female television producers, each chapter addresses different types of producers while remaining focused on the second unifying fact: all are women. We record the independent producer, the network producer/executive, the actor turned producer, the writer/producer, the line producer, the sheltered producer, the studio executive producer. For a few, the production credit might be considered fringe to their other roles in the industry. In our minds the order of the conversations has a logic which allows us to respond to the historical backdrop and which places each participant in the most appropriate setting to be heard and understood.

The remarkable unity one finds in the stories related is enhanced by different personalities engaged in a common cause, telling good stories that reflect a vision, regard for quality, and character. As the reader listens to the uninterrupted three-hour discussion which comprises Part 3, the terms "vision," "quality," and "character" become common themes for all the women whose words will bring to the reader an accurate sense of their work.

What follows bears our names and we do not shirk responsibility for the content or our commentary herein: we have participated fully in hundreds of discussions on the issues we have addressed here. But the ideas you read and the voices you hear are almost exclusively those of women who have consented to allow us to be the conduit for their concerns, insights, opinions, and dreams.

Finally, we learned in the preparation of this volume that time can become an enemy as authors polish the final draft involving so many different persons in a complex and changing industry. When we first undertook the task of composing this work the three dominant television networks were in almost total control of the medium. We are now in the year 2001 and significant change has occurred both among the women we have cited and among a new generation of women producers. In addition, television itself has been transformed into a megabusiness controlled by persons who appear unfamiliar with either television's history or its unique character.

In those heady days of the 1970s a cozy relationship between the three commercial networks and the Federal Communication Commission kept competition even from PBS at bay. Within a few years all that had begun to change. In 1981 we were invited to attend an annual conference on television sponsored by the networks and lavishly laid out at the resort in Keystone, Colorado. President of NBC Fred Silverman was days

away from departing that position and the talk in the corridors focused on the fear that NBC was likely to fold. Because of the wisdom and leadership of Grant Tinker as the new president, NBC not only survived, but thrived on the new comedy, *The Cosby Show*, co-produced by Marcy Carsey (see Chapter 6). But the salad days of network television were at an end. "Broadcasters" have largely been replaced by CEOs generally reflecting the primacy of the bottom line over taste or quality. The once proud legacy of Sarnoff and Paley and Murrow lies in the dust as over-air networks have been gobbled up by the likes of Disney, General Electric, Fox, and Time-Warner. The internet, cable, and their progeny represent the new century and within a decade or two there may well be no such thing as television broadcasting. The dramatic arts on television as practiced with the twentieth century technology may soon be a relic to be examined on the History Channel.

This being said, many of the women we came to know and interview are involved in this transformation, often as major players.

The evolution of television about which we are speaking can be seen in sharp relief in the newly announced women's cable network, Oxygen. It was launched in January 2000 by Geraldine Laybourne, Marcy Carsey, Tom Werner, and Caryn Mandabach. Interviewed in February 2000 by Leslie Ryan of Electronic Media, Carsey was asked whether there is still much room for an independent producer in television. She responded: "It doesn't seem so, does it? There's no reason why there wouldn't be. Just because there's lots of vertical integration going on, it seems to me that independent producers could still flourish within that system. So there's nothing inherent in that vertical integration that would disallow independent producers, and I think it would be very valuable if these companies actually used their resources to promote independent voices." However, she also noted that it "would be very hard" for a company like hers, completely independent, to be formed today without a studio saying they want a chunk of the company.

The discussion moved to network involvement and Mr. Werner commented, "All things being equal, a network is going to pick the show that they have a profit percentage in. If I were running a network I'd be dishonest if I didn't do that as well. So we just have to assume that there will be a place on the (schedule) for hits." In fact, that observation confirms the analysis of the impact of FinSyn on the independent producers affirmed by most of the women we interviewed.

Returning to the new network, its primary impetus came from Gerry Laybourne. In a wide-ranging interview with CNBC on 9 February 2000 she commented: "As I thought about what was missing in the world, I thought that in this new millennium, what was missing was a new voice for women, by women, for women. And that's what Oxygen

is. So it's a combination of the internet and television. It's not really a television brand; it's really both. And we believe in convergence and we believe in women, and we think we have something to offer." Pressed on the future prospects for the venture, Laybourne asserted: "We are close to ten million subscribers right from the get-go. And the contracts that we have in place put us at twenty million by 2001 and thirty million in the subsequent year. . . . And it's because there isn't enough stuff for women. I mean, cable operators understand that women are paying the bills . . . and that they watch more broadcast television than men, but less cable television. So all you have to do is look at the numbers to see that they're underserved."

Asked about the nature of the programming, Laybourne noted: "It is a big challenge. And we made a decision early on that we should do what we know best, which is program a network for women who are taking charge of their lives, pro-active about their lives, who have a sense of humor. And we know that our sense of humor won't appeal to all women. But you know, . . . humor is what helps you breathe; humor is what makes you creative. . . . [T]hat's really important to us."

Part 1
History and Contexts

1

✦ DISTINGUISHED WOMEN IN THE EARLY DAYS OF TELEVISION ✦

Partly as a result of being disenfranchised, women executives have traditionally had to fight hard for things they believed in.
—Nora Ephron

IN MARCH OF 1776 FOUNDER ABIGAIL ADAMS ADDRESSED HER HUSBAND, JOHN, admonishing him and his comrades, in their deliberations over a new nation, to consider the rights of women. She wrote, "That your sex are naturally tyrannical is a truth so thoroughly established as to admit of no dispute, but such of you as wish to be happy willingly give up the harsh title of master for the more tender and endearing one of Friend."[1] As James Madison's 1787 Notes on the Constitutional Convention make clear, he and his male colleagues were oblivious to her admonition, nor would they likely have trembled at Abigail's warning that "If particular care and attention is not paid to the Ladies we are determined to foment a rebellion, and will not hold ourselves bound by any laws in which we have no voice, or Representation."[2] We can only imagine how horrified she would have been that when armed rebellion came it was not on behalf of the disenfranchised, but on behalf of slave owners. The remarkable leadership of President Lincoln turned that conflict into a battle for human rights. And, as the twentieth century dawned, the inheritors of Abigail Adams's spirit were near to her goal. On 18 August 1920 the Constitution was amended to affirm women's right to vote.

However, the amendment did not make equal rights a reality, and women and men alike know that the democratic promise remains unfulfilled as the new century arrives. Abigail Adams's words continue as an unsettling reminder of unfinished business. She was cautiously hopeful

when she wrote, "Men of sense in all ages abhor those customs which treat us only as the vassals of your sex."

Over the years, both in our public presentations and in our writings, we have suggested that a thoughtful examination of this unfinished national agenda is a natural activity for leaders in the television industry and for critical viewers of the most popular art. There is a continuing opportunity for television to encourage and stimulate the nation in developing the full promise of a more perfect union; little in the current climate surrounding network and cable operations suggests that such a goal has a high priority among executives. While an occasional "cause" may grip the various facets of the television industry, evoking syrup and tears at grand awards ceremonies, the daily diet of television fare belies any serious concern for equality of women and minorities in the body politic. Indeed, as we will demonstrate in the pages that follow, much of the slow progress toward parity regarding women in television, evident in selected network television by the late 1980s, has stalled in a medium more and more controlled by cable offerings. Nevertheless, television has, in its sixty-year history, come a very long way.

The business of television was an extension of a radio industry that came to full flower in the years just prior to World War II. In those years women found a singular opportunity to advance at least a few careers in the new format of the soap opera. From *Portia Faces Life* to *Ma Perkins*, these daily broadcasts were aimed at women, in homes across the nation—perhaps with a child home from school with a cough or a fever—listening to those stories in rapt fascination. The "soaps" were followed in mid-afternoons by numerous adventure programs aimed at young boys, arriving home from school, who listened to *Jack Armstrong, the All American Boy* and *Captain Midnight*. These fictional characters were frequently drawn from comic books, a major fad at the time. In the evenings, Sunday through Thursday, the usual fare, drama and comedy, focused upon adults, but with children, boys and girls alike, definitely in the sponsors' minds (e.g., Edgar Bergen, Charlie McCarthy, Jack Benny, Fibber McGee and Molly, The Great Gildersleeve, Bob Hope, Fred Allen). From 1935 to 1945 vast numbers of children heard voices that would be embodied a decade later on television.

Those radio programs portrayed, in most instances, the patriarchal family model. A fair representation of the African-American population by the networks was never in evidence. *Amos'n'Andy* was the most conspicuous image of African-Americans to be broadcast. Depicting the lives of men and women in Harlem completely through the eyes of White writers, actors, and executives, it was an egregious caricature of life in African-American homes and communities. In the early 1950s, CBS would remove the television version under pressure from the NAACP, whose

lawyers were vigorously pursuing, in the Supreme Court, an end to racial segregation in public schools. The authors of this volume listened regularly to *Amos'n'Andy* in the 1930s and 1940s, entering college just as it moved to television. There is no doubt in our minds that it had an effect upon our perceptions of African-Americans, and it was not a good one. Beyond that, children of that era were exposed to extreme stereotypes of African-American women.[3]

Sports was a significant weekend event which radio beamed to men and boys. In the years immediately following the end of World War II, radio transformed college sports and encouraged educational institutions to spend more and more for athletics. With the advent of television, college football and basketball were on their way to becoming multi-million dollar ventures in support of semi-pro teams allied with the networks and sporting-goods conglomerates. For the most part, little attention was focused upon female athletes until the 1970s, when the government began to pressure colleges and universities to provide equal treatment to women's sports. By that action women were allowed to become college athletes who could be marketing tools to sell shoes. There is little doubt that radio was the pioneer in the corruption of higher education in the name of profit.

Finally, news became a significant part of the radio day. In the 1930s and 1940s, millions of citizens met President Roosevelt at his fireside chats. With the onset of war in Europe, the news took on an ever more significant role and, after 7 December 1941, the content of the evening dramas and comedies was directly affected by what was now "our" war. As nine-year-olds, we heard and still remember that fateful Sunday when we learned about Pearl Harbor. In those years the adaptability of radio to transmit the sounds and feel of the war in Europe was best exemplified by the words of Edward R. Murrow. You could feel the event as he spoke to us during a German bombing raid: "This is London." Of course, in keeping with the times, war for Americans was defined as the "men" protecting our democracy in defense of the innocent women and children. The WACs and WAVEs were "auxiliary" to the war effort. On our continent we were close to the conflict's horror only through the unending telegrams informing mothers and fathers of the death of their sons. The harsh realities of the conflict felt by the populations in almost all of the European nations had a quite different and lasting impact upon them. As the war engulfed all of Europe, women were regularly seen as heroic figures rather than as victims in the face of war and destruction, taking their place alongside the men.

In the United States the end of armed conflict resulted in the displacement of women from "war work" by the returning soldiers. Women were urged by the government to go back to the home to act as wife and

mother. The same government that had urged women to enter defense work was telling them, by 1945, to go home to do what women are supposed to do—cook, clean, and rear children. Even the growing number of women for whom this was not a reality were swept up in this harsh discrimination. The new mass-produced houses that comprised Levitttown, New York, quickly becoming a model across the nation, was the perfect mirror of that mentality. The houses and their location prescribed a "traditional" picket fence world with father off to his commute to the office while mother tended the children and managed the home. With quickly developing shopping centers the gulf between the "downtown" and the suburbs rapidly widened.

That perspective was given impetus through a major influence on public opinion in the years following World War II in a theater film short series called *The March of Time*. With the stentorian voice of Westbrook van Voorhes accompanying what we now know were staged docu-dramas, Americans were instructed on how women were supposed to behave in a time of peace. A particularly revealing example of this audience manipulation was a 1948 *March of Time* episode, "The White Collar Girl." This film purported to be a look at postwar women at work and it is doubtless true that a large percentage of the audience believed themselves to be watching honest news reporting from the company that published *Time* magazine. Today viewers appear to believe the same about *Forty-eight Hours, Sixty Minutes, Primetime Live,* and *Oprah.*

"White Collar Girls" opened with the statement that one in every four persons employed in American industry is a woman. "It is no longer a man's exclusive world." To "an ever growing list of jobs they bring qualities of patience, applicability, adaptability and charm." And white collar girls were "energetic, competent and purposeful." Among the successful women listed was Frieda Hennock, noted below as the first female appointee to the Federal Communications Commission. The film chose to highlight women seeking jobs in the fashion industry and featured the 1948 graduation ceremony of a prominent School for Fashion Careers, at the Waldorf-Astoria.

The audience is reminded that career girls must start at the bottom of the ladder. We learn that dresses that will not shrink cost $14.95 and that career girls earn about forty dollars a week. But there is "unexpected help" when a man takes a girl to lunch and he pays. These women, we learn, are motivated by success, power, and material compensation. "Every woman likes to feel that when the state of her morale or wardrobe calls for a new hat or new dress she can afford to buy one without asking any man's permission."

At this point the camera moves to film some women in exceptionally drab apparel as we are told, "To many career women, especially to teach-

ers who put up with pay and working conditions few others would tolerate, rewards of career are of less concern than the inner satisfaction it offers. No women are more tireless than teachers with low pay." Still true!

In the midst of these various turns the announcer informs the viewer that "Today, for the first time in U. S. history, the married women who are wage-earners outnumber the single women." Early in its history the television networks and advertisers made massive use of this fact.

As the film drew to a close it offered a striking image in the following dramatized exchange:

Husband: "I think that job's taking too much out of you, why don't you give it up?"
Wife: "And what would we use for money? You don't earn enough to pay all the bills and we couldn't get along without my salary."

The final segment of "White Collar Girls" reminded the theater-goers that gender equality remained quite distant. The scene was an actual radio show presided over by John McCaffrey on WOR in New York. The show "What Makes You Tick" involves the emcee, a guest (Miss Bates), and two psychologists. The psychologists had the job of listening to a three-minute interview with Miss Bates and then rating her on her determination to be a career woman. To summarize, Bates is asked how confident she is with superiors at work. "Pretty confident." She is asked "Do you ever tell off your boss?" "Not too often." How does she handle emergencies? "I'd be able to manage most emergencies." Did she feel women have too much talent and ability to waste on a home and children? "Yes, I think many girls do. Some girls have a great deal to offer and they certainly don't make any contribution to the business world sitting at home with the children or cooking dinner for their husband. Many talented girls desire a better life than that. They need that feeling of independence of competition that they don't get at home. They deserve the luxuries they can buy with the money they earn."

The emcee moved to a second range of questions. Would Bates give up her career if a man proposed marriage? "No." "Even if your dream Prince Charming were the man?" Bates replies, "I haven't met him. I don't think I'd give up my career even so." Does she read love stories? "Occasionally." Does she picture herself as the heroine in such stories? "Yes, I do sometimes." McCaffrey then pounces, "Then you have thought about yourself in the character of a wife." The reply: "I have, but in a very detached sort of way."

McCaffrey turns to the "experts" who tell Miss Bates that out of a possible 100, she has scored a 62. After all, they say, she has "a definite

yearning for romance." The other panelist opines, "Miss Bates's determination to continue with her career obviously has not yet been tested." Then we are shown an audience wildly applauding this foolishness, the same kind of applause that now greets guests and host on numerous daytime talk shows.

The film ends with the narrator asserting, "And in spite of traditions and prejudices which have tended to keep them in a subordinate position, many of America's white collar girls have won at last what they sought long and hard—fame and fortune in what was once a man's world. Time Marches On!"

A new generation of women would have to face these stereotypes in the media as they were transferred to television. And, unfortunately, the United States population took little time to ponder such questions respecting women in the work force before it was plunged into postwar realities and myths that would dominate public discussion for thirty-five years. The greatest obsession was fear of Communism in what we knew as the "Cold War." Those of us who lived through that era know that the media were almost entirely dominated by men. It was an era made for the cloak and dagger mentality of men like J. Edgar Hoover, John Foster Dulles, Joe McCarthy, Richard Nixon, Billy Graham, Fulton Sheen, and Cardinal Spellman. The prominence of the clergy in this list is testimony that the Cold War was being promoted as a "holy" war. God was a warrior. And television was there to help him. Women like Senator Margaret Chase Smith of Maine, the first senator to challenge the outrageous behavior of Senator Joseph McCarthy, and American United Nations Ambassador Eleanor Roosevelt were viewed as anomalies. It is against this backdrop that we must start our inquiry into the role of women in the early years of what Horace Newcomb has called "the most popular art."

By 1952 the nation was captured by a sense of nostalgia. Looking back, the citizens elected our World War II leader to the presidency. In some ways the United States did not really enter the twentieth century politically until 1960, when it elected a macho president who seemed mesmerized by the group he labelled the green berets in 1962, used women with reckless abandon, and left Vietnam as his most lasting legacy. For a brief period in Lyndon Johnson's administration concerns about equal opportunity emerged, but it was not until the election of Jimmy Carter in 1976 that the nation had a leader who genuinely championed equal opportunity for women and Blacks in the twentieth century, thereby bringing us into greater harmony with the Twenty-first Amendment (1921) and "Brown v. Board of Education" (1954). Bill Clinton, with all his foolish and destructive sexual antics, is the second president to understand that quest for equality.

With these thoughts in mind, we offer a dual focus on our subject. We begin by examining a selected history of television as it has related to women in the industry from 1948 to 1972. Second, in the remaining chapters, consuming the balance of the book, we offer case studies of women in the industry of television, most of whom came to the networks after 1970.

The first twenty-five years of television's history is—as radio before it—almost exclusively the story of men shaping programming without evident regard for equality. Even as late as the mid-1970s, Twentieth-Century Fox executive Nancy Malone described the reality quite effectively when she commented in a 1975 interview with us about a gathering of television executives in New York. "There I stood in this room, invisible, just invisible. There was only one other woman without a husband in the room. . . . They [the men] had trouble relating to us as women and they were uncomfortable relating to us as executives." Commenting on the same time period, Tandem/TAT executive Virginia Carter has a similar story of invisibility. She recalls a meeting in the office of a high-level network executive where she was the only woman in a group of six or seven. As the group entered the room the host solemnly shook hands with each of the men and simply ignored Carter.

That was the reality as television celebrated its twenty-fifth anniversary. Of course there were the exceptions and it is to them that we turn first.

There are no convenient dating schemes by which to outline our historical survey. In 1946, television was a landscape inhabited by the Dumont Network and NBC. The former was on the air three hours a week and the latter eight hours—five of which were devoted to live sports events. In 1947 the numbers were five hours and thirteen respectively. Then, in 1948, an almost full evening schedule was offered by NBC, Dumont, ABC, and CBS.

With the new medium in place, the Federal Communications Commission expanded its role beyond radio as it became totally involved in the regulation of the new medium. In 1948, President Harry Truman appointed Frieda Barkin Hennock as the first woman to serve on the commission. At the first meeting that she attended the commission chairman, Wayne Coy, simply insulted her: "We've had rectitude, fortitude, and solemnitude, but never before pulchritude." (*Time*, 19 July 1948, p. 65.) One can imagine the "suits" chortling at that feeble introduction even as they likely smiled condescendingly at Hennock's serious challenge: "It seems fundamental that in this field—so peculiarly affecting women—the viewpoint of their sex should be presented." In 1955, in his book *Clear Channels*, Max Wylie[4] commented on Hennock: "Though a slender woman and very good-looking (especially when considering the work she's in), she has held the big stick over entire networks, while

beckoning with her free hand for the educators to come on in and get noticeably busy." (*Clear Channels: Television and the American People*, 1955, p. 213) Such remarks as those of Coy and Wylie suggest the tremendous challenge Frieda Hennock faced as she became the single most articulate FCC member on behalf of educational television.

And who was Frieda Hennock? Born in Poland in 1904, her family emigrated to the United States where her education included a degree from Brooklyn Law School in 1924. She moved from the practice of criminal law to corporate law, where she had a distinguished career that caught the attention of President Truman. In her seven years on the commission she was responsible for persuading the FCC to reserve channels for non-commercial television stations, the forerunner of public broadcasting. She accomplished this by first dissenting from the majority of the commission when it refused to set aside channels for educational purposes. A vigorous campaign by Hennock that included a large number of national interviews on radio and television set the stage for an FCC hearing in 1950 on the allocation plan. A large amount of data and evidence was offered by educators at the hearing, sparked by the efforts of Hennock that found almost no programming on commercial television that could be considered educational.

Hennock used the testimony of the educators to create her case for channel reservations. When the FCC published its new rules they included such reservations for education. Writing in the *Encyclopedia of Television*, Lucy Liggett noted "Still, it was not clear that these were to be permanent. Hennock wrote a separate opinion urging that reservations for non-commercial stations should be permanent." The FCC report for 1952 included 242 channel reservations for non-commercial stations. Without Frieda Hennock it would not have happened. She was often outspoken on the issues that came to the FCC, none more interesting than as the single negative vote in the approval of the merger of ABC and United Paramount Theaters. One can only imagine her comments on the recent ABC/Disney merger.

Describing her efforts on behalf of education, she wrote, "We need programs which will emphasize our great cultural heritage; we need programs which will effectively prepare and assist our people to assume the responsibilities of citizenship in a great democracy. The way to do it is to have noncommercial interest an integral part of radio and television. And it is on the educators that I lay the principal burden for doing this." (*Clear Channels*, p. 168). In 1953 Hennock was invited to speak during the premier broadcast from the first educational station, KUHT-TV in Houston. Her reward for her pioneering efforts was a refusal by President Eisenhower to renew her appointment to the FCC in 1955. This rebuff—amounting to a disenfranchisement of her point of view—was

predictable since she had been a severe critic of violence in television programming and angered many broadcast executives by warning of the growth of monopolies in the industry. Indeed, apart from the education channels issue, she wrote several dissenting opinions challenging FCC actions. The maverick was replaced by a team player, Richard Mack, who left the commission in disgrace, charged with selling his vote in a Miami license contest. The thin female line had begun to manifest itself, and it was seen and treated by industry leaders as a threat.

While Hennock was confronting fundamental issues in the society, the television industry and the public were fixated on such matters as female clothing and necklines. Faye Emerson became a megacelebrity by way of her plunging necklines; and when Lilli Palmer began her new TV show in 1951, *Time* seemed most impressed with the fact that she "also blazed a new trail by wearing an evening dress that modestly covered her neck, shoulders and bosom. This was a precedent-shattering break from the tradition. . . ." A writer for *Portia Faces Life,* Mona Kent, seems to have been on the mark when she commented in 1949, "When I think of that big, listening ear out there, I think how wonderful it would be if some writer could find a formula for giving women the substance and not the shadow of life" (*Time,* 12 Sept. 1949, p. 72).

Perhaps the most striking remark about women in television in those years came from Martha Rountree, founder of *Meet the Press,* when she commented in 1954 on how women might succeed in the television business. "A woman has to consider every new idea very carefully before she makes a decision. If she acts too quickly, men call her emotional. You have to treat suggestions like you were considering suicide There is no turning back" (*Time,* 3 May 1954, p. 66).

What we know from the record is that beginning with the earliest days of television network decision making, women were rarely in the board rooms. And the product communicated to the American public reflected only a tiny role for women in writing, directing, and producing.

To be sure, there were dozens of women in prominent starring roles in popular comedies and dramas after 1948, but the production credits included only a minuscule number of females. It is to these hardy pioneers we now turn.

In the beginning there was Gertrude Berg. She had created the character of Molly Goldberg for radio in the early 1930s, and in January of 1949 she introduced *The Goldbergs* to CBS television audiences. Her autobiography, *Molly and Me* (1961), chronicles her success and her control of the series which lasted until the fall of 1954. She and her son Cherney defined that series on television; it was a Berg production. She remembered that "America, in those days, was the land of opportunity, and everybody who lived then seemed to sense it. The country was not

only full of opportunities but of optimists who knew what the knock at the door meant" (p. 66). Berg sought to relate Molly to her European background by noting that "she became a person who lived in the world of today but kept many of the values of yesterday." Molly could change with the times, as did her grandmother and her mother, but she had some basic ideas that she learned long ago and wanted to pass on to her children. "Next to the Constitution of the United States, the Ten Commandments came first" (pp. 190–91). Berg revealed something of her intention for the series when she commented, "I didn't set out to make a contribution to interracial understanding. I only tried to depict the life of a family in a background that I knew best. The reactions of the people who listened only showed that we all respond to human situations and human emotions—and that dividing people into rigid racial, economic, social or religious groups is a lot of nonsense" (p. 218).

Gertrude Berg created an image of a wise, humorous matriarch, charmingly mangling the language, directing her family with care and determination. Molly was the family authority, a multidimensional character who assumed control. Jake, her husband, was the dutiful father who knew that in their household Molly made the decisions. But he was not irrelevant. He ran the family business well. In real life, Gertrude Berg ran the business.

It was tragic that her series should become the focus of a nasty crusade in 1951 to purge persons from commercial television who were rumored to be Communists. That crazed movement against American citizens meant that the biggest decision concerning her creation was not hers to make. Frightened men of power in the advertising and broadcasting businesses—General Foods and CBS—combined to abandon the show that year because the hate-driven publication *Red Channels* listed Philip Loeb as a Communist sympathizer. Loeb played the part of Jake, Molly's husband. In Loeb's case, as in most others, there was no evidence, but TV executives and elected officials did not care. From that era came the term "blacklisted," which meant unemployment. Unable to perform, Loeb experienced depression and finally in 1955 took his own life. Berg had reluctantly agreed to the firing of Loeb, stating that any other decision would have meant the loss of employment for an entire company. Following that decision NBC offered Berg a new home in 1952. Loeb was expendable and was replaced.

We believe that the atmosphere of fear and saber rattling, with attacks upon the Bill of Rights, affected television not only in the case of *The Goldbergs*, but in programming for a decade thereafter. Television became a means to foment fear. As Ring Lardner, Jr. noted, the only kind of drama allowed on television was either focused upon the cold war or on some tiny niche of reality like *Marty*.[5]

Except for *The Goldbergs*, early television reinforced a style of a traditional American family with the wife as catering to the will of the husband. An example is *Mama* (1949–1956). It presented an old-world perception of marriage as a division of labor, the husband bringing home the money, recognized as "head" of the family, and the wife dominant at home where the father neither challenged her authority nor volunteered assistance. Unlike *The Goldbergs*, Maxwell House Coffee, sponsor of *Mama*, injected the American twentieth-century image of women when it featured Peggy Wood, in the lead role of Mrs. Hansen, brewing a pot of coffee. The male voice-over told the viewer that the role of the mother was to "please that man of hers with a good cup of coffee." Stove Top Stuffing, White Cloud, and Cascade carried on that tradition well into the 1980s.

But it was to be the second generation of family shows, originating in the 1950s, all produced by men, when the dependent housewife was most clearly affirmed in *I Love Lucy, The Danny Thomas Show, I Married Joan,* and *The Donna Reed Show.* And even in the less blatant case of *Father Knows Best,* Jim Anderson says to his son, Bud, "Women are too busy thinking about themselves to notice anything else."

Television, in its infancy, was shaped by men in a society gripped by fear of the atomic bomb. By 1956, TV networks had access to over eighty percent of the population. With stations numbering over five hundred and with 40 million homes watching five hours of programming a day (Erik Barnouw, *Tube of Plenty,* 1975), the appetite for ideas and story lines was voracious. There were, of course, numerous female stars who had been or were on television series by 1956. But few followed the road of Gertrude Berg.

The film industry had brought to the screen in the 1930s and early 1940s a splendid array of talented female actors. By the late 1940s many of these same women faced the loss of star billing due to age, something few men encountered. This condition was exacerbated by events in that industry following the end of World War II in 1945. Roles for strong women characters diminished markedly, largely due to an age bias. Faced with that reality many female actors turned to television, which needed "stars" to attract audiences. For these women it was risky to "downsize" to television after illustrious careers as established or rising luminaries, but it was the best choice for many. As they began to seek television outlets for their talent, the most prominent male actors of their generation rejected offers from television because they were still good box office draws on the big screen.

Fully a dozen distinguished film actresses moved to television, including Spring Byington, Jane Wyman, Ida Lupino, Donna Reed, Betty Hutton, Barbara Stanwyck, June Allison, and Loretta Young. Lucille Ball had left film earlier to pursue a radio career and became the most prom-

inent woman on television in the 1950s. All these women commanded top billing in TV series.

The reader should not presume that such an age bias against women has capitulated to reason sixty years later. The October 20, 1999 issue of *The Hollywood Reporter* announced that one Kimberlee Kramer, age thirty-two, had created a new identity for herself as nineteen-year-old Riley Weston. The reason was simple: at age thirty-two she could not get work because she was too old. Creating a new identity and age quickly won a $300,000 contract from Warner Brothers Television. The *Reporter* opined, "People trusted Weston. She lied to them anyway." In fact "Weston" never existed outside the weird world of industry magnates. Frank Rich had a better take on the situation when he wrote in *The New York Times* of October 21st, "At last there's a liar we can all root for." In fact Kramer faced the same dilemma encountered by the Hollywood female stars of the 1940s, with one major difference. The latter escaped to television, the former had no such alternative.

But what of those high profile "stars" of the silver screen? Did the strategy work for them? As we note below, occasionally it did. Loretta Young found a whole new acting career while exercising more control than she—or any other woman—ever had in film. Ida Lupino was a film star whose career began in 1932. She created a new film career in directing and producing, beginning in 1949, and moving to television in 1953. However, for most women performers who made the switch, it was to act in a television series, the production of which was in the hands of men who fashioned shows that seldom broke new ground. Women's acting careers remained under the control of men.

We now turn to explore the careers of those few women who, for lack of a better word, controlled their television destiny beyond the script in hand. As a gateway to our study we have chosen to explore in some detail the careers of Loretta Young and Ida Lupino.

LORETTA YOUNG

The Loretta Young Show premiered on NBC in September 1953, exactly the same month and year that *The Goldbergs* faded from the NBC schedule. Young was the first genuine female movie "star" to enter television.

Even an objective commentator on Loretta Young's politics and "riproaring" (her own term for herself) Roman Catholic morality might be reluctant to describe her as a voice of feminist activism in her series. Yet she herself was a female activist, injecting her own voice into a series she produced and controlled. She described that control in a taped interview we held with her at her home in August, 1979. She affirmed that her power was derived from the fact that the network was happy to grant it,

because NBC was so glad to get one of the Academy Award winners to acknowledge television. Before signing with NBC, Young had a conversation with long-time colleague and friend, movie producer David O. Selznik. He told her that he loved her dearly but that television was the enemy of their picture business. She was warned—by him and others—that if she went over to the enemy she would not get any movie scripts. In fact, it was twenty years before she got another one. However, she told Selznik that she had to do what she wanted to do. She loved films but she reminded him that she had made millions for him and the studios. Now she was forty, she had won her Oscar, and she wanted to have a career that would really mean something to someone else. Implicit in all this was the anticipation that the choice of movie roles would change for the worse as she moved past the age of forty.

In spite of the warnings, and perhaps partly because of them, Young signed for her show, which would last until 1961. The series was a half-hour anthology, with a different story each week. While there were numerous guests, at least half of the eight seasons of episodes starred Loretta Young herself; and, except during an illness, she introduced every story and appeared at the conclusion. Two things distinguish her show from all other dramas of the decade. First, it was totally controlled by one person, a powerful female movie star. She told us that in the long run every producer and director who ever worked on the show ultimately deferred to "Loretta." Second, the series was consistently *about* something of consequence. She went into television to inject into the mainstream of life at least one good idea a week. She liked television because she saw so many threats to decency and "goodness" (her word) going on everywhere that she felt she could counter them by using this powerful medium. And indeed her show had a diet of moral and religious messages. Among other traditional values she promoted, she insisted that the traditional family was the core of the nation and she was seeking to make that point each week.

Her control of the production company, *Lewislor,* was complete, even though she carried the title of associate producer. Her husband, Tom Lewis, was involved in production for the first two years and was followed by John London who held the position for all but one of the remaining years. Young says he was excellent, a sensitive man who furnished a point of view that was healthily different from hers. But always the staff was reminded that they were cutting *The Loretta Young Show* and they had better watch *her.*

It does not appear that ego was the primary force here, but rather a burning interest in film excellence coupled with a personality that was comfortable only when she functioned freely, without inhibitions, in her business.

Young said the sponsors gave her anything she asked for. But she did not mean money. She made the shows for $30,000 a week, out of which her salary was to be taken. They gave her the money and she made the show and then gave them the finished product. She took $1,500 a week in salary, which she put back into the show. She noted that she was on record as receiving $10,000, but they would not have had a show if she had taken it. Other cost-cutting included the generosity of friends who worked in movie studio wardrobes and lent her the costumes.

The term "control" continually surfaced in our conversation. She did not want a stranger, presuming to know her business, trying to tell her what to do. In turn, having hired the best, and having directed them in what to do, she did not interfere with *their* duties but trusted them to do their jobs.

Part of the reason for the control issue lay in the moral content of the show. It was decidedly conservative politically and socially. But shining through it all was a powerful streak of concern over women's rights. She produced many episodes about the plight of women in a male-defined environment; and in the mid-1950s she addressed, in a sympathetic fashion, women working outside the home.

Ms. Young liked the anthological format because it was a challenge and because it was different. In some ways the anthology form was congenial to her purpose of dramatizing each week a new idea that she was attempting to get into the mainstream of life. In order to be successful in this mission she felt her company needed to cast the writers as carefully as they did the actors. Consequently, her point of view was always present, and yet in Young's mind, that was the very reason the show was canceled by Proctor and Gamble. She insists they did it because of the content of the movies she was making. The fight began in 1959, the year she received her third Emmy for Best Actress. According to Young the sponsor told her that the mail opposing her viewpoint was frightening them, but she refused to alter the content. Young believes that Proctor and Gamble dropped the show over political differences. While sponsorship was assumed by Listerine, Young contends that the debate over content had scarred relationships, resulting in cancellation shortly thereafter. She is convinced that facing issues cost her the show, and while she may be correct, it is also true that her series never was in the top twenty-five on the air; and in her final year, 1960–61, NBC had only four series in that top twenty-five list. The following year NBC captured nine of the twenty-five slots in the ratings that included new shows *Dr. Kildare, Hazel, Car 54, Where are You?,* and *Joey Bishop.*

A digression is in order here to explore briefly the statistical world of "ratings." From the beginning of the television era, network programming was subject to the overriding influence of ratings as generated by

Table 1.1 Data from National Audience Demographics Report, October 1977

	Households	working women	women	men
ALICE	23.2	17.2	19.9	15.4
ALL IN FAMILY	24.5	20.1	21.5	16.4
BARNEY MILLER	21.0	13.3	15.3	10.3
BIONIC WOMAN	17.2	13.6	12.6	12.0
CHARLIE'S ANGELS	26.0	23.0	20.3	15.8
FAMILY	21.7	14.9	18.5	10.9
HAPPY DAYS	29.7	20.6	22.0	17.3
LITTLE HOUSE	20.4	12.6	17.4	10.7
LOVE OF LIFE	5.8	2.0	5.0	.9
M*A*S*H	20.4	14.9	15.9	12.0
MAUDE	17.9	14.5	14.9	9.0
NCAA FOOTBALL	14.5	7.3	6.1	14.3
NFL MON. NIGHT	21.0	8.1	8.3	19.9
ONE LIFE TO LIVE	6.6	2.3	5.5	1.1
SIXTY MINUTES	22.4	20.1	18.2	18.4
SOAP	21.7	17.2	17.8	13.6
WALTONS	16.8	10.3	14.7	9.1
WORLD SERIES #6	25.9	9.3	17.1	21.1

the Nielsen Company. The company began broadcast audience research in 1936 with a new device, the "Audimeter." It provided "a mechanical link between the tuning dial on a radio receiver and a moving roll of paper" indicating the broadcast to which the radio was tuned. The Nielsen Television Index (NTI) was first employed in March, 1950. By 1966 the demographic data about audience composition was added to the collected information. By 1976 this had become a thorough household tracking report.

This tracking process separated the television audience according to a large variety of categories. A random sample of data from the NTI "National Audience Demographics Report for October of 1977" (*Nielsen Television Index,* A. C. Nielsen Co., Vol. 1) appears in Table 1.1 and provides a picture of the process. The study has an array of categories including working women, women, teens (male and female), lady of the house, men, and children. We have chosen five popular shows of that year to illustrate how male and female audiences responded. The numbers above are in millions.

When the classification "women" is separated into age groups, the most important is "Women 18–34," the group that spends the largest

sum of money and is therefore courted vigorously by advertisers. Comparing *Family* with 24.1 million viewers in that age group, with *The Waltons*, having 11.2 million for the same age group, one can understand why the difference in total households—21.7 to 16.8—has far less significance for potential advertisers.

This being the case, it is still a fact that only one of the series and specials listed above was produced and written by a woman—Susan Harris of *SOAP*. In the chapters that follow we will explore the perceptions about how that situation may have changed and how significant that change has been and/or will be.

Such figures as cited above, beginning in the 1950s, became sacred to networks and sponsors alike. Obviously, each network executive wanted to attract the largest audience to his offerings. But equally important figures focused upon the demographics. Who was watching? And which viewing block had the most buying power? The situation was somewhat fluid in the 1950s since most of the dramatic programs were produced by the sponsors. Each had its particular purpose revolving around its product. But in the aftermath of the quiz show scandals in 1959, the networks took control of the programming and quickly developed a scheme similar to that of magazine advertising. That is, the shows belonged to the networks and they sold spots to advertisers. In magazine publishing the advertising rate was determined by circulation, with both raw numbers of readers and demographics fairly easy to assess. One essential difference between the printed page and television is that magazines would be restrained by the logistics of circulation and sales. No matter how attractive it might be in theory to double circulation, the reality was that a too-rapid growth could undermine profits. In point of fact, a magazine like *Life* could risk its existence by overexpansion. In contrast, television costs were nearly identical no matter how large its audience became. Before cable there was absolutely no downside to rapid audience growth. If the CBS affiliate in New York saw its audience double every year, the cost of production was fairly constant. Having garnered a huge share of the available viewers, one might spend money on improvements in transmission and variety in order to hold the established audience. But in the 1950s quality was seldom an issue, and the huge influx of viewers beginning early in the decade was a financial windfall for networks and local stations alike.

Returning to our discussion with Loretta Young—she was, without doubt, the center of power of her show in a way comparable to her male counterparts at the time, and the single most obvious exception to the traditional male domination of television productions. With Young's departure from the medium it would still be two decades before a new generation of women would claim for themselves the kind of power she exercised.

Reflecting on television in the 1970s, Ms. Young told us she felt it was necessary now to have censorship in the industry; otherwise, "you would have pornography on the air." Young said Americans couldn't depend on Norman Lear and the ACLU for good taste. But even as Lear balked at network censorship in the 1970s, so did Young in the 1950s, as her long discussion about script control demonstrated. Her fights with the sponsors became Lear's struggle with the networks.

As we departed from our interview, Young reminded us that few writers have cared about female roles in society. There was, she said, a paucity of historical research. In the 1990s a new generation of female historians is creating that tapestry upon which talented novelists and television writers may draw to provide the next generation of female actors with the sorts of scripts that Ms. Young was forced to wrench from the current newspaper accounts of social crises involving women.

IDA LUPINO

The second luminary of American films to affect television was Ida Lupino. Unlike Young, her move to TV appears to have had less to do with a fading film career and more with the opportunities afforded in television for advancing her career as actor, director, and producer. Our intention was to interview Ms. Lupino for this volume, but sadly she died in August of 1995 even as we were exploring that possibility. Our assessment of her career in TV is culled from the best available scholarship on her work in film and television.

Her directing career in features began with *Not Wanted* in 1949. In 1953 she was highly praised for her direction of *Hitch-Hiker.* Was her obvious success repeated by other women of the time? Clearly the answer is negative. She "was the only woman to direct a visible body of films in 1950s Hollywood."[6] Annette Kuhn, who has edited a book[7] on Lupino's career, comments on the nature of her unique work. "In spare, pacey [sic] dramas set in dreary small towns and blue-collar neighborhoods of anonymous big cities, young women face up to and survive unwanted pregnancy, disability, bigamy and rape. . . . Lupino's stories are different in being, more often than not, told from the point of view of the woman."[8] She observes: "Lupino's is the least invisible face in an entire hidden army of women working in various media production jobs— scriptwriters, editors, continuity girls, and many more—at a time when women were meant to stay at home and polish the furniture." As to her career in writing, Kuhn quotes Ms. Lupino: "I never wrote just straight women's roles. I liked the strong characters. I don't mean women who have masculine qualities about them, but something that has some intes-

tinal fortitude, some guts to it."[9] In explaining her move to broaden her career, Lupino noted she was tired of "being typed the poor man's Bette Davis." By the time she entered the world of television she had broadened her career, "establishing herself as one of the key independent filmmakers of the period."[10] Indeed, most film historians, referring to this period, are prepared to assert that she became the only female director of her time.

After the mid-1950s her work was largely in television, but by no means exclusively. She specialized in westerns, action dramas and mysteries that included *Four Star Theater, Alfred Hitchcock Presents, The Untouchables, The Fugitive, Bewitched* and *The Bill Cosby Show.*

Evidence that she was in a special class among her peers is reflected in a 1987 story in the *Chicago Tribune.* "At her best, Lupino brought an unexpected depth to stock characterizations, filling out her roles with a manic, driven quality that could suddenly veer into a surprising tenderness and vulnerability."[11] She was named best actress of 1943 by the New York Film Critics Circle for her work in *The Hard Way,* but for the most part her work failed to garner awards.

But Lupino's career as an actress represents only part of her contribution to American film—and in the minds of many film historians, the minor part. In the late 1940s, frustrated with the roles she was being offered, she formed a production company with her then-husband, writer Collier Young; their first offering was to be *Not Wanted,* produced and co-written by Lupino, but when director Elmer Clifton suffered a heart attack a few weeks into filming, Lupino took over.

In the years that followed, she directed six more films for her company, and in 1952 became a co-founder—with Dick Powell, Charles Boyer, and David Niven—of Four Star Productions, a company that produced series for the fledgling television industry.

A final note is appropriate respecting Lupino's view of women in film and television. In her analysis of Lupino's body of work Annette Kuhn addressed this issue directly:

Feminist critics, too, have been less than willing to wave the flag for Ida Lupino: understandably, perhaps, in light of the comments she was wont to drop in interviews ("any woman who wishes to smash into the world of men isn't very feminine. . . .") But on the other hand, for a woman wanting to continue working in a very macho industry, refusing to call yourself a feminist might be deemed an astute, if not—by the values of a later era—a politically incorrect move. It certainly doesn't justify confusing a film-maker's work with her politics and then dismissing it, as did one 1970s feminist critic, for dealing with feminist questions from an anti-feminist perspective. . . .

For, in common with other women working in these male-dominated industries, especially at a time when being properly feminine meant never competing (at least openly) with men and when other women could not be counted on as allies, Lupino must have had a rocky path to tread to stay in work. In this light, her pronouncements that she did not care to order men around, that directing is not a job for a woman—not to mention her alleged delight at being called "Mother" on the set—ought to be understood for what they were—essential tactics for professional survival.[12]

Although Ida Lupino continued her active career into the 1980s, when *The Loretta Young Show* ended in September 1961 network television no longer had any series with a powerful female producer who actually made the critical decisions. It had been a thin line dating to Gertrude Berg in 1949.

At this point the reader might ask, quite understandably, what about Lucille Ball? Did she not own her company? The evidence is overwhelming that the production decisions on *I Love Lucy* were made by men, central among them being her husband Desi Arnaz. In a 1956 *Look Magazine* interview Lucille Ball identified her style: "I had to learn to lean, to be dependent. I feel sorry for us American women sometimes. We're brought up to take care of ourselves, to make our own way—and who needs it?"

This same attitude is borne out in the series itself. In a *New York Times* article (20 April 1958) Cecelia Agar went directly to the point when she wrote about the Ball and Danny Thomas series. "Both households operate in the Mediterranean tradition; the husband is absolute monarch; the household revolves around his way of life; his house is situated in the environment he prefers; he does not post a timetable of his comings and goings nor a map of his whereabouts away from home; each of his returns home is a boon conferred upon the rest of the inhabitants. The wife runs the house, rears the children, winnows out any possible source of irritation to her husband, and seeks to advance his career from what she alone sees as her place in the background." Technically, Ms. Ball was a producer, but the evidence throughout her career makes clear that she depended upon others (men in almost every instance) to care for the production tasks and the selection of material. Her portrayal of the comic character she created always focused upon her dependence upon men to make decisions. This was particularly clear in the stories developed on *I Love Lucy*. Thus, we pay tribute to her remarkable success and impact upon the medium, but we find scant evidence that she stands in the line of women who were challenged by the inequities of sexism in the television medium.

It is proper to ask, if, as the popular wisdom asserts, the modern women's movement began in the post-World War II era, why did television not reflect that fact? We agree with author D'Ann Campbell that the visible "movement" was still a decade away. In *Women at War with America* (1984), Campbell observed that "We can conclude that while the war certainly caused an increase in the average number of women employed, it did not mark a drastic break with traditional working patterns or sex roles. . . . There was no evidence of increased careerism and no indication that women's primary interest in home affairs was lessened." However, Campbell's thesis must be tempered to the degree that while many women were indeed happy to lay down their factory tools and return to hearth and home, public policy robbed thousands of working women of the right to pursue careers. Government propaganda after 1945 is a lesson in unrestrained sexism on the part of public officials. Women were told that it was patriotic to return home and give their jobs back to the men. Connie Field's 1980 documentary film *The Life and Times of Rosie the Riveter* has brilliantly exposed the collusion of media, government, and business in this massive propaganda campaign.

One other dimension of the Campbell study is worthy of note here. She writes: "When, in 1945, American women of various generations, classes, and races withdrew from choice positions in the labor market, picked up life as usual, and benefited from growing prosperity to devote time to their homes and families, they were not, in fact, returning to the world of their foremothers, but—consciously or not—reinterpreting it as a legacy for their daughters and granddaughters" (*Women at War*, p. 238). In some ways June Cleaver underscores that new dimension that Campbell describes. "The most valuable aspect of marriage for half of all American wives at mid-century was 'companionship in doing things together with my husband'" (Ibid).

Yet, even as June Cleaver represents, almost alone, some progress in her independence and equal status with her husband, Ward—a fact frequently affirmed on the show—she was imprisoned in cultural patterns that restricted options that would provide outlets for her talents. As she said to Beaver in one episode, "Girls today are becoming doctors and lawyers. They are just as ambitious as boys." June appears to have seen herself as encouraging those changes in which she was not to be an active participant. And it is certainly true that most viewers in the 1950s likely did not pick up on the nuances suggested here. Nor do we suggest that the producers of the show were conscious of that dimension. We are certain that the vast majority of the television audience would have seen June as the traditional white middle-class housewife living in the small picket-fence town of Mayfield.

For most series it was business as usual. Some of the most egregious

examples of the stereotyping of women for the purpose of humor came in shows like *Our Miss Brooks,* where Eve Arden played a teacher with only one thing on her mind—catching a husband. She "cruises the high school corridors on the heels of Bob Rockwell, . . . who is impervious to the most blatant advances from Teacher Brooks" (*Time,* 8 February 1954, p. 49). Similarly, in *Love That Bob,* Bob Cummings "plays a dame happy bachelor photographer whose major problems are to avoid marriage" (*Time,* 9 April 1956, p. 109), while degrading his secretary, played by Anne B. Davis, in a weekly sexist romp. Ann Sothern did possess the power to shape her show, *Private Secretary,* but she seemed content to let the men produce and direct, as indicated in a brief remark during the run of the series: "I just read the script and they shoot it." There is little evidence of concern for the working woman. Sothern's character was largely focused upon scatter-brained behavior in her job and an overwhelming need to "get a man." She remained little more than a cardboard stereotype, reflecting an attitude she voiced in 1953. "What I want," she said, is "a man who is 40, rich and Catholic. Then I'll quit the business in a second" (*Time,* 20 April 1953, p. 64).

What we discern from the facts at hand is that the potential women producers in television were firmly held in check by the male establishment and its mentality. This is illustrated by a 1960 book, *TV Guide Roundup,* which included an unsigned article entitled "Where Women Are Welcome." It is obvious that the writer had searched in all the nooks and crannies to develop a list of women active in television production. The article identifies Gail Patrick Jackson, executive producer of *Perry Mason;* Mildred Freed Alberg, producer with *Hallmark Hall of Fame* specials; Doris Ann, producer of *Frontiers of Faith;* Dorothy Culbertson, producer of *Continental Classroom;* Jacqueline Babbin, producer of *Armstrong Circle Theater;* Jean Kennedy, associate producer of *Open End;* Jean Hollander, producer of *Beat the Clock;* Geraldine Toohey, producer of *To Tell the Truth;* and Norma Olsen, director of program operation at ABC in Los Angeles. In the entire list there were only two women holding production jobs anywhere near the top level—Alberg and Babbin. It is a list that hardly warrants the writer's closing comment: "It should, by now, be perfectly clear that women are welcome in TV."

Returning to our survey of strong female voices, that thin-line link with the past was continued with the emergence of a third female voice in the 1960s, Marlo Thomas. On 10 September 1961, the last episode of *The Loretta Young Show* was telecast. On 20 September 1961, Marlo Thomas made her acting debut on *The Joey Bishop Show.* It was she who would carry on the legacy of Loretta Young.

As we searched for a bridge between 1961 and 1971, Bill Persky[13] directed our attention to Ms. Thomas, a young woman directly influ-

enced and driven by Betty Friedan's monumental contribution to the feminist movement, *The Feminine Mystique,* published in 1963. Thomas was raised in a traditional, father-dominated family but, always an independent spirit, she discovered her humanist voice in the aftermath of the Friedan book, became friends with Gloria Steinem, and created, with her father's assistance, her own sitcom, *That Girl* (1966–1971).

We interviewed Marlo Thomas in 1987 in her home in New York City, where she related to us her growth and development in the 1960s. "I had done a pilot for Universal and ABC, called *Two's Company.* It was with Paul Lynde and I played a model who had just gotten married to a young man named Ron Husman. Paul Lynde was the model's photographer. It was a wonderfully funny show done by Peter Tewkesbury, but it didn't make it. Edgar Scherick at ABC had said to me, 'Marvin Koslov and Bristol Meyers feel that you could be a television star, so we're going to look for an idea for you.' It was really Marvin Koslov who felt that they could sell Clairol with a young woman like me. They needed a way to sell hair products and they didn't have anybody in television to do it, and he was going to sponsor *Two's Company* because they felt it would appeal to young women. But then the show didn't make it and Marvin Koslov said, 'Find a show for her. She can be a television star. You find it and I'll sponsor it.'

"So they came to me and told me this. They said they'd come up with something, and if I thought of anything I should let them know. I hated having been sent *My Mother, the Car*—playing the wife of the guy whose mother was the car—and a whole lot of terrible scripts. I kept reading all these awful scripts, and I was so angry, I said to my agent, 'You wouldn't know what to do with Jean Arthur if she were my age right now.' They didn't know what to do with young comedy actresses. I thought, 'why don't they just do a show about a young woman who wants to be an actress and doesn't want to get married, has just graduated from college, whose father wants her to get married. I mean all the things that I was. Why not a show about that?' Well, I went home and wrote down that idea. Then I went in to see Edgar Scherick, a friend and prominent producer and said to him, 'OK, I hate all the ideas that everybody's sending me, here's my idea. What do you think?' I said I could get Bill Persky and Sam Denoff to write it—when in fact I didn't know whether I could or couldn't, but I'd already learned, by osmosis at home, how to deal in the television business.

"And I brought him the book *The Feminine Mystique,* by Betty Friedan. It had recently been published. I said, 'Now you should read this, because women aren't what they used to be, and you can't keep writing about women the way they used to be. You should figure out what women are thinking about now. You should really read this book.' So Ed

Scherick read the book, which I really admired him for. A couple of days later he asked me to come back in. The first thing he said was, holding *The Feminine Mystique*, 'This isn't going to happen to my wife, is it?' The book was only a year old and a lot of men hadn't read it. But I had read it, and most young women at that time who were thinking the way I was thinking were reading this book. This book was the beginning for a lot of us. It was all just starting to rumble, and it was like an earthquake. You knew it was your own earthquake. I think that's why they called it 'The Movement.' I mean, the earth was moving. A whole lot of women were saying, 'What's happening? Let me out of here.' So I took the idea to Persky and Denoff, and they said, yes, they thought they could write it and that was that. I went to the network and sold the idea which I had called *Miss Independence*. They thought that title sounded like a Cole Porter musical for the thirties. But that is what my Dad had called me as a kid so I thought it was suitable, but Persky's and Denoff's title, *That Girl*, was much better."

Marlo Thomas provided some insight into how she intended the series to develop and consequently gave a clue as to the power she possessed with respect to its content. "I remember saying to the network, 'I don't want to be the wife of somebody, I don't want to be the daughter of somebody, I don't want to be the secretary of somebody, I WANT TO BE THE SOMEBODY!' And later, after the movement and I had grown together, and *That Girl* was in its fifth year, they wanted us to go on for three more years and have Teddy [Bessell], who played Don, and me to get married and have kids and all. Just continue the show. Like Lucy, having a baby on the show and all that. But I said, 'No, I can't do that with this show. She has to end up single. This is a show about a single girl and if I marry her off at the end it looks like that's what you have to do.' Instead, in the last show I took Donald to a women's liberation meeting. But the network and the sponsors all wanted her to get married.

"While I was doing *That Girl*, it became clear to me that I would become a part of the feminist movement. Before that I had never heard of the women's movement.

"But now, there were thousands of letters a week, from all kinds of women. A sixteen-year-old girl who was pregnant and was afraid to tell her father, wrote to me. A woman who was twenty-four years old and whose husband beat her didn't know where to go for help. Another woman who was twenty-seven years old and had two children and wished she had never gotten married was warning me not to marry Donald. There was all kinds of mail. We didn't have the words then. As Gloria Steinem has always said, 'In those days when a woman was beaten up, we didn't call it battered. We just called it life.'

"At first I kind of resented all this mail. I resented it because I knew I had to answer it, and I didn't know how to get the answer. I thought, 'How the hell do I know?' But I wasn't going to write back and say, 'I don't know, check with your clergyman.' I mean, I had to answer. That's the terrible thing about being responsible. So I started to dig around. And there wasn't anything. I mean there was nothing. There was maybe a convent somewhere you could go, to have a baby. There was nothing else. There were no information centers, there were no clinics. Nothing. I had lots of letters about being raped. There were no rape crisis phone numbers. There wasn't anything. And the more I got involved, the more I became outraged.

"And then an agent asked if I'd meet with Gloria Steinem. They wanted me to play her story about being an undercover writer who poses as a *Playboy* bunny. She was a young woman whom I had heard about. So I met with Gloria, in 1966. *That Girl* was a big hit that year, its first year. And then I became very involved with Gloria. She helped me help all these women who kept getting in touch with me. We're still best friends today.

"That was it. That was my radicalization. I became a radical feminist. Because of *That Girl*. And I don't think I would have felt responsible in such a palpable way if I hadn't received all that desperate mail. From everywhere."

Although Thomas was more actress than producer and her relation to the producers was in no real sense the norm, her unusual position and her remarkable success justify identifying her as a link between the few women producers of the 1950s and the embryonic movement toward equity in the work place, mandated by government regulation, that began in the television business in the 1970s.

"Before I met Gloria and before I knew what feminism was, and even when I first heard about what feminism was, I thought that I was one of them. I mean, I was obviously *it*. Here I was producing my own show and totally involved, owning it and signing the checks. Who could be more feminist than that? But what I've learned from the movement and from Gloria and from all the women I've met is that that's not what feminism is; that's just being a strong woman and being in charge of your own life. Feminism is helping other women get there. And that is a big part of my life."

SOME OTHER SELECTED WOMEN PIONEERS

It is important to note that we have not named *all* of the women who contributed to the medium's history in its first twenty-five years. In

addition to our analysis above, there were several other powerful women who made major contributions to the new medium.

Irna Phillips was a pioneer in creating a style of daytime drama on television that still dominates the broadcast television of today. She has been described as the mother of the soap opera. She began her career at WGN radio in New York, where, in October 1930, her program *Painted Dreams* premiered. It is generally considered to be the first radio soap opera. In 1937 she created *The Guiding Light,* and by 1943 she had five programs on the radio. As Cary O'Dell has noted in the *Encyclopedia of Television* (Horace Newcomb, ed., 1998) Phillips was the first to use organ music to blend scenes, the first to develop "cliff-hangers" to hold the audience, and the first to address social issues. In 1952, *The Guiding Light* premiered on television. Appropriately for the creator of the soaps, her single sponsor for all Phillips's television productions was Proctor and Gamble. In 1956 she introduced *As The World Turns,* and in 1960 *General Hospital.* In 1964 she raised the issue of abortion on *Another World,* and she quit the show *Love is a Many-Splendored Thing* when the network refused to allow her to introduce an interracial marriage. Her success continued through the 1960s, but by 1970 the soaps, a highly profitable industry, moved to ever-more sensational stories and Phillips fell out of fashion. She was fired by Proctor and Gamble in 1973 and died in December of that same year.

Agnes Nixon began her career working with Phillips in radio, and in the early 1960s she became head writer on *As the World Turns,* produced by Phillips. In 1968 Nixon created her first show, *One Life to Live,* for ABC as that network sought to compete in the soap opera derby. It was a show that relished social issues such as race, ethnicity and, of course, sex. Her success led to *All My Children* in 1970, a show that examined issues of child abuse, the Vietnam war and abortion. That war led to an episode related to protesting the Vietnam involvement and a strong stand against it by a central character. Mary Fickett played the mother of a Vietnam soldier and she delivered a speech opposing the war. With this body of work, which spans the period from 1957 into the 1980s, Nixon has been dubbed "queen" of the contemporary soap opera. She was inducted into the Television Hall of Fame in 1993.

A third woman of considerable note is Joan Ganz Cooney, a producer who began her career as a reporter, quickly moving to NBC television in 1954. She then moved to New York's WNDT-TV (now WNET) in 1962, where she produced several documentaries, including *Poverty, Anti-Poverty and the Poor.* In 1968 she proposed to the Carnegie Foundation that it fund a study of the use of television in preschool education. *Sesame Street* was the result, airing first in November of 1969. Cooney

went on to create a second show, *The Electric Company*. In the mid-1990s she remained active, working with *Sesame Street*.

Other names of genuine significance include Deanne Barkley, whom we interviewed in 1976 just as she had been named Vice-President for Dramatic Programs at NBC. Four years earlier she had become the first woman to serve as a vice president in the programming department of any television network when she assumed the title Vice President in charge of ABC's *Movie of the Week*. She was proud of the fact that she had been instrumental in increasing the number of women writers at ABC in those four years.

The Marlo Thomas series ended in September 1971, even as *The Mary Tyler Moore Show* was emerging on a CBS network intent upon reshaping its image from the days of *The Beverly Hillbillies* and *Green Acres*. But there is a disconnect at this point. The Moore show was owned by Moore and her husband Grant Tinker; however she had no evident role whatever in production or writing.

But there was another event in 1971 that would set the stage for a new angle of vision. Under pressure from the Equal Employment Opportuities Commission the three television networks were forced to hire more women as the decade began. Unlike Lupino, Goldberg, Young, and Thomas, most of these newly employed women were not actors. The networks, in responding to EEOC demands had, unintentionally, created a road to television production for a new breed of women who would, like their male counterparts, be professionally committed to careers in that part of the business. The succeeding chapters unfold that drama through conversations with some of the most significant participants in this revolution.

Notes

1. Letter from Abigail to her husband, John Adams, while the latter was in the city of Philadelphia in March, 1776. Her remarks were all the more pertinent because John was about the business of composing the Declaration of Independence. Letter in possession of the Library of Congress.
2. Ibid.
3. See Marlon Riggs's film, *Ethnic Notions*.
4. *Clear Channels: Television and the American People*, 1955, p. 213. Max Wylie wrote and produced *The March of Time* and *Wide, Wide World* for television. He is best remembered for his creation of *The Flying Nun*.
5. Ring Lardner, *The Hollywood Ten*, video tape by ABC, 1947.
6. Annette Kuhn, *FILM*, "The Independent (London)" August 24, 1995, p. 12.

7. Annette Kuhn, *Queen of the 'B's: Ida Lupino behind the Camera,* 1994.

8. Annette Kuhn, *FILM,* "The Independent (London)" August 24, 1995.

9. The Guardian Newspapers Limited, *The Observer,* September 10, 1995, p. 17.

10. *The Washington Post,* August 6, 1995, p. B 07.

11. *The Chicago Tribune,* Dave Kehr, "Retrospective Directs Notice To Ida Lupino," February 5, 1987, TEMPO; p. 9C.

12. See note #4 above.

13. Bill Persky became a producer/writer for *That Girl* and later went on to produce *Kate and Allie.*

◆ TELEVISION BUSINESS AFTER 1970:
A BRIEF REVIEW ◆

THE BROADCAST NETWORKS

AS WE MOVE TO CONSIDER THE STRUGGLE FOR GENDER EQUALITY IN THE television industry, beginning in 1971, some comment is in order concerning the changing character of the network business over the past thirty years.

In the year 1970 network broadcasting entered a brief but remarkable golden decade. The leadership in this new era belonged to CBS with the confluence of the talent of persons such as Grant Tinker, Norman Lear, James Brooks, Allan Burns, Alan Alda, Earl Hamner, William Link, Richard Levinson, and Carol Burnett. NBC and ABC had similar talent emerge in the late 1960s and early 1970s. By 1973 the top twenty-five series on the networks included *All in the Family, The Waltons, Sanford and Son, M*A*S*H, Maude, The Mary Tyler Moore Show, The Bob Newhart Show, Happy Days,* and *Good Times.*

Concurrent with this promising programming there was an eruption of charges against the networks, claiming they were a primary source of violence in our culture. This was not a new issue. In 1954 there was a Senate hearing suggesting television as a primary cause of a rising crime rate. Another round of hearings came in 1961. In 1968 the President's Commission on the Causes and Prevention of Violence targeted the television networks. In 1972 the surgeon general's five volume report on television violence made a major stir, leading to Senate hearings that year directed by Senator John Pastore. Growing pressure by public groups mounted and Congress began to threaten action concerning "sex and violence" on the air.

Fearful of repercussions in a time when cable television was first making an impact in select metropolitan areas, the networks shuddered at the

possibilty of losing their all-too-cozy relationship with the Federal Communications Commission, which, in turn, was under severe pressure from Congress, its funding source, to respond to the allegation about violence. The FCC and the networks entered into an agreement on November 22, 1974 to create a "family hour" for prime time television. In 1975 the FCC announced Family Viewing Time from seven to nine in the evening. Some members of Congress inquired whether "the concept of family viewing is essentially an attempt at self-regulation by the industry, or whether it was established primarily in response to 'informal' regulation by the Commission."[1] In short, was the family hour accepted by the networks with the understanding that they would enjoy future "considerations" by the FCC? Some accused the FCC of being a "kept" group of intellectual lightweights. Our efforts to confront the FCC Chairman Richard Wiley with these allegations were thwarted when he found it necessary to cancel our appointment and offered no opportunity for an alternate date. In any event, the Family Viewing Time was strictly business with no apparent consultation with producers, directors, writers and actors.[2]

To add to the bleakness of rational discourse on 13 October 1975 *U.S. News and World Report* carried a scare article labeled "What's Happening to American Morality?" The claim was made that the networks had launched "wholesale assaults on traditional values: . . ". As we noted at the time, this type of criticism evoked in the networks an effort to find economic security through public relations, in this case the Family Viewing Time idea.[3] In 1976 the entire FVT charade lay in shambles following a lawsuit against the networks by a group of producers led by Norman Lear which charged restraint of trade. Lear won in a California federal court, and Family Viewing Time was abandoned after the ruling that it involved collusion between networks and the FCC and violated the First Amendment. In the same decade a major industry writers' strike crippled television production for several months and created serious ill will. And by 1980 the heady days of financial security at the networks were fading. As we noted previously, that changing landscape was clearly evident in the 1981 Keystone Conference. Within a decade NBC would be owned by GE and the proud legacy emblazoned atop the former RCA building was gone forever. Broadcasters were being replaced by managers. Frank Rich made a similar point concerning network news in his *New York Times* column for 14 November 1998.

> Like many media critics, Oliver Stone believes that "to link the news to profit is a historical disaster," and he dates the phenomenon back to Laurence Tisch's short-lived, news-downsizing ownership of CBS. That link explains not only why ABC promotes Disney products or some-

times hides Disney embarrassments; it explains the entire culture, hardly limited to ABC or CBS, that gave us ratings-driven All Monica and All Diana and All O. J., and that turns once reputable TV journalists into performing seals. It says much about how steep the slide in news has been that Mr. Stone now has every right to seize the moral high ground: while he, too, has provided feverish, speculative entertainment about an American President or two, he has never pretended to be a journalist while doing so.

Another significant change that became obvious in the 1990s was the sharply declining audience share held by the networks. In 1975 cable was a dream for almost all communities. A. C. Nielsen reported that 11.2% of the country's households subscribed to a cable service. (In 1980 that figure had risen to 20% and by 2000 cable had become the dominant player in television transmission as the industry moved into its sixth decade of telecasting.)[4] In the 1970s the typical viewer had access to the three commercial networks and PBS. The income of NBC, CBS, and ABC was high. The race for first place among viewers did not threaten the existence of the losers. Management could, and did, concern itself with audience reactions through their broadcast standards departments. We understand that the creative community saw such oversight as censorship, and sometimes it was just that. But there was another side to their work. Broadcast Standards executives like Herminio Traviesas and Van Gordon Sauter presided over systems that focused upon audience responses to network offerings. We have seen hundreds of letters from viewers that were distributed weekly to all network executives. Of course, much of that activity was self-protection, but it also had a salutary effect. Network executives read letters and they answered many. It was a business for profit, but the customers merited a modicum of respect in those years.

The 1980s ushered in the accelerated network audience shrinkage that has not seen its end. Indeed, on 22 November 1998, as we were in the midst of preparation of our manuscript, *The New York Times* published a front page story entitled "Shrinking Network TV Audiences Set Off Alarm and Reassessment." The reporter, Bill Carter, noted that, "The network's share of the television audience has fallen steadily for years, but this year's performance is particularly stark: . . . network totals were down . . . about nine percent from last season." He went on to note that the cable ratings were up about ten percent. That trend is continuing in the new century. The facts are convincing evidence of the likely eventual demise of broadcasting altogether. Does anyone seriously suggest that in the year 2025 there will be significant over-the-air broadcasts? That medium will be as obsolete as mechanical typewriters are today. If local

stations survive this change, it will be as a result of switching their telecasts totally to a cable alternative. This, in turn, will remove the FCC from the picture entirely.

WOMEN IN THE TELEVISION WORK FORCE: 1971—2000

With the strength of the EEOC behind them, women entered the broadcast business in ever increasing-numbers in the early 1970s. For thirty years since, there has been a slow, but perceptible, increase in the percentage of women in decision-making positions in the broadcast networks. Even so, as late as 1985 the National Commission on Working Women was less than sanguine about that progress in the business. Maureen Bunyan, local news anchor for the Washington, D. C. affiliate of CBS, made the following remarks that year while moderating a panel for the Commission on the status of women in broadcasting in Washington, D.C.

> I think there is greater sensitivity toward hiring women on the air and in production and sales and administration. However, we do live in an extremely racist and sexist society, and "window dressing" is just that. Women and minorities can appear to be powerful, and in fact, have absolutely no power behind them. When you go to a TV station board meeting or management team meeting, you will probably see white men, and no diversity in terms of race or gender. In some sense, women and minorities are still in the stage of being used by the industry. I think we're beginning to be sensitive to this and are beginning to learn the skills needed so that we can positively use the industry to our benefit and theirs, too. As the sensitivity increases, so does the power and willingness to make change.

We take as a given that by the 1990s there had been considerable progress. Yet, as the reader will quickly discover, that progress was put in jeopardy by the congressional decision in the early 1990s to empower networks to own not twenty but eighty percent of the products they produce. This put in serious question what the future might be for the independent producers interviewed herein.

In August of 1998 *The New York Times* published a significant article by Lawrie Mifflin entitled "After Drought, Networks Put More Women in Top Posts." But, as Mifflin notes, "this younger generation is different from the pioneers—different in ways that give some people hope for a brighter future for women in television but also in ways that make other people pessimistic. The pioneers were loners when they got to the top, women who got there using only their own creative compasses with little

help or guidance. Their styles were more individualistic and less buttoned down. They had to make noise to be heard at all." The interviews that follow, and comprise the heart of this book, confirm that judgment many times over.

Eerily reminiscent of thoughts expressed by Virginia Carter in Chapter 7 was the next paragraph in the *Times* article. "The new generation features women in their 40s who have climbed to executive heights without the burden of being outsiders—earning M.B.A.s, learning the ropes on roughly equal footing with their male peers, establishing themselves as team players rather than individuals." If this is an accurate description of a trend, then Carter's analysis of the changes favoring male M.B.A.s may apply equally to women. In this new world "business is business" is an apt description of a change from the days when, to some degree, the broadcast business occasionally sought creativity. In retrospect, even as women were finally making inroads into the creative community, that community was fading. No matter how one assesses David Sarnoff (NBC) or William Paley (CBS), they were broadcasters who had a sense that their work was distinct from, say, running Macy's or General Foods. While they had no qualms in allowing discrimination against women and minorities, the business they directed could, on occasion, reward the creative artist. Yet, by the close of the 1980s, just at a time when many women were establishing themselves as independent producers, the ground rules changed. Broadcasters were being replaced by corporate CEOs who appeared to us to be clueless about television drama or comedy as a popular art form. This was quickly coupled with the above-mentioned change in the federal laws to allow ownership by the networks of eighty percent of their air fare. Today there is far less room for a budding Garry Marshall or Norman Lear as well as for a Marian Rees or a Diane English.

In a recent conversation with Lynn Roth (February 2000) we asked whether there were any television executives who really know television and really care, the like of Paley and Sarnoff. Her answer: "I think such men (and I mean *men*) are disappearing more each decade. A network used to be one man's vision, as earlier in film (Sam Goldwyn, for example). Fred Silverman's imprint was visible wherever he went. The imprint of his personality. Now ratings and other aspects of 'the business' have replaced such vision. There is a mass-production mentality. Creative vision has been replaced by economic factors. A proof to me is what happens when you flip from one channel to another and find virtually the same program everywhere."

The women interviewed in this book have seen all these changes. Their history is rooted in a broadcast system now only a shadow of its former self. And those changes began just as women were finally winning

their battles against discrimination. Suddenly, the old order was history as the networks moved away from chief executives with broadcast experience to managers. The challenge laid down by the women one meets in this volume must now be directed to a new order. Addressing this issue in *The New Yorker* (20 April 1998) Ken Auletta just didn't get it. He notes, "In the end, in the company of women, I was struck by the parallels between the management styles that women executives described as specific to their sex—nonhierarchical, team-oriented, willing to listen—and the newly minted wisdom of so many modern business gurus." This comment ignores the nature of the corporate mind as applied to the arts today and trivializes the characteristics he identifies as "specific to their sex." What women mean by those terms must be read within the context of a business that would demonstrate a modicum of respect and understanding of its audience. Nothing we have seen from the mega-companies like Time-Warner or Disney or GE suggest that such concerns are even on their minds. The women we interviewed would insist that their "management style" is not a gimmick to be taught in an M.B.A program. It was never about managing "people" but finding common ground for good programming, with no serious thought as to how one could better manipulate the public.

Today, television, as a business, has no evident interest in the issues of equality and equity except where they may be required by law. Our analysis certainly recognizes that viewer demographics has an inordinate impact upon television executives. In an era of impersonal and ever expanding multi-purpose conglomerates one could expect little else. The twenty-first century has shown no inclination to arrive with better conditions for women in that corporate world. As the global economy becomes the center of the lives of all nations, here in the United States women have not been noticeably involved at the top of the giant mergers and new corporation. These are regularly orchestrated by an expanding group of male moguls from Bill Gates to Michael Eisner. It was a top news story when, in early 1999, Hewlett-Packard announced that their new CEO was to be a woman. While reports of the antics of these monetary male giants appear regularly on our cable television sets there are few women identified at the pinnacle of negotiations and action. As Virginia Carter once remarked to us, the constant reinforcement of the second class status of women in our society creates a "cotton-pickin' mess."

Notes

1. See the letter from Congressman Torbert H. MacDonald, Chairman of the Subcommittee on Communication, to Richard Wiley, Chairman, FCC, November 20, 1975.

2. See Torbert MacDonald, " 'Family' Rules a Classic Case." *Variety,* 7 January 1976, p. 103.

3. See Robert S. Alley, *Television: Ethics for Hire?* Abingdon Press, 1977, Chapter III.

4. See *Nielsen Television '75,* p. 17 and *Nielsen Report on Television 1980,* p. 16.

Part 2
The Interviews

3

✦ BETTY FRIEDAN ✦

THE FEMININE MYSTIQUE AND WOMEN IN TELEVISION

IN 1987 WE, WITH OUR NEW COLLEAGUE PROFESSOR JANE HOPKINS, DIRECTED a conference in Oxnard, California in which a gathering of women television producers and writers, joined by some half-dozen successful male producers, writers and directors, explored the altered face of television since the publication of Betty Friedan's *The Feminine Mystique* in the early sixties. The discussion over two days was wide-ranging, opening with an address from Ms. Friedan. One session focused upon her commentary and keynote address as the group in attendance recalled that in 1964 she published a two part article for *TV Guide* exploring her thesis as it related to television. She observed at that time that if television's portrayal of women reflected reality then women must be writhing "in self-contempt and unappeasable sexual hunger." She saw that image at the time as a "stupid, unattractive, insecure little household drudge." She concluded that women watching saw "how television had trapped itself in the feminine mystique." (*TV Guide*, 1 Feb. 1964 and 8 February 1964.)

In her remarks to the group Friedan entered into a colloquy with two leaders in the television industry—Virginia Carter and Georgia Jeffries. In the presentation and the discussion that followed it was concluded that Friedan was a kind of marker against which the group could interpret current conditions. In fairness, it must be noted that in the past decade Friedan has come under sharp attack by other feminists who now dismiss much of her commentary. We make no judgments on that ongoing dialogue. But, with all the cross currents at the time, the three of us felt it was instructive to generate a dialogue with Ms. Friedan. We concluded that most of those present drew strength from her dialogue with them.

In her opening remarks to the assembly Friedan argued that she could not separate what is occurring in television from what else is happening in society.

Friedan saw her actions in the 1960s as having broken through the feminine mystique and proclaimed women as people. She said that women began being Americans, and demanding equality of opportunity, and that a lot of women were in the television industry as a result of that discovery.

We think Friedan had it right when she noted that the plot of the family situation comedy, which seemed to celebrate marriage and the family, was a war between the sexes, with women, for survival, out-manipulating men. She also felt that such programs denigrated men as well.

Friedan agreed with our panelists that the changes in the past twenty years could not have occurred without first having sex discrimination laws enacted and then getting them enforced in the areas of education, employment, credit. They began to file the class action suits against the networks and the news magazines.

Friedan saw no altruism on anybody's part. Women, she remarked, fought for economic survival and their humanity.

Friedan recognized some significant changes in television, and the greatest advance had been in entertainment programming. She cited *Cagney and Lacey, L.A. Law, St. Elsewhere, Designing Women, Golden Girls, Kate and Allie, Moonlighting, The Cosby Show, Family Ties, Cheers.* (We would add, all but three of these were produced by men.) Friedan then addressed her Oxnard audience directly. She sensed a new cloud on the horizon: women should go home again, what was being described as a new feminine mystique. It was a growing tendency for the media to accentuate certain problems that exist with working mothers, and suggest that perhaps women should go home again. The claim is frequently made that corporate women are leaving their jobs to go home and take care of the children. Panelists all agreed that is a myth, because most women with little children are working out of necessity and cannot afford to "go home."

Friedan concluded with the assurance that she was not a complete pessimist, nor did she deny progress.

AN EXCHANGE OF VIEWS

Following her address Betty Friedan was joined by respondents Virginia Carter and Georgia Jeffries. Carter and Friedan were old friends from the women's movement. Jeffries, first as writer-producer on *Cagney and Lacey,* and then as a producer of films and other series, is among the feminists whose high-quality work in television promotes the cause of equality: we witnessed frequent praise of that show.

Carter began by denoting two areas that concern her especially.

Carter: First, it seems that women characters on television must always be portrayed with a degree of vulnerability in their characters that far exceeds any male that might be portrayed on television. Second, with a very few exceptions, there's an absence of any clearly defined heroic roles on television for women. I have always thought we would have made it when mediocre women can get as far ahead as mediocre men.

Ms. Friedan then noted that you want to have women as the highest authorities, because that empowers women everywhere. There was also the matter of vulnerability, which she called victimization. She noted that there are still secretaries and nurses and victims in abundance, or sheer sex objects, like those on MTV.

Jeffries: I think the most believable, most realistic characters, male or female, are vulnerable. They are flawed. The danger in television is that they will be all good or all bad, or in some way oversimplified. So I think vulnerability is good and not necessarily victimization. I'll mention the men and women on *St. Elsewhere* as well as *Cagney and Lacey.*

Carter: I agree, but I want to add that vulnerability is frequently interpreted by those who write and produce television to mean potentiality for victimization. Interpreted correctly, and creatively, vulnerability can mean a character with whom one can identify, with whom one can empathize. The problem is that in the virtual absence of female heroes, to only have women who exhibit vulnerability as their essential characteristic gives you a distorted or skewed presentation of female characters; and I'm very uncomfortable with that. I have sat through endless note sessions at the networks and elsewhere, where the essential comment was "Give me a central female character who is more vulnerable." This gets tedious. I want, at that point, to be concentrating on developing a female character who has more backbone, who'll stand up a bit more, speak out a bit more, who'll not always be pulling punches so as not to offend the male in the show or men at the network.

Friedan commented that the "heroine" usually signals a love story and is not in any way the female equivalent of "hero." In romance novels, the heroine was central, but the focus was on her relationship with a man. Now that women can in real life have at least some action, those old-fashioned romances are not selling quite as well as they used to, thank goodness. Her students are always clamoring for a heroine, when they talk to writers and producers. They want a woman to have more adventures and not just be more touchy-feely.

41

Jeffries: Let's talk about that. How do we define a female hero? How does she differ from a male? How is she different from Cagney, who is very active and who speaks up to any man, any woman, at any time?

All three women agreed that, in the context of their discussion, at least, Cagney was a hero. She can be vulnerable, but she initiates action. She takes risks, physical as well as emotional. Another example, suggested by the audience, was Jessica Fletcher, Angela Lansbury's character on *Murder, She Wrote*.

Crossing from here to the real world, the panelists asked how might it be possible to empower women to take this kind of risk in the executive suite—the kind of risk now being taken by a few fictional women.

Carter: The reason women aren't in the executive suites was explained to me last week at lunch with a prominent agent. He said that the reason women couldn't have these big important jobs was not only that they were physically weaker but psychologically weaker. I thought we'd got past that; but he just knew it. That's the way it is. By definition. He's defining his world. So we're grappling with that mentality.

Jeffries: I was in Washington recently, talking with men and women in Congress about why there weren't more women in both houses of Congress; and the consensus was that women still appear more emotional and frivolous. Those words were used together; if you're emotional, you can't be taken seriously. And yet we see men on television who are very emotional: Bill Cosby, for example, is a very emotional man. That's why he's so endearing to everyone. But why is it that when feelings are attached to women, they're still dismissed?

Carter: I had an interesting experience last year, when we were having a discussion about who would take over in a certain company. The reason that the woman couldn't take over was that she cried. And in a later conversation with another person in the same company, the reason that the man got the job was that he cried. The one was to indicate her weakness and the other to indicate his strength—the new male. This new male is "beyond macho,. . . a man who feels as well as thinks, who listens to a woman as well as directing her."

Jeffries said that there are more men emerging "who are discovering different parts of themselves."

Carter: I have got all kinds of contacts in the industry with men who are beyond macho. And, as for imagery, I'll mention Dr. Huxtable, and some of the men on *St. Elsewhere*.

Jeffries: There's a female style that typically differs from the traditional male style. The corporate mentality in the executive suite, in the hierarchy, is to rise through pinpointing your enemy and then dividing and conquering. That will have to change if we are to get more women to higher levels of power. She doesn't have to follow the male model, though she can use those rules if she needs to. She'll say she won't divide and conquer, but negotiate, and garner different kinds of support systems. I do think there are different modes of operation for men and for women. I see a gradual shift in hiring of women. I graduated from college in 1971 and went to work for KTIX, CBS, a Westinghouse station in San Francisco. It was a promotional job and every woman employed by the station was listed as a secretary. I protested having to type, but the notion of women as typists permeated the station. My boss said to me, "My wife sews when she wants to be creative!" I stayed there four months. I moved to Los Angeles and began writing for magazines. I decided to do serious writing and had some articles published by *American Film.* While I found that most doors to jobs for women were closed, female networking got me a job. I then went on to do scripts at Tandem for *Mary Hartman* and *All that Glitters.* After my first script I joined the Writers Guild of America in 1978. It remains true that men are overwhelmingly the ones in the business who can say "Yes." That is power. And for women the glass ceiling remains. Feminism is about equal opportunity. The individual matters. But even today you do not find it possible to show extraordinary women to the TV audience. Older women are in sitcom ghettoes.

Carter: It's very difficult to change the rules if those who are making the rules are serving their best interests by keeping the rules just as they are! And the way many women seem to be handling that impasse is by getting out of the system and forming their own entities. Marian Rees [see Chapter 5] sets a good model for all of us. Like increasing numbers of women around the country, instead of trying to rise through the male hierarchy, she stepped to the side, formed her own company, and moved up that way. She is a risk-taker.

～

At the conclusion of this extended exchange there was a genuine excitement about the conversations in the offing. The interviews that follow are in many ways the fruit of the two days in Oxnard.

BONNY DORE

4

✦ BONNY DORE ✦

Affirmative Action does work. It's a lie to say it doesn't work.

IN OUR 1995 INTERVIEW WITH BONNY DORE SHE EXPLORED NOT ONLY HER own career, but provided a context to many of the themes developed in this volume.

~

Dore: If you look at my resume, which spans a period of twenty-five years so far, at the beginning of my career there were signs that the Equal Employment Opportunity Act [EEOA] was going to affect women as bits and pieces of it were being added. By 1974 that Act included the protection of women in the work place. One of the key clauses was based on the findings of the National Commission on Women. It provided that women had to be considered as a minority. That was huge. It affected every woman I know either directly or indirectly.

My career began in 1973 when I went into public television in New York. I was a TV production supervisor and I know the Equal Employment Opportunity Act had something to do with it. I was in charge of original programming for all nine television stations in the state of New York at the age of twenty-three. It was a pretty big job and I had no idea, when I took it, how big it was. I had already put an educational community TV station together as well as a community-based radio station. I think there weren't that many women who had even that much experience at this time. They hired me and figured that I could do this. The money for public television at the time was in children's programming. When I went to New York my focus was to work with a small group of independent educational stations. Almost immediately I participated in a

45

meeting, one of those where you have two minutes to come up with a proposal, and the group determined that we had ten days to come up with a TV series that was multicultural and multiracial. The responsibility was mine and I said, "OK, how long does the presentation have to be?" At that point they handed me something like a four-hundred page document. I said, "How many people do I get?" They said, "Honey, you're it." We were one of many competing for the money. I created a show called *Vegetable Soup* which was a kind of multi-ethnic, multiracial *Sesame Street*.

We got funded for three million dollars, the largest grant since *Sesame Street*. That was the beginning for me. And it was directly related to being female. At the time companies were interviewing all over the country for women. When I went into New York I was the only woman in the immediate television organization and they had told me when I got the job that if I made any mistakes and I got fired, no woman would ever be hired again, ever. That is saying, when a woman fails, she fails for all of us, forever. I've never seen women have the kind of teflon coating that male producers, executives, and writers have.

Affirmative action does work. It's a lie to say it doesn't work. They would never have talked to a woman about those key entry level positions if they hadn't been forced to. When I got hired at ABC they said to me, "Fine, there's a shot here and you've got some experience so you're going to have a chance." I'm sitting at my new little cubbyhole. It's been explained to me that I'm a grade-z-level executive—no window—and the public relations guy comes in and he starts creating this whole long story about me and, let's face facts, my resume wasn't that long. I didn't understand and he told me, "This is for the trade papers." I thought, I'm the manager of children's programs. That would be a one-line item in the trades. I said, "I don't understand." He said, "Well you know that affirmative action thing, we've got to prove to everybody that we're promoting women." That was in May of 1975. I knew that was not the only reason I was there, but it was certainly a big reason. They pushed the doors open. Now that we've been around twenty-five or thirty years everybody thinks, "Well, yeah, it would have happened anyway." Not true.

Between 1972 and 1976 we saw people like Deanne Barkeley and Nancy Malone starting to get some good jobs. There were very few and when I got to ABC it was a special moment. There were only three of us on the West Coast at ABC: Marcy Carsey, Loreen Arbus, and me. Of course, there were secretaries, but it was made very clear to us that no secretary was allowed to cross the line into management. My secretary, Noel Resnick, became the very first secretary at ABC-TV to cross that line.

And actually all things come full circle. I am the co-chair of the Lucy Luncheon sponsored by Women in Film. It takes place the day before the Emmy awards. It is in its third year, created because Joanna Kerns (the chair) and Loreen Arbus and I (the co-chairs) felt that Women in Film needed to sponsor something totally for women in television. I wrote the criteria for the Lucille Ball Award, and one of the people we honored last year is not a woman, it's Fred Silverman. And there's a reason. When Fred went to ABC in 1975 Marcy, Loreen and I were already there— Marcy and Loreen a couple of months, I a couple of weeks. Fred felt that women worked harder, were twice as loyal, and so he promoted the hell out of all of us. It's a pleasure, I must say, that Marcy gave the award to Fred. He and Norman Lear, probably more than any two people in Hollywood, particularly in that era, had everything to do with the careers of at least fifteen women I know. There was also Garry Marshall, particularly on the production side, whom we are honoring this year at the Lucys.

However, on the executive side, the networks, there was serious resistance to promoting women. If, in the past, a woman got to be a manager she was in and out quickly. In, and then a man got promoted over her, in for a while and then a man got promoted over her every time. [See Virginia Carter's remarks in Chapter 7.] At a certain point at ABC I got promoted very fast by Michael Eisner and Fred Silverman, as did Marcy. However, there were some old holdbacks, internally. They didn't want us to get promoted. I won't name them because they're still around. It was OK to have us there, but to get promoted, to get stock, what is this? It was real underneath stuff going on, but Fred just cut right through it and said, "They're terrific, they get promoted, that's it." Fred had more female vice-presidents at ABC than any network before or since.

However, other obstacles have appeared. First, everybody thought entertainment was recession-proof, but it's not. In a recession you downsize, and women, being the last in, are often the first out when the bridges are pulled in. Women are not always on those bridges. Second, in the eighties Hollywood became very "in" for M.B.A.s. They went to law school, got M.B.A.s at Harvard, came here, and decided to become film and TV executives. And the old-boy network sprang up worse than ever. And the old girl network—believe me, Nancy [Malone] and I are part of it—we tried to help each other as much as we could. Nancy can tell you that most of our friends are men because they had to be. Certainly we wouldn't be here, as we are, if men hadn't helped us. There were no women to help us. We thought we were a generation uniquely positioned to try to help other women if we could, and we did. If you didn't get on the rung of the ladder before the retrenchment started, it was a lot tougher. Women between the ages of twenty-eight and thirty-two

right now—my heart goes out to them because I know how tough it is for them. It's related to the M.B.A.s of the eighties. They came in at entry-level positions. Now they're in the middle- and upper- level positions. All things being equal they help their friends, largely men. Women sometimes just have to make it on sheer talent, and be absolutely better than anybody else.

The day a woman can succeed and be mediocre, we know we have arrived—this is my joke. When I was at ABC I was sometimes really embarrassed because men who were my friends and my mentors would feel compelled when introducing me to other high-powered executives to give my full resume. I had a few women mentors. There weren't many. Lillian Gallo. Deanne Barkeley. Marian Rees. It was a hard time because above you there just weren't any women. We were like the leading edge. There is a critical mass of women in production now. We just keep coming! That's why there's some tension. Our numbers are there. But the tension comes with the question, Who gets to be what? It gets real intense because the business is changing so rapidly and everybody is scrambling to find a place on the ladder. It's like musical chairs. We've gone from the seventies when there was a plethora of independent companies, when you had smaller independent entrepreneurs like Norman Lear who could take chances with people, and could move them around. When I was a producer and executive with Sid and Marty Krofft, we promoted from within all over the place, and people moved up quickly and got wonderful experience and they all prospered. When you start having six giant behemoths it's a different story. You *are* your resume. It's harder and harder to get those key credits.

The key event revolved around the Financial and Syndication Interests Rules [FinSyn]. Marian Rees, Dorothea Petrie, Lillian Gallo, Marcy Carsey, and I were deeply involved politically in Washington trying to retain those rules. We are all in the Caucus of Producers, Writers, and Directors. Two years ago, I was the first woman ever to be co-chair of the Caucus, a very powerful group, 240 of the most influential producers, writers, and directors in television. It's harder to get into that than any sorority or fraternity. They don't want you until you have a body of work in television. The membership idea is that we should be smaller, not bigger. It was a great moment for me when I was invited to be a member of the Caucus. I ran for the Steering Committee and won. In my very first meeting I became the first co-chair—a real shock. I have been on the FinSyn Committee from the day I entered the Caucus. I felt that was crucial to the way the business was going to be run for the rest of my life.

The FinSyn came into being in the early seventies. And it was no accident that places like Tandem and MTM and all those people happened at that moment. Small independent mid-sized companies could be

created because the producers could own their work while FinSyn prohibited the networks from owning more than a small percentage of products they aired. [Ownership became fundamental in an industry that, since the early 1960s, has been driven by the potential for enormous profits in syndication.] It's also no accident that in April, 1994, when the FinSyn rule died, one vote, one man, made all the difference."[1]

In the middle eighties women were taken with the idea of independent production. I opened my company in 1983 and I've been in continuous operation ever since then. And it's not easy. In 1987, how can I say it, there were turnstiles in the executive world, and you went through that turnstile and as Garry Marshall eloquently said, "You go from the vast wasteland of the networks to the overcrowded condominium of producers." In that world women found that it was much easier for them to become independent entrepreneurs and depend solely on their own talent than to try to ease their way into the middle level of the studio/network Old Boy Network. It was a lot easier to depend on your own talent. Marcy Carsey is a perfect example of that. Marcy and Tom [Werner] were partners. The three of us worked together at ABC. Marcy was in charge of comedy and variety, Tom ran comedy, I ran variety. So I've known Marcy from the beginning and she's the perfect example of one who did the broken-field running. She got there in time. In 1982, when she left ABC to become independent, she had three pilots, the third pilot was *Cosby*. Marcy had been after Bill Cosby since I had been working with her. They tried to develop it at ABC and ABC said they didn't think Bill Cosby was a star. Marcy wanted six episodes, not just a pilot, and Lou Ehrlich at ABC said, "It's got to be a pilot." Marcy said, "Fine, I'm going to NBC." And there [the late] Brandon Tartikoff made the difference. He knew Marcy was right—Cosby was a star. Brandon started his career at ABC, with Marcy and me—most people don't know this—in a broom closet. I at least had a real office. Brandon was in a converted broom closet around the corner. He did OK after the closet!

Marcy took the risk. She and Tom were paying their own mortgages trying to get there. They had a little tiny office in Westwood. It was as Mom-and-Pop as you could be. Marcy just bet the farm on it. She said, "I know I can do this" at a time when sitcoms had died, remember? In 1984 comedy was officially declared dead. Marcy took the risk and the *Cosby* thing paid off. Marcy took what commitments they gave her when she left. She should have gotten much more. Given what she did for them, she should have taken half the network. They don't do that for women. She never became head of everything. She wanted to run the network. She wanted to be Fred Silverman. She was more qualified than anybody there and I certainly give Michael Eisner credit for recognizing that. ABC was number three going to four when I got there in 1975. Fred

came and we went to number one in eight weeks. Marcy led the charge.

When Fred left, Marcy should have been considered for head of the network, but wasn't. No question about it, it was because she was female. I worship Fred Pierce. I think he's one of the best executives that any network ever had. And I think Elton Rule was a genius. I came out of the ABC stations and I know what an extraordinary team of male executives we were blessed with. But Marcy just couldn't be allowed to make that last step. They adored Marcy; they thought she was brilliant. And she was. And they certainly were good to me; I could never complain a bit. But there was that final step they were not going to let her take.

I think it's going to be harder and harder now to maintain total independence if you're looking at all of the companies. The companies are all making deals with the networks. So the larger companies have no choice but to make some kind of arrangement where they share ownership. In the old system, medium size or independent production companies used to own completely what they produced. They took all the risk, and then if they actually hit a home run they owned what they produced. Now at best they're going to have to share what's left. Deregulation has been the banner word in Washington with no inherent understanding of what it is we do. Ninety percent of the time I spent in Washington was explaining what I do for a living and how I do it. I kept trying to convince all of them that, no, buyers are not inherently benevolent, no they're not. "You have twenty-five years being a Representative, I have twenty-five years doing what I do, please don't tell me how to do it." When you kid with them to a point, they do listen. Finally one Senator said to me behind closed doors, "Look, we understand but there's nothing we can do. The deregulation thing is just the theme and specifics are kind of washed out with the baby." The Caucus went to the mat with the studios trying to change it and we lost by one vote. Amazingly one man stood at the center of all this. You like to think of this huge country with all that we have in the television and media business, and all the people who are involved, that it would not come down to one person. But it did. Since April of 1994 it's a new world. That goes for everybody, but especially for women. It's much harder in terms of being an independent entrepreneur. It affects women like Nancy Malone and Marian Rees and Dorothea Petrie and Blue Andre—a group of women who have done excellent independent television work in the past. One thing is consistent in all of this and that is, if you weren't there as an independent already before FinSyn died, getting there after FinSyn is going to be real tough. Probably your best bet is to make a partnership with a network and do it that way because you will have financial underpinnings and most important, promotion. If you don't tie up with somebody whose advantages of promotion are huge, your product is just going to get lost.

If there had been more women in Congress, or at the networks, I don't think FinSyn would have died. I'd like to believe that; I'll never know. Women have an inherent concern about overwhelming monopolies. They're pretty much corporately run, these monopolies. And corporate America doesn't necessarily include women in decision roles. They do occasionally, but not always. If you look at the changes that have happened in the last year [the big mergers], gosh, I looked everywhere for women's involvement—and thank God for Gerry Laybourne and Anne Sweeney at Disney (with Eisner and Ovitz) or women would have been shut out. How do we make our impact? Our impact has always been based on our talent. It's just talent that can't be ignored. You just keep coming through with shows that work. And you keep doing it against all odds. It is regularly repeated that it's amazing what Linda Bloodworth-Thomason can do, it's amazing what Diane English did, but you know it's not amazing at all. Now, sitcoms have become a haven for women similar to Movies of the Week.

I can remember a time when I was a development executive trying to get a movie with a woman as a star. It was almost impossible. If it didn't have a man in it they didn't want to buy it. Now it's quite the opposite. It's definitely a woman's medium now because somebody in Research woke up about eight or nine years ago and said, "O my god, 65% of the people who watch Movies of the Week are women. Maybe if we did women's shows they'd watch even more." Now it becomes a women's thing. In the last six years it's all women's movies. So that has sort of ghettoized women producers to some extent. And it isn't just the writers.

On the series side, the quickest escalator up is as a writer, because sitcoms are all about writing. Marcy and I are probably two of the few producers who are not writing producers. We work wonderfully with writers. But the fastest escalator up, and it's true in features as well, is writing. It has no gender, it's good or it's not. The problem exists for anything except writing. Directing, producing, they are a little bit more subjective.

And that isn't to say that there aren't a lot of us doing well. Yet I see just below us a real problem. There was an eight- or nine-year block when we came in for entry level positions and got out there and started doing our own things. When I opened my company in 1983, believe me, there weren't that many women with their own companies. It was a big risk. I did it without commitments. And that was even a bigger risk. I was lucky. If you pick between talent and luck, I'd say luck. When you're a woman you can have the talent without the luck to go with it and it doesn't work. I think our group, as we were coming up the ladder, as we came out of the entry level jobs and were catapulted into wherever we were going to be, women were very hip and sort of became the media darlings. Isn't it wonderful that certain people were really lionized? Then it

sort of became like the problem with Affirmative Action at the moment. Look at all these women: we don't have to worry about them any more.

As I have suggested, in the middle- to late-eighties when Los Angeles was the center of the universe, and everybody wanted to live here, all the M.B.A.s said, Wall Street's a disaster, we're all going to jail. Let's go to Hollywood instead and get a tan. And they came in droves. I think they had a bus at Yale, that said, "Everybody for Hollywood get in here." There were a few women, but there were a lot of guys. They came to be executives, they came to be development executives, they were everywhere. They weren't filmmakers. They weren't people who woke up in the morning and said, "Let me write, let me direct, let me produce, let me go find some actors in an acting class." For them it was, "Let me go make money."

I can tell you when it all changed: in 1986 when the three networks got sold. The men who ran broadcasting—and I was very lucky to be there in the 1975–86 period to see what it was like—weren't like Larry Tisch at CBS saying, "Who can we cut today?" I can tell you that Elton Rule, Leonard Goldensen, Fred Pierce—these were men who had broadcasting in their souls. I saw some of the greatest leadership in my life. These were terrific executives to be in awe of. They are gone from running the networks. It's the corporatization of America. Deregulation has only underscored that.

I have been a client at CAA [talent agency] for seventeen years and what's happened in the last year? Of the guys who founded it—Michael Ovitz, Ron Meyer, Phil Haber, Roland Perkins—Haber's doing charity work, Myers has become president of Universal, Ovitz is head of Disney [he lost that position in 1997], and Perkins is a producer. You are seeing a critical change in this last year that is equal to 1986 and back in 1972. Between deregulation and the changes that have happened here, the Golden Age of the agent describing the deal is dead. Is there a reason why these guys who invented it have bailed? They bailed because they know where the power is. With deregulation and the demise of FinSyn it's not going to be with the agents anymore. There were thousands of little companies and everybody is scrambling to get in the door to get distribution. The agents were kings. They packaged all my shows and they had an enormous amount of power. But in an era when production is in-house, it's all changed.

Is there a feminine perspective in your work?

Dore: I saw something on NBC, with Katie Couric interviewing someone who said the difference between men and women can be seen in shopping. Men hunt a shirt. They get a spear, they go to Nordstrom's. Women are gatherers: they have the big perspective; they have to go and

see everything. There's a lot of that in what we do. If there is such a thing as a perspective, I think we bring our own content to what we do and our experiences, and those are as unique as the individual. In terms of perspective, in terms of being a producer, we're very family oriented. Not necessarily just a head of family, but we see ourselves as team leaders. Women are often team leaders. We see ourselves that way. My joke is that any woman who can put on Thanksgiving for twenty people, on time and on budget, and can make everybody behave, can do a movie. Producing is from lights-on to lights-off in television; the producer is the woman who thinks of the idea in television, takes care of every last detail to the last interview, and closes the door.

In terms of producing styles I think that women do have a different producing style. I think they look at group dynamics. They think the group is greater as a whole than any single individual. In the old days when I worked with ABC, often the companies were run by very charismatic singular men. That person was the one around whom the whole thing revolved. I think that women deal with authority differently. When the woman is the boss, you know she's the boss; but the idea is that you're going to bring people together to accomplish the common goal. It doesn't mean that women don't have egos, they most certainly do. But I think they're often willing to submerge their egos for a goal. I've seen men get in their own way with their egos and actually sink the ship because that's the problem. Not every time. But women tend to have a bigger vision. Men spear the shirt; women see the entire store. Because we haven't been allowed to be at a certain level, we had to see the big picture; we had to do the broken-field running. We've had to find the open window; because of that I think we see things in a broader perspective.

There are risks in becoming independent. I think sometimes when you are in a comfortable power circle of men where there's support, you don't have to worry about whether you're going to drop off the turnip truck if my next thing doesn't work. It's a different perspective.

What are your thoughts on minorities in the business?

Dore: A Black executive once said to me, "Sure, Bonny, it's one thing for a White man to fail, but for a Black man to fail, there's no one to reach out a hand and fix it for me in two days. There will be nobody to pick me up and put out a hand. I might go a year or two years. . . ."

Is this still true?

Dore: I can count the number of minority executives on two hands. If it's a minority woman, that is even rarer. Kelly Goode, a Black

woman at CBS in Los Angeles, has been in charge of both comedy and dramatic series there. It's a powerful job. She started in comedy. There's also Winifred White at Tri-Star TV. Julie Karmen is a wonderful Latino actress/producer. She's part of the Latino matrix here that's struggling but moving. She wants to be a great producer and I think she'll make it.

To me L.A. doesn't reflect the reality around us, either in gender or in cultural diversity. All you have to do is walk down the street in Los Angeles and know that it's a joke. I was just in Chicago and was overwhelmed by the multi-ethnic and multiracial environment. In Chicago's suburbs, the browning of America is real. I think it's totally non-reflective in L.A.

David Poltrack [CBS Research] is the only television researcher who speaks the truth. David knows that TV changes forever every time research comes out with a new idea. Years ago they came out with big news: Black people watch TV, so there were a lot of Black shows where there were none before. In another twenty-four months I think they're going to discover the Latinos. David forced CBS to do a five million dollar survey of viewers over fifty years old, addressing buying power, products, etc. All of this eighteen-to-forty-nine all-inclusive data is all a lie. Nielsen is not presenting the whole picture. People over fifty watch TV and spend billions on products. We have a special committee in the Caucus on ageism. Loreen Arbus is co-chair. She interviewed writers over forty [about] what had happened to them; they were interviewed in silhouette. She herself is a comedy writer but she hasn't gotten her own show. She's going to start getting pushed out of the door simply because of her age. She hasn't established a beachhead of her own show. The executives keep getting younger; they're now in the thirty to thirty-two year age bracket. After a certain age when a woman tries to get a new agent, the agents don't want her. She knows the reason is age, so she goes off and gets crazy stuff like plastic surgery. And this woman is not an actress, she's a writer! Reality is reality, and the tape that Loreen did is absolutely fabulous. They use the agism thing in a metaphorical parallel with the black list, because it's the gray list.

\sim

Returning to the theme of the feminine perspective, Dore observed:

\sim

To be perfectly honest, I have turned down, at great sacrifice, especially over the last couple of years, a number of movies because I couldn't do them—another stalking movie, another woman gets raped, murdered, or skewered. I just couldn't. I have no bad feelings about someone who

took that job. I just couldn't do it. I said that would be forever with my name on it and I just can't do that. I really believe when you're a hands-on, creative executive producer, which is what I think I am, I live with a movie, live it, breathe it. For it to be really good, you've got to be deep inside of it. It's something I get inside of and do from the ground up. If I'm going to live with something for a year, or with a mini-series perhaps two or three years, if I don't love it, if I don't believe it, how in the world am I going to make it a hit? When I look at something that, going in, is just awful, not necessarily technically awful, but conceptually or emotionally awful, I don't know where to begin. When you're producing you have to get up every morning and fight for your project, in a positive way. There are always these people who are trying to do what they need to do in their own way for the good of the movie. Often as executive producer you're as much a protector as you are a creator. Sometimes the creative part has to be protected—the vision of the movie has to be protected. In order to do that I have to believe in it. It's not only a good piece of material but something that will have an enormous impact out there. With the advent of video, bad films live *forever.* Unfortunately, the executive who wanted you to do it no longer has his name on it. For me, that's too hard to face.

Corporations have gotten caught up in a syndrome. TV is very cyclical. If one *Friends* works, let's do twelve *Friends.* When one game show fails, there aren't any game shows. People ask me how I decide what I'm going to do and I say I look for what's not on TV. What is it that I or other people are thinking or feeling that I know is not being addressed? That's why I wanted my own company.

One of the things that's essential to the Caucus is a belief in quality. Leonard Stern says, "My best TV is not on TV but in the drawer. I put on what they'll let me put on." One of the reasons the Caucus of Producers, Writers and Directors has taken the position on sex and violence in TV that they have, is that we are portrayed in the media with a very ugly brush: greedy, money-hungry. These days, when I say to someone outside of Hollywood that I'm a producer, they put me just below a used car dealer. They think, "Oh, you do all that trash." It's terrible. Then I tell them what I have done, and they say. "Oh, well, I *like* that." Senator Paul Simon of Illinois recently said to me, "I'm now part of the converted, but I'm gone, I'm retiring."

TV is the media core, it pays the bills; and I'm tired of the makers of television being considered second-class citizens. Far more people have seen *Laverne and Shirley* than will ever see *Star Wars.*

My favorite statistic is that the third greatest agent of social change is Movies of the Week, according to a study done at an eastern university and reported in *The New England Journal of Medicine.* Television series

have a long-term effect reflecting culture and how we know it. TV Movies of the Week and mini-series have a one-two punch. We can focus on an issue. At this level, dealing with missing children or heroin-addicted sons (as I did in *The Jill Ireland Story* for NBC) you can really focus on it and make an entire country aware. It has a great potential for social change. We can spotlight a problem and truly have some immediate impact on it. That kind of power is a gift, one that every producer of quality that I know respects at every level.

~

Note

1. The reference here is to the chair of the Federal Communications Commission.

MARIAN REES

5

❖ MARIAN REES ❖

Just by chance

"WE BRING A LOT OF OURSELVES TO OUR WORK. I THINK WOMEN, MORE THAN anything, try to integrate who we are with what we do and what is really important to us. Men can endlessly compartmentalize, but it is not that easy for us." These words from Marian Rees reflect the perspective of one whom Virginia Carter says is the epitome of a woman who moved out of the male-centered establishment— insofar as that is possible—to control her own product by forming her own company. That company, Marian Rees Associates, in its beginning was located in Studio City, just across Radford Avenue from one of the venerable Hollywood studios. Rees's chief partner, virtually from the beginning, has been Anne Hopkins.

We first met Marian Rees in 1983 when she was one of six influential producers in a round-table discussion convened by David Levy in the offices of Chuck Fries. She was the only female in the group. It was obvious, however, that hers was a respected voice around the table. Fries, Levy, Alan Courtney, George Eckstein, and John Mantley offered a portrait of the past and the present. Rees was to become the bridge to the future. Her words are found throughout this volume, but in this chapter we focus upon a particular interview in her office in mid-August, 1995.

∼

Rees: I am at a point now where I'm beginning to think about phasing out. A lot of things come to mind.

I began in television in 1952. Just by chance. I had graduated from the University of Iowa in 1951, with concentrations in sociology, psychology, and religion. But I couldn't get a job in social work.

So I went first to New York. From the tenth grade on, I had had a dream of working at the United Nations. I went to New York without an appointment—just my hat and my gloves!—prepared to say, "I'm here, and I'm ready." Naive? I remember the guard made a call, and I got in to see the personnel director at the United Nations. I think that he gave me the chance partly because he was so astonished at my audacity and partly because he was curious that I was so corn fed. At any rate, this was a very, very important moment for me. This woman, the personnel director, was so palpably compassionate, that she quieted my nerves in an instant. She asked questions, I relaxed, and thought "This is not so bad." My real credentials were shorthand and typing, and I was the best. But then she asked the defining question: "How many languages do you speak fluently?" I never thought of that.

It was the moment that my tenth-grade dream collapsed. But I have never forgotten what happened that day, and I've always tried to hold on to the lesson. I spent the rest of that day with a special tour that this woman had arranged for me. I observed the General Assembly and had lunch. The last place that I visited was a black cavernous room in which there were a lot of dials and panels; and there were little boxes with pictures coming out of them. They were the television monitoring screens from the General Assembly. That was the first television I ever saw, except for General MacArthur's speech that I had seen at the University.

Now I knew I was without a future. So what to do? I went to California and interviewed for four different openings for which I didn't have the credentials. I called home on a pay phone. I told them I'd get a job for bus fare and would be home by summer. I went to NBC to interview. Again, I went without an appointment to see the personnel director, and got in, and told her I just wanted a temporary job. My skills, typing and shorthand, were appropriate and sufficient there, and I went to work the next day at NBC in a temporary office above a drug store on Sunset and Santa Monica. I was secretary and receptionist to seven men who were unit production managers in a brand new enterprise called television. They were the budget guys, all network and advertising types. There I learned the language of television simply typing all their reports. But I had no intention of being in the business. Instead, when summer came, I did go home, seeking a teaching position. I quickly learned that I wasn't really qualified for this career: I lacked a teacher's credentials. And the State Board of Regents wouldn't waive the required degree.

I went back to California. The personnel director had saved the job for me. From then on, there were a series of opportunities over which I had no control, yet I took them as offered. I had thought of TV only as a job, yet gradually it became a career.

The first break after my return came within a month: the associate director of *The Dennis Day Show* asked if I'd like to be the production assistant in the booth—the script girl—timing the show, right up to the point where I would take it off the air. Remember, this was live television, so you couldn't make errors. Paul Hening [*Beverly Hillbillies*] had created the show and was the head writer. John Rich was the associate director. He took a week to teach me how to use the stopwatch and how to backtime and do all those things that were probably done by five or six women in the business at that time. This was my job for a season.

The next step occurred in 1954 when RCA (sponsors of *The Dennis Day Show*), J. Walter Thompson (its advertising agency), and MCA (the talent agency) asked me to meet with Buzz Kulik, who was at J. Walter Thompson and had moved West to direct *Lux Video Theater*. He hired me with the title of production assistant, which meant script girl and everything else, to assist the director in getting the show on and off the air.

During that summer, there was a rotation of directors on *Lux*. George Roy Hill came out from New York, and Fielder Cook. At the end of the summer, George told me that Ted Ashley from New York (later of Warner Brothers) was forming the first independent production company outside the networks. It was to be called Unit 4. The principals were George, Fielder, and Frank Schaffner. Worthington Minor was the executive producer over these three. Young and Rubicam, the advertising agency for Henry J. Kaiser, was sponsor for the shows—to be directed in series, the first by George, then Frank, then Fielder. Frank was really the senior partner and George was the maverick. I was one of two assistants.

I went to New York and we set out to do this series of original dramas, most of them focused on issues of the day. They were put on kinescopes so they could be sent to Mr. Kaiser, who had to put the final seal of approval on each one. George Roy Hill was very radical in his ideas (for example, I think we were the first to do a story on rape), so it wasn't surprising that he and the agency got into a big brouhaha about an issue that they thought was just too radical and that Kaiser wouldn't tolerate. So George quit. He demanded total creative freedom. I ended up working for Fielder and Frank for the rest of that year, 1957.

I was very unhappy in New York, so I came back to Los Angeles and took a year off. Then I was persuaded to take a job as associate producer on a special that Bud Yorkin was putting together. I really didn't want to do it. I was looking at the possibility of a career change, doing some work in history at UCLA, falling in and out of love. My life was on hold. But I took the job to help out.

The job was with the first Fred Astaire show, and it was the beginning of my *career* in television, as opposed to my *job*. That show, "An Evening

With Fred Astaire," was an enormous success. It won the Emmy for Best Longer Musical or Variety Program for 1958–59, along with awards for writing and directing.

Let me tell you about that stunning evening, as one of the defining moments of my life. It was a very complicated show: we were the first to integrate three tapes into the live show as it was being telecast East. We had pretaped three major musical numbers. David Rose was the conductor, and Hermes Pan the choreographer. As you can imagine, every rehearsal and run-through varied in length of time; but I was theoretically experienced enough to backtime, to hit that exact second when we were to go off the air. If we needed spread, I'd tell Bud, or if we were behind, I'd tell him that. I'd cue the sound effects, I'd cue the music, I'd cue the stage managers—in those days you'd just do all these things. I had never had any formal training; I had just learned it. John Rich had been a very strict and good mentor. And I learned well from George. I had worked with some of the finest directors.

It was one of those magical nights. The integrations of the pretaped material had gone well. The audience was ecstatic. We had a fifteen-minute medley that couldn't be stretched or abbreviated, because we wouldn't stop for applause, so it was pretty well set. The team had all worked together, and everything was flowing. I got so involved that I just became one of the audience. When Bud asked, "Where are we?" I absolutely froze. I had gotten totally lost, and Bud had to take the show off the air, just using the big clock—which isn't accurate. I remember somebody prying the stopwatch out of my hand, I was so frozen up. Bud was furious and pandemonium had now broken out down in the studio. The phones were ringing from New York even before we went off the air. I crept out the back door into the parking lot. I had committed the worst professional error you could think of. I went home and sobbed. I was the consummate failure. I had let everybody down, particularly Bud. And I left town for a week.

Eventually I had to come back to the office and, when I did, there was a note in my mailbox. It was from Norman Lear, telling me that he and Bud had formed a company, called Tandem Productions, and asking me to join them. They had worked together on *The Colgate Comedy Hour,* Norman as the head writer, Bud as station manager. So that was the beginning of Tandem Productions and I was there. We made a lot of specials for sponsors, and I was the associate producer on all of those. And then they graduated into features: *Come Blow Your Horn,* and *Cold Turkey.* I was doing a lot of miscellaneous jobs, including being in charge of development. So I was the one who read the manuscript for *The Night They Raided Minsky's* when it was first delivered to Tandem. I said, "You've got to do this."

Then Norman got hold of the rights to the English series *'Til Death Do Us Part* and made it into *All in the Family*. That was our entry into television series, in 1971. I was associate producer on the pilot. And that's when Anne Hopkins came into the company. Norman had brought her out from New York. *Sanford and Son* was being developed, again from a British hit series.

And then, in 1973, after fifteen years at the company, I was terminated with only two weeks' notice. Virginia Carter was hired in my place before I was fired. The change had been engineered by Frances Lear, [Norman's wife, now deceased] who wanted to redesign the company and hire someone with a feminist viewpoint. Virginia and I later had lunch together and we found out the sequence. Virginia hadn't known. I can talk about it now, but it was terribly hurtful. It was at a time when you didn't have contracts. Employment agreements were based on intentionality. We want you, and don't worry, kid. It never occurred to me to ask for a document or covenant. But there were a lot of changes and I was the first to leave. I struggled to make an adjustment, which was complicated by the personal fact that during those years I had married and subsequently divorced.

As I think back over my years at Tandem, I remember the show that gave me my first producer credit. It was called *We Love You Madly,* a two-hour special with Duke Ellington, one of the last TV things Duke ever did. Quincy Jones was the spark for it: he was music director for *Sanford and Son* at the time. Bud called me one day and asked whether I thought I could sell a special on Duke Ellington that Quincy wanted to put together. I later learned that he just called to get Quincy off his back. But I made a call to CBS and sold the project on the phone. Bud was surprised when I called him back and told him we had sold it.

But the show was madness. It was the antithesis of the Astaire show. Everything that could go wrong went wrong. It was the first event in the Los Angeles Shubert Theater, before the fire marshal had even approved of an audience there. The taping started at 7 P.M. and there were remnants of the black-tie audience still there at 4 A.M. By that time Duke had a temperature of 105 degrees. We had been on the phone the entire time with his physician in New York, as Duke's temperature went up and up. But the show got on the air, despite the odds. Norman and Bud were at odds over many things and this special magnified the situation. But it was a great show that now languishes in a vault somewhere because of "untenable" residual problems. There was a seven-minute medley with Peggy Lee, Roberta Flack, and Aretha Franklin that was just stunning. So I remember that disastrous, brilliant night as my first producer credit— or discredit, some might say.

Tandem and I had parted; so I knew I had to think about what I was

going to be doing; and I knew it would depend on me. Fay Kanin became a mentor to me. For two years we would meet, we would have lunch, she would call me. We talked a lot.

And then Mona Moore, an agent, told me about an opening at Roger Gimball's Tomorrow Entertainment. Roger was looking for an executive administrative assistant. Mona was a luncheon partner of mine, and she knew what had happened to me at Tandem. I should mention also Berle Adams, a good friend whom I first met in the "temporary" NBC television days. It was Berle I had recommended to come into Tandem to help deal with the money that had so quickly accumulated. Berle negotiated a severance pay for me for fifteen years' service. At that point I would not have done it on my own; it just wouldn't have occurred to me. It was a modest sum but it was self-respecting.

So I went to Tomorrow Entertainment. I really wasn't told much about what my duties were, and I didn't feel qualified at all. I found out that I was supposed to know something about editing. Well, I had not been mentored by the men I had worked with. At that time men helped each other, but there was no mentoring for women from the men.

Luckily, Marcy Carsey was already there, at Tomorrow, as a story editor. She was such a dynamic force in that company. She was very comfortable with the emerging networks and with the world of network politics and she was very good at her job. It was just remarkable what was getting done in that new company. I learned by watching her.

I was in charge of development when *General Electric Theater* was re-inaugurated. I worked with Roger, General Electric, and CBS. That was also when I first worked with Fay Kanin. She was writing a movie of the week called *Tell Me Where It Hurts*. That was the season, 1973–1974, when Fay won a double-Emmy, for that show and Writer of the Year for a Special. We did a lot of shows for GE, but then the company decided to abandon the entity, and—$22 million later—they folded it. Tom Moore, the president, took the library; and Roger took the development and asked me to come with him. We took offices at CSR Video Center across the street from where I am now. I was there for six years as the head of development.

That was the start of selling for me. I had a stroke of luck, probably because that was a time when real issues could be dealt with, and that fit my inner dynamic. I could sell the material to which I genuinely respond. But it was hard, hard work. I remember keeping at it many a night until the sun came up.

Then the success of the company was such that Roger felt he needed to bring in a senior executive. So he brought in a college friend of his and gave him a contract at double my salary and the executive producership title for all the films. I had received executive producer credit on

one of the projects, Dorothea Petrie's *Orphan Train.* I thought, "Something is wrong with this picture."

At about that time, a group of men who had been working as a creative team at Tandem formed their own company. One of them, Don Nichol, remembered what had occurred at Tandem. Out of the blue he called and, over lunch, asked me to come in with them and start the feature division of their company. They said I could hire whomever I wanted, get my offices, have a lot of autonomy. This gave me a great sense of affirmation, and I agreed to go. I asked Anne Hopkins to come over; she had been story editor at Tomorrow Entertainment. We did several pictures, one of which, *The Marva Collins Story,* was our first Hallmark Hall of Fame. We also did *Angel Dusted,* with Jean Stapleton.

Now came another crossroads: just two years after we teamed up, Don died of cancer. He was a magnificent man and was much too young. Again I talked with Fay about the future, as well as other trusted executives I had met along the way, one of whom was Bill Hayes, formerly business manager at Tandem. The men, including Bill, said, "We think we've got the job for you." So, at their suggestion, I went to see Bob Wood, who had just taken over Metromedia and was going to get that company really rolling. Bob had been president of CBS when *All in the Family* started and it was his faith in the show that saved it from cancellation and gave it its chance at success.

So the old boys club agreed I should go with Bob. I went into this big office at Metromedia. And he was sitting, with his feet on the desk, with his cigar, and was as amiable and congenial as always. He just assumed that I would join him and this was merely a perfunctory meeting, because he had a golf game, and so he said, "I'll see you Monday, kid," and just stood up to leave.

But I just couldn't do it. I agonized over it, tearfully, but I felt I just couldn't go through this again, helping to start a company and make it work for someone else. There had been four such jobs and I had no equity in any one of them.

So I called the only one who understood, Dixon Dern, and said to him, "Dixon, the only way I'm ever going to get equity in any of this is to start my own company. It's never going to be given to me, and I've never asked, so it's my own fault. But now I know what I want: I want to own the film." I hadn't really put it together until the feet on the desk and the cigar and the golf game I was delaying!

Dixon was wonderful about it. He understood my need to invest in myself, at long last. And he saw that I was ready to go. Along with a few others, one of the properties that I had been developing was *All-American Beauty,* which was so advanced at CBS that we were waiting for an

order. I told him about this, and he said, "I know you can sell. I'll support you and I'll work out the papers."

So in 1982, I was the owner of a company. I mortgaged my house and car and put everything on the line. I even accepted a $10,000 loan from my dad, which was the hardest thing in the world to do. And then we waited for three months for that film order that was imminent. Steve Mills at CBS just would not give the order for a film that was now housed in a company of three women, headed by a woman. I was paying out the payroll: I had to pay a secretary and part-time assistant. Anne went on unemployment for a year, just because she knew what we were trying to accomplish. Then *I* went on unemployment. We waited and waited, until Peter Frankovitch, the CBS guy who was working with us, took me to lunch and told me that Steve Mills was uncomfortable giving the order to a woman who had no track record and could not meet the fiduciary requirements of an entrepreneurial producer. He said, "Marian, you're just not going to get the order. You're a woman and there's a discomfort factor, a fear that you're not going to be able to deliver. There's no confidence."

I got mad. And I said that we would just stick it out. I was in the office right across the street from where the decision about the order was being made. I sat in this chair, stared out the window at CBS and prayed every single day. We had taken these offices because I knew I—a woman—couldn't run my business out of the garage or out of the den, the way a man could. I had to have a business address, had to have a telephone number. We had to be serious. Annie and I went out and borrowed some more money.

Finally, Steve called. It was Christmas when he said, "Oh, go make the goddamn movie." I don't know who put the pressure on. But I do know that I had been responsive in the process through all the stages. I had the deficit protected by mortgaging my house, signed it over to the bank. Those papers had been delivered to CBS Business Affairs. The going bond for the male producers at that time was $200,000. I, on the other hand, had to come up with $300,000, which I did. This inequity had to surface, and apparently it did in some way. So there wasn't anything that we hadn't responded to. The only thing left to do was to expose the resistance. I never asked Dixon or anybody else to call. As I said, I felt it was very necessary to do it in a completely businesslike way. Maybe it was Steve or maybe somebody in Business Affairs over him, but somebody said go do it. We made the movie and we came in $60,000 under budget. It was a great launching. I was able to get title to my house back and repay my father.

Since that time, we've made twenty-four films. My house has been on the paper for all but three of them. Today, I'm sorry to say, I would

never do this. Things are so changed. The sensibilities are so different. The network culture is so different, so adversarial with no sense of the collaborative way which was, I think, the environment when we started. There is such fierceness now.

Have there been those kinds of problems since then?

Rees: It was always hard. After the first show we did with Hallmark, they had confidence in us. The story was so strong. We believed in it, and Dick Welsh, our liaison with Hallmark, believed in it. It won the Emmy. So in a way, you override the network system; you have a direct deal. But still it was hard to service the network.

Have other women broken some of the same barriers in their quest for independence?

Rees: I don't know. As the entrepreneurial producer, I put up my own money. It wasn't through a bank or a studio; it wasn't umbrella-ed or sheltered. We were just out there on our own. There are those who think that Hallmark sheltered us, but on the contrary our arrangement with them was picture to picture. We had to submit our proposals to them like anybody else. I do think that Dick gave us more confidence than anybody else ever had. Also, I think people have respected me. I always felt respected.

If I stayed in the parameters, it was comfortable for everybody, but the minute you start to push out, the resistance is there. It's never intended to be personal. That I know. It was just difficult. It was just a different way of doing business: women were not the entrepreneurial producers. But we've held out. We've wanted to be in control and in charge of our own creative life. If you go down, you go down on your own terms. If you succeed, same thing. Making big money is not the goal for most of us who do what I've done; that's just not the route to riches.

We often talk about taking control of your own career and your own professional life. You have to define it for yourself and then for the industry, so that they can respond to it. You can't be vague and amorphous. Some women actors, especially in feature films, took their star power and have created their own production companies and are working them well. People like Jane Fonda and Michelle Lee are producing, sometimes directing as well. Often they produce films that they're not even in. The defining difference between being sheltered and being independent is the risk-taking.

I'm not at all criticizing the women who don't take that kind of a risk. Freyda Rothstein never puts up a deficit. Dorothea Petrie never does. I

understand and respect that. I myself don't have an immediate family: I don't have children, so I didn't feel the responsibility of putting other people at risk.

A final thought: along the way I never felt I was working in or with a community of women until Women in Film came into being. In 1973 Tichi Wilkerson's vision gave focus and shape to that organization, whose mission was to foster an environment in which women could realize their career potential, and assist other women through mentoring and networking to achieve in their chosen field. Nearly twenty-five years later the ranks of the membership bulge with high-profile women in a male-dominated industry who have reached success in all areas as studio and network executives, directors, writers, entrepreneurs along with those who can now aspire in almost any endeavors they choose. I have benefitted by inspiration and have tried to be a role model. I consider my two terms as President of Women in Film my greatest opportunity to give back. We, together, forged a distinctive presence, and all women benefit.

~

MARCY CARSEY

6

❖ MARCY CARSEY ❖

I didn't know any better

THE PHENOMENAL STORY OF CARSEY-WERNER HAS OFTEN BEEN TOLD AND IT will not be our purpose to rehearse all the details here. An excellent reprise may be found in Jeremy Gerard's lengthy article in *The New York Times* (25 November 1990, Section 6, p. 55.)[1] The reader is also directed to Part 3 of this volume in which Carsey, in a wide ranging discussion with the authors, expounds on the highlights of her career.

A brief history will set the stage for an appreciation of her work. Her career began in New York as a tour guide for NBC; she then worked for a while as a gofer on the *Tonight Show,* then in the programming department of a New York advertising agency. She married John Jay Carsey, a writer on *Tonight,* and moved to Los Angeles, working as a script writer and story analyst. In 1974, she made her big move—to ABC. "ABC was for me. They were scrappy, there were women who worked there, you didn't have to wear a suit. I figured I would succeed wildly or get tossed out in a year. Michael Eisner hired me, and he hired me pregnant. He taught me well. As it happened, I was right about the company, and I moved pretty fast."

A colleague at ABC, Tom Werner, was also on the fast track. They were part of the team that brought ABC from the third- to the first-rated network by the late 1970s, with shows like *Mork and Mindy, SOAP* (see chapter 11, on Susan Harris), *Barney Miller* and *Taxi.* By 1979, the *New York Times* article reports, she was senior vice president for prime-time series, a position somewhat curiously described as "a cushy job" by *Business Week* (19 June 1989) with Werner as "her lieutenant."

But with Eisner's departure to Paramount, Carsey felt that the "scrap-

piness" that had made ABC such a great place for her was no longer operative.

"The job had become less wonderful and the network had become less wonderful. I didn't want to run the television division of a studio and I didn't want to work at another network, so the only thing to do was to go out and produce. If I were going to do that logically, the only way to do it was independently. When you share your financial risk with a studio, you give away part of your creative control, too."

So she and Werner opened a one-room office above a Seven-Eleven Store in the Westwood Village section of Los Angeles, where they began operations as an independent production company—perhaps the riskiest of all ventures in television, as Marian Rees has well demonstrated.

In debt to the point of barely being able to pay their phone bill in 1983, they suffered several blows: a failed adventure show, whose pilot tested poorly; a cancellation of their first sitcom, *Oh Madeline!* (starring Madeline Kahn); and a poorly reviewed television movie, *Singles Bars, Single Women.*

But then NBC asked them to develop a show for Bill Cosby. Initially the show was about a chauffeur (Cosby) and his wife, a maid; but Carsey and Werner suggested he play someone closer to the urbane person that Americans were familiar with from *I Spy* and all those lovable *Jello* commercials. Brandon Tartikoff, then head of NBC's entertainment division, also takes credit for suggesting this metamorphosis—to which Carsey replies, "It's possible Brandon talked with Bill before we first got together with him. But the show we brought to him is the show that went on."

Contractually, ABC had the first option on the show. It declined. Then CBS passed. Obviously, no one thought it was going to work. With NBC, Carsey-Werner had to make up a deficit that ran about $120,000 per episode—a deficit being the difference between the cost of the show and the amount the network gives as a licensing fee. "Economically, it was ridiculous," said Carsey. "Unless we had a megahit, it was insane."

It was definitely *not* insane. *The Cosby Show* premiered on 20 September 1984. By January, it was first in the ratings, regularly drawing nearly forty percent of the audience every Thursday night at eight. And since 1986, when episodes of *Cosby* began to be sold into syndication, the series has earned more than $750 million—by far the richest syndication deal in the history of television. Syndication windfalls was one of the network's prime motivators for the new FinSyn deals. All those profits go to Carsey and Werner, or to people who are part of the deal, but not a penny rebounds to NBC.

It is worth noting here that an unusual feature of Carsey-Werner Productions is the hierarchy of ownership. Again, from the *Business Week* article: "Once Carsey and Werner come up with a strong idea for a show,

they hire top directors and writers to shape the production. Next, they offer some of this behind-the-camera talent a percentage of a show's profits. That's an unusual deal in television and it works: C-W won the services of director Jay Sandrich by giving him a piece of the action in *Cosby*." Sandrich moved his family to New York City and directed the series in the old Astoria Studios in Brooklyn.

The inevitable spinoff of *The Cosby Show* came at the star's suggestion, but *A Different World* (1987) was not an immediate hit. It was eventually salvaged by Debbie Allen, who became director, having been recruited by Caryn Mandabach, president of the Carsey-Werner organization. Women were obviously well represented in the power structure of this show: Carsey, Allen, Mandabach.

But the female powerhouse of the 1990s, Roseanne Barr, was just slouching towards television to be born. During the first season of *A Different World*, Carsey and Werner suggested to Tartikoff a six-episode deal with comedienne Barr. They got only a pilot, because Tartikoff was unhappy with their work on *A Different World*. But, as everyone knows, *Roseanne* was an instant hit. It established ABC as the up-and-coming network and Carsey-Werner as "the hottest television producers in Hollywood" (*Business Week*, 19 June 1989).

Now they moved quickly with another show, first titled *From This Moment On*, then *Chicken Soup*, in which Jackie Mason and Lynn Redgrave played unlikely lovers. Mason had just won a Tony for his Broadway show, but, as a pre-broadcast review put it, "Some advertisers who have seen early footage fear that Mason's fast-paced delivery, which worked in Catskill resorts and on Broadway, won't appeal to audiences outside of New York" (Ibid). Sure enough, it was canceled after two months.

In 1990, Carsey was still stung by ABC's decision. "It took us so much by surprise, that we reacted without a plan; we just said, 'But guys, give us some more time.' I don't think we had a strategy, we just said, 'Please.'"

But more time had to be spent over the *Roseanne* brouhaha than regrets for *Chicken Soup*. Certainly the media have had a field day with Roseanne, allowing her abrasiveness (if that's not too weak a word) to occupy more print space than coverage of all the other Carsey-Werner accomplishments put together. An article in the *Los Angeles Times* (26 January 1989) detailed the problems between Matt Williams, who created the show, and Roseanne; thereafter Roseanne's headlines included "creative differences" with just about everybody with whom she worked. Her public spectacle at the San Diego Padres game, a new context for "bombs bursting in air," escalated all the way to the White House and President Bush's description of Roseanne's singing of the National Anthem as "disgraceful."

Not so ridiculous, however, was the perception that, as the *New York Times* reporter put it, Barr "was beyond the control of the people who had made her a star and who continue to support her publicly." True, Carsey in public statements was very protective of the show and its star. Over and over, the women we have interviewed for this book stress the importance to them of a harmonious set—for the wellbeing of each show and its staff, at all levels. As one producer told us, "We women like to think of ourselves as smooth arbitrators: and usually we are."

With Roseanne, Carsey-Werner moved into a blue-collar world seldom exploited by television. *The Honeymooners, The Life Of Riley, All in the Family* were early examples, but *Roseanne* was different: the main character was a woman— and not a glamorous, well-dressed, well-coifed, sexy woman. Carsey has said, "I couldn't believe there weren't any good shows about working mothers. About 65% of mothers work, and most of them just barely make it through the day." The everyday world of Roseanne, her husband, and children was the sort of a day that one can only make it through with some combination of sheer will, dogged humor, and—yes—family love. It was a series, in its early years, with an eye to family values, emphasizing communication between parents and children.

The *Roseanne* phenomenon brings to mind some thoughts expressed by Miriam Trogden, who has been an executive producer and writer on another Carsey-Werner show, *Grace Under Fire*. She contrasted that show with the style on *Roseanne,* on which Trogden also worked.[2]

"Brett Butler is very involved in our show. She doesn't write, but if she has a speech about something important to her, she'll rewrite what we've done: edit and change it a little bit. That's a new trend, to get a stand-up comic, somebody who's developed a character in stand-up, and move that character into a situation comedy. [Stand-up comedians in this category include Paul Reiser in *Mad About You,* Ellen DeGeneris in *Ellen,* and Jerry Seinfeld in *Seinfeld.*] Brett will come into the casting session and read with the people, especially if it's a big part. She'll give notes after every run-through about what she likes and doesn't like. She likes to touch all aspects. She reads all the scripts and gives notes.

"As a contrast, Roseanne just came in and did only what affected her: the overall story for the season, making sure she got a certain kind of story that she wanted. She had the power to do what she wanted, but she never came to casting or cared about who got cast.

"But there are many things Brett and Roseanne have in common. I think the show *is* what Brett wants to say. The same is true with Roseanne. Especially on the big issues like abortion, women's rights, women's role in society, men, there is little difference between them. And both are volatile."

Other Carsey shows have come and gone. "A great series," Carsey

told the *New York Times,* "requires wonderful talent on and off camera, terrific performers, a flash of comedic brilliance somewhere. You have to have terrific writers, direction, and a vision. It should be more than the sum of its parts. It should be an original of some kind." Her description of their method was to "start with an intention rather than a concept or a star or whatever, something that's affecting us in our lives."

In 1990, the network asked Carsey-Werner to develop a show for very young viewers and their parents. As with *Roseanne,* which addressed a new audience, Carsey describes the starting place for a new series: "The intention with this show [*Davis Rules* premiered in 1991] was to indicate that something was missing in how our kids were being educated. All of us have at least one kid who isn't sitting in the classroom that well. And you start mentioning education to other people and everybody has a story to tell. So comes a half-hour comedy idea." The signing of Randy Quaid and Jonathan Winters was a coup, but the show encountered problems and changing of the cast may have contributed to the demise of an exceptionally original premise for television.

But, with *Cosby* and *Roseanne,* Carsey-Werner have a cushion against failure—at least an economic one. They forge ahead. "You go in with certain beliefs, and one of my beliefs is that the work should speak for itself," says Carsey. "If it takes politicking, I'm not interested. There are other things I can do." In 1988 Brandon Stoddard, then president of ABC Entertainment, said, "If my life were made up of Tom and Marcy, I'd have to come to work about one week a year."

The success of Carsey-Werner cannot be explained by any simple formulae. Some ingredients might include the following.

First, *The Cosby Show* served as a strong corrective to the negative image of Black citizens on television. Although commentators (Marlon Riggs in the documentary film *Color Adjustment,* for example) have suggested that the doctor/lawyer combination on *Cosby* is too removed from useful imagery for Blacks in this country, many viewers would demur. To the charge that no one is home to care for the children or keep the house while the parents work, Bill Cosby had a ready answer. The premise is that most of the action is either on Saturday or in the evenings.

Second, *Cosby* initiated the revival of the situation comedy, a genre which had been declared dead by many "experts."

Building on that foundation *Roseanne* advocated an astringent blue-collar feminism. It wielded an ax against American machismo, itself a bludgeoning of women. Its broad appeal was also in its seeming contemptuousness of institutionalized feminism. And the regular exchanges between mother and daughters, while frequently acerbic, were also usu-

ally directed at a kind of child rearing that was authentic in the eyes of viewing children and parents alike.

With the phenomenal success of Carsey at the old MTM/CBS Studios on Radford Avenue, where many of the Carsey-Werner series including *Roseanne* and, more recently, *Grace Under Fire* were produced, the problem of rising costs was a constant factor. Coupled with this was union activity leading to shutdowns. Carsey-Werner hit back with a strike-breaking mechanism. This solution created deep divisions in the industry and many members of the various guilds supported the union. One distinguished director refused to accept an offer to direct, on a regular basis, a new, highly touted series, because it was to be done under this plan.

Returning to their production techniques, Carsey-Werner initiated conversations with CBS wherein they reportedly sought to reorganize the entire network process. In a time of sagging audiences, they were hoping for a joint venture in which they would supervise the entertainment division and introduce new methods of developing programs. Carsey was quoted as being "so excited, because it had to do with how a network does business so that finally viewers would get the best possible product." This occurred just months ahead of the time when restrictions were removed on the number of entertainment shows that the major networks were allowed to produce and own—a move, allowed by the FCC, that has, as noted earlier, repositioned producers, male and female, all along the line. In the wake of this change talks were soon broken off, and the joint venture never materialized.

Facing that reality, in 1998 the Carsey/Werner name was constantly on view over the networks. From *Cybill* to *3rd Rock from the Sun* their logo was an ever present reality in 1990s. In 1995 Carsey commented to the authors, "We knew the end was near. We are the only independent left. We realized that it was live or die. Our buyers were our competitors now and we had to get some more leverage fast. That's why we are shooting three pilots in two weeks. But it's only because we are making hits and they reluctantly took ours when they would much rather put their own shows on. Fortunately the networks haven't learned how to make a good show yet."

Notes

1. Quotations are from this article unless otherwise specified. [eds.]
2. From a 1995 interview with Miriam Trogden, a member of the production company for *Grace Under Fire.*

VIRGINIA CARTER

7

✦ VIRGINIA CARTER ✦

Our view of life is just a little different from that of men.

VIRGINIA CARTER'S CAREER IN TELEVISION REFLECTS AN ENTIRELY DIFFERENT perspective from that of any other woman involved with this study. It is a fact that Carter got her position in Norman Lear's Tandem organization because she was a strong feminist. It was the primary reason that Lear brought her in at the precise time that many of the persons we have met were benefitting from new guidelines from the EEOC. In the Lear household Frances Lear was, it seems, the resident EEOC. So it is only natural that we begin this chapter about Carter with her views on gender as explored with the authors in 1995.

~

Carter: I used to think a lot about whether there are differences between men and women—and of course there are—but whether they are primary or secondary is up for grabs. Early on in my career I came to the view that I still have: that, aside from all the boring obvious stuff, the difference has to do with how we come up in the world. And in this regard maybe the essential difference is the expectation of power.

I think in my day, anyway, it was very uncommon for women to have an expectation of authority. And not being brought up with that expectation has all kinds of repercussions—some negative, some positive. For example, if we didn't expect to have power and then we find ourselves, at least on the surface, in a position to have it, it's startling and destabilizing, it's energizing, it's confusing and it *can* be a lot of fun. The unexpectedness of it, maybe, forces us to think about the situation a little more deeply. If it was all just taken for granted—HERE I AM AND I'M

THE BIG BOSS—than maybe it doesn't make you pause and question yourself.

I myself never felt quite sure that I was in a position of authority, that I had power. Others told me I did. I was certainly perceived by others to have power. I thought a lot about the concepts of authority and power and how one could make the most of being in charge, be proud of it. But I was never comfortable. It's the way we come up.

As the world changes, and younger women move into it with every reason to expect that they may have some authority as they move through their lives, maybe all of that doubt goes away. I don't know. I haven't been, and cannot be, a 1990s woman at the age of thirty moving into a position of authority. It might feel quite different.

⌇

Virginia Carter, a transplanted Canadian, came to the fields of television along a very unlikely path. After college at McGill University and a masters degree in physics, she went to work at McDonnell Douglas, followed by ten years of research physics at the Aerospace Corporation. Her interest in television at the time? Nil. And so, quite naturally, she had never heard of Norman Lear, the man who was widely being credited with "changing the face of television." But she *did* know his wife, Frances.

⌇

Carter: It was 1973. I was working at the Aerospace Corporation, flying pioneering satellite experiments, but my other major interest was in the burgeoning field of feminism. Although I was very middle-of-the-road politically, I became an extreme activist in the feminist community, even serving for two years as president of the Los Angeles branch of the National Organization for Women. I gave speeches, lobbied the media, and generally made noises that were heard. I met Frances Lear through our common activism in the feminist movement. Her husband, Norman, was three years into the revolution that he had created in television with *All in the Family*.

⌇

That series premiered on 12 January 1971, following a decision by CBS President, Bob Wood, to seek a new image for the network to replace the bucolic heritage of *The Beverly Hillbillies* and *Green Acres*. By the seventh episode the show was rising rapidly in the Nielsen ratings and became the top rated series in the 1971–72 season. By 1972 it had become a virtual American institution, generating enough centrifugal force for *Maude* to become the first of three spin-offs.

~

Carter: Norman's great contribution to television at that point in his career was to bring significant social issues to prime time comedy. Under his leadership the sitcom became politicized. Norman found me, through Frances, because of my expertise about the Women's Movement. I knew more about that than Norman did, or Frances, or almost any other person in Hollywood at that time. I had been an extreme activist. Norman had certainly given much thought to social issues of all kinds, but he didn't have the entre that I had into the feminist community and their thinking. But it's equally important to note that he was sufficiently secure to be open to my thinking and to the kinds of discussions that were sure to follow from it.

Frances introduced us; he made me an offer to join his organization and become a television executive; I accepted the offer with the hope that I could be useful in advancing a good cause. I understood that the only reason possible to explain my presence in television was my expertise in the Women's Movement. I knew I could be very productive with this focus, supplying this deficiency. And my only feeling of belonging derived from this source. I didn't know what a director was. I wouldn't have known one end of a camera from another.

When I telephoned my parents to tell them of this career change (wow! is *that* an understatement) they were absolutely stunned. It might have helped a little that, during the very week I accepted Norman's offer, he was on the cover of *Time*. But we all understood that there was a lot of thin air under where I was standing.

Norman Lear is the most remarkable person. He's a giant. I still admire him. He put my office next to his. He put every single script in storyline and in draft form on my desk; and I could go to him at any time of the day or night with any comment I wished to make. Our views often differed, which was possibly but not necessarily the idea in hiring me in the first place. Sometimes our arguments were horrendous—Donnybrook discussions when we really clashed. This was good for both of us. I got my feet back on the ground after being in the relatively rarified atmosphere of the feminist community where everybody comes at everything from at least the same general direction. It was good for me to be with Norman, to hear what he had to say and to understand his perspective. And in these battles, he changed his view often enough for me to think this was worth my while.

~

Carter expanded on what she meant by a "Donnybrook." She recited a story about the series *Maude*.

~

Carter: Walter, Maude's husband, was an alcoholic. The plans for the series included a story line patterned after Sabrina and Bob Schiller. Bob was a writer on *Maude*; and Sabrina, his wife, was proposing to run for the state senate in California.

Bob Schiller didn't really want Sabrina to run, because he loved her and if she won she wouldn't be around much. She'd be busy and he'd be an after-thought. And Sabrina on the other hand loved Bob a lot but saw herself as a fully functioning, viable, action-oriented concerned human being who had a shot at the state senate. And so, translated into *Maude*, the husband, Walter, didn't want her to run, and Norman was going to have Maude agree not to run.

I didn't think that that's how those kinds of arguments were generally resolved in families, just by having the woman cave in; nor did I find this resolution to offer a particularly good role model. As an audience, I was certain that I would have been much less interested in the Maude who simply caved when this incredibly exciting opportunity presented itself. Norman's argument was that the reason she was to remain at home was that Walter had a disability [alcoholism] and she was going to sacrifice to help him. And Norman was going to make the point that she was wonderful because she would stay home and nurture the needs of her husband. The lesson to the public was going to be that she was the stronger one and her decision was a fine thing.

I argued that that would be considered so unexceptional, so blah, that there was no drama in it. Who would be interested in her decision? Not me. I thought such a situation in a [real] family would be much more violent than the one planned for the series. On another tack, what I also knew to be so was that anybody who ran for political office first time out was going to lose. That's a given. Sabrina, for example, ran and lost. So why didn't we play the part out as it would really be? Maude, like Sabrina, really had something on the line: her *Maudeness.* Who the devil *was* she? There was bigger drama there, and it was more important to me to show Maude in all her prickly aspects and confusing sides.

So you see, I had this ideological argument about role models and advancing the feminist cause. But I also had an aesthetic argument about the conflict inherent in the situation. And there was a practical, realistic side to making the story plausible: that first-timers don't win. There was also a fourth part of the argument, a psychological element involving the disease of alcoholism. There is the truism that the partner of an addict has to disengage with love and not cater to the sickness. Working with Norman, I got in touch with many of the major groups that were dealing

with the questions of alcoholism and drug abuse and I learned so much, that I pulled that argument out of the hat.

We began this Donnybrook at the office and continued it at his house. His position was, to me, inconceivable; but he wouldn't back down, and I went home from his house that night very distraught.

~

At this point our own research became a participant in the "Donnybrook." Bob Alley had just met Norman Lear and Virginia Carter two days prior to that Sunday evening Donnybrook in July 1975. He was invited to Lear's home on Sunday to discuss some of his research which Carter had described to Norman. In the interim the disagreement between Lear and Carter surfaced and consequently there was a witness to that spontaneous and intense conversation which ensued at Lear's Brentwood residence that evening. The following verbatim transcript of the conversation that sent Virginia "home from his house that night very distraught," was taped with their permission.[1]

~

Lear: What's disturbing about Maude running and losing is that it's a wet rag. She's entering a race where the odds are against her. If she loses there is no drama in it.

Carter: It is the reality of one's political aspirations, however, that on the first run you are sent to the slaughter. It's how you get your political scars.

Lear: If it's a drama about politics or its machinations, that is the making of a *Playhouse 90*.

Carter: Are you sure of that? Maybe there is something to be said for the process of politics, that it is an "upper" instead of a "downer." We go around these days (I do with my friends) saying, "Christ! it's not working, the system is designed to put idiots in office." I have a nervous feeling about that. Maybe it's so, maybe if one explored the process . . .

Lear: But that's not what this is about. This is about a man and woman, about a male-female problem, at this time in the seventies. Should she be allowed her thing? To switch into a political story would be . . .

Carter: It comes back saying that life is a wet rag if when you ask a question, Should she be allowed to do her own thing? The answer is no, and she is the one who will disallow it.

Lear: It's not a wet rag to me if she breaks for any reason, and to save her marriage gives in and her last line is: "It's so unfair."

Carter: That is the same argument though, Norman, as the alcoholic's argument. If she gives up what she wants to save her marriage what she has done is ruin it. She doesn't have any marriage if that's what she has to do. Self-sacrifice at that significant level in a person's aspirations is exceedingly unattractive.

Lear: Well, we might examine the man's situation, too. That's where this marvelous drama exists; exactly the same thing happens to him. If I sell my store because I will not be without her—I would rather be with her and move to Albany—I have taken what I have worked for thirty years and have chucked it. I have tried to see it her way to a point where I've sacrificed everything. What have I done to our marriage?

Carter: What is the reaction to the other possibility, if Maude says, "I want to do this," and Walter says, "If you do what you want to do you have forced us out of marriage or forced me to sacrifice myself."

Lear: I don't accept those semantics. I won't say if you do what you do, you are breaking the marriage or forcing me to sacrifice. I'll say, "Maude, why are you going to leave me for five days a week, nine months a year?"

Carter: And she's saying, "Because I want to. I've balanced these two things, the five days with you and the political career, and I'm telling you, Walter, I've decided it's a fair trade. I want to live up there, and I'll sacrifice for five days." She's saying that, by saying she wants to run for office, "I am prepared to sacrifice you because I want this other so badly."

Lear: He can't do that.

Carter: When he says, "I can't handle that, you will have to stay home," nothing he can say will get her back because she's already told him, "I've balanced those two things and I've decided I'll sacrifice you. . ." Any compromise that is total self-sacrifice of one partner for the other is sick.

Lear: I think if we pull it off the best thing we could do for women would not be for her to continue (even if it were the last show and nothing mattered). I'm not sure her running is the best thing for women. I think the best thing for women is to develop the four episodes so

that men and women alike want her to run. But for Maude there is just too much left of society's male attitude. There is Walter, who can't give up his thirty years' identity, and Vivian, who thinks Maude's place is with her husband, and a daughter who says, "Mother you have to make your own decisions." Everywhere Maude turns there is no help. If, at the end of four episodes, she caves and says, "It's so unfair, it's so unfair" and 80 percent of men believe it is unfair and 92 percent of women think it's unfair, I think we will have done far better for that point of view than to have her run and get 40 percent of men to feel, "I'm glad she ran," and no point is made at all.

Carter: I disagree with you strongly. When Maude folds, 80 percent of men are going to think that's precisely what she should have done and 60 percent of women, because women always fold in the crunch. They are the ones who sacrifice. In the stresses and strains between men and women in marriages, when career aspirations are on the line, the women always fold! They are told to.

Lear: I understand that, but it would be a first if any amount of men were sorry for it. If they saw it mirrored and were sorry.

Carter: How would we all feel towards Maude forevermore? As a stranger, coming to the show, watching it happen, I'll think my symbol of strong independent womanhood just caved before my very eyes.

Lear: Your symbol of strong independent womanhood is already too strong for many of your feminist friends and not strong enough for others. There is no way you make it work for everybody.

[The discussion turned to questioning how Walter's alcoholism would affect the plot.]

Carter: The alcohol people say that neither spouse should make an act of self-sacrifice in an effort to be helpful or support the individual who is the alcoholic. That being the case, neither one should make an act of self-sacrifice What the alcohol people say is that when you are married to an alcoholic you should detach with love. There is no other way to bring the problem to focus. So it cannot be alcoholism around which this play revolves in the final analysis, or we will be sending the wrong message. As to whether it's a feminist question or not, I cannot conceive of a television program in which the man aspiring to high office chooses not to run because his wife wants him to stay home. But put all that aside too, and then ask the question, "Where are we in 1975?"

We're at a point when for the first time in the history of this country significant numbers of women are running for state and local office.

~

This extract from the 1975 transcript of the Lear-Carter debate ends here. Twenty years later, during our interview, Carter's memory of this "Donnybrook" had obviously remained sharp. And for those unfamiliar with the episodes, Virginia Carter prevailed. Maude did run for office, and in an effective concluding scene the drama was retained. In a last-minute TV appearance Maude took a stand for freedom that brought her from a landslide defeat to a close loss. Politics was an "upper" and the entire four-part sequence was far from a "wet rag." Carter made the most salient point when she remarked to us in August of 1995, "But the next morning [Lear] came in and told me that he had changed his mind. Ironically, I think that the AA and not the feminist side of the question was the one that finally persuaded him.

"There are very few people who were in Norman's position of authority at that time who would have been willing to have that debate. I think that's one of the reasons his shows remained so successful; he stayed so open to other people's points of view."

The subtext to this story about *Maude* concerns the power of Virginia Carter's beliefs and her perceived responsibility for arguing them when they really made a difference. That episode of *Maude* was seen by perhaps twenty million people, and who knows how many in reruns. It was not a trivial moment.

This transition from real life to fictional script was typical of the Lear way of thinking. Research for storylines often took the form of clipping newspapers and magazines for promising topical issues, along with memos about personal experiences such as the Schiller one. Lear once remarked to us that it was exciting to read a story in a July newspaper about some significant event and be able to have a show about it on the air in September. Ironically, in our interview with Loretta Young, who held a very dim view indeed of Lear and his politics, we found that she employed exactly the same method. Lear and Young constitute, for us, a producers' Point/Counterpoint of liberal and conservative philosophies.

We inquired of Carter concerning the question of aesthetic, psychological, and ideological—especially feminist—principles, do they ever clash?

~

Carter: Sometimes. In general terms, a feminist would be most comfortable with a woman speaking out. She wouldn't feel it necessary to make the argument that a man should speak out because guys just do that: they expect to, and they're expected to. Whereas women generally, in

those days, tended to suppress their aggressiveness. A feminist might call a woman "assertive," whereas she might be perceived by the larger audience as "aggressive."

I, however, would want women to be more *aggressive,* to express rage, to say "here's a part of my life that matters to me." But creatively that doesn't always work. The network people and the Milquetoast director/producers always say that women have to be "vulnerable." Aggression doesn't work; make them vulnerable. And of course there's an extent to which that's quite true. You can't present too aggressive a female lead.

Even Maude turned out to be too aggressive to be commercially successful. She worked well in network television; but when it went into syndication, nobody wanted to buy it. Enough people liked the show so that it garnered huge ratings over the years. But when it came to syndication, the young, aggressive males, the station managers, didn't like Maude, so they didn't buy. Somebody [John Carmody of *The Washington Post*] said that Maude was the cause of the defeat of the ERA, because men got so frightened of that kind of woman. I don't know about that, but they certainly didn't buy the show. In syndication it made much less than its ratings suggested it would.

We recalled that *In the Beginning,* a brief-lived (20 September-18 October, 1978) sitcom with McLean Stevenson and Priscilla Lopez, was an unpleasant experience for Carter.

Carter: Right in the middle of that travesty of a show, it was cancelled. I didn't think I would ever see the day when I would be so thrilled to have a cancellation. That show was a mortification to me beyond words.

The story was complicated, but brief. You see, my power derived directly from Norman and he wasn't there for that show. And of course, my feminist view of life is that my being female didn't help. As long as I was in an office next to Norman's and he owned the company, people had to listen to me, whether they wanted to or not. If a man had held my office, it might have been different. It was always a problem that I was a publicly identified feminist in an era when being a feminist was not a particularly good thing to be, so that I was a crazy, a radical. And yet, it was hard for me to believe that any rational mind couldn't see how appalling that show was. But I couldn't make that point, even with the skills I had developed, as I argued against episodes of *In the Beginning.* I had been in show business for a while; I knew the ropes; I knew the personalities; I knew where to tiptoe and where to shout (although there was never an occasion where shouting was good). But I couldn't get through to anyone at all. Even Al Burton [Lear's senior vice president] didn't have a clue, let alone the other producer/writers.

~

The episode in question involved a pregnant young woman who wanted to make her child "legitimate" by getting married prior to the birth. The premise was marriage at all costs, no matter the absence of love or commitment or caring. A frantic effort to get the father and mother together for the wedding culminated when the young man arrived at the hospital just as delivery was imminent. As the gurney careened down the hall toward the delivery room with the priest and the father running alongside, the marriage vows were completed moments before the birth. In our view Virginia's adjective "appalling" is an understatement. Yet without Norman's presence in the company the power center for good sense was missing. As Virginia recalled, even as they were arguing over the script the network informed Tandem that the series was canceled.

For about five years, Virginia Carter rode the Lear rollercoaster, as it hurtled along with its half-dozen hits and its relatively few failures. As Lear increasingly turned to other pursuits, Virginia found some of her power waning, and in 1978 with Lear's physical departure from his office, her clout was sharply diminished. Even as she continued producing, the company took new shape and form.

~

Carter: Here's what happened. Norman turned more and more of the running of the company over to Alan Horn, a very bright Harvard Business School graduate. [See Chapter 4 and Bonny Dore's discussion of the business school graduate invasion of the television companies in the 1980s.] He took over the running of the company and wanted to put somebody in charge of comedy, which was properly my position. But he gave the job to one of the lawyers who worked under him. This is not an uncommon move in Hollywood. My credentials were in place; I had the experience; I had worked at Norman's right hand for eight years. That position, had I been male, would probably have gone to me. But it didn't. Alan explained it on the basis of his belief—and this has great truth to it—that being a female and being me, Virginia Carter, with my kind of sensibilities, trying to sell half-hour comedies to the network folk at the higher echelon was going to be a very uphill road. Whereas taking a business affairs guy, a lawyer, also a Harvard graduate, and putting him in charge meant instant simpatico with the network. Alan said that I should go off and become president of PBS. That's an actual quote!

Well, that was a difficult time for me. I wasn't entirely sure I wanted the responsibility of running the half-hour comedies; but when you get by-passed, that's hard. Not only that, but to have a lawyer come in and be my immediate supervisor—well, that was a little bit difficult.

Norman was still enough involved so that he (or perhaps it was Alan) said to me, "Go and do what you want." So I replied that I would like to develop some dramatic programming, whereupon they made the head of facilities (the man in charge of janitors) the head of the drama department! And that was difficult for me.

So I went and did a film called *The Wave* as an After-School Special. Since I was female, it was appropriate that I do children's programming. Of course they let me do that. And I got an Emmy and a Peabody for it. And still the head of drama was the former head janitor and the head of comedy was the former legal affairs lawyer. I hadn't a clue how to produce drama, but I had the good sense to hire Fern Field to help me with *The Wave*. She had produced before and I really hadn't.

All this time a number of people were saying to Alan a lot of sarcastic things about who was running drama, while there I was, doing whatever I could find to do but not fitting into the company's structure. They didn't fire me, because—I don't know—maybe they thought Norman wouldn't have been pleased; and yet they didn't give me a position in the hierarchy. So I just dangled out there and did what I could. After "The Wave" I served as executive producer of the Eleanor Roosevelt movie, *Eleanor: First Lady of the World,* which to my great delight was named one of the ten best television movies of the year by a major ratings service.

Eventually, they made me head of drama. Michael Grade came in, and he and I were very attuned; so I got to try to protect him from some of the long knives. Alan was always unhappy with very bright young men who came into the company, and he dispatched quite a bunch of those; but he didn't get Michael out of there for a couple of years.

While I was still there, Alan left the company and went to work at Universal, then became one of the three founders of Castle Rock. He took with him the head of business affairs, whom he put in charge of comedy. As I see it, Rob Reiner has the creative talent in that company, in terms of drama. He has wonderful natural gifts, but to hone those he came up through *All in the Family,* where he went through eleven years of schooling. Alan is a world-class dealmaker, but his creative instincts seem off to me. I remember, while he was in our company, he made his first movie, called *Emerald Forest.* It came out very shortly before that great film *The Mission,* which it might have resembled in some way if handled correctly. The original premise was so grabbing: an oil man had been down working in the South American forest and had had a young son who was blonde and beautiful. The son got lost in the forest and was not to be found again, and the natives of the jungle had found him and raised him as a jungle person. This is an anthropologically interesting premise, and you could have done wonders with that. But Alan took it

and in the first six to twelve minutes of the movie, the father had found the son, and then it became submachine guns and native women with no tops on running around in brothels and scaling the outsides of big buildings in Rio, and you get the idea. Ludicrous. About that time, *The Mission* came out, and I thought, "My goodness, I would rather be in the company that made that one."

You know, I'm getting so old that if I don't start telling somebody some truth sometime I'm never going to, so I decided when I saw Norman recently I was going to tell him a couple of truths instead of the politenesses. So I told him that Alan Horn was not sensitive or caring, and that he was disparaging towards women. But Norman said, "That's not true, Alan's a good man; it's just that he's not nice to women." If only I had thought to tell Norman that you could say the same about Hitler: he was a good soul, it's just that he wasn't nice to Jews. I wasn't quick enough, dammit.

Somewhere along the way in all this long story Norman had withdrawn and then sold the company to Coca-Cola. They already owned Columbia; but instead of merging, they told us it was healthy to have competition within the larger company, so Embassy, which had spun off from Tandem, remained Embassy and Columbia remained Columbia. The stated idea was that the two companies would compete in the marketplace and the corporation would reap the benefits of both. All of which was total nonsense: they were just waiting to merge. And so within two years they merged the two companies. I was running the drama department at Embassy rather successfully at the time. I had hired a pretty substantial staff of really good people. But my job was not without interference. For instance, when I tried to hire Earl Hamner [*The Waltons, Falcon Crest,* etc.] I was told by Gary Lieberthal who had been head of syndicated sales and was now head of the company, that Hamner wasn't acceptable at the networks. So I couldn't hire him.

Anyway, before they merged the two companies, I was running a department I was extremely proud of. We had shot about four movies in one year, all substantive and all fairly successful. We had a bunch of projects in the works. Our efforts had flourished with a very minimal staff. In spite of these things, I was certain that my efforts were not highly regarded by the people who ran the company, because they were really focused on half-hour comedies, not drama. So knowing that I was sort of there on sufferance, I watched the budgets very closely and brought everything in on or under; and we did pretty good work. We kept the staff pared so that everybody who was being paid was creatively active. I had a relatively small overhead.

When the merger occurred, the overhead suddenly became enormous. They had six people doing my job. There was a twenty-three-year-old

they now said I could report to. Or perhaps she was twelve. "Report to" was my phraseology, and they called me on that. I suppose it was my military and aerospace background that makes me think in hierarchical terms like that. They said of course I wouldn't "report to" her. The person who told me was Barbara Corday who, I remember, was not helpful, but she didn't have a lot of elbow room, so I'm not going to feel badly about her. She didn't last long there. It was a tough environment.

I assessed my situation as follows: my interest in the broadcast media had always been and continued to be in content; I continued to believe that television was the single most influential force in the world; if I couldn't make headway there I really didn't want to be in show business. And so I quit.

I haven't regretted my decision for a moment. It was a great adventure, those fourteen years. I learned a ton. But in the final analysis the way things work in show business is exactly the way they work if you are the president of a local chapter of the National Organization for Women and you're trying to run the Board. The financial stakes are just a whole lot higher. Being president of NOW, I learned a whole lot of stuff, especially about group dynamics.

I was conscious that working in that environment was difficult. It's difficult for everyone—for Al Burton, Norman Lear, me, everyone. In asking Why is this difficult? How can I succeed? Why am I not succeeding to the extent I would wish?—I can always say, "It's because I'm female and the industry is male." In asking those same questions Norman doesn't get to come up with the same easy excuse. So there's a big danger there.

On the other hand, I'm not making it up when I say that it's more difficult to be female in an environment where the power is in the hands of men than it would be if I were male and relating to guys. The reason I'm so sure of that is that when I walk into a business office where power is being traded and if the people I'm required to relate to are female, some of my barriers go down, some of my tensions diminish, some of my expectations turn more positive. It just is so for me. And I don't think I'm special in this regard. So I figure that when I come through the door and I'm not one of you, there's just a little more to overcome.

Our view of life is just a little different from that of men. I know enough guys in the world now to know that a lot of us are very much in sync. I mean, Norman's the one who brought that so firmly to my mind. We were so much attuned that the barriers weren't always there; but they are there often enough for it to be a real issue.

There's a wonderful bit of research that points out a very annoying phenomenon: some people took a bunch of technical papers and put women's names on them and had them graded, and then took the same

papers and put men's names on them and had them graded; and there was a grade and a half difference on the evaluations. The graders were all men.

You see, these problems are in physics, too. If I did it, it couldn't have been of as much consequence as if a man did it.

Carter turned to the subject of harassment.

Carter: A lot of it was veiled. If somebody vetoed a concept of a character, or a casting choice by saying "I wouldn't want to go to bed with her," that would be extremely overt and very rare—at least in my experience. Normally it would be much more veiled than that—twinkly exchanges of looks between the fellas in the room or a yo-ho-ho kind of environment. Sexual innuendos were much more common than blatant statements. Heaven knows what it would have been like if I had been a guy sitting in the room instead of a gal. It would probably have been much more blatant. But I was frequently—no, most of the time—the only woman in the room.

Was there any support system for women in those fourteen years?

Carter: Yes, certainly. There was a reporter for the *Hollywood Reporter* named Sue Cameron. Norman wasn't crazy about her because she had reviewed *All in the Family* when it premiered and had not been kind. I think she was shocked by it, as were many critics who were not prepared for its boldness. At any rate, she was very helpful to me, filling me in on characters and personalities in Hollywood, who was who and what was what; and she effected introductions when I asked for them.

And there was a casting director, Ethel Winant, at CBS who had been there forever and become practically an institution. A lot of people found her to be quite prickly; but I always found her to be most helpful—and a delightful person. I didn't consider myself particularly wise in matters of casting; in fact, I considered myself to be quite inept. Ethel's guidance was helpful, especially when I produced *Eleanor: First Lady of the World*.

Fay Kanin was also very important, one of the few people, I thought, whose power derived from her own work, as opposed to those of us whose authority flowed from a man, like mine from Norman Lear. Fay did it herself. She wrote her own stuff.

During my time in the industry, there was a growing support system among women. But I was too far out in my feminist perspective to be much moved by them. By the time I was leaving television, there was a group called Women in Hollywood. Tichi Wilkinson Miles, the owner of *The Hollywood Reporter*, had started it. There was another group that got

very politically active, in support of candidates who advanced women's issues. I found both these groups quite uninteresting, because they were so establishment. Women in Film was another such group. They were having thoughts and doing things that were very important, but not interesting to me. They were discovering ideas that I had discovered and moved past—not because they were passé, not because they represented goals accomplished—but because I had been there, had thought that, and wanted to move on. So they were no longer interesting to me, but they were very important. They may still be there.

Although I have never worked with them, the New York-based organization called Women Make Movies is more attuned to my ideas. They seem quite far out. I would be more interested in talking with them than Women in Film, although I don't mean to put Women in Film down at all. It's as if feminists got co-opted by their own success, so that the mainstream moved in, and that's exactly what we all wanted to happen. But when it did happen, it wasn't terribly interesting.

There was a group that used as its symbol the praying mantis; after we have sex, we eat our men. I'm much more interested in crazy thinkers. I like the stimulation of that.

～

We recalled a Women in Film session in Hollywood in the mid-1980s when a panel of female producers and directors were asked whether there was such a thing as a woman's perspective. In that gathering the reaction was hesitation, at first, then a definite consensus that there was no such identifiable trait, and even if there were it would be useless or retrograde to promote it.

～

Carter: Yes. It's very difficult to get women to speak up in support of other women when there are such issues as "women's perspective," because they feel that then they are branded as "one of those." Somewhere along the way I got clear about that in my own head, as I got real comfortable with myself, and so I was able to say things quite blatantly, maybe even stronger than I really meant, just to get the point across.

But I do think that there is a female perspective. You have great difficulty getting people to admit it. But if you got that same group of women from the Women in Film panel together quietly in a room and began to discover where their angst arose from, you'd have a female perspective in a flash.

And women are also afraid to admit a female perspective because it would tend to undo their struggle for equality. Coming into broadcast media, we all bring a very simple question of what is it we wish to make.

There is so much trash being produced, that you could ask almost any-one and he or she would say, "I want to make something better than that." But the trash has within it more elements that are male than female: violence, sex, violent sex. Making this stuff is not Marian Rees's first choice; it is not mine. And I think that most women in show business would not, as their first choice, be out there doing violence and sex. They just wouldn't.

There's a different perspective, as measured by what you want to get on television. You look at the half-hour comedies that are on now, where the guiding lights are female. They are not doing violence and sex. Some of them are very insightful about interpersonal matters.

Diane English had a lot to do with setting the tenor of [*Murphy Brown*]. Allowing Murphy Brown herself to be so abrasive is hilarious. Along with that, the show takes twists and turns that are so unexpected.

But having said all that, I'm wondering what "perspective" means. If it means the emotions you have within you as you belly up to the table to try to make your agenda move forward, then there's definitely a female perspective. At least, that's my opinion. But if it means what you want in the long range to accomplish, there probably isn't much of a female perspective. We all want good television programming, though we have to define what "good" means. We all want success. We all want, probably more important than anything, to be recognized.

I suspect there's a slight difference between men and women in the area of recognition. A woman would probably be more rewarded than your average man by being recognized for her contribution. Guys would be more rewarded by money. I don't mean that the man doesn't want to be told he's done a good job; but that would probably move the inner psyche more for a woman than for a man. And that guess derives from my feeling that women are less secure. I remember the flush of joy, to the point where I would think this has never happened to me before, when Norman would say to me that I'd done a good job. He did this so well: when I would do something good, when I would move something forward or offer some insight that turned the trick on a script, he would take me aside and say, "You know, you are a phenomenon. You were the best thing in the room today." And I would have given up any amount of money to have that kind of recognition.

If you had to point to one big difference between women and men, you could say that women are more scared than men. They are more tenuous in their positions, with less money to fall back on, less certain of their capabilities than men are. And it's that ability to risk that really moves you forward. I was scared; I can't imagine why, in hindsight. If I had to do it again, I'd go right through it, without having a moment's fear. I don't mean to say that men aren't scared; I'm just talking about degree.

94

We talked earlier about support for women by women. Mine seldom came from women when we were in mixed groups. I was more likely to get support in a mixed group from a bright young man. He had nothing to risk. He was so bright and so able; and he had a mentor, another man who made him feel he belonged there; so he was able to take my side with no risk at all. I got some super support in that way. I tried to figure out who was bright and secure and move my efforts in that direction.

I think that everybody doing television is bringing his or her own attitudes to the script. They can't not. Norman Lear for one was very upfront about it, though not always publicly, when he'd say he was just producing the best possible drama; but he was very comfortable about putting his own attitudes in those shows.

So was I. That was what attracted me to television in the first place. The worry is that, as the broadcasters, the creators of telecommunications become bigger and bigger as the result of mergers, fewer voices are having their say. That's very worrisome.

～

In 1986, shortly before Carter left the television business, she gave the keynote address to a Symposium, a provocative challenge to the seventy-five women in the television industry in attendance. At the conclusion she spoke about the condition of the feminist movement in Hollywood in that year.

～

Carter: At the point when I joined Norman Lear in Hollywood, the feminist movement was in its heyday. We were spending our time talking about Equal Rights, we were talking about equality, we said we women deserve what you men have, we deserve equal pay, we deserve equal access to education, we deserve equal rights of choice—choice about whether or not to have a family, choice as to our living arrangements and life style, we deserve the Equal Rights Amendment. What can be so bad about being guaranteed equal rights under the law? We kept talking about equality. And then people would say to us—those who were upset by the content of our argument—they would say to us, "You're trying to be men." And we'd say, "No, no, we want to be equal, we don't want to be the same, we are not the same; but we want to be equal." We in fact, as I look back on it now, tried not to talk about the ways in which we were different. We dodged that. Maybe not consciously, but I find myself, in looking back on those days, wanting to avoid a discussion about those ways in which we women were different. We wanted to avoid it because it was a trap. Every time the subject of our differences came up, those differences didn't seem somehow to work in our favor. If

we were different, we were different because we were less strong; and so there was protective labor legislation that legislated us right out of opportunities for certain kinds of jobs. If we weren't the same, then another way in which we were different was that we were verbal but we weren't logical. That's why there weren't any women physicists: we weren't logical, we were no good at logic, and if we weren't logical, how could we possibly manage major corporations? How could we be the bosses? It was tough, and we dodged those subjects.

In those years there were all the issues having to do with the failure of women to be represented in appropriate numbers in various job categories.

And it was the most satisfying, the most invigorating war. It was frustrating and infuriating, it drove me crazy, I often went home in tears. But we won some of the battles. And the more we struggled, the more people seemed to come in on the side of Right, Virtue, and Good, as perceived by Carter. And I felt in those days that I was in the heart of where the action was. There was a positive, constructive social revolution. It felt great. And now here we are, twenty years since this second wave of the Feminist Revolution. And I have had to stop and ask myself, Where are we? I have a sense of mild futility because I feel like we're slipping back a bit.

～

In the 1990s Carter was engaged with Population Communications International, a plan to use television and radio, the popular media, in Third World and developing countries, to introduce messages about family, population control, and the status of women.

～

Carter: The project does a very careful study of what the government in question purports to stand for. They will study those documents to which the government is signatory; the recent population conference in Cairo has India's signature on the bottom line claiming certain principles as national ones. In addition, researchers pull in all the relevant sections from that country's Constitution that reveal significant principles the people support.

This work in partnership takes a year or two of research and then analysis of the findings. Then workshops are held: demographers attend, along with writer-producers from the country itself and a training team. And out of the research we pull the attitudes and values that are worthy of note, some of them obvious, others more subtle.

The next step is to ascribe attitudes and values in patterns to the characters. It is important to remember that the writers, producers, and

directors are *all* from the country in question. So everything is predetermined, all laid out. The mission is to confirm the good, and change the bad to good. We find documentation, for example, that China officially believes that men and women should have equal value within the culture. They should be paid equally. The government and the people subscribe officially to the doctrine that girl children are not to be considered less valuable than boy children. And the stories will confirm these values—and in doing so contradict certain actual practices. I sense strongly that the population explosion around the world threatens us all, threatens us and our kids, pollutes the environment, kills girl babies. The numbers are staggering.

~

Reviewing this commitment to a radically different use of the medium one is reminded of Virginia Carter's rationale for entering the Lear company in 1973. She noted that the only reason to join Tandem was "my expertise in the Women's Movement." It had to be *about* something.

Note

1. Significant portions of that conversation was published in Alley's *Television: Ethics for Hire* (1977, pp. 129–133).

NANCY MALONE

8

✦ NANCY MALONE ✦

Television has a responsibility to change the values of society

WHEN NANCY MALONEY GRACED THE TENTH ANNIVERSARY COVER OF *LIFE* ON 25 November 1946, she was described as "one of the most successful younger Powers models." It was the first year of network television broadcasting for Dumont and NBC. With her name changed to Malone, there followed a productive acting career in New York in theater and television that culminated in a four year stint performing as Libby in the popular *Naked City* on ABC (1960–63). She was nominated for an Emmy for best supporting actress in 1962–63.

Malone was one of the first people we interviewed in Los Angeles. At that time, 1975, she had just become Vice-president of Television Development at Twentieth-Century Fox. We begin this chapter with portions of that interview, followed by excerpts from conversations in 1975, 1976, 1979, 1986, and 1995.

In 1975 Malone was asked whether conditions were now better than they had been for women in television drama.

〜

Malone: Much better, from a couple of points of view. At least now, even though it's *Police Woman* and *Get Christie Love* [starring African-American Teresa Graves as a supercop and running only one season, 1974–75], at least women can be seen on the air. In the days of *Ben Casey* they weren't there. Of course, *Get Christie Love* was more of a cartoon than a realistic cop show.

I acted in a series called *The Long Hot Summer* based on some writings of William Faulkner. There was a very strong male lead, and not an

equally strong female lead, but at least a part with some complexity. Both leads, though, were somewhat overshadowed by this incredible superstud Ben Quick, played by Roy Thinnes. I think just after I did that show [ABC, 1965–66], the roles for women that had any kind of meat to them started to disappear. There was a terrible decline until about two years ago when "real" women started to come back again. Very slowly, however; there is still a great deal of resistance.

The Angie Dickinson role on *Police Woman* I've heard called a sort of caricature, almost a professional prostitute for the police department. Maybe that's what women do a lot of in that branch of police work. So the charge could be made that there's a return to that kind of stereotype, even with her. Look at other television women who have authority. On *Amy Prentiss* [1974–75] Jessica Walter is a very personable, attractive actress, and she played the boss of all these people—another cop show; but the writing undercuts her power. She was drinking coffee most of the time. This put her in a mental kitchen-type atmosphere; and I think that's the result of tremendous fear on the part of the network, maybe the result of audience reaction, testing, demographics. She should have *been* authoritative, she should have *been* out there with the gun if you must, done the shooting, the arresting, instead of always coming in after the real action.

That show was dropped. I think it killed itself. If you buy a show about a woman who's a boss and who's strong and is a detective and has authority, then let her use that authority instead of whitewashing it. It's a waste of the audience's time, the actor's time, to commit to saying we're going to present a show where a woman is going to be in a position of strength and then take away the strength. Ridiculous.

In 1975 were there portraits of stronger women on television, perhaps, for example, Mary Richards?

Malone: I think *The Mary Tyler Moore Show* was an enormous break-through. I think Mary is terrific, a very strong-minded career lady; however, it breaks me up that she's always calling her boss "Mr. Grant" and she's always "Mary"; maybe that's the way it is in Minneapolis. However, I don't feel it's always true, and after four or five years, it seems time for her to say "Hello, Lou!" She is in essence held down; I'd like to see her break through more. But I think if she did, the series would be gone, because what makes the series work are all those combinations. Mary was way ahead of the rest of us at first, but now I feel we're going ahead of her. I'd like to see that change a bit. *Rhoda* is, I think, right on the nose these days. It's a show for which I have tremendous respect. I love the way they've written it, affectionate and very true to life. Grant Tinker and the writers have a sense of what's going on.

But I think if you talk about this kind of education in television, Norman Lear is the champion. He puts his characters into situations that are comic but also perform a real public service. He has changed the face of television comedy; you can no longer do *Father Knows Best* or any of that old sitcom format because people will not accept it. After you've been in a living room with Archie Bunker, you can't go into three flats and a cyclorama set with the superficial life of a *Father Knows Best*.

Basic to all this discussion is my feeling that television has a responsibility to people to change the values of society. And I'm not just talking about people who want to watch *Studio One*, but just the general level of people. I think it's obscene to present dramas that say the only way to solve problems is by violence. That's a terrible danger, promoting anti-social beliefs and behavior. Also in relationships: there are very few series that show the intricacies of friendship, what it takes to make a friend. Friendship, love in general, is a very difficult thing to maintain. That subject has tremendous conflict, passion, even violence in its own growth. Those areas are lying there fertile for us to explore, waiting for a writer to come in who wants to work on that level, to at least inject that subject into a show.

One show I produced was *Winner Take All* [1975]. It was a story with a strong female protagonist. Her gambling addiction brought her into contact with a close friend upon whom she depended for help. It's rare to see scenes written for two women, one needing help and the other coming to her assistance. Shirley Jones and Joyce Van Patten were terrific.

I think, first of all, if you have any kind of soul as a producer or creator, you do have a certain idealism, stars in your eyes. Unless you are totally without sinew, you can't start off a project asking how fast can you make this show and for how little money. You might as well stay in bed. It takes a lot of strength to get your idealistic impulses over. With *Winner Take All* [a product of Malone's Lilac Productions] I felt I had to do a story about a woman who had a gambling problem, the way we have dealt with men and their drinking problems. Other than the Lillian Roth story, we've never gotten into the compulsive woman. I was especially interested to discover how women with a gambling addiction disguise their problem. I went into this with the hope that the show would reach out and help people who had this problem and prompt them to call Gamblers Anonymous.

The idealism I've just described is not the norm. There are studios and production companies and others out there, who shall remain nameless, who think first and foremost of their overhead, then of the demographic situation.

Now, to be honest, to some degree and in some areas I have to think that way, too. But that kind of thinking does not now consume me. I still have my ideals and I hope I will never forfeit them for the sake of the budget or the demographics or the network demands or whatever.

~

She spoke about the network situation in 1975.

~

Malone: Well, they're the people who can say yes or no to whether it gets on the air. Sure, the airwaves theoretically belong to "us" in this country, but in reality they don't belong to us; they belong to the people who make the decisions about what goes on the air. That's the bottom line, let's face it. So you have to find things that will please them. You're pleasing the taste of collective thinking—and the collective decision-making is always hard on the creator. If you're dealing one to one, that's terrific: you know my ideas, I know yours. But instead, you send something in to someone and he (almost certainly "he") checks it out with the sponsor, and this one and that one, and by the time it comes back, it may bear no relationship at all to what you originally started with. The whole process is extraordinarily difficult and it's somewhat of a minor miracle how anything gets on the air.

As for my future, all I want to do is develop and be associated with shows that have some kind of moral base, something that says that one can function in life with a certain amount of love and faith. That's the arena in which I want to work. I may be lonely out there.

I came here to Fox in March 1975. Before that I had been with Tomorrow Entertainment since 1972. It produced *The Autobiography of Miss Jane Pittman*. To some small extent I was involved in that, in its getting on.

~

We expressed particular admiration for the final scene of that extraordinary movie, when Cicely Tyson as Miss Jane slowly and deliberately walked to the "whites only" drinking fountain to expose the ugliness and horror of the segregation laws.

~

Malone: Everybody identified with that final scene. Northerners, Southerners, Blacks, Whites, men, women, all. The subject was the suppression of a *person*. That's the kind of show that should be seen on television more often. However, I've talked with other networks that say they

wouldn't have bothered to put *Jane Pittman* on the air. Their reason: it didn't get the great numbers of viewers they wanted.

What impact has been felt by there being so few women on television in the past few years?

Malone: Sociologists tell us that this absence is a very dangerous thing, because it leaves children—at least in those hours they spend in front of the set every day—with no way of identifying with women.

A lot of my female peers, because of the fact that television has more or less dismissed them, have left the acting business out of necessity and have gotten into other things. Ellen Burstyn, for example, is in a play right now, but she is a part of the AFI's director's program; she wants to be a director. There are almost no women directors now. And a few of the other women have gotten into scriptwriting. There's a woman here at Fox, Rhonda Gomez, in charge of creative affairs for feature films. You'll find women peppered in amongst the networks and studios. Originally they were there for tokenism, but I think they are finally being heard.

This has been a male-dominated business from the days of the old silents. Producers came from Europe and some from Seventh Avenue— the garment district of New York City—where women were models. "Shut up and go in the other room," and that sort of thing. The turning point has happened; it's just a question of letting men not lose face and not be threatened by the fact that a woman can be smart, even smarter than a man. People need to see that the existence of a bright woman doesn't necessarily put men down, but is just a fact of life. All that other nonsense needs to be gotten rid of, once and for all.

〜

A year later Malone, 1976, relaxing in her commodious 20th Century Fox office, spoke frankly about her new position and of women in the business.

〜

Malone: They have made me a vice-president this week and I think that is a rather large achievement for Fox, not for me. . . It's very tough. It's tough to get in there and sell. I was recently at a party in New York that Columbia threw for a network executive and everybody from Fox had to fly back to the West Coast, so I was left to represent Fox at the party. And all the rest of the community was there—MGM, Paramount, Universal—and there I stood in this room, invisible, just invisible. There was only one other woman without a husband in the room. Deanne Barkeley

and I began to talk about it. She noted that it was difficult to get network executives to look you in the eye. They had trouble relating to us as women and they were uncomfortable relating to us as executives.

⁓

Two years later Malone and Virginia Carter exchanged views on the state of women in the television business. By that time Malone had left Fox and was seeking to produce films sensitive to women.

⁓

Malone: I can't help but think that if a woman were in a top executive position in a network the "jiggle" shows would not be on. . . . Television should be giving us role models for young women.

Every single day is a fight to get programs that represent true human values and feelings and there is no true image of men either. . . . I am encouraged by the fact that Clairol is concerned over the image of women and is producing a series of hour specials on ABC and I am producing some of those.

⁓

In a 1995 interview Malone picked up these same themes. Her determination had not faded.

⁓

Malone: It's hard to speak in generalities, but I think at least some women bring a different perspective to an issue. Every woman, of course, brings a different perspective because everybody's different; but if we can talk about a movie: if it's a woman-driven piece, if it's about rape or some problem a woman might face, I would want to hire a woman director. I would try to find the best out there but I would also try to find a woman director who would relate to this on a visceral level. There have been great male directors throughout history who have done women's stories because there weren't any female directors. But in the nineties, where women have been allowed to have a voice to some degree and a mind to some degree that they're allowed to express to some degree, it's valuable not to exclude their point of view.

When children grow up watching TV and motion pictures where there are very few women role models it's very dangerous. They don't know that such a species exists, women in any kind of position of authority. I think we're missing a great deal by not letting that voice be heard more often. As Tennessee Williams said, "Each minute is goodbye" in one's lifetime, and I see that so much time has passed without this point of view. It saddens me.

⁓

At this point in her career, in 1995, Malone was primarily interested in directing. Although Lilac Productions, her company, still exists today, and although she continues to develop projects to produce, her work is largely as a director. She works continuously.

~

Malone: The networks control who gets to direct. There are lists. And the networks have people who they think are appropriate for the project and the producers have their lists and between the two of them they decide which one is going to be doing the project.

When a director goes on a set he or she is in charge of seventy-five persons, almost all men. There are very few women on a crew. It's tough. As a woman one has to be strong but feminine. One has to keep the energy going because the hours are astoundingly long. When most of the crew members are men they talk about things like sports and "broads." There's a lot of small talk that can go on between the guys that women won't be invited to join. I had to find other things to make the time at work seem enjoyable. I'm sure there are a lot of women who know a lot about sports and cars and the rest of it. I don't know anything about those things.

A lot of progress has been made because of anti-discrimination laws. For example, I would leave the set to make a phone call and step into one of those little rooms to find a telephone. I was faced with posters a mile high of women in various bits of underclothing, or none. And many sexist photographs and jokes. That offensive scenery seems to have disappeared, thank God.

I've been blessed with a good sense of humor. That's saved my life many a time. When I was an actor, the crews meant a lot to me. I get to know all my crew very, very well. And that bonding is carried over to my directing relationship with them. I really get involved with them. I really like them. I'm good friends with a lot of the crew. I take care of them like they were my children. I don't make them do things over and over. I respect what they do. I realize they want to get home to see their wives and their kids. I can show them I care that they have so few hours to spend at home. They're tired. They leave late, some have to wrap the show; they're there when I get there, and I always come an hour early. So I get by with humor and sensitivity to others.

I've seen directors who, when they walk on the set, are the kings. By contrast, I'll bring a cup of coffee to a grip sitting there. It doesn't do any harm to my ego. I know what I do and I'm secure in what I do. If I do say so myself, crews love me. They always ask, "Is Nancy coming back?" because they appreciate the fact that I care about them and it's genuine.

What about organizations, such as the Caucus for Producers, Writers, and Directors?

Malone: I was one of the first members of the Caucus. Then I dropped out, and now I'm back again. There really aren't that many. There's the inequity of fewer women than men there. But there comes a point where I feel I've done my bit. I've done more than a lot of other people in this town have done to create and promote and so on. And there comes a time when you say, "Somebody else do it now, somebody else lead the way." I was a pathfinder. I hired women, I promoted them from within. Along with eight others I founded Women in Film.

The Caucus is by invitation. You have to show a body of work and you have to be passed by the people who are in charge of the membership. It's liberal-minded; nobody's keeping anybody out. If women had been raised to think more about "belonging" to organizations, with more of a membership mentality, greater numbers of women would probably want to be part of the Caucus. But women are kind of scatter-shot, each one for herself trying to get places to work here and there. There's no sisterhood. There are a lot of adventures that men share and women seem not to have the same opportunity. Men play golf, or they go to the basketball games together, there are a lot of activities that men have that women don't have an equivalent for. We haven't been conditioned to have that kind of communication.

Yet there are beginnings of networking. I've never been to any of these networking meetings, but I think what happens is a short-range thing. People come and have a conversation about what they're looking for, and then they just go away. I think they're sincere, but I don't think people are in a position to follow it up with action. They fall short of saying, "We're going to call this The Women's Film Production Company and we're only going to hire women and only push projects that are helpful to women—writing, producing, directing, selling, distributing." That will never happen.

I was so lucky. I wanted to do this story, *Winner Take All*. I met the writer, Carol Ledner, who developed it, I went to the network and sold it. I said I was the producer, and when they asked what I knew about producing I admitted this was my first stint as a producer. Bob Papazian of Jozack Productions and Jerry Eisenberg who ran the company said they'd walk me through it, and I had a great time, I learned everything. Jozack needed a picture and I needed it to start my producing career. The guys took on the difficult aspects for me, getting locations for example; I was riding with Bob for most of it. I hired the star and the director. I got everybody I wanted and the picture was successful.

So I say, as a producer I was lucky, with no great problems. It was all

handled so well and so I didn't get any black marks against me. I think my success with Lilac, forming my own production company, was inspirational to other people coming along wanting to produce. I did many more movies of the week and they got easier each time.

As a director, however, there are some problems. The male producers don't necessarily think women can do an action-adventure show. There's a sense of what women can and can't do. The networks, including cable, are used to hiring certain favorites who coincidentally just happen to be men. When a man fails, he fails for himself. When a woman fails, she fails for the gender.

So that makes it a greater risk for a woman to hire a woman. If there's a failure, it's double. Her boss says to her, "See what happened when you hired Mary Smith?" Then she feels bad for herself and the other woman. If it's a guy, the boss says "That guy you hired was a real turkey," but he can walk away from it.

If there's any key to my work, it's that one of my characteristics is to assume responsibility. As a child actor I had to accept responsibility for the role I played. That has carried all the way through to this moment. I'm not afraid of responsibility. I embrace it.

∼

9

✦ SUZANNE DE PASSE ✦

[Authors' Note: While Ms. de Passe was unavailable to us, because of her significant role as a producer, we have chosen to examine her activities as a producer and her perspective through use of two significant conversations on the Internet.]

In June 1988, Berry Gordy, founder and chair of Motown Productions, sold his legendary record company to MCA for $61 million. The January 30 edition of *Time* announced that Gordy "is now plunging his company into the equally high-risk field of movies and television, . . . banking on the talents of his ace protégé, Suzanne de Passe, 42, the president of Motown Productions and one of the most promising new mini-moguls in Hollywood."

Aside from the somewhat unflattering title "mini-mogul," the article is extravagant in its praise of de Passe for reaching "near the top of Hollywood's mostly white, mostly male elite." Yet *TIME* is careful to quote her as not interested in jumping to a major studio (read "not interested in reaching *too* far into the white, mostly male elite").

Her debut into television was auspicious: in February, following the June appointment, the eight-part *Lonesome Dove* began its wildly successful run, leading to repeats and sequels. In snaring the movie and television rights of Larry McMurtry's epic novel for $50,000, she had overruled the conventional wisdom that had led all three major networks to turn down the rights. No one, they reasoned, was ready to watch westerns these days. Some have suggested that the chief cause of this disenchantment was Lawrence Kasdan's *Silverado,* a sprawling 1985 western that failed miserably.[1]

Turning to the Internet interview, de Passe commented."The *Lonesome Dove* project really began a long time ago when I was first introduced to the author of the book, Larry McMurtry, at a dinner in Tucson. A short while later, we had lunch and I asked him what he had kicking around the old trunk that hadn't been produced on film. He told me that he had a book coming out in June but didn't think I would be interested because it was a western. I told him on the contrary, that I would be very interested. I love westerns and have been a horsewoman for a long time."[2]

"All these people had passed on it before it had been published. I still have the letter from one of the studios that said 'this is the most ridiculous, tedious, boring book in the world and nobody will go to see it.' It was a surprise every step of the way."

With this property, de Passe was continuing her thirteen-year success at Motown, which included several hit records and the historic act of persuading Gordy to sign the Jackson Five, then relatively unknown (little Michael was then nine years old). *Time* claims that she "is widely credited with bringing Motown to life by expanding into TV movies and other programs," wielding a budget that increased from $12 million to $65 million dollars between 1980 (when she was put in charge of Motown Productions) and 1989. *Lonesome Dove* won seven Emmys, a Golden Globe Award, and a Peabody Award.

In October 1989, *Essence Magazine* cited Ms. De Passe for one of its awards of distinction. Part of the page-long commentary follows.

"If being Black *or* female has traditionally been a hardship in the film industry, the idea of a Black *and* female success story sounds like a Hollywood fantasy. No one should tell that to Suzanne de Passe, however. . . . The odds against de Passe never stopped her, but they certainly made her stop and think. 'At the end of the day you can't let the stats [statistics on racism and sexism] overcome the tasks. You can't be more invested in the details of what those odds may signify than you can in your own ideas. It's not that you never notice these things, but it's how you handle them. You have to keep your mind on what is truly most important, and that's the work. . .'"

In *Ms. Magazine,* January 1986, Rosemary L. Bray wrote a very thoughtful article about de Passe, concentrating on the Motown experience—three years before *Lonesome Dove* transfixed all subsequent reporters and commentators to the exclusion of much of her other work. But it does look forward to that success story. "Today, she is the key player in Motown's effort to reposition itself, to summon in film, television, cable, and video the magic it consistently creates in the world of music. De Passe, along with a staff numbering less than two dozen, is fueling a new era for the Black-owned entertainment company that began in 1959 in a run-down section of Detroit."

Bray's assessment of de Passe's childhood is succinct and based directly on her interview. "Harlem was home to de Passe. The daughter of a schoolteacher and an executive for Seagram's, Inc., she grew up in the Riverton, one of the small cadre of New York apartment buildings known to shelter the Black elite. It was a childhood that provided what de Passe terms 'a certain security—though not financial. I definitely was aware that I was Black, but I also was aware that I had ability and hope and promise.'

"Her parents sent her to New York's New Lincoln School, a multiracial, multicultural private school that fostered in de Passe a sense of assurance and self-esteem that would never leave her. 'It's where I learned to express my opinion about things—and that's been the reason for my success: opinion, analysis, all that stuff.'"

Bray's interview reminds the readers that de Passe's work has frequently focused upon the subject of race. *Motown 25—Yesterday, Today, Forever* was originally a five-hour gala benefit for the National Association for Sickle Cell Disease, reuniting many of the greatest names in American popular music—the Supremes, the Four Tops, the Temptations, the Jackson Five. It was edited into a two-hour special that won de Passe her first Emmy in 1983. Her second Emmy came in September, 1985, for the extraordinary gathering at the Apollo, the unofficial shrine of black American music. Bray mentions the importance, for this show, of Jewell Jackson McCabe, head of the National Coalition of 100 Black Women. McCabe was then working with New York's Inner City Broadcasting Corporation. The five-and-a-half-hour show, starring Bill Cosby, was edited to three hours for NBC.

The Hollywood Reporter has closely tracked de Passe and yields dozens of references to her work. One of the more interesting is dated 6 July 1995, under the banner *"Dove Not Peaceful Anymore,"* in which Jonathan Davies notes the increase in violence for this second mini-series of the show. "It's impossible," he writes, "to ignore the irony that a series created as 'wholesome family entertainment' will have more shootouts, violence and vengeance next season in order to stay on the air . . ." Rob Kenneally, Rysher Entertainment's executive vice president for creative affairs, is quoted as admitting to more gunfights. "But he also agreed that without the new, more violent edge, the series—newly dubbed 'Lonesome Dove: The Outlaw Years'—would not be there for a second season."

Davies quotes de Passe as justifying creatively the newer, meaner central character of Newt, now given the job of bounty hunter. "'We have to understand that there is an organic reason for this change in his character, and there will be credit sequences into the story that will give the viewer a sense of who he was—and how he has become who he is

now . . . You don't want to slip over the edge into violence for violence's sake.'" An earlier article in *The Hollywood Reporter* gives evidence that de Passe has always sought to keep her values clear amidst the swirl of Hollywood trends. Speaking of the stampede towards westerns, she says, "Some people get it and some don't that westerns are a fertile territory for great tales. But whether in the West or outer space, you've still got to have a great story. But the overall resistance to setting a great story in the West has become less recently. There was a time when you could have the greatest story ever told and not get done if it was a western" (Kirk Honeycutt, "Hollywood Blazes New Trails," 28 September 1992).

Given this demand, the producers (de Passe and others) were faced with a not-unfamiliar problem: the maintenance of their integrity in the face of an externally forced need to turn the kinder, gentler Newt into the more violent bounty hunter—and, consequently, adapt a bloodier story line. Critics of industry violence may be quick to judge this decision as cowardly, or wrong-headed, or all-too-typical or even an example of "women becoming men" when the script demands it. But in any assessment of her career to date, de Passe's contributions have not been exploitive or especially violent. We would agree that her television shows have legitimately earned her the respect of her peers and that she has been worthy of her many awards.

In 1995 the American Film Institute presented to de Passe its Charles W. Fries Producer of the Year Award (Marian Rees was a previous winner). This honor, named for one of Hollywood's most successful producers, in the words of its benefactors "is presented to an individual, selected by a blue-ribbon AFI committee, who has made a distinguished contribution to the world of television." The AFI press release describes the 1995 recipient as "one of the most influential executives in the entertainment industry," one "recognized for possessing an unusual combination of creative talent and business acumen. In a business known for its revolving door, she spent 20 years with one company, Motown, before establishing de Passe Entertainment. . . . Ms. de Passe serves on the Boards of the American Film Institute and the Los Angeles Opera, and has received numerous industry and civic awards and accolades for her achievements and contributions. [In addition to her Emmys] she has been honored by *Essence Magazine,* named Revlon Woman of the Year, and received the Women in Film Crystal Award, Equitable Black Achievement Award, and National Urban League Achievement Award among many others."

She has moved from a company perceived as a Black music company (so described by her in "Motown's Other Mogul", *Channels,* September 1987) to a mainstream Hollywood powerhouse. *Forbes Magazine,* no less, noticed her on 23 January 1989. Graham Button's article, "The

Golden Dove" (pp. 58–59), deftly traces her career, along with Motown's, from "a Detroit record company with a list of predominantly black recording artists that included Smokey Robinson, Stevie Wonder, and Diana Ross" [who had been lured away by major labels by 1989] to "a small-time film and tv outfit set up almost 20 years ago when the parent company first moved to Los Angeles." Button continues, "Under de Passe, who has headed the studio for the last eight years, Motown Productions has had successes with musical variety specials featuring former Motown rock and soul stars. Now, with *Lonesome Dove,* both de Passe and her studio are on the verge of either a spectacular success or a major setback."

Happily for the company that became de Passe Entertainment, the scales of justice (or at least reward) tipped in favor of "spectacular success."

In the aforementioned "Coffee with Suzanne dePasse," host Russ Myerson, along with members of his audience, interviewed the producer on the Internet. One of the earliest questions elicited a response especially appropriate to this volume. "The business itself is very inhospitable to women as decision-makers. I think that's changed a bit. What I love about television is that it is the producer's medium in that you are really able to influence the outcome of the product; not totally, because it's also very collaborative and you are servicing a lot of different masters. But for my own personal, creative, and business juices to flow, I find that television is the most exciting."

In the matter of her independence, she is equally helpful. "We find ourselves in a unique position. We are an independent production company. I started this company with two of my colleagues, Suzanne Costen and Tony Patillo. . . . And four years later, I will tell you that we are alive and kicking in a climate that is completely given over to mergers, acquisitions, and the swallowing-up of people like me. And us. So, the only thing that can keep us independent for as long as we possibly can be, because that really is my desire, is great work. And great properties. So we tend to explore, because we are software producers. . . anything that makes the hairs on the back of our necks stand up. . . And we are also clear about those things that do not excite us because we're not big enough to do it. We have to do things that really ignite our passion and our energy. So . . . it doesn't matter what it's about as long as it's a great tale, a great story, a great yarn, a great subject."

"I am very hands-on, as are most of the people in my company. I believe, philosophically, that as independent producers, it is important for all of us not to just be executives and sit behind a desk. So virtually everybody in the company who is an executive has been involved in online production. It is not just a concept to them. These people have been

on set. They have developed a script. They have gone through post-production. They understand, from the inside out, what this is because I think it's very important for us to be in a dynamic, creative conversation with the directors and the other producers and the writers that we work with. . . . So the reason that I can be CEO and Chairman, Founder, whatever that is—owner—and in the studio, at five o'clock in the morning, wanting it to be done, is because as independent producers, that's what I think you have to do. You have to know your product and you have to create it in a way that you can stand behind it."

One of the most recent programs produced by dePasse was *The Temptations*, which appeared as a four-hour mini-series in November, 1998.

Notes

1. Kirk Honeycutt, "Hollywood Blazes New Trails." *The Hollywood Reporter*, 28 September 1992.)

2. Russ Myerson, "Coffee with Suzanne de Passe," on-line interview, 1996; http://www.rysher.com/tv/lonesome/depasse.html.

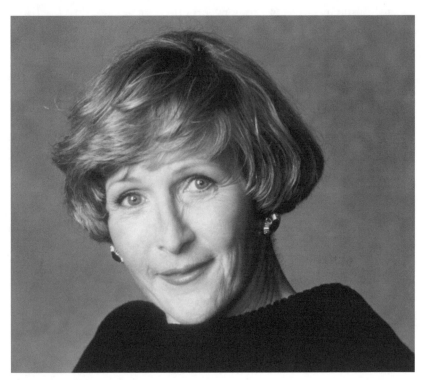

GAYLE MAFFEO

<center>10</center>

✦ ON THE LINE ✦

GAYLE MAFFEO

My job . . . translate it to the screen

OUR INTERVIEWS WITH GAYLE MAFFEO BEGAN IN 1977 AND CONTINUED VIRTU-
ally every year through 1995. What follows is almost entirely from the
most recent conversations.

⌒

Maffeo: There are several different roles that carry the label producer. My
role is different from that of Marian Rees. I am not a creative producer.
I don't write. In early television, those who produced the shows were not
writers. However, soon the writers wanted the title "producer" to give
them creative control over their material. Today there are numerous
producers listed, but my credit is unique, "produced by." There is only
one person with that title on any single show.

My job is to take what the writers have written and translate it to the
screen. I am the generalist, not the specialist. I take everything from any
direction. I can be somewhat involved in casting, involved in all the
physical day-to-day activities, and also with all the budgeting process.
And in our case, I'm involved with the persona of the company, how it's
reflected to the public. I'm also involved with how our company is
perceived in the community. There are so many things that a producer
like myself does whether male or female. In the beginning, it was quite
unusual for a woman to be doing this job with the title "produced by."

I abhor the term "line producer" because it defines people in such a small area. I started out as what would be described as the line producer, although I never had the title. I fell into the old definition which was basically anything handled "below the line." But I was too feisty. I always wanted to make sure I had a look at what was "above the line" too. I wanted to be above the line.

My position has changed somewhat within the company. On *Home Improvement* I am now referred to as "producer." In the sixth season, [1995] there is now a producer who works for me who does more of the day-to-day work while I handle the administrative details that have to do with the network. In addition we are in syndication, so the complexity of production here is quite different from the show's first year.

I am now the Senior Vice President of Television for Wind Dancer Production Group. I started on the Disney lot with *Carol and Company*. We are a separate entity at Disney. They are our partner in television. With regard to the role of women in production, for me there was a conscious decision in 1993. I decided I was no longer the office wife. I definitely had to undertake some personal thought as to my style and to produce and administrate as just a professional with no gender involved. I used to trip over being female. It may have been easier for other women, but I always thought it was very strange because I started way back when a woman's job was definitely defined in terms of "women don't do this and men do that." I never dreamed when I began that I could attain the position I'm in today. There were a few women in production when I started. Carolyn Raskin worked for many years as a producer. She was an associate producer when I first met her. She did many variety shows and I have the greatest respect for her because she was the first woman I saw on a stage who could quietly go about her business. She was not out there blasting her own horn, but was very effective. She was heard, and I thought "that's the way to do it." That became the style that I wanted to emulate because I could see she was very successful. She was very intelligent, and she knew how to get the job done without having to carry on a personal drama. I worked with her when I first came out here in variety television. She went on *Laugh-In*. However, I haven't had very many women to be able to use as role models. There is networking infrequently.

My first boss was a woman and in her attempt to attain authority and power she would go through all kinds of things. She had so many strange rules. I played the role of executive secretary to a high level executive, which she wasn't. And she was so impossible and made me so miserable that I said to myself "I'm never going to be like this." I decided I would never want to make it torture to work for a woman. That was a long time ago. At the same time, there was another woman who handled personnel at

CBS whom I admired because of her ability to work with many different people with a grace and sophistication I thought was remarkable. I have never appreciated the woman who takes on a male role to accomplish her goal. I've always felt it unnecessary to be "one of the boys," taking on their language, their wardrobe, and their haircut, and acting tough.

An important lesson came early when I was an associate producer with Jack Benny. Irving Fein was associated with Benny and he became my mentor. He had been very involved in publicity years before in radio and television, and he kept telling me "be tough, that's how you'll get it done, be tough." A woman doesn't have to play out those male games. I always play it straightforward and communicate the best I can. If I communicate with people they will listen and take me seriously as a person. Irving taught me how important publicity is, how to use it wisely, and not to be frivolous.

Until I became involved with Women in Film I rarely interacted with other women in the industry. In the early seventies, Women in Film offered a workshop on negotiating skills. The workshop was offered because negotiating was the most difficult for women. At that time, men had a style and a way of dealing with each other, peppered with baseball terms, but women hadn't grown up on the playing field. So we had to figure out a way to negotiate. Georgia Jeffries, who became one of the writers on *Cagney and Lacy,* was in that class. We came in from the Valley together to these meetings and practiced our style on the way in the car. This class taught women to maintain their femininity, maintain their persona, and find the ability to meet the difficulties of these negotiations. We learned effective tools for women to become good "win-win" negotiators. Of that group a majority of the women are still in the industry and successful in each of their own areas. That was a very thrilling experience.

When I first started in the industry all women would "get the coffee." Now I do it as a matter of choice because it is comfortable being a hostess to people and making them feel at home in my office. There was a joke about it in the office today. We were having a production meeting and I asked a new person in the group if I could get him something. He said a cup of tea and I asked what kind of tea he would like. I don't have a problem with that and I don't feel insecure revealing my feminine side. I do like the way the stationery looks and am concerned with the presentation of the company. I like putting flowers from my garden in the office and I love to go nose to nose on the budget and put our heads together to negotiate for something we need or fighting about something that is unjust. Sometimes you have to negotiate for something you don't totally believe in, but you have to deal with it because it is the project. Women have had to step up and take responsibility. That is the biggest change. The old way of life in the forties was that women on the

whole stayed home and men went to work. Women did not have the final responsibility. They had to answer whenever hubby came home. One of the reasons marriages held together so much longer was because women never had to take care of themselves completely. They depended on their husbands for security. I have always wanted to take responsibility and be self-sufficient if necessary—although I have no objection to being taken care of from time to time.

I think there was a period of real consciousness-awakening. I was well into this career before that happened. I was still playing out my mother's Midwestern role trying to do both—I was a housewife, carpooling the kids and mothering, but then I set that aside and for six weeks became an associate producer, handling those production details. I would step from one area to the other and on occasion they would overlap.

Prior to the *Mary Tyler Moore Show* things were just beginning to change. In the days of the *Dick Van Dyke Show* we believed that Laura Petrie was fulfilling the woman's role. You went home every day and thought, "This is the life I am supposed to live, this is the way it's supposed to be." We were living out our mothers' lives, in the fantasy roles that were showing up on television.

Of course, after the sixties the pendulum went totally the other way, but I never went all the way with it. I was uncomfortable with the new women's role. I stayed in the middle of the road. My career started in the sixties and here we are in the nineties (I'm not done yet!), and I feel as if I have done and seen it all.

I think the system is still changing and we are not all the way there. I now have more and more associates who are women. It's very interesting what several women can do when they put their heads together. I use as an example the time when I was at Carsey-Werner. We were in a terrible quandary trying to decide what to do about the show *Roseanne*. We had finished one episode and walked right into a Writers Guild of America strike. We had nowhere to shoot the show and we had an all non-union crew working on it. We were trying to do the series in the most economical way. A friend of mine, Rita Burton, who was then with CBS, ran all of the facilities. She and I had a conversation about where to take this show. All of her stages were going empty and she said "The buildings aren't union, isn't there a way we can figure this out?" Carsey had been so terrific about bringing talented women into the company. Four women from the company sat down and had a conversation on how to resolve our problem. We got together with CBS and as a result, put all the Carsey-Werner shows on the CBS lot by agreeing to four-wall the shows inside the studios thus avoiding a conflict with union rules. It put many people to work and it was a tremendous accomplishment.[1]

I share a lot of information and I have an interest in mentoring other

women, but quite honestly I want to put the best person in the best position. Earlier I would make sure I had a male and a female on a stage crew with the DGA. Now I hire the best two people I can find. If you walk around you will discover we have an equal number of men and women. Now there isn't a job I can think of within this company and within Disney that isn't available to both male and female. I don't even think about it, but if I actually sat back and started to look at all the departments, there is a real balance. It has become a non-issue.

In the early days men would not take the best person. It was assumed that because you were a woman you couldn't administrate and people wouldn't take you seriously. I don't think it's necessary to rule with an iron hand; however, a friend did give me this sign for my desk, "The Velvet Hammer."

Hiring is a little bit like casting. You have six people line up who are perfectly capable of handling the job. It just depends on the style you want. If you were going to pick out a computer you'd have four of them sitting there and you'd pick out the one that appeals to you. They all operate fine and if this works well and you like it you really don't want to change it. You'll upgrade it for more features. Regarding the upgrade analogy, quite often women tended to get into positions where they were very good at what they did. No one really wanted to advance them because they were so good at what they were doing. Men would advance, not women. Now it's different. The competent person moves on if she has the ambition and the drive.

When I walked in to interview for my first job in 1962 I wanted to be a producer. It took me until 1977 to finally attain that position. That's a long time, but it was what I wanted to do. I have had a tug of war with myself over the past seven years whether I wanted to move into that next phase. I now know I'm ready. It's time to move and delegate.

Many people have a quest for power and move up even when they are not capable of doing the job. I have a real thing about power. I've watched people misuse it. You are more powerful if you don't try to be powerful. I'm more of a planner and I really believe that the race takes time.

Being a vice president is a big change. You're not in touch with every detail. I hope I have nurtured my associates along the way, and that I don't need to be in control, because they are.

Today I can wake up with an idea, see it as interesting, ask a couple of questions, and initial it. For example, I thought we really should do something for Habitat for Humanity so we made an episode in Atlanta about it. It did something for the community. We have contributed something. I am very proud of that. Our next emphasis is ecology.

Home Improvement is about family values. People can take comfort from our strong happy family. Both parents work and [both also] work

at home. We're trying to be as realistic as possible without being preachy. I think our executive producers work by example; that is, most of them have families. All have normal, very normal, conventional home lives. As a result what's being portrayed on the screen reflects their own families at home. These people are solid citizens, one and all.

There is a conscious effort to make sure we have women on the writing staff so that the women's point of view is there. Patricia Richardson has much to say regarding the woman's point of view. "I wouldn't say it that way. This is how I'd react."

The way I deal with people is to have them work with me, not for me. It maintains everybody's dignity. One should feel that he or she has been heard and has contributed. I try to give everybody the opportunity to follow a dream. I take real pleasure in each success.

∼

DEBBIE SMITH

DEBBIE SMITH

Moving up is very male-oriented

WE MET DEBBIE SMITH IN 1989 AS WE BEGAN WORK ON *MURPHY BROWN; Anatomy of a Sitcom*. In 1996 she was one of a very few remaining members of the original production team. She uses the term "line producer" to describe her activities.

~

Smith: I'm a line producer, although there's no real definition of that term. In fact, the term "producer" can mean almost anything. I've always been in production, being a part of what was going on on the set, making sure the crane was there, the time cards, the equipment the crew needed. Then I got a chance to work in post-production, like editing, and became associate producer on *My Sister Sam* and coordinating producer on *Murphy Brown*. In the jargon I moved "above the line."

Most of the shows I worked on were canceled within six weeks. In retrospect that was good. It forced me to move around and meet a lot of people. It's good to be on *Murphy* for years, but when you get off the show, you have to start over. Babies have been born, producers have been born.

In your early days did you have a mentor?

Smith: Well, Diane English. She hired me as associate producer on her show *My Sister Sam* [1986–88]. She's the kind of boss who, if you do something right, gives you more to do. And you have the opportunity to increase your repertoire with her. When she trusts you, she trusts you all the way. She isn't threatened by really ambitious and efficient associates, as some people are. Instead, she uses you to her benefit. Some people have the fear that you are going to usurp something. She doesn't have that fear at all. She knows what she does and she has complete confidence in her own work. The better you are, the easier her life is, the better life is for her on the show.

I've been lucky. Most people I've worked with have been good. I haven't worked for many jerks in the business. And there are a lot of them.

Has you been discriminated against because you are female?

Smith: That's kind of hard for me to say. I'm going to find that out, because I was given a promotion, to be a producer on this show, instead of co-producer, where I started. We're essentially a new show, with Diane

out and many essential staff changes, so everybody is kind of vying for position, figuring out exactly where they fit in. And the Unit Production Manager, Bob Jeffords, got the title of producer also. He and I get along very well, there's no competition. Had he been another person, it could have been very difficult. He's been around more, not only in television but also in features; and someone like that probably knows how to push people around if he really wants to. There are things he does that I have nothing to do with, and things that I do like post-production that he has nothing to do with, and the big things in the middle we're constantly consulting on, without any fear. We'll see how things shake out, but I think it will be all right.

I don't think about *power*. On the matter of power in this town, Michael Ovitz has it. There's no power on this show; we get together to move it as swiftly and efficiently as possible, to get it on the air on time.

There are a lot of women in Hollywood who have power. But I don't know how you define power except to say that there are a lot of women in very responsible positions. You see them in the office buildings, it's not just people on the set who are at work on the show directly. There are a lot of women in the corporate structure. Now I'm not part of that corporate structure, so I don't know what their problems are, whether they have the same old boys networking causing them problems because they're shut out of it. When that happens, it must be horrendous. But I don't know about that for sure. I do know that when the networks come over here to supervise projects, there are some very vocal outspoken women who have influence over what's being done, and they're listened to, in the same way as the men. I know there isn't a woman president of a network, and I don't know why that is. Barbara Corday got close, for about five minutes. And no one took it seriously for whatever political reasons, and her five minutes ended and she was gone.

My exact title now is "supervising producer." It's a title I asked for when we started changing executive producers. I didn't know them, so I thought I needed this title to establish with them that I knew what I was doing. The job is the same; the title is different and establishes my niche on the show. But I don't really think in terms of power or hierarchy. Partly because on the shows I've worked, the authority figure was the person running the show, and everyone else worked underneath. That person made the final decisions, and you did what you did as well as you could, making whatever decisions along the way you could, but they weren't the final ones. I'll never have the authority that a writer/producer will have. That's where the power is, when you are writer-producer and you own your own show. That's where Diane English is. Yet I have a lot of responsibility. Or, to put it another way, I could really screw things up!

Diane and Joel [Shukovsky] have left *Murphy Brown*. They now have nothing to do with the show. Although their names are still on the show, it's Warner's. A Warner Brother's executive and the network are in charge—people Diane had to deal with also, when she was here. There are executive producers now who run the show; she just got more money than they do, because she created the show and owned a piece of it. She was a partner with Warner Brothers, but she could also be described as an employee.[2]

I know a number of women who hold positions similar to mine. A lot of them come up through tape [that is, shows which are taped rather than filmed], which is different; because in tape you don't have a production manager so if you're an associate producer that's basically the same on a taped show as a production manager. You're hiring the crew and making deals with the crew and following all the set stuff through from planning to performance. So a lot of women are coming up through the way of associate producer and trying to work their way over to film, for whatever reason.

Last year and the year before everybody was trying to go to film with series, because of the supposed arrival of HDTV, so nobody wanted to do tape until that came. The difficulties of transfer will be enormous. But HDTV has been slow to come. So this year they're doing a lot more taped shows than I would have thought. It's cheaper, and most new shows aren't going to make it, so the investment is smaller and the losses less ruinous. The problem with getting a new show off the ground is money, because there's no guarantee it's going to go beyond the season. If it doesn't, you lose money and the production company, which has deficit financing, has a very big bill. You don't recoup any money from syndication until after you've been on for three or four years. Sometimes, I think, the budget is so top-heavy above the line, with stars, that it precludes using film. There are twenty-three shows being shot here at Warner Brothers now and not all twenty-three are going to make it through the season. So a lot of money will be lost, and it'll be less money on tape than film.

What are your plans when Murphy *comes to an end? Is there something that draws you to television, or is it just a job?*

Smith: It's more than just a job, but security is the thing that matters most. I'd love PBS type stuff or a wonderful miniseries or a documentary. But they already have their particular groups of people. There are so many little compartments in this business. Even from one camera to multi-camera films, people will hire from those with experience in that particular mode. I did all multi-camera after *My Sister Sam*; I did all one-

camera before that. Employers will see multi-camera on my resume and figure I can't handle one-camera, certainly not produce it.

Are there more women in the business now than when you came?

Smith: I actually worked for two women when I started, in 1976. It was at Lorimar Productions, and a woman was head of business affairs. Her secretarial assistant, who was handling business affairs, was Julie Waxman who became a senior vice-president when Lorimar and Warner Brothers became one company. When I negotiate my deal now, I talk with Julie, for whom I was a secretary nineteen years ago.

I worked as a secretary, pure and simple: I typed, got coffee, answered phones. It wasn't any different from any other corporate secretarial job. When I got into production, production managers seemed to be mostly men. Within the past ten years the Director's Guild has been very active in getting new women. There are now larger numbers, with more responsibility.

In the end, I think if they find that the person can do the job, she'll get hired. It's probably harder for women to break into certain jobs where they have to deal mainly with men. I mean jobs like those of the network people who have to sell shows and advertising to local stations, who will mostly be men. And maybe that's why presidents of networks haven't yet been women, because of advertisers. But there are more women now in the advertising business. A lot of important men came to television from advertising. And so it was natural for them to be in an all-male environment: women weren't part of that business world in any numbers in the 1940s and '50s.

Do you handle problems on the set in any different way from your male colleagues?

Smith: I don't know how to verbalize the difference. And I don't know whether it's a female thing or just me. Because I'm dealing mostly with men—here and there there's a rare female—I do have to be careful how they perceive me. It's that back-and-forth kind of thing. He's looking at me looking at him. And I'm trying not to overpower them, trying not to bruise their male ego. And I do have to be aware of that. I'm not a guy and I'm not going to pretend to talk like a guy, because I can't. I don't know what that means even, but I know there's a certain way they might speak to each other. I have to be very careful. And it is hard. It's constantly difficult to give people orders, so to speak. They don't want to take an order, for the most part. You have to say Please.

There are producers, male, who are tougher than I am. By tough I

mean a certain cut-and-dried attitude that lets everybody know they're going to run a set a certain way. Now men will follow this director, even if they don't like him. But they're not going to put up with it from a female. If I came in and started laying down the law, they'd say "Yeah, right . . . we'll see." There is ego there. It's a fact of life and you have to realize it. I don't think it's going to change.

From another perspective, though, I don't think there's anything wrong with being polite, anyway. Nothing wrong in having respect for what people do. The only time these days I have any difficulty comes when the guys misperceive my attitude, when they're reading something that isn't there. And that happens sometimes. They don't like it if they think I'm too much concerned about one little thing. When they feel that, they will actually turn the subject around into something else. I've had that happen and it's a very frustrating thing. I try to deal with it very straightforwardly. I try to let him know that it's not me dealing with him personally, but that we have an issue here and we need to deal with it. It's not my order, it's the network's and we need to solve this problem. I'm just giving him this information. And he might say, "But you don't know what you're talking about." And I have to say, "Well, yes I do; I know what you do, I know what your job is; I have been on the set for eighteen years." But they'll turn it into something else.[3] So that's probably the most difficult thing that I have to overcome: how I deal with people and how I surpass that problem. This isn't something with older men or younger—it's cross-generational. A lot of it is personalities; some people are more difficult to get along with than others. But I do think it's often a male/female thing and has to be overcome. That's the point where, if you're perceived as having some kind of authority, that's where you have to get along with everyone and work together, because if some one of your colleagues, on your level, rolls his eyes, once, to a crew member, it's over. The respect has to come from your peers. I don't think people are afraid of authority so much, but they are afraid of power. They don't want to be powered out by you.

You have to earn that respect. And you have to establish it over and over, with each new group of people. They have to see that you know what you're doing. That's why if the people who work around you show respect for what you do, it spreads to the others. That's what was very good about Diane: she didn't belittle people in front of other people. There are times when we have discussions in front of others, but they are discussions. If I told Diane she couldn't do a certain thing on the show, she'd want to know why and I'd tell her. She would never say, "I *am* going to do this and you're an idiot and you work for me, so find out how to do it and I don't care." There are a lot of people like that, who

don't care; and then even if you are right you look like a moron. I really enjoyed working with Diane, and that was one of the many reasons. She's very respectful.

It is a personality thing. There are a lot of people on that set, coming in with a lot of problems. And the interaction among them is tricky. We spend a lot of time with each other, and everything has to happen in a certain way. People are coming in in the morning and they have their own lives, their own problems, and you don't know what happened at breakfast. You can't just go over and tap them on the shoulder and make a command. If you're changing something you got straight with them yesterday, you might start off apologizing, saying you misunderstood yesterday what they wanted, and we have to start over to solve a problem. It may be that women are better at this kind of negotiation and renegotiation, but whether they're born better or are just forced to *be* better, I don't know. Because, again, if a guy comes on and says he has power, it'll get done, and that's all he cares about.

It's not cowardly, but it is a brand of tiptoeing. And it's not limited to our business: if you go into a department store and want your money back and you see a certain type of edgy salesperson you have to tiptoe around that person, too. A lot of it is personal dynamics. I talk with friends about this, who agree with my experience. You always have to be careful in your approach. With a woman, it's not just the issue at hand; approach is a factor.

What are the roles of some other women on the Murphy Brown *set, such as Marge Mullen, who worked for MTM?*

Smith: Marge started out as a script supervisor, which is a traditional female job, one of the lowest paid jobs on the set because it was a woman's job. Men have tried to break into it, and there are more now, but it's a tough negotiation because it was always the "script girl." And then Marge made her way into doing something more complex and more responsible, which was probably a new job at the time she made that move, because multi-camera film brought about a lot of changes. Then a lot of men got into it. One of our dolly grips left and went to another show to do the job that she does. He was watching her to learn; this big tough guy now is doing what she does.

Will the new move to in-house network production affect independent production?

Smith: It's hard to guess, because the situation is just on the edge of changing now. It seems to me it would be an enormous expense for the

networks to produce all their own shows. It's cheaper for them to license another company. Of course, if it's a hit and you can make a lot of money, that's different; but that's not the way it works. And networks are downsizing now. Maybe if they were being bought by someone like Ted Turner instead of large corporations like Westinghouse the networks might change more. Disney buying a network might, because they have distribution and syndication in place already. Maybe they'll find that the thing to do will be to produce one hundred percent of what they put on the air, but I don't think so. Disney has bought some theaters in Los Angeles and New York that only put on their movies. They and the other networks are doing more in-house productions but they're buying from each other: *Caroline in the City* is done by CBS but airs on NBC. Also, there's cable, which is a real factor in the business. HBO does some of its own movies, but they license out to other companies, too.

To return to the question of men and women, when I'm assessing differences between women and men, I'm not so sure it's me as a female or me Debbie Smith. In dealing with Diane or any of the other executive producers or producers—and they're all different, with their own little ways—I tend to be there all the time. I have no qualms about knocking on their door and telling them they have to pay attention to me. Or in the editing room. You have to let people go through a process: as executive producers they're trying to figure out maybe a timing process, why this isn't working, and you have to keep your mouth shut, because they're working through something. You have to know your moment, when you say "Well, maybe I'm wrong, but maybe if this shot was on the wide and then you cut to this, maybe that would jolt a reaction and give you the timing." I don't know whether the waiting part, or not being in there and aggressive is female, male, or me. When I'm doing my job I'm not on a show with anybody else to observe how others in my position handle it.

I do have some female friends who are in similar positions on other shows. We roll our eyes a lot, commiserating with each other about our treatment. I do find that men see themselves as playing a game; in fact, they often use the term "player." It seems that they always have to see an angle: they make a relationship with this person and it will pay off down the line. They always have to get something out of it, anticipate a checkmate somewhere down the line. And that's the biggest thing my friends and I complain about. I think we as women operate very directly: this is who you go to, tell it to, and you just solve the problem. You don't have to have anything extra waiting in the wings for you.

There are people—possibly women but more likely men—who sometimes create a problem so they can be the one to solve it. Then they'll look good. Or they'll make a problem a little more complicated than it

needs to be when there's a very easy solution—or at least a direct way of solving it instead of going into all different arenas. To be known, to be seen, to have attention drawn to you, to have the solution be about you and not the problem—that tends to be true of certain males around us. This sort of thing, with men, means they have another toe in the door, because people will say, "Oh, *he* can handle this because he did the last time." Perhaps it's a corporate model that males have created. You always have to beat someone else out. But remember, these are my friends with whom I was discussing all this. Maybe there just aren't enough women for us to beat yet. We're just trying to get to the next step.

The system says move up, right to the level of your incompetence says the Peter Principle. You do something well and you move up! It seems that if you're not moving then people will perceive you as a loser. Following this guideline, a person will think he or she is happy in a job, doing well, but feel the need to be perceived as a mover and want to move up. Perhaps that's one of the reasons why there aren't more women in the network top jobs. They are difficult jobs, you have to sacrifice most of your personal life: your personal and professional life become one, which is to say you don't have a personal life. Women like to have relaxation time and do other things. I see nothing wrong in being happy in your job, doing it, and going home. It seems to me a very civilized way to live.

Moving up is very male-oriented. Why do people want the worst job in the world, presidency of the USA? Everyone hates you, is out to get you; as soon as you get there people are trying to push you out.

I want to come back, though, to the men-versus-women theme. It's very hard for me to male-bash too much. I work with terrific men, who have helped me without needing anything in return—people who let me learn, and do more. Or even if I wasn't working for them, they'd help me get a job somewhere else. I would call them and ask them to listen out for a job, and I'd hear from them a week later, telling me someone had a job opening and was expecting my call. And the same way with women. I know there are barracudas and every other kind of horrible fish out there. My career isn't over yet, so I know I'm going to get bitten by a number of them. When you come back for Part Two, I might have a whole different story, starting with "Ohmygod, I had no idea what was going on out there." When *Murphy Brown* is over, things will be very different. I'll be interviewing for a job and meeting all these new people. Executive producers are usually writers/creators and they're not familiar with my experience nor am I with theirs, since they've just created the show. You don't know what their personalities are going to be like. That's why I'm hoping that some people I know, like Steve Peterman and Gary Dontzig [writer/producers in the early years of *Murphy Brown*],

will have a show for me. And the competition out there will be very different, too.

What has been your experience with Women in Film?

Smith: I don't have any contact with Women in Film and I don't know why. The most civic thing I do for this business is go and sit on the blue-ribbon panel for the Emmys every year. It's a Saturday and Sunday of watching television and voting. I'm not for some reason very civic oriented. The episode about Murphy being a judge came about from a discussion where we were all laughing as I was talking about how awful judging was. The writers had gone through it, too, and thought the experience could make a very funny episode.

I think there's a need for Women in Film. I haven't actively rejected it; I've just not wanted to be a part of it. I like the idea of such an organization to support women, but I don't think about it very often. The group is not very visible. I've received more information from the Sierra Club than from Women in Film. I've never even been approached, and don't know what these women do. I've never felt a need for them; but maybe after this show, when I can't get a job, I'll need to go to them and say that I'd like to network now!

\sim

ANNE HOPKINS

ANNE HOPKINS

The male executive bosses made it very difficult

ANNE HOPKINS HAS BEEN CLOSELY ASSOCIATED WITH MARIAN REES SINCE EARLY in her career. In the year 2000 she was a partner in the firm Marian Rees Associates.

~

Hopkins: My route has been circuitous. I got started as a secretary, as a lot of women did, but mine was in a job that really interested me and one that launched me in an unique way. In that I was fortunate. It was at the Metropolitan Opera. The main benefit was that this job introduced me to theater and to audience participation, audience reaction. It also began a sequence of relationships that primarily but not exclusively have been with women. I wasn't aware of this until just thinking about it to talk to you.

When the Met job finished, I had the opportunity to work on a Broadway production, introduced to me by a woman who was a lighting designer. I was the producer/director's assistant on the play *How To Be a Jewish Mother,* which was produced by a woman named Stephanie Sills. The writers were a team, Renee Taylor and Joe Bologna. It was a very important experience for me because I got to be more hands-on, from a production standpoint. All of my work has been associated with producing. Even as a secretary I was a producer's assistant. I've concentrated on how an idea becomes a fully developed project so that an audience can appreciate it.

When *How To Be a Jewish Mother* closed, because I knew the writers I got to go on to another show also produced by Stephanie Sills. It was called *Lovers and Other Strangers.* Again I was in the same relationship to the play, as the producer/director's assistant. I saw the evolution of the show, from script through early rehearsals to opening night on Broadway. I really learned the valuable lesson of how a story gets shaped by how an audience responds to it and how a director imprints the development beyond the writer. The casting and the whole process was compelling to me, and thoroughly enjoyable.

When that was over, it was Charles Grodin, the director, who introduced me to Norman Lear. Norman was finishing postproduction on a feature called *The Night They Raided Minsky's.* I was hired at the end of the postproduction. It was Norman who brought me to California to become a part of his company, then called Tandem Productions.

That was when I first met Marian [Rees]. We didn't work together

closely, but I met her there and began to be aware of her relationship to Tandem as a vice president and how she worked for them to find material and new projects through publishers in New York. That was a new area for me to learn about. I worked on some of Norman's specials, and when *All in the Family* came about, I went to work on that show as a staff member. They called it the assistant to the producer in those days. It was like doing a play a week; so everything I had been doing up to that point came fully into use. I watched the script change through the rehearsals, seeing the impact of the director, actors, and others. I worked on that show for a year, and then three years on *Sanford and Son*.

That's where I got to know about writers—who they were and how you worked with the Writers Guild. The next step was learning about the budget: how the associate producer creates a crew, and the larger picture of putting a production together.

When I left *Sanford and Son* in 1974 I was at a crossroads in my career. To stay in half-hour series you either have to be a writer and take the path towards writer/producer; or you have to stay in the more technical side as assistant or associate producer. Without being a writer, you find it very hard to get farther ahead in a series. I think Gayle Maffeo is one of the few exceptions to that rule. She has created a very strong niche for herself as a very valued producer without being a writer. I worked with Gayle when I was at Tandem. We did a Robert Young special. She was the assistant to the producer and I was her assistant. It's nice to reflect back on what a good mentor she was. I learned a lot from her: her demeanor, her deportment, her professionalism. And the technical skills.

I didn't know about timing or other technical matters, and Gayle was a wonderful teacher. In addition to the nuts and bolts, she taught me how you could be a nice person in this business: you can be bright and good and do your job and be respected.

But Gayle hadn't become the model for the job she has now, so I couldn't learn from her how I was going to fit into that world, because I'm not a writer—certainly not in half-hour comedy. This crossroads led me to Marian Rees, who had by this time left her position at Tandem and become an executive at Tomorrow Entertainment as head of movie specials. I learned she needed an assistant. She said to me, "You don't want to go back into an office and be a secretary again. You've just spent seven years of your life *not* doing that. Why do you want to do it again?" But I thought that if you wanted to learn something new, you go back to the basics and learn it from the bottom up. I don't respect people who just sort of wing it—people whose philosophy is to start here and get a certain title and then figure out what you're supposed to do. It was a very smart decision. So I went back to a secretarial job, working for

Marian, whose creativity, vision and character inspired a turning point in my career.

As a secretary doing all the basic things, I learned how the two-hour dramatic form is different from comedy. It's a different way to tell a story. And Marian is peerless—in the work she does, and in her generosity of spirit. She's always reaching out, always available to people who need anything. It was a perfect way for me to learn a new dimension of the business. I didn't know where my career would go, except that I loved writers and writing and the storytelling part of it. Finding a project and seeing it evolve through script really appealed to me. Then, when we went with Roger Gimbel to EMI Television, Marian was Vice-President of Development and I became the story editor. That was the next major phase of my career.

When we created Marian Rees Associates it was for us to find and tell stories that we cared about that we felt would speak to the audience. We would find stories that touched us, that meant something special to us. Marian was to be the executive producer and guide everything and I was more the development person, finding the projects and nurturing the scripts. Where we departed from a lot of other companies was that we were both hands-on throughout the script development and I would stay on through postproduction—because the story has its own reshaping at that point. I think this methodology helped strengthen the films. The benefit to me was that I learned a different aspect of the technology that I didn't know before. So my job description was unusual in television because it bridged both ends of the storytelling—from finding the project right through the editing. Most people come either from the film school sense of how you do a film, or they're writers who decide to control their project and not have somebody else interpret it for them.

So my career was really a serendipitous evolution: a lot of hard work applied incrementally, so that everything that I had done along the way impacted on the next phase. And there weren't any wasted steps. It was just not quite as straight a line as most. But if I hadn't wanted to be a secretary again or I didn't have those skills, any one of those moves could have been short-circuited.

What about women in the television business?

Hopkins: At the time I was moving in, there weren't a lot of women executives, so there weren't a lot of role models and not much mentoring from other women. Marian was a rare exception. Because I came into this part of the business through my working relationship with Marian, I knew first-hand the discrimination she was experiencing. I was aware of the transition at Tandem that had been so painful for her. Also in subse-

quent situations I saw how male executives were given contracts and screen credits that were denied to Marian and other women despite their hard work and talent. It was very close to home, to see these harsh dynamics of the business working.

When Marian decided it was time for her to think about creating some equity for herself—and it's very clear that women have to work different-ly at creating equity for themselves, because it's not a given—she decided to create the company. The choice seemed so clear to me: I had great respect for her as a person and for what she was trying to do; and I believed in her vision. If she succeeded, there was the possibility of equity for me as well. At that time, in prime-time programming, there were only two significant female executives who could really buy, and develop: one at NBC and the other at CBS. They were receptive and responsive. But I know that the male executive bosses made it very difficult for them to buy from us, a company of women.

The first movie that we had was a very good project that was ready to go; and we waited a year and a half for that order. Marian was told, off the record, by another executive at the network that they would never give us the order because Marian was a woman. We paid a higher com-pletion bond to the bank than anybody else was required to do. And it's not as if she were brand new to the business and had no experience.

The evidence is all around. Nobody will say, "You can't," or "You're not allowed," but they make it difficult enough that you might fall away from it.

I don't think this is still going on in the same way. It's one of the reasons I have such respect for Marian. She was a pioneer in this; she had the courage to start out on her own against pretty tough odds. I think where she's still unusual, maybe unique, is in taking the risk to have her own company and not be underwritten by somebody else. Marcy Carsey is another in this very rare category. She and her partner Tom Werner did it on their own, without a studio. Most other producers, many of them women, haven't been entrepreneurial and haven't taken that risk.

There are those who think we have made a mistake, that we should have run for cover years ago—gone with a studio, or some other form of protection. But Marian has this fierce independent streak, and there are certain stories that we passionately want to do that may not seem finan-cially effective to larger companies. And if they say you can't do it, and that's what you need to express, then it's hard to give up that opportu-nity. That may be different for women than for men. I don't know.

Hallmark [which had been the mainstay of Marian Rees Associates] has changed its business format significantly. The major difference is that now they own everything. The business has become monolithic and everybody has to be in the driver's seat, basically, whether it's Disney and

ABC or CBS and Westinghouse. Hallmark has created its own in-house production company which not only owns everything, but controls every aspect of a production as we do. The fact that we were an independent company made us potential competition. Sadly, it no longer has to do with the history of the relationship or the nature of the work, but rather the nature of the deal. That, incidentally, seems to be a big difference between how men and women do business.

The change at the networks, with the in-house productions, is also having an effect on independent companies like ours, also. Now all these companies own everything, so companies like us become a mere service organization.

I hesitate to ascribe gender to a lot of this, because this is all happening at the time when there's a dramatic shift in the nature of the business. I've heard it suggested that big versus small is a factor; that is, perhaps women find the small, more personal company more congenial than do men. But I think there are some men with production companies about our size; and they're struggling too, because of the changing nature of the business.

∼

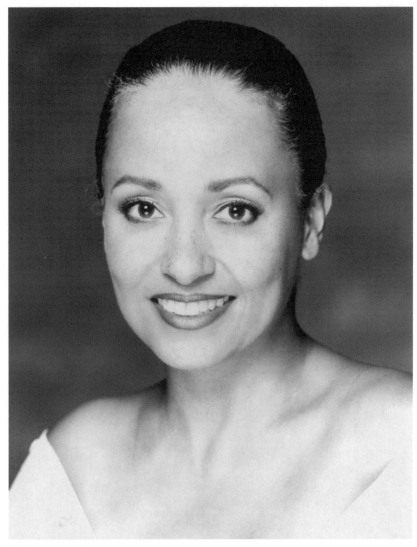

DAPHNE MAXWELL REID

DAPHNE MAXWELL REID

It's not so much that they exclude; *they just don't* include.

DAPHNE REID, AN ACTRESS/PRODUCER, IS A STUDY IN PERSEVERANCE AND AD-
aptation. She has made a mark on the television industry with talent and
by grit and determination. From her home near the Blue Ridge Moun-
tains of Virginia in 1995 she discussed her career with thoughtful reflec-
tions.

~

Reid: I started off on television in Chicago. I was print modeling at the
time and got called to audition for a commercial. It was my first such
job, a national commercial, which is always a nice way of getting intro-
duced into the business. I went on to do many more commercials in
Chicago and continued that career in Chicago and New York.

When business was slow in front of the cameras, I was nosy enough to
go behind the cameras and produce industrial films and slide films, and
get to know the business from the other side.

I got into voice-over work and had a lucrative career doing voice-overs
in Chicago. There were also narratives, as well as some teaching videos
that I ended up producing later on.

Before that, I was "discovered" by the actor Robert Conrad in Chica-
go. He came there to do a television show called *The Duke* [NBC,
1979]. He put me in the first episode, the pilot, and then told me he
liked my work so much that he was going to write me into all the rest of
the episodes. He was a man of his word, and I was handwritten into most
of the seven episodes that were aired. He told me if I ever came out to
California to give him a call.

I happened to go out about a year later and he put me in an episode
of *A Man Called Sloane* [NBC, 1979–80]. I started doing small parts,
guest starring on a lot of television shows: *Hill Street Blues,* and *Cagney
and Lacey.* A lot of the people I met kind of spun me off into other jobs.
I met Tim Reid [her future husband] the first year I was there. I hung
around with him when he was doing *WKRP* [CBS, 1978–82], and I did
two episodes of that show. And then he had a continuing role on *Simon
and Simon* [CBS, 1981–88: Tim Reid played Detective Marcel "Down-
town" Brown from 1983 to 1987]. I got called to do a small part on
Simon and Simon. So I was kind of the tag-along for a while. After *Simon
and Simon* Tim moved on to his own show, *Frank's Place* [CBS, 1987–
88]. He and producer Hugh Wilson decided that there was a part on
that show for me. After *Frank's Place* was canceled, we had a deal with

CBS and we did *Snoops* [CBS, 1989–90]. Then we had a deal with KingWorld and did a talk show—*The Tim and Daphne Show.*

After that, I quit! I had had enough. Tim and I working together started to affect our relationship at home. Sometimes they were very good jobs, but there was more tension than I could deal with. We moved to Virginia and I said, "Thank you, I'll take a rest here." I stayed home and gardened for a year.

Then I got my feet wet again, with an idea that I had desired to do since childhood, design clothing. I'm an avid practitioner of sewing. I sent a proposal to McCall's Pattern Company as a way to expand their home sewing business, to market it on QVC, by developing some tapes and patterns that we could sell. I put the deal together and the President of McCall's said yes, he was interested, and QVC was interested, and they said, "OK now, who's going to produce these tapes?" And I said, "I am." It was like a shot in the dark, but I knew that I could do it, from all the experience I had had behind the scenes helping on all the shows that we had done. On *Frank's Place* and *Snoops* we were not only in front of the camera, but Tim was writing, and we were involved in mixing and in editing. We felt we had to pay attention to everything that needed to be done on a television show. There was a bit of sabotage, on *Snoops* especially, from forces within the network, so we had to watch closely all the different aspects of the show. We had a hard time with that, but by that time we were well-versed in complete television production. We were doing music, sweetening, everything. We worked seven days a week. It was the hardest thing we've ever done, but it was satisfying work for both of us. So I knew that I could produce, because I had been exposed to it and because I had had hands-on experience.

When McCall's asked, How much money? I didn't know how to budget, so I said, $150,000. They gave me that amount and I set it up, had it shot with three cameras, I did the set design, the costuming, the hiring. I had to do every bit of the editing, because nobody knew what it was supposed to be. The people I was working with had no concept of what the outcome was supposed to be.

They were tapes that were supposed to be part of a package to be sold on QVC. It was a teaching package, teaching you how to sew. Four outfits. I came in at $151,000, and they were very pleased. I went on QVC with our package, which was beautifully done. McCall's did a fine job of designing the package, which cost $82 each, and in the first forty-five minutes we sold sixteen hundred packages. Ultimately, on QVC we sold ten thousand copies. Then we put it in the retail stores and sold another fifteen thousand. But it's not something easily sold off the shelf; it needs demonstration.

After that was done, we said, "OK now where do we go with this

project?" I said, "I can produce, so I know I can do that for a follow up."
Then I got on *Fresh Prince of Bel Air* [NBC, 1990–96], and I didn't
have time to do anything else. I told McCall's I would have to put them
aside for awhile because I couldn't develop any other markets until after
Fresh Prince. So they decided to do a pattern line of me. I've just gotten
off of *Fresh Prince* this March and have been on vacation until this week
[August 1996], when I had to jump back in the fray.

When I was off from *Fresh Prince,* I helped Tim with the movies that
he did. In *Once Upon a Time . . . When We Were Colored,* I was a second-
unit director and had my hand in everything that was done because Tim
had his hand in everything that was done, and I needed to help him. So
I was like the ghost helper or the all-around pinch hitter, nurse, bottle-
washer, typist. I'd type up shots lists, order equipment, do anything that
needed to be done that fell through the cracks or attempted to fall
through the cracks. In this way I became quite versed in getting some-
thing done, by hook or by crook, and I've continued to learn an awful
lot.

I feel very knowledgeable, but I haven't taken that skill and sold it—
as a skill.

*It is clear that you have moved into production in an unorthodox fashion
and your career has taken you in numerous directions. In all those years
were there gender related obstacles?*

Reid: There's a whole old-boy/new-boy system, where things are hand-
ed down, gender-wise, unless you make yourself well known as a person
capable of doing something. Then, once you do it, there's no qualm, but
you've got to just about force yourself on people because they're so used
to not looking towards a woman but towards a man. There are certain
jobs that they look towards women to do; others, it never crosses their
minds. It's not so much that they *exclude*; they just don't *include*. And
a Black woman has a double non-inclusion.

I have not, myself, sought to be included in those areas closed to me
by tradition. So I'm not speaking of my personal experience. The things
that I have gotten are by being there; I have not attempted to attain a
goal—I have not *set* a goal—like achieving a production deal or produc-
ing something. It just sort of happens, and I take advantage of the
opportunity and make the best of it. But I'm not striving to be a produc-
er or a director or an actress. I enjoy doing every facet of the business
and that's what I want to do—everything.

As for the old-boy/new-boy system (same boys), I have felt a very big
difference in those who are in charge of hiring or deciding who is to
produce a show or deciding what gets to be produced. And I'm very

disappointed that now it's down to money people who are running the business rather than the creative people. The money people have no idea about creativity. They have bottom lines. They know what worked before so they're sure it will work again—which limits creativity. And the younger people who are in these positions now have grown up watching television and they're regurgitating it. They want to do the same things over again, because—according to my theory—they haven't the gumption to try something different. All they see is the bottom line and so they appeal to what the masses seem to say they want. They have no concept of *leading* the masses. And this situation has gotten worse. I think television has gotten very sad.

~

Reid was quite animated in her agreement with Bonny Dore and Virginia Carter concerning the influx of M.B.A. graduates in the late 1960s.

~

Reid: Those Harvard M.B.A.s that Bonny speaks of haven't read a book. They don't know the classics; they don't know old movies; they just know television. To make a movie out of *The Brady Bunch* is ludicrous. There are so many wonderful stories, but they had to regurgitate *The Brady Bunch*.

~

Concerning Women in Film, Reid is familiar with the organization and has been to a few meetings.

~

Reid: I think it's a great networking group, and when they network they get a lot done. People like Bonny who are producers can look around and see people who can be adjunct to what she's doing; and it grows from there. It's excellent. There is also Black Women in Film—again, I've just gone to several meetings. It is a networking venue. You get to see that there are other women who are doing things, and you can at least put them on a list of resources. Otherwise you don't get to know these resources. ABET is the same way. You don't get to know these people exist unless somebody is saying, "Hello, we're over here." So I think it's a good thing we're screaming.

~

On a related note:

~

Reid: Suzanne de Passe is quite a success story and she really had to beat the bushes to get it done. They still don't give her the respect that she deserves, I feel. She's Black and a woman—I can't think of any other reason, because she's an excellent producer.

Have you had mentors?

Reid: Obviously Tim. Robert Conrad. And there were some men in Chicago in the voice-over business, in that phase of my career, who were very inclusive. Doing narrative work is a very tough field, and those who are in it like to keep it to themselves. But there were some men in Chicago who shared that field with me and taught me, introduced me, and gave me a big boost. They are Harlan Hogan and Steve King. They were very instrumental in my exploring a whole different side of the business that I never would have been exposed to in any other way. They would have to physically bring me to meet someone, for example.

What about the idea of a feminine perspective in your work?

Reid: I would hope that every woman would bring a feminine perspective to her work. A lot of women in the early eighties were so busy trying to be included that they put aside their feminine ways; they sublimated them to making sure that they would do everything that the guy would do to get and maintain the job. If that meant staying away from their husbands and ignoring their families because they were working late, they were willing to make that sacrifice. I think in the nineties we're saying, "Hey, wait a minute here. I can do this job *and* that job at the same time. I don't have to give up my maternal side, my humanistic side for my work side. I can separate them and I can do them both."

We are now acknowledging the fact that there is a difference between a woman's and a man's touch and we need that balance in viewing whatever's going on in the world. There's a difference between the way a White director sees a scene and a Black director sees it. That difference comes from a cultural difference and from a difference in sensitivity; and hopefully there's a difference between men and women. We need to maintain that and keep it strong. We need differences; we do not need homogenizing. Homogenized stuff is boring. I want to *see* that there's a difference between that person and this person. I want to see that there's a cultural difference between two Black people—because of the way they were raised, because of the part of the country they come from, because of the part of the world they come from. These are the things that make

life interesting. I would hope that whoever comes to doing a production or doing a directing job would bring himself or herself to that job and put some of that self into it and not just make a product that is palatable to the masses.

Are there roles you would refuse?

Reid: I have to truthfully say that I'm not usually given the opportunity to choose a role from among many; but what roles I am offered, I weigh with a bottom line question: "Will this affect my integrity?" If I can maintain my integrity and hold my head up high to my family, then it works and I go do it. There are roles that would explore a different side of me, but I've not been offered these roles. I'm not considered an *actress*-actress; I'm kind of like the working girl. Yes, I do the job, but nobody is looking for me to give an Emmy-winning or Oscar-winning performance. I'm a utilitarian actor; I'm the team player. I'm not the star. I accept that role because I haven't set out to achieve anything more than that. I really enjoy the process of acting. I really enjoy the process of doing everything having to do with the medium of film and television—behind the screen, in front, all over the place. Editing is one of my favorite things. On my vita I would say I'm an actress; but right now I would have to say I'm an entrepreneur. No, right now I would have to say I'm a wife. Until I get back to work I'm a housewife.

Tim and I do have a company and we've opened a production company that we use when we do productions ourselves. That's Reidmont Productions, named after our farm in Virginia. We haven't done anything through that except my McCall's sewing videos. Tim has a company with Bob Johnson and Bush Lewis, United Business Entertainment, and that's what he does his movies through. Because he's been so busy doing other things, we haven't used Reidmont often; he hasn't had time to do small productions.

I have all kinds of options, depending on what opportunities are there. And I like to make opportunities. I'm going to be writing a couple of books (on normal, everyday life, like cookbooks) and opening a line of jewelry. Tomorrow I'm going to New York to talk with McCall's and the next day to Los Angeles to have meetings, basically to help Tim. We're gearing up to do a group of productions for Proctor and Gamble, producing television movies. I'll be a big part of that project although I am not in a company with him doing that. I'm basically what they call his "pillow partner" doing that. Producing, as it is usually defined, is part of my work, but I combine it with acting, creating, editing, and even whatever gofer work is needed to make a project successful.

⁓

Currently, the Reids are beginning what is perhaps their most ambitious project to date: the eleven-million-dollar New Millennium Studios, located on a sixty-acre tract in Petersburg, Virginia, some twenty miles south of Richmond, which opened in July 1997. The Reids are currently trying to develop support services and create a trained work force, to attract producers nationwide. The studio will have an initial permanent staff of about seven. The Reids, along with Hugh Wilson (creator of *WKRP In Cincinnati,* co-starring Tim Reid), will produce their own films but also rent to other filmmakers. They have begun with several feature films and television series.

Notes

1. It is important to note that this solution created deep divisions in the industry and many members of the various guilds supported the union. One distinguished director refused to accept an offer to direct, on a regular basis, a new, highly touted series, because it was to be done under the Carsey-Werner plan. [Authors]

2. English and Shukovsky returned to *Murphy Brown* in the fall of 1997 and the series concluded in the spring of 1999.

3. See Ch. 15, in which Beth Sullivan talks about men forcing women to fight on their turf.

LYNN ROTH

11

✦ THE WRITER/PRODUCER ✦

These barriers can eventually be broken

WHEN ONE OF TELEVISION'S LEGENDARY WRITERS, FAY KANIN, WAS UNABLE TO attend a conference at the University of Richmond in 1987, she urged us to invite Lynn Roth, "a remarkably talented young writer/producer." She has continued to be one of our most helpful advisors. What follows is drawn from our interview in 1995.

～

Roth: I started writing in 1972—a time when there was a push for women to get into television—to start infiltrating. I remember that every time any one of us accomplished something, it was a news item. And we were always referred to as a "woman" this or a "woman" that. In 1978 I became an executive at 20th Century Fox, and I was always called a "woman executive." People would actually come into my office and say, "Well, I know another woman executive." As if you were a Zulu and a person would say, "Well, you know I once met a Zulu." We were that rare; but gradually the labels dropped off for writers, producers, everything except for "a woman director."

I started in comedy in 1972. I think there were seven of us female comedy writers. I remember that my agent wrote a letter to one of the comedy shows. He said, "You should meet with Lynn Roth. She has even longer legs than Susan Silver.' [Silver was a comedy writer at the time, who had written for *The Mary Tyler Moore Show.*] Of course I was furious. I would be ten times more furious today.

147

The first show I wrote for was *All in the Family*. But I wrote the episode with a gentleman who gave me no credit and only one-eighth of the money. Norman Lear liked the episode; it turned out well; and at that point my co-writer said, "Oh, well, I wrote it with a young woman and maybe you should meet her." And that's how I met Norman Lear.

We did another episode together for Norman, and then I started with *Love, American Style*. Although it was run by men, I think that was a show that gave women a lot of opportunities.

There was plenty of prejudice against women. It's hard to believe that so much existed. A typical attitude was, "How can you be funny if you're pretty?" The whole idea of a woman writer being funny made people uncomfortable. All the comedy writers were named Bernie and Sol and Harold and they had ambivalent feelings towards their wives and mothers. It was an all-male club.

Another part of the problem surfaced with a bad script. If a woman had written it, it was always labeled as the show that a woman wrote, and they wouldn't hire another woman on that show for the next ten episodes.

And now they can't get enough female writers, or performers, or night club entertainers who become head of their own show. But that was not the case in the seventies. One reason why Mary Tyler Moore made everybody so comfortable was that she was so self-effacing. Look at the difference between Mary Tyler Moore and Roseanne. Although the character that Roseanne portrays is not nearly so abrasive as the actor herself, it's still pretty raw. The character is still not a "nice person."

In a perverse way, I sort of miss those days of the horrible chauvinistic remarks. Now it's confusing . . . the men are so polite. . . .

I wrote a show called *Chico and the Man,* with Jack Mendelsohn. We went to the taping of the show. And the man who was running the show, Jimmy Komack, making the introductions to the studio audience, said, "And this is Freddie Prinze—applause—and these are the two people who wrote the show, Jack Mendelsohn and Lynn Roth," and then he added, "God, how do you concentrate in a room when you're with her?" These were things that were said in 1972 and 1973. We all have these "lists," whether written down or just committed to memory.

From *Chico* I was eventually given a show to run myself, an hour dramatic show, *The Paper Chase*. There weren't many women doing comparable jobs then—maybe Joanna Lee, who was doing *Room 222*. *Paper Chase* was in need of resurrection when it was given to me, for cable, after a CBS run and cancellation [1978–79]. The people at Showtime got the idea to bring it back. They asked me to be executive producer, largely because of my relationship with John Houseman, the star of the series. I had not produced before, but Houseman and I had both been at 20th Century Fox at the same time. He directed a play

written by David Rintels, who wrote *Darrow* and was my boyfriend at the time. Houseman and I became very, very close friends and remained so until the end of his life. We had started a company together, which lasted for a while, and it was during that time that Showtime got the idea to resurrect the series. When I agreed, we dissolved our company but worked together on *Paper Chase* [1982–87]. I laughed and said to Houseman, "This is great. I'm your boss now!"

That was a completely different era. We went from [being] the cutesy comedy writer *girls* to the formidable *women* who created shows: Susan Harris, Diane English, Linda Bloodworth. *Paper Chase* was a fantastic experience. I myself approached the show as a girl, and left as a producer. They really let me run the show. I didn't have a partner, or a husband in the back working with me. In the minds of the people who worked with me, I think I went from being cute to being tough. Adjectives aren't used democratically. If you're a man you're strong, decisive; if you're a woman you're aggressive and opinionated.

The man I reported to was Harris Katleman, who was running the television division of the studio. But Houseman was my mentor; and I think that when they saw that I had been trained by him, that I could even handle him, they felt secure. So maybe they felt there was a man looming over me and that made me safe. A friend says that when I got the job, I called him in the middle of the night and wailed, "What does a producer do?" So I went from that wimp to being the boss, the woman in control of the show. They were right to let me do that. It was a good experience for everybody.

I didn't take a lot of writing credit on that show. I believe that producers running shows shouldn't take writing credit away from staff writers and freelancers. I was given this show that was dead and given the task of resurrecting it. When I took it out of the closet and blew off the dust I saw that it was about law school and it was all male. So I immediately introduced two or three new female characters. I brought in Lainie Kazan, who played a divorced woman going back to law school; and two younger women. So right away the series changed. It was reflecting what was happening in law schools. During the time when the series was moribund law and medical schools were starting to change and I wanted to reflect that reality.

I would sometimes read an article in the paper about an issue that seemed important and relevant to the show. We did an episode about abortion, one about anti-Semitism; in fact, we did an episode about everything that was important to me. But we didn't concentrate on gender problems. Once we got the women in there, then there would necessarily be male *and* female points of view. But when the series was first given to me, it was predominantly male.

After that, I went into television movies. All that I've done has been about women and their emotions, their fantasies, their love relationships. Every one that I've chosen to do has had a strong feminine patina. I feel very comfortable with this. One was *Babies,* about three different women and the technology of having children in the 1990s. It was very women-oriented; I think that the women who watched it very much related to it. Another was called *Just My Imagination,* with Jean Smart. It was about a male rock star who had come from her town, and his latest greatest hit was all about her. The song was slightly pornographic, so she goes out to find him, to see why he wrote a song about her, when he never even said hello to her in high school. It concerns the dreams about the man who's famous, as opposed to staying at home with the person who loves you.

The movie I did with Gregory Peck and Lauren Bacall, *The Portrait,* was from the daughter's point of view. It dealt with how she had to reconcile herself with the fact that her parents paid more attention to each other than they did to her. This was an adaptation of a play by Tina Howe called *Painting Churches.* Howe's play was a little more absurd-ist—although I'm not sure that's the word—it was a little less accessible, a trifle surreal, bizarre. In making it more accessible for the television audience, I focused on Fanny's love for Gardiner [the Bacall and Peck roles]—how deeply in love she was with her husband all these years, and how much that love meant to her and to them. There are those who tend to call love a primarily female emotion, but perhaps it's just that women are more comfortable talking about love than men are. But then why have some of the greatest love songs and romantic movies been written by men?

I have done an adaptation of a book called *The Patron Saint of Liars,* by Ann Patchett. It's about a Catholic woman who marries the wrong man and flees from him. It becomes the trajectory of a lie. It's very internal, definitely a woman's story.

I've developed a five-hour mini-series with David Wolper, produced for CBS in 1997 and for NBC *A Will of Their Own.* It's a *Roots* for women. It traces a woman coming over on a boat from England—her daughter and her daughter and her daughter for five generations.

There was a show called *A Century of Women* [produced by Turner Broadcasting] that about twelve of us were involved in, and I just learned we were all nominated for an Emmy for it. It's a documentary/dramatic six-hour series that explores women's lives vis-a-vis work, family, sexual-ity, social justice, image and popular culture.

Now that I talk to you, I realize I do a lot of women's stuff, and they would probably not hire a man to do the kind of material that I've written or produced for television movies.

In the matter of networking, or bonding—that's where we have real problems. There *is* networking. It exists. For example, there is Women in Film and all these situations (like mentoring programs) set up for women to increase their opportunities in the business and to help each other. But I have found that now that we are advancing and we are in very pivotal positions (not *the* pivotal positions, however) we do not yet have the courage to help each other and to bring enough of our imprint into everything. That's my personal opinion. Women are still too afraid to help each other. Maybe they have in mind that there are only a certain number of slots and once you're in one of those slots, there aren't enough for other women who want it. Maybe it's innate competition among women. It's something that I talk to my girlfriends about all the time now. There's definitely an old boys' club in this town: when men hit a bumpy time, they take care of each other. But I don't feel that women do that for each other yet. That's our next big battle.

My friends and I suggest, in these conversations, that we think about each other, that we don't become so tunnel-visioned about our own careers; but there is such insecurity. If you're secure, this would not be happening. So the basic problem remains insecurity.

We can't point to the lack of an old girls' network as the consequence of acculturation, because we *are* taught to be nurturers. Isn't it odd that when it comes to business, the men can be nurturers and the women can't? That's what's so shocking to me, that the men are more nurturing to each other in the world of business than the women are. Again, I think it's security versus insecurity. There are not a lot of women mentors. And I think if you would talk to female students here, you'd find that if they did have a mentor, it's a man. There are exceptions: Lila Garrett was instrumental in helping me and my career. She's a very volatile woman, very colorful; but she is a woman who absolutely helps women. She's very strong-minded and outspoken, and because of that most men can't get far enough away from her. If there were more Lila Garretts, there would be more women in the business.

I had actually met her at a networking party for women who were writers or wanted to be writers. She called me the next day—I was about twenty-two years old—and said, "I have a job and a man for you. Which do you want first?" I'm ashamed to tell you my answer (if you put this in your book, just be sure to include my shame): "Let's start with the man; maybe I won't need the job." Anyway, I got the job and the man both. The man was David Rintels and the job was on *The Helen Reddy Show*, or maybe it was *Honeymoon Suite*. Anyway, that was twenty years ago!

I think we're still trying to find a critical mass of women. We're still baffled. We're trying to identify the problem. We're not as far along as

resolving to do something about it. There have been many women who've shown up at the network who it's hard to believe are women. By that I mean it's because of the way they operate. Maybe this is what we're learning about ourselves, that there's much more male in us than we ever knew. These women are revealing to us how multi-dimensional our personalities are. Or maybe it's just that we're trying to imitate men. Sometimes I think we're just doing a bad impression of men. But it's still surprising to me that a woman would not return a phone call. That doesn't seem to be natural to us; and yet we're just as good at it as men are. Maybe our own perspective of ourselves or of the world has not been right: you would think that a woman would never pick up a phone and talk to somebody in the middle of a meeting, and yet it's done all the time. If we're imitating, then we pick up the phone because that's what they do.

I wish I could say to you that since women came into the business, something specific has happened. But I can't point to anything. I wish I could say, "Look what's changed."

I guess, in the evolution of this whole thing, we're still in the middle. Maybe the process is still happening; but this is not very encouraging. I can't tell you to look at a flurry of movies that marked progress in the position of women in the industry. There *has* been a proliferation of television movies during the past several years, but I don't know if that's attributable to women. Just as the whole variety show in the past was the big thing, now we have television movies. And they are geared primarily for women, so perhaps that area represents progress. But unfortunately too many times these movies are focused on the woman as victim: she's harassed, or raped, or killed. Now even she might *be* the killer; but we don't get normal women. NBC will say, "This is how we want you to approach the material: she was just a simple housewife, until. . . ." That's what they want. That's so women all over the country can identify with it from a starting point. Boy, this is depressing.

The syndicated newspaper columnist John Leonard has spoken of this woman-as-victim bias on television, especially the Monday night movie.[1]

I think in comedy now we can accept very multi-dimensional women—characters played by Helen Hunt and Candice Bergen have more freedom than their counterparts, the characters in television drama. It's OK to have complex women if we can laugh at them.

Another subject I think about a lot is the pressure to keep the women young. The women who are most powerful now are the baby boomers, and you would think that they would keep women like Murphy Brown in other comedies and in dramas; and yet there's been more pressure, with trendy shows like *Melrose Place, Beverly Hills 90210, Friends,* to drop ages down ten or fifteen years. That's most disconcerting.

At the same time Paul Newman can play the romantic lead in his seventies, opposite Melanie Griffith. He can take a shower and have things droop, but when a woman droops for a second, it's a crime. So Newman and Clint Eastwood can be lovers at their age, but when did Angela Lansbury last have a love scene? This is a place where women should be making a difference because we know that no woman who's not airblown looks this way. We do not look this way, so why are we continuing and promoting the myth of this image of women? Perhaps the female audience eats this up, as much as the men. The women are living vicariously in the world of their fantasy, their unconscious, or their dreams. So if you're going to watch, you like to see somebody who's near-perfect; or if they get into trouble, somebody who's going to suffer more than you and then redeem herself at the end.

But I think we seem to be touched and moved by people who remind us of ourselves and are more real. I'm surprised that there are not more older women who are given better parts and more roles. Except for Lansbury, there's almost nothing. Some of the soaps drag out old stars to play a matriarch, but primetime still seems to shy away from older women.

I do see the boundaries being crossed behind the scenes in all areas except for directing. There are virtually no female star directors in television. It's going slowly. With half-hour comedies, network employers seem comfortable, and in hour-long drama. But in two-hours, less comfortable; [with a] miniseries they'd be nervous. "My God, six hours and multi-millions. Can we give this to a woman?" The bigger it gets and the more money at stake, the less they might be willing to work with a woman. But most of the time I feel these barriers can eventually be broken.

So my question is, When women have the power, do they really bring their own sensibilities to the program? When something comes out of Susan Harris, Diane English, or Linda Bloodworth, where it's such a clear vision, I think these women know these characters, or *are* these characters, and they're extensions of themselves. But how about the women who have been in position to make decisions about what kinds of theatrical movies are being made? I'm afraid that there the commercialism outweighs the female perspective. And where are those "hands-on" producers now, in 2000, the counterparts of, say, Steve Bochco? Perhaps I should mention Martha Wilson of *Touched by an Angel*.

Some people will remind you that the presidents of the networks or studios are not women, the CAA powerful agents are not women. But I feel that if a woman really wants it, she can get it now. The question is whether women want those top-level jobs. Whether we even want power, or, if we do and get it, whether we're comfortable with it. You get it and you lose a lot of the other aspects of life. There are, admittedly, new outlets for talent now, but the in-house network production companies

are making it more difficult for independent producers. Oxygen [the women's network] may be a hopeful beginning. I just don't know. But there is another perspective I'd like to mention. We are at a very exciting time, with which many people are pleased while others are apprehensive. The end of broadcast television is in some ways comparable to the end of radio, when television came and killed it. That was also a time when something very exciting was happening.

~

SUSAN HARRIS

There's a male experience, and a female experience

SUSAN HARRIS LIVES WITH HER HUSBAND, INDEPENDENT PRODUCER PAUL WITT, in Brentwood.[2] Witt-Thomas-Harris (the third partner is Tony Thomas) after twenty years stands out as perhaps the most successful independent production company in the history of television. Since Harris considers herself to be only a writer, her name does not appear with her partners on productions she did not write, but on her creations, such as *SOAP* and *The Golden Girls,* her role of producer has provided her with tremendous control over the words she has written.

~

Harris: I first worked with a friend on *And Then Came Bronson.* Neither one of us knew how to write a television show, and we picked the one that had the loosest stories, the one with very little structure. We adapted a short story that I had written. We sold it in a month; and she and I split up, and that started my career in television.

My next assignment was *Love, American Style* [1969–74, with re-runs on ABC daytime 1971–74]. They gave me a fifteen-minute test segment. I had met Garry Marshall by then; but his company didn't want to take a chance on me because I had only one show under my belt. Garry guaranteed it: he said if my script wasn't OK he'd fix it. They gave me the segment to do, they were thrilled; and I think I did ten more after that. So once that happened I was out there, doing episodes.

I think of myself purely as a writer. The term "producer" now is very ambiguous. Now the title is frequently given instead of more money, just one of those things you get as part of the deal. Because I worked with Tony and Paul, I didn't need producer credit to control what I'd written. I've worked with them for so many years. They had joined forces in 1971 and I came in several years later. They're the producers. I'm called an executive producer. In Witt-Thomas-Harris we all own a part of the shows. As one of the three, during the early years I was in on all the stages leading to production. It was important to have input into all the preliminaries, like casting. But I was never involved in the daily matters of production.

Have you felt a part of a community of women in the business of television?

Harris: No, not in terms of work. When I started, there wasn't really a community of women. There were a handful at that time: I remember

Treva Silverman [writer of fifteen episodes of *The Mary Tyler Moore Show*], for example, but there were very few. When anything like a "community" could be observed, we had already been in the business for ten years.

In those early years did it make any difference that you were female?

Harris: Absolutely. I felt that I wasn't taken seriously very often. Certainly the difference between then and now is enormous. Back then, because I was a woman I had to prove that I was a very good writer, something that a man wouldn't have to do.

So I wasn't taken seriously as a writer until I wrote; and once they saw that I could write, then they treated me more seriously; but initially I never felt accepted as seriously as a man in my position would be. Very often I felt as though I were the token female, that I was actually doing them a favor by writing one of their shows—so that they could say they had employed a woman. I was an oddity, because there were practically no women around. I became successful with *SOAP*, but even before *SOAP* was broadcast there was a great deal of negative publicity about it—so much of that came from the fact that the creator of that show was a woman. So it works several ways.

There were a number of people who did open doors for women. I think Jim Brooks was one, although I never worked with him. Eventually, there didn't seem to me to be a significant differentiation between men and women colleagues any more. I would go into a room and be taken seriously. I was often the only woman in that room of writers. That didn't bother me as much as it did some women. The boys would have their little jokes and sometimes say things that were offensive to me. They would sometimes forget that I was there, and I'd be embarrassed by things that were said. There were casting sessions that would make me uncomfortable because of the way they would talk about women—actresses who had left the room. But generally the context was the same as everywhere else in your life. I didn't feel at all stifled by it.

You mentioned Garry Marshall as being helpful. Do you characterize him as "gender-blind?"

Harris: Yes. I did an awful lot of sitcoms at that time, and Garry was unique in that regard. He was the one who started me. I had no women mentors at that time. Garry would take young new writers under his wing, and guide them and teach them. He was wonderful. Garry was my mentor.

Do you use comedy as an expression of your values, or your point of view?

Harris: No, not when I was with *Love, American Style.* It was a job. It was whatever was funny, and whatever worked. But certainly it had nothing to do with point of view. For that show I just gave them what they wanted. And it was that way for me basically until I met Norman Lear and saw the pilot of *All in the Family,* which was very different from anything before. I started writing episodes for Norman and then I could have a point of view. I wrote the *Maude* abortion show. Originally I had the Rue McClanahan character, the next door neighbor, as the pregnant one; but Norman liked the basic issue so much that he said we had to give this to Maude herself. So I rewrote it for Bea Arthur. I think that using television to raise audience consciousness a little bit started with Norman.

What about the opening episode of SOAP, with its spoof of soap opera sex, involving the tennis instructor with Jessica Tate and the priest with Corrine Tate?[3]

Harris: It was much more shocking to have the women committing adultery than for a man to do so. People took notice. It was enough that it was a divorced woman at that time, on her own, living her life, dating, with a husband who wanted her to come back. That was enough of a stretch for the audience. The very fact that she was going to sleep with another man was simply out of the question. But it was never my intention to change American morality. My primary intention was to entertain; and I think it has to be, if you're going to survive. Once I had done that, then I'd think of making points. And yes, I would certainly want to address issues. I found that the issues were served up in a much less threatening way if they were part of a comedy show.

I learned a few lessons as I went along. It took me years to realize that the forum we had as television writers was absolutely gigantic. It was after some years that I learned that you could pretty much disguise a point of view, however intolerable, with enough jokes. And gradually it became impossible, after Lear, for me to write something that didn't have a point of view, that wasn't *about* something, that couldn't touch you in some way.

In *SOAP,* for example, the two sisters became the focus, but initially it was about two families. And then in the process of creating the show, the focus narrowed to the two sisters. I remember discussing early on that apparently Jessica had never had an orgasm. That was a big fight with the network. I thought that idea was really worth exploring. We

didn't wind up winning, but we would have spoken to men, to women, to whoever was watching—who would have thought "My God, I haven't been the only one in my entire life with this thought, or that feeling." So it became really essential to feature subjects like that. That's not to say we always were message-oriented. We had a lot of fun with *SOAP*; that show could be anything. But basically, during and after *SOAP* it was important to me that I wrote something with some meaning.

When I watch *SOAP* now, while I'm on the treadmill, it's like watching something new. It still works; and I've forgotten a lot of it. I was working so hard at the time that it was difficult to appreciate what was going on on the stage. The first year and a half I wrote every episode of *SOAP*, all alone. After that, we found Stu Silver, who was an enormous help. We shared the work. We kept trying other writers out and firing them, because I'd have to rewrite everything. We never had groups of eleven writers as they have now. It was just Stu and I, until the very last year.

SOAP got so convoluted that we had, at the beginning of every year, a storyboard where we wrote down everything that was happening in all the episodes. We had to. And basically much of it was interchangeable: every week there was one show that could be moved into another show. Because it was a continuing story, you didn't have to pay much attention to plot; nothing had to have a beginning, middle, and end. There were scenes of just talk. Whatever you wanted to say at the time, you said, "Let's have a scene about this."

We got so much flak—most of it—before *SOAP* even went on the air. When it finally aired, people asked whether this was what all that emotion was about. Their expectations were so high that I think we disappointed them. I think I'm fair in saying *SOAP* never got the critical acclaim in this country that it deserved. It did all over the world—it was a popular and critical success—but not here. I don't know the reason. We never really recovered from the pre-show adverse criticism.

If there was one underlying subject in *SOAP* it was a family, with strong ties. It was about relationships, love, and those connections, family or not. That's what counts, that's what keeps it all together. But there wasn't a social message; you certainly couldn't say it was about family values—if so, we committed suicide! At first the gay community was outraged. I asked them just to wait, that the pilot was just the characters in the broadest strokes. You can't introduce thirteen people in a half hour and make them three-dimensional. I asked them to please give this time. They were right to be upset, because at first Jody was a one-dimensional joke. He was a punch-line. There he was in the first episode putting a dress on. So I asked gay protesters to wait and they'd be pleased, because he was going to be a person. And they ended up loving the show. Jody was no different from anybody else.

Witt-Thomas-Harris has flourished, for about twenty-five years. I'm no longer with it, nor do I intend to be. If I write now it'll be something else—a book, a play, but not television. I get very attached to what I do and that means I would have to stick with it. When you're young and hungry, the issues are different. You can stay up until four in the morning and you can work seven days a week, and even if I could do that anymore, I don't want to. How much time do we actually have? It's limited. There are other things I want to do with my life. Most days I would get off the sound stage and it would be dark and I had never seen the daylight. It was another day gone, totally consumed by a television show. At that time it was fine. Had I known a little more about Buddhism then, it might not have been.

～

Concerning other shows Harris commented:

～

Harris: *Fay* was ahead of its time, I think; but it also had a suicide slot, as I remember it. It *was* different, and they didn't give it a chance to build. Lee Grant was a different kind of woman than women were used to seeing. You could hardly call Lee Grant or the character she played "sweet." People were threatened by her acerbity. By contrast, Maude was married, and even though she had a big mouth, Walter, her husband, still prevailed. Maude played so much bigger than life, you didn't relate to her as being anyone real. She didn't pretend to be all that real. Whereas Fay *was*. And I think it was too threatening.

With *Golden Girls* we were showing how women over fifty didn't have to be relegated to the ash heap. I have said a number of times in my career that I was through with television, and it was during one such period when Paul came home and said NBC had a wonderful idea for a show, they just needed a writer. I asked what it was and he said, "They want to do a show about old people—you know, older women." Well, he knew that I loved to write older characters. I immediately said I'd love to do that. It turned out that what they meant by old people and what I meant by old people was completely different. I thought it was going to be about women in their sixties and seventies and they thought of women in their forties. So we had to compromise. Actually, I don't think we ever mentioned age in the show. They really didn't want "old." Older women, to them, were women in their forties. We fought about it. That's why I finally got Sophia in there. I protested that they had got me in there, they had seduced me, by saying this was to be a show about old people. So I asked for at least *one* genuinely old person to be in it.

But it was less a compromise than our good fortune with casting. We

got incredibly lucky. The women who read were somewhere in their fifties. So we didn't mention age, but the show made it apparent that there was life after whatever age the audience wanted to make them.

I stayed with the show the first year, then left. It changed after I left. We had a good staff but they made some choices I might not have made. In the later years of the show, I felt they had strayed from the original premise. It was no longer the show that we had done; it was really a joke machine, with a lot of emphasis on sex. There came to be no reality base any more. That's what happens when you leave a show; it becomes molded by the hands that are there.

A lot of television writers shy away from writing what's real. They seem afraid to write the real moment. They're afraid not to be funny. For me, the pleasure always lay in that fine line between taking something that was tragic and something that was comic and being able to laugh at that. Those were the moments that attracted me. But I always found that most people would write away from truth. It would be set-ups and jokes. I don't know why: maybe the fear the public wouldn't respond. Everybody thinks that writing television comedy is writing jokes; and I was never comfortable with jokes. I would insist that I didn't write jokes, that the humor came from character. I never used to watch television because I thought there was nothing to watch. I would occasionally watch *Mary*, but after those years I couldn't find anything. But now I find shows I like. Television has gotten much better. I watch *NYPD Blue, Chicago Hope, Seinfeld, Friends*. They're wonderful. I think television in a lot of respects is better than film now.

But as far as working in it, I think television is a young person's game. To make it good you have to work very hard. You've got to be young and hungry and very single-minded.

I never networked with other women in the business. I never joined any of the organizations like Women in Film. I'm sure they are very useful, but I just never became a part of them.

Is there a feminine perspective in your work?

Harris: I think there's no escaping that. Paul had an idea for a movie about three divorced men, that I wound up writing. I said, "I can't write that. I don't know what men are like when they're not with women. You're asking me to write about something I would never be present at. You'd have to be a fly on the wall to know how men are when they are without women. They've got to be different. I know women are, when they're without men."

But I gave it a shot. I wrote a scene. I had no idea what I was doing, so I asked whether it was accurate, whether it reflected how men were.

And Paul assured me that I had got it absolutely right. So I wrote the screenplay.

But I do think there's a male experience, and a female experience. And I do write from my experience as a person, and a major part of that is being a woman. If I don't write from that I'm really not writing from the truth. I write from that core, which is not just being a woman, but being the other things I am also. If I don't write from my central truth, I'm writing in a superficial way.

～

Notes

1. Leonard wrote, "While all the men are watching quarterback abuse on *Monday Night Football*, America's women switch channels and settle back to watch themselves being menaced and mangled by a wide variety of berserk males, almost all of whom pointedly look like devoted husbands or the wholesome boy next door." Leonard calls this phenomenon "a religious festival of the women's victim culture." *Richmond Times-Dispatch*, 7 January 1996, F-5.

2. The authors' interview with Harris was conducted at her home in 1995.

3. For readers unfamiliar with that famous episode, there was also Jody, the homosexual son in search of a trans-sexual operation—all treated comedically. The pre-show press, *Newsweek* in particular, made it seem, in director Jay Sandrich's words, that "Western civilization would collapse on the day following ABC's broadcast of that episode."

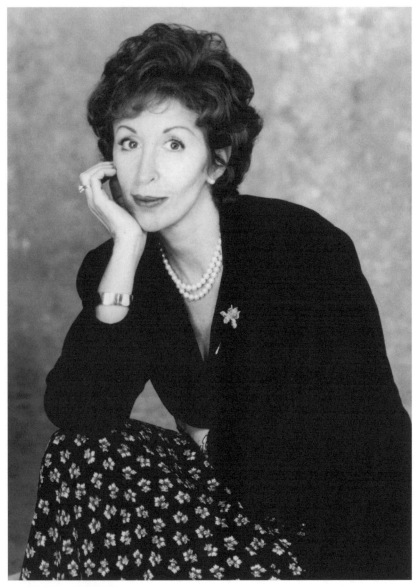

BARBARA CORDAY

✦ BARBARA CORDAY ✦

I work here, but it's not where I live

AS WE MET WITH BARBARA CORDAY IN AUGUST OF 1995 SHE HAD ONLY RECENTLY assumed responsibility for producing a new talk show with Alana Stewart and George Hamilton.[1] Taping of the show had not yet begun as we settled in to update ourselves on her thoughts and ideas. She began with a discussion of women directors.

～

Corday: There are so few women directors because the director is the one who is looked upon as running the set, the one who is "in charge"; and probably eighty percent of crew members are not only men but are middle-aged men who are in unions that protect them. They are, by and large, a very rough-edged group, not your intellectual elite—I don't mean that they're stupid, I just mean that they're not intellectually forward thinking. Most people believe that women would have a very hard time getting these guys to work for them and do what they're told by a woman. [Nancy Malone, who has directed often, bears this out in Chapter 8, with testimony about her experience in dealing with the male ego and winning men over with a little gentleness and a quiet show of efficiency.] On the other hand, women who are producers and writers and aren't on the stage so much are having an easier time (if one can say that they're having an easy time, at all) because the men that *they're* working with are more attuned to the rise of women and women's issues. Men in suits tend to be a little different from men in overalls. You might think of it as a practical thing, this absence of women directors, practical because of a basic situation on the set.

I do, however, see some change. There are definitely more women directors working in television today than ever before. Years ago I think Ida Lupino was the only one. There are women making a living at it today, even the ones who are not famous, like Helene Head, who is a Black woman (talk about having a tough time). She's a very competent director who goes from one episode to another, makes a very nice living, does a very good job. Most people have never heard of her, but she's as good as any man who's directing episodic television. She may never become a star, but she's doing OK. And there are other women, like Nancy Malone, who is a competent episodic director. I don't know that she will ever be a star as a director; but Mimi Leder on the other hand could be. She could go and do a feature at any moment and I wouldn't be surprised. There's a young woman named Lesli Glatter who I think is going to be a very, very successful director. You have to want to find them, because they're not going to pop off the tongue of that many people. You're going to hear about the hot guys. You're not going to hear the names of the women yet, because I think people aren't used to including them. They're barely used to including them as writers and producers.

But I can still name, without looking at a list, virtually every woman who is the executive producer of her own television series. I can't do that with men. The numbers are so vastly different. So we're still getting people used to that idea, I think.

I started about 1972 as a writer with my partner, Barbara Avedon. The women's movement was gearing up at that time. There were some women who were getting started as writers then. They were "flavors of the month"; that is, it was fashionable to have a female writing team working on your show. So there were a bunch of us who used to run into each other at meetings—we were all auditioning for the same roles, if I can put it that way. Barbara and I were very lucky that everything kind of came together in the early seventies. The major difference with us, which I feel obligated to say, is that Barbara Avedon had been a writer since the fifties, in the days when there were very few women comedy writers in the business. So she had credits then, which I didn't. She had worked on shows like *The Buddy Hackett Show* and *Bewitched* and *Father Knows Best*. She had taken some years off, and when she and I met and started writing, she hadn't been writing for several years, and so we came in the early seventies as a new team and were looked upon as one of those new teams of women. But her earlier credits really helped us. In addition, she had some relationships, with Danny Arnold for example, whom she had worked for on *Bewitched*, so that when we went in to see Danny about a job, we had a leg up and in fact did get the job. I've always been tremendously grateful for that. I don't know how easy it

would have been for me to start even in those times when people wanted women if it had not been for her. [Barbara Avedon died in 1996.]

The other thing that happened to us—this was in 1974—was that we broke into the one-hour drama business, which had even fewer women than comedy; our agent at that time told us there was a series at Universal which was set in high school, and they'd be open to having a woman writer. We understood what was not being actually said: that because it was about kids, it was all right to have a woman writer. I'm sure no one actually said that to us, but it was very clear to me that it was not like we were going in to write *Baretta* or *Columbo* or whatever those big Universal shows were at that time. We were going in to write a high school show, and that was somehow more acceptable. We wrote three or four episodes of that series (when we went there, I believe the title was *Senior Year* but when it went on the air it was called *Sons and Daughters*). Then we wound up writing a lot of shows at Universal that weren't kid or woman oriented. They sort of accepted us. We did *Lucas Tanner* and *The Doctor* and shows like that in the seventies. We got on a path. But I think if it hadn't been for that teen show, we might never have gotten to do a dramatic show. I met Barney Rosenzweig on *Sons and Daughters*. He had just been hired by the executive producer, David Levinson, to produce the show. Barney lasted three weeks. He and David did not get along. Barbara and I ended up doing several episodes, but Barney and I started dating on that show, in 1974. We were married later.

Did the Equal Employment Opportunity Act give impetus to more women in the business when it was interpreted to apply to women as minorities?

Corday: I think that might be more true corporately than creatively. It's hard for me to imagine an executive producer sitting around and saying, "Boy, we'd better hire a woman to meet this quota." They might say, "We'd better hire a woman because it's fashionable" or "because the lead actress on the show needs a woman's voice writing for her," or for a lot of other reasons. I've heard that statement made in companies when I've been an executive, but I don't ever remember hearing it within the creative community.

Marcy Carsey's a very interesting case. I don't know whether you could get her to tell you this or not, but when she was pretty much running the West Coast Operation of ABC—she was doing all the creative stuff—I worked for her at ABC—she was told by Fred Pierce, who was then president of the network that a woman would never be president of ABC Entertainment. So far, he has turned out to be correct.[2] But my understanding is that what he said was the major reason she left, because she had gone as high as she could go. She may have said to him

that she thought she should have the job, when Tony Themopolous was leaving, which in fact she should have. I think that's when and why she was told it wasn't going to happen. It was OK to have a creative job, but not OK to run the company.

When I look at how successful women have become in the business during the last twenty years I think it's important to note that just like it was OK for me to write a show about teenagers but not about cops, I think it's always been OK for women to do creative jobs, development, and things like that—but it hasn't been OK for women to do business-oriented jobs or to run the company. We get called president of production when we're incredibly successful, or we get called president of this or that division, but there's always somebody over us who's controlling the purse strings. Even Sherry Lansing, whom I love, and who is chairman of Columbia, still has Jonathan Dolgen sitting on her left shoulder "helping her make the decisions."

I've been president of a studio, president of a major production company, and executive vice-president at a network. I've had probably the highest jobs of any woman in the network television business ever, and I still have never had full control financially of any division that I've run. And I've wanted it. I don't think you can really run a division unless you have that power. You don't push for it, because you're told when you get the job that full control is not part of it. Of course you have a certain amount of financial discretion, but you're not really running the company.

At Columbia, I had a tremendous amount of autonomy. I happened to be working for two guys most of the time I was there—Herman Rush and Frank Biondi—and for a while Dick Gallup—who gave me tremendous independence; but there was always somebody sitting there telling me I was going over budget or reminding me of something like that. On a day-to-day basis I got to make most of the decisions, but when it really came down to it, the Coca-Cola Company, which owned us at that time, had the final control. Yet they were very proud of the fact that I was the only woman in the one hundred year history of Coca-Cola to be president of a division. I thought that was absurd, but they were quite pleased with themselves.

Is the satisfaction of the job well done more important to you, and perhaps to most women, than moving up?

Corday: I think when you move up too far you move out of the creative arena completely. When I talked with you before [1988 and 1991] I was feeling this, but still I was having fun learning all the business stuff that I had never known before. Now, as you can see by the [talk show] job that I've chosen, I'm going back the other way to be more of a hands-on producer. I'm really enjoying doing that. I'm executive producer of

this show. I had come to a moment during this past year when I had said I wasn't going back to work at all unless I could do something I had never done before. It was one of those be-careful-what-you-wish-for things, because the phone rang one day and somebody offered me this job. I've never done a talk show. I've never done a five-day-a-week show of any kind. I jumped at it, because I like learning, I like saying—as I do every day of the week—What do you mean by that? What *is* that? I was in a meeting yesterday with the associate director talking about graphics for the show; and I said, to everybody in the room, "Is she speaking English, or is there a language that everybody in the room but me understands?" I had absolutely no idea what she was talking about. And I found that the most fun meeting I had been in for five years, because I needed to learn everything she was saying. And at my age, to have an opportunity to do that is fantastic.

Is a definable feminine perspective at work in the creative or business side of television?

Corday: I think that women do look at things in a different way. I would not want to be heard as saying that we can't do a job that needs to be done similar to the way a man does it, because I think that's silly. But I do think we bring a perspective to entertainment and to work that is simply different—neither better nor worse—than most men, because our life experience is different. From what people tell me, and what I have observed in my life, it is different to work for a woman. We had a practice show on Wednesday that was difficult, very technical; and it went kind of long. It was the first day we were using cameras, and about five minutes before the show was over, when we were still up on the stage, I said to my assistant, "Go back and get one of the runners to go to Baskin Robbins and get ice cream for everybody, and have it down in the bullpen when they all finish." And then I went on with the show and forgot about it. And when I came downstairs after the show about a half hour later, thirty people said to me, "That was so great; how'd you think of that?" Well, I didn't think it was much of a big deal. I would do it if I were taking kids to a Little League game, too. But apparently most men producers don't do things like that. I'm not patting myself on the back, I'm just saying that's a very easy, key thing that women do. We rarely have meetings without food. We rarely have meetings that start without some sort of personal conversation. I rarely go to a meeting where someone in the room doesn't say, "Oh, nice shoes," or "Where'd you get that suit?" I don't hear men doing that in meetings. There's a humanity that exists where women work and where women have some control, that does not always exist where there are only men in control.

And that carries over into writing. I think it's really, really hard for women to write something that holds no interest for them at all. Men have learned to do that, because they've been taught all their lives that business is business. There's an expression that I'm sure is used in other businesses, but it's much overused in the entertainment business, where you'll have some fight with some man over something and he'll say, "Well, you know, it's only business." I don't think most women feel that way. There's no such thing as "only business." There's how you act as a person, and how you don't act as a person. There's no category called "it's only business." And I personally wouldn't want to be part of a world where that was an acceptable category. I think you treat people—even people you're having an argument or a dispute with—in a certain way. You don't slam phones down and you don't threaten people.

In the category of writing, I've never been able to write a show unless I could find some way into it that satisfied something in me, something that made me want to know or to watch or to be part of it in some way. That doesn't mean that I can't write a cowboy movie, if somebody wanted me to; but I would have to find something within it that interested me—as a woman.

I remember being a little girl in Brooklyn going to our local movie theater, The College, around the corner, and sitting on Saturdays for the ten cartoons and watching movies that I'm sure you guys watched also. Sitting there at seven, eight, nine years old, I remember wondering, "Where's the girl?" I remember vividly wondering when the girl was coming in. And I don't want girls to have to do that any more. I do think that's a consciousness that a lot of women producers, writers, actors, directors, and others bring to television and film today. I don't think little girls have to do that so much any more.

As for an old girls' network that's in any way comparable to the old boys'—first of all, I don't think there are enough women to form anything like a network comparable to the men's. Second, I think that the women who are trying to break into the business do much more networking than those of us who are already there and successful. I think that women are nervous about seeking out and hanging out with other women because they don't want to be perceived as rejecting the people at their own place of work—peers who may not be women. There are a number of organizations like Women in Film where women do network, where they try to help each other with mentoring and job placement, for example. All the women I know, including myself, when we get into a position where we can hire, will hire other women. This show I'm working on now has more than fifty percent women on staff—in such jobs as segment producers and researchers.

I don't think women network in the same way as men. They usually

have lives to go home to at the end of the day, and aren't going out for drinks with the guys, the way men do. A guy mentioned to me not long ago that he had noticed I try to get out of here by seven o'clock each day, and I laughed and told him, "Yeah, I have a husband. I have a stepson who's spending the summer with me. I have a life!" I told him that I work here, but it's not where I live. I think men continue to be more willing to give up time in those personal areas to make points at the office.

I've always said to people who work with me, "I want you to take your vacations. I don't want you here until eleven o'clock at night. I want you to have a life, because I think that makes you a more interesting person." I think it brings more to the work if you have a life outside. I've never found it praiseworthy when somebody tells me he hasn't taken a vacation in three years. My response is not an awestruck, "Wow, that's really amazing!" My response is, "Well, take one." I think there are some men who have to be the first car in the parking lot and the last to leave at night. And good luck to them. I have no desire to live that way. And I think there are fewer and fewer of those Sammy Glicks. Most of the younger men I know, men in their thirties and early forties, who have families, are really making a tremendous effort now—contrary to their counterparts a few years ago—to get home and spend time with their kids, to go to the school play and Little League. When I started men were just not doing any of those things. And I now feel that wasn't lack of interest but just a feeling that the family was not as important as work; or perhaps they felt that they were going to be in some way chastised for slacking off. And now they know they're not going to be.

Barbara Avedon was my main mentor. I don't know what direction my career would have taken without her. I've certainly had others, male and female. I consider Herman Rush a great mentor for me, and I think the main reason was that he never noticed whether you were a man or a woman. That's a really wonderful trait in a boss. When I was at Columbia and Herman hired me to basically take over his job when he was moving up, one of the major papers, the *The LA Times* or *The New York Times,* called him and asked how he felt about having a woman in that job, and he said to the reporter, "Oh! Is she a woman?" Completely unimportant to him. I thought that was the best possible answer, instead of some long philosophical bull. I thought in those days, 1984, that it was brave for Herman and Fay Vincent, and Dick Gallup and Frank Biondi to let me take over the reins of what was a huge money-making piece of the Columbia jigsaw puzzle (in those days the television division made all the money and the feature division was not doing well). I was very impressed that they would hire me to do that, and very grateful. There were not other women doing comparable jobs at that time, as

president of a television division of a major studio. And I don't think there have been many since then—Lucy Salhaney at Fox comes to mind as an exception.

Do you agree with Virginia Carter that since the mid-1980s men from the East with M.B.A.s began to take over, demonstrating little appreciation for the artistic or creative side of television—or, for that matter, its business civilities?

Corday: I think that's exactly what happened. All of us who grew up in television making shows as opposed to making money were very struck by this influx. It was a very obvious change, and we used to talk about it a lot. It was the first time in my life that there were people in the office next to mine doing "spreadsheets." I had never even heard that term, "spreadsheets," before 1985. They were saying things like "We don't think you should do this show, because we've made an analysis and we don't think that five years from now it's going to make as much money as . . . some other show they'd name. But my job, as I perceived it, was to get shows on the network. As a studio head, you develop shows, you have relationships with producers, you sell them to the networks and get them on. And what happens five years from now is somebody else's problem: the syndication guys had damn well better sell it. That was how I was raised. And suddenly there were people coming along saying, "No, no, when you're developing a show, you have to think about five years from now." That was a new thought for most of us.

It was hard for us, and a lot of us rebelled against that idea. But in the last ten years, that way of thinking has definitely become normal. I think it was Lucy Salhaney who was the first studio head to pull a show that was going to be picked up off of the network, because she didn't think it was going to sell in syndication. That was the Jamie Lee Curtis/ Richard Lewis *Anything But Love*. Lucy had a brief moment when she was running Fox Television. She came out of the syndication business, the station business. She believed, from her experience, that the show would not set well in syndication. There was obviously someone sitting with her and running those numbers, saying "This is not going to do well." That was a cause celebre for a while, because no one had ever done that before. And Harris Katleman, who was head of the television division, who then held essentially what my job had been at Columbia, was pretty upset by that decision, because his job was to get shows on the air. So a lot of things like that have happened in the last ten years that have changed the way television is sold and made.

Lucy Salhaney is one of the few who come from a business and syndication background and did not come up from the ranks of the

creative area. I think that her decisions are less the result of being female than the consequence of her particular learning track as she came up through the industry—working at a station, then being head of syndication distribution at Paramount for years, and then going to Fox. Most of the women in business—television and features both—came up through development, where the story is the thing. And those of us who learned that way fall into the category that I was mentioning earlier. Very few have come the way Lucy has, and I don't see that as a trend.

The syndication business is even more male dominated than the production business. Very few women are doing what Lucy did.

I don't think there were obstacles thrown in my way, because in the seventies people wanted women to come and work with them. They often didn't know what to do with them, but they knew they were supposed to want them. Barbara and I did have a couple of experiences relevant to this subject. A man, a writer, said to us rather loudly in a Writers' Guild meeting, "Why don't you two get out of the business and let a man who needs to support his family have the job?" At that time, Barbara and I were both single mothers supporting our families, but that didn't seem to make much difference to him. Another time, we were doing an episode of *Maude*: we had pitched an idea and came back and cleared the story and we were being sent off to write the first draft of the script. The producer walked us to the elevator with one arm around each of us, him in the middle; and as we stepped on the elevator, he said, "This is great; I'm so glad you guys are doing this; you know, we've started a lot of secretaries on their writing careers on this show." And the elevator doors closed and Barbara and I looked at each other. "Does he think he's giving us our first job?" His perception was that every woman writer at that point, in 1973 or '74, yesterday had been a secretary, that there was no other explanation of how we had just appeared in their offices.

People didn't think anything at all about saying things like that. It's one thing to think like that, but no one even thought there was anything wrong in saying things like that.

The other obstacles, of course, which have nothing to do with people trying to keep you out of work, comes about when women are working and trying to raise a family—and I think this is still true today. Women are for the most part expected to raise their kids and go to the grocery store and make sure lunches are packed and go to the school play and make the meeting with the teacher—do all of that as well as working. And I consider that an obstacle: if you don't have any help doing those things and you're supposed to put in a full work day. This isn't an obstacle set up at your office. But it's harder to get ahead if the guy in the office next to yours doesn't have to do any of those things. It isn't

just that men expect this of women, but women expect it of themselves, children expect it of their mothers. Teachers, doctors, mothers-in-law, grandmothers—they all expect it of you. And I think to a lesser degree every year, but still to some degree, husbands expect it of wives. I do think the younger men are changing their expectations, but it's still there. It'll take a few more generations to get rid of it completely. And, of course this situation is not unique to the television or entertainment industries, it's everywhere.

I'm not talking about that poor woman who's a bank teller for four hundred dollars a week. You can be high income, with help in your home—housekeeper, nanny, all of that—you still are a mom and there are things that you have to do, that your children expect of you, that you *want* to do. And you shouldn't have children if you're not going to be there for them. Sending your nanny to the school play doesn't cut it.

Were there men of power in the industry during the 70s who made it easier for you and for other women?

Corday: Names that come to mind for me are Norman Lear, Danny Arnold, Grant Tinker. They were men I worked for and who opened doors. They were running companies; and they allowed women writers to blossom. On the drama side, people like Don Brinkley, for whom I did *Medical Center,* were very open to us, very nice to women. The seventies were much more open than the sixties.

Is Women in Film an important instrument?

Corday: I haven't been active in Women in Film for a while. I still go and speak to their groups. I just did a breakfast for them about six weeks ago, but I'm not active in the organization much any more. I am very active, though, in the organization called Hollywood Women's Political Committee. [This Committee disbanded in 1997.] I was a founding member, and I'm on the board. Virtually all the members are in the entertainment business, but it's political: we support candidates and do other political work. It's not an organization set up to network for women, but clearly since you're in it with other women who are in the same business, there is a certain amount of networking. Friendships develop.

The subject of politics is an interesting one to me, in the context of women in television. You know, I don't think women knew until about ten or twelve years ago that they could write checks. If you asked women for checks for politics or charity, they would say, "Oh, I'll ask my husband." That was a very common answer, and no one thought anything about it. But what they always could do and did do was organize the

dinners, put together the clothes for the charity, do the drive for the canned goods. So what we've tried to do in our Hollywood Women's Political Committee is tell the women you can take all that energy to do the good things you've always done, but you can also write a check. You can be the moving force; you don't always just have to do the canned goods. The group has been very successful, and in the '84 election, which is when we started, we really struck a nerve. Women came out of the woodwork. We started with fifteen members, and we now have about two hundred and fifty. I think women were so excited to just be able to *do* something. We've given away almost six million dollars in the last ten years, all raised by the women of the entertainment community.

~

Note

1. Corday left this show after a brief period. Shortly thereafter the program disappeared.

2. As we note elsewhere in this volume, in the summer of 1996 Jamie Tarses became the first woman president of ABC Entertainment. After a somewhat stormy tenure Tarses left ABC in 1999.

DOROTHEA PETRIE

13

♦ DOROTHEA PETRIE ♦

Coming into the business, it's hard being a woman

OUR CONVERSATIONS WITH DOROTHEA PETRIE BEGAN IN THE MID-EIGHTIES. SHE
continues to be one of our most trusted advisors. Most of the following
remarks date from 1995. Her observations provide a glimpse of how one
woman developed her career in television.

~

Petrie: I was an actress originally. I went from the University of Iowa to
New York, where I auditioned and was lucky to be cast immediately in a
weekly radio show. I met my fella, Dan, in a class at Columbia. He was
getting his Master's degree and acting on Broadway. We married and
went to Chicago where he was performing in the National Company of
I Remember Mama. This was supposed to be a nine-month tour, and we
were married on the strength of that contract, but the play folded after
a month. That made Dan realize that the acting world was not steady
enough for him. He enrolled at Northwestern University, taught acting and
worked on his Ph.D. I was doing radio shows on NBC, ABC and CBS.

When Dan finished his course work we moved to Omaha, Nebraska
where Dan was to write his dissertation and head the English Depart-
ment at Creighton University. I was Director of the Theater Department.
Creighton was best known as a Medical School so being "Director of
Theater" was not as important as it sounds. But we did have some fine
talent there. Just a little aside: I had one student who was truly outstand-
ing and played a lead in all the productions I directed. I suggested he go
to New York to continue his acting career; but he decided to go into
advertising with Butternut Coffee in Omaha. In a few years Butternut

was acquired by Coca Cola and Donald Kehoe went on to be the president and now CEO of Coca Cola. He made a wise choice.

A year later Dan was invited to join NBC TV as a director. It was the very beginning of its television network. We moved back to Chicago and a few months later he was called to New York City to direct *The Billy Rose Show*. Typical of my generation, I never thought about my own career. In New York, I moved from acting to casting. I was the Casting Director for the Theatre Guild's *United States Steel Hour*, a prestigious hour-long live drama. Later I became an agent with Lucy Kroll who represented such talent as Carl Sandburg, Helen Hayes, and Horton Foote.

It was important to both Dan and me to raise our family together so we always traveled with Dan wherever he was filming. But I always managed to find some exciting work. For example, the first time we lived in London I worked as a reader for a West End producer. I recommended plays that I thought could transfer from Broadway to London and vice versa.

Returning to New York, my main job was to raise our four children but I also worked for Hall Cook Associates three days a week and helped develop a television exercise show. It was with Bonnie Prudden, President Eisenhower's fitness person. We attracted General Foods as the sponsor and took it to the networks, who told us, "Women will never watch women exercising." We were ahead of our time.

In 1970 we moved to California and I received some very tempting offers. But my children were almost teenagers so it was important to me that I be there when they came home from school. So working in the film and television industry with my "at home by three" rule did not appeal to employers.

When my daughters were in high school and the boys started college, I was ready to go back to work. I asked myself what I would most like to do. I've always liked being in charge of things. I'm good at that and I'm good with people. I know casting and actors, I recognize fine material and fine writers. So, I thought producing would be the best avenue for my talents. But you can't just walk in and say, "I'd like to be a producer." Dan was already well known and although that's both an advantage and disadvantage, I wanted to be accepted for my talents.

I needed to find a project. In 1973 I took my mother to the centennial in Dysart, Iowa, the small town where she was born. She introduced me to an elderly gentleman who, as a child, had come from New York on an orphan train. My mother told me that when she was a little girl it was a regular occurrence for her to go down to watch the train come in and see the children who were brought out onto the platform. Whoever wanted a child in that town would take one—not adopt, but take—and

the rest would get back on the train and go on to the next town. I had never heard of an orphan train and it fascinated me.

I tried to find some information on an orphan train but there was no information even at the best research libraries. So I flew back to speak again with Ben Pippert, who was at that time eighty-four years old. He had the original name tag which had been pinned to the jacket he wore. On one side was his name, and on the other side were the "Rules for Placing Out," and in small type at the bottom was "The Children's Aid Society of New York." I flew to New York and discovered that there had been not one train but hundreds of orphan trains and the information was buried in the early New York social history of the Children's Aid Society.

In 1854, Charles Brace, a young minister, saw so many destitute children living on the streets of New York. Some had been abandoned, some orphaned, and some had parents who died on the ocean trip coming to America. Reverend Brace had seen a plan that had worked in Germany. Children from the cities were put on trains and taken out to the farmlands to see if anyone would take a child to be fed, clothed, housed, and educated.

He decided that the plan would work in America with the hundreds of children living on the streets, abandoned through the death of their parents or other circumstances. So he started the orphan trains. From 1854 to 1929 over one hundred thousand children were "placed out" in homes across America.

I thought this was a great story. I further researched it and wrote a treatment for a feature film. My agent took it to United Artists who agreed to develop it as a feature film for Steve McQueen and Ali McGraw. I was going to co-produce the film with Joe Wizan, an important and experienced producer. I had no writing in my background, but because of my knowledge of the material and the fact that I had written the treatment, the studio asked me to write the script. They had liked what I had done with the treatment and they insisted. My oldest son, Dan Jr., was in college and was a very gifted writer, so I asked the studio if I could get him to work with me on the script. They said they didn't care how it got done as long as it was done well. So I hired Dan Jr. (who is now a well established writer and director) to work with me on it. But by the time we finished the first draft, Ali McGraw and Steve McQueen had split up. United Artists told us they would do the picture only if we could find comparable stars.

Now, at that time, there weren't comparable stars to Ali McGraw and Steve McQueen, at least not ones that would be right for *Orphan Train*. I asked to buy the property back, and they allowed me to do it, by paying their lawyers' fees and returning the money they had paid us for

the script. Then, in spite of other feature interest, I decided television would be the best place for this project. I took it to EMI and Marian Rees, who had been interested in it from the very beginning. We went to CBS (this was right after the success of *Roots*) and they ordered ten hours. Well, I didn't have a story that could fill ten hours. We went back and studied what we had and decided on a three-hour dramatic special.

I asked a fine producer, Bill Gilmore, if he would co-produce *Orphan Train* with me. I wanted to work and learn with the best. Bill had been an editor, a unit production manager, as well as a producer, having produced many of Robert Redford's films.

While we were in pre-production on the film, EMI, the company, had a big movie, *SOS Titanic,* being shot in England. The production was in trouble. They needed Bill Gilmore. They really put pressure on me, explaining they were nine million dollars into the film and it must succeed. "But what about *Orphan Train?*" I asked. They said, "Can't you do it? You know the work, you've been doing it." I came home and asked my husband if he thought I could produce alone. He said, "Do you think you can?" I thought a moment and the answer was "Yes, I can." So for better or worse that day I became the sole producer of *Orphan Train.*

Then it happened again. I had also researched and hired the best editor/associate producer/post production person I could find, Academy Award winner John Martinelli. But *SOS Titanic* also needed him desperately. In his place, however, they suggested a veteran editor, Aaron Stell, a gifted, lovely man. He had edited *To Kill a Mockingbird,* and a number of other wonderful films. In postproduction Aaron allowed me to be right beside him while he worked. So what seemed to me a disaster at the time turned into an opportunity: a priceless course in editing from an award-winning editor.

Earlier on, my agent had sent my treatment to The Dial Press, who called and said they'd like me to do *Orphan Train* as a book. Having never written a book, I felt I at least needed a collaborator, someone talented, easy to get along with who knew history and didn't mind working with a "first timer." The publisher chose James Magnuson, originally from the Midwest, who had written several books for Dial Press. Jim had also been a social worker. He proved to be a splendid choice. Dial Press published *Orphan Train* and the book did well. . . . There were three printings and an auction for the paperback rights which were purchased by Fawcett. *Reader's Digest* selected it as one of the twelve best books of 1979. It has been published in many languages and I am very proud of it.

In the treatment, book, and film of *Orphan Train,* I made the person in charge of taking the children across the country a woman because I

could write from a woman's point of view. My mother was a rather Victorian lady so I based the character on her and had the historical Reverend Brace put her, his fictional daughter, in charge.

Millard Lampell, who wrote the script, won the Writers Guild Award for his work. And I won the Writer's Guild Award for Best Original Story 1979. The show received critical acclaim and swept the ratings as well.

My next picture came as a result of a call from Marian Rees who asked me if I would like to do *Angel Dusted*. I was thrilled. We had a wonderful cast, Jean Stapleton, Arthur Hill, Helen Hunt, and John Putch. Then I brought Marian a film, *License To Kill*, which grew out of personal experience. When I was seven, my father was killed by a drunk driver and I had, for many years, wanted to do a film about this subject.

In *License To Kill*, I wanted to show perspectives from both the driver and the victim's family. Our story was of a high school valedictorian getting ready to go to college when she is killed by a man who has just had too many martinis. The driver is a highly respected businessman in the community who didn't realize that he often drives under the influence.

I wanted to feature a drinker whom people in the audience could identify with, about whom people who occasionally drink too much could say, "Hey, that could be me." The Don Murray character was a fine upstanding man with a lovely wife and two young children, but that day he just had one drink too many. It was a very successful show and has been used often as an educational film.

I worked with Marian Rees on several other very successful films. *Love Is Never Silent* is one of my favorites. It was a difficult film to get made and we worked tirelessly putting the project together. CBS wanted Paul Newman and Joanne Woodward to play the deaf parents, but in spite of our respect for the Newmans, we kept insisting on using actors who *were* deaf. We wanted Phyllis Frelich, the brilliant actress who won a Tony on Broadway for her starring role in *Children of a Lesser God*. The executives at Hallmark Hall of Fame and Marian had given me permission to begin pre-production, to select the director, Joe Sargent, to go to Vancouver and start setting our crew and cast. But two weeks before shooting we still hadn't filled the leading roles. CBS executives wanted movie stars only because they were afraid the story wouldn't otherwise attract an audience. I had always had Mare Winningham in mind, not only because she was an excellent actress, but she knew how to "sign." CBS still resisted, so, with Hallmark's permission, Anne Hopkins, Marian, and I went to NBC and asked them to read our script over night. They liked it and our casting. Mare Winningham, Phyllis Frelich and Ed Waterstreet were brilliant. *Love Is Never Silent* was awarded the Emmy for Outstanding Drama Special for 1985.

Foxfire, starring Jessica Tandy and Hume Cronyn, and *Caroline* with Stephanie Zimbalist and Pamela Reed are other Emmy Award- winning films that I'm especially proud of. All were produced for *Hallmark Hall of Fame.*

Another interesting project was *Crash Landing: The Rescue of Flight 232.* I was approached by AT&T to produce a true story of a plane crash in Iowa. Two young producers from Paradigm Entertainment had the story but little experience. AT&T said they'd consider making the film if I'd be the executive producer. I didn't think a crash film was my type of story, but the producers convinced me. It was about a community, first of all. One of the characters was a young maverick who worked for the sheriff's department and who kept warning people that the city wasn't prepared for an emergency. He finally convinced the town fathers to put together a rescue unit and place him in charge. Gary Brown "practiced disasters": drilling the public, organizing the hospitals, the police and the fire department, not only in Sioux City, Iowa, but in surrounding towns. Our movie was to be about these communities and how they came together already prepared to help in a disaster.

The disaster occurred when one of a DC-10's engines had broken off and cut through the hydraulics. That meant the pilot had no control; he just had to hang on knowing he was going to crash with 287 people aboard. The pilot, Al Haynes, radioed for help. The Sioux City Airport said, "Come to us, we're ready." And because the Sioux City Rescue Units *were* ready they managed to save over 189 lives.

Now, I was fully sold on the story. We flew to Sioux City and met with community leaders. We explained to them that we couldn't pay everyone for his or her story (over one thousand people were involved), but that this was about their city and about Nebraska and South Dakota as well, three states in that corner of the American Midwest that practiced and really came together when Flight 232 was coming down. What we offered as compensation was a contribution from AT&T to the rescue units. Any person who wanted more would simply have to be left out of the story. There was only one man who wanted money. Needless to say, he's not in the movie.

In July, just before filming was to begin, AT&T called and said that $20 million had been cut from their advertising budget, jobs were being eliminated and they couldn't justify doing the film.

But our pre-production was almost finished. We were all ready to go, with a terrific script by Harve Bennett; a wonderful director, Lamont Johnson; the two young producers, Joe Maurer and Brad Wigor; and Bob Huddleston, a brilliant production manager. Charlton Heston, James Coburn, and Richard Thomas headed a superb cast that included firemen, police, doctors, nurses and 450 rescue personnel provided by the Air Force plus hundreds of townspeople who had helped in the actual

rescue of Flight 232. All these folks plus a fine crew were already hired. So I went back to the community leaders and said, "We can't do our movie. We have money from ABC, of course, but we need an additional half million dollars." They said, "We'll give it to you in goods and services." And they did!

Crash Landing was a wonderful experience. The many people who helped us are so proud of "their" film, as well they should be. It premiered in Sioux City and was honored in Washington, D.C. It also resulted in rescue unit budgets being restored or made available to towns and states around the country. Recently, I called Gary Brown and Jim Hathaway when the Iowa floods occurred. The Missouri River was right up to the door at the hotel where we had stayed. They told me, "We're watching it. And we're prepared to help."

Another different type of production was a fine adaptation of Marsha Norman's play, *Getting Out,* for Signboard Hill Productions. It's a very strong story about a young girl who was in prison, about her experiences there and after as she is released years later. In the play two actresses play the role. In the film, Rebecca DeMornay plays the mature Arlene who, when pressed against the wall by circumstances, reverts to Arlie, the spiteful abused young kid. It gives the audience a rare glimpse of what a young woman faces returning to society, coping with her life, past and present.

In production, organization is very, very important. That's one of the things I learned from Marian Rees. She's a perfectionist and highly organized, and now I am too. My strengths are working with people, recognizing good material and knowing fine writers, talented actors, and strong directors. I believe in having a great sense of loyalty to the director and crews I work with. They make me look good. We all work together as a team, and as the producer it's very important that I make everyone feel that he or she is a vital part of the picture. And I do see that each gets credit for the job she or he is doing. Craft service people for example— they're the ones that have the soft drinks and snacks out for the crew and clean up after a hard day of filming. I want those craft service people to feel they're part of the team and say "This is my picture." Everyone is crucial to the movie and needs to feel appreciated for a job well done. I don't think there is enough credit given today.

Let me go back to the beginning of my producing career. At first it was thought that I'd ride in on my husband's coattails. He was a very successful director doing some of the finest work in television and films. Everyone just assumed he would be my director and that's how I would get my projects on. That was never in our plans. We always helped each other with scripts and casting informally but never officially. And I've been fortunate enough to work with some of the finest directors in the business.

~

DIANE ENGLISH

14

✦ THE QUEST FOR INDEPENDENCE ✦
DIANE ENGLISH

Right now there are just not a lot of good female roles

WITH A SOLID REPUTATION ALREADY ESTABLISHED THROUGH CREATING AND producing *Foley Square* for CBS in 1985–86, Diane English was seen by Warner Brothers as a valued asset and they requested that she salvage a sputtering but promising series, *My Sister Sam,* by producing it. Speaking with her on the set of that show in the summer of 1987, we asked about published reports that she was discriminating against men and she denied it vigorously. Our observations of her on the *Murphy Brown* set, beginning in 1989, the second season, support her rejection of the charge. And her success with that series makes it a natural point of entry for discussing the English style of producing.

~

English: *Murphy Brown*. That's an interesting story. You know, a lot happens in traffic. I do a lot of thinking on the way back and forth between Warner Brothers in Burbank and home. I had been struggling for months with an idea for another series, and it just wasn't clicking. One day, driving to work, I told myself that if I didn't have the answer to this particular problem by the time I got to Burbank, I was going to abandon the whole idea for this series. By the time I got to the final freeway interchange, things were looking pretty bleak. I was getting really bored with the whole idea. I have no explanation for this, but I just started to let my mind wander and something entirely different popped into my head. By the time I got to the office I had all of *Murphy Brown*

put together. When something comes that easy to you, you know it's meant to be.

I was a theater arts student in college and I had always been torn between the two fields of theater arts and broadcast journalism. I'm still torn, to this day. And I think one of my subconscious ways of working this out was to create *Murphy*, where I'm actually writing about a broadcast journalist. I can use all of my skills that I gathered in school majoring in theater arts to write about the thing that I thought I might want to be.

So that was the inception of the series. I got to Burbank, ran into my husband's office, and said, "Forget about the other idea." I sat him down for ten minutes and pitched the whole thing out, including telling him who the characters were and giving him the first six stories. We called Warner Brothers, the studio with whom we had an overall deal at the time—they bought us for two years—and we talked to the head of television. He asked us over to their offices, across the lot, and we pitched the idea to them. They liked it. The next step was to make an appointment over at CBS. We sat in a tiny office with what seemed like a huge crowd of people. There we pitched it to the network and they bought it. We made a pilot and it went on the air in November 1989.

Of course, things weren't quite that simple. When we first pitched it to Warner Brothers, they objected to Murphy's being a recovering alcoholic. They felt very uncomfortable about that. They suggested instead that she might be returning from a health spa where she had been trying to put her stressed-out life back together again. They didn't want any mention of alcoholism.

But Joel [Shukovsky, husband and business partner] and I felt very strongly about that facet of her character. We really didn't want her to be on a pedestal. We wanted her to have flaws. We knew that alcoholism was a problem that was increasing with women; and furthermore we thought there was something heroic about a woman who had this problem and was going to tackle it.

The people at Warner's were afraid the audience was going to turn it off. But they did allow us to take it to the network pitch. The network was uncomfortable with it also, and asked us whether we would back off of that part of her personality. When it came time to write the pilot, I was still fighting that battle, so I asked them to let me write the first draft the way I wanted to, and I could show them that this character trait wasn't going to be as threatening to audiences as they feared. Murphy would still be likeable. They said I could do that, but if they still didn't approve we'd have to continue to discuss the problem.

I wrote the pilot and then the Writers' Guild strike hit. This was lucky for us, because once the strike hits you can do no further writing. So they were stuck with this alcoholic woman! And the ironic thing is that they

were so pleased with the result that, had there been no strike, they would have asked me to go further with that rather than remove it. So that's one lesson in hanging on to your instincts and fighting for what you believe.

There are some autobiographical elements in this series, in addition to the one I mentioned about my struggle between theater arts and broadcast journalism. For example, Miles Silverberg *is* my husband, Joel, when he and I met, in 1971. We were both in our early twenties, and he was very much that personality. As a matter of fact, they look very much alike—people always mention it—and Grant [Shaud, who plays Miles] loves to hang around my Joel to get ideas from him. There's a force to his personality. He's irrepressible. This was a character that I wanted to come up against another character much stronger than he, much more experienced. That's how we see the irrepressibility that's such an important characteristic of my husband: there's an energy so strong that no matter what happens you can't beat him down. The fact that he's Jewish is also an important part of Joel's and Miles's character.

People ask me who Murphy is, and I say she's really Mike Wallace in a dress. Her interviewing style is very hard-hitting, like his. But she is also like me—somebody whom I myself had begun developing into. I was turning forty. I was raised to be a very good girl. I was an A student. I always wrote the perfect bread-and-butter note after staying over at my girlfriend's house. I was raised with the idea that you never make any waves.

But the longer you stay in this business, the more you can get steamrolled over, so I started to develop a more assertive side of my personality, and that evolved to become Murphy. And interestingly enough, Candice Bergen was going through the same thing, so she found something in this character she could really sink her teeth into. She worked out a lot of what might be called her "blossoming" in this character and I would write it for her and me both. We knew that Murphy was a lot more courageous than either of us would ever be, but we both were able to work a lot of things out through that character. So I would say there's a lot of both of us in there.

I did not, however, have Candice in mind when I originally wrote the character. I find that if you have a particular actor or actress in mind—your odds of getting him or her are very slim—you close yourself down. And also, if you involve the actor up front, in the development process, the problem is that the actor has too much control, the tail begins to wag the dog, and the writer loses power. You wind up with a Roseanne or a Cosby where the star is ruling the show and he or she doesn't always have the best judgment about what's best for the big picture. So I try to write the most interesting character I can, and then try to cast it from there. At that point it's definitely an advantage to have a star in your show, because it generates more publicity and gets people to watch. There's so much on television, and it's so bland that you really need to

do something to cut yourself away from the herd. So for my script I would look for the best actor to do it and it would be terrific if that were a recognizable name that we could work with; but I wouldn't involve that actor from the beginning.

Since Miles Silverberg was to represent the character and personality of your husband Joel, was the casting for the part particularly difficult?

English: Casting Grant Shaud was especially dramatic. The worst panic you can experience is when you're putting the pilot together and you're down to two days before you have to start rehearsal on a one million dollar investment and you still have one role to cast. You have gone through everyone in the universe and there is no one who can play this role. We thought the role of Miles Silverberg would be the easiest to cast and as we started our month-long casting process we tried out guy after guy after guy. They were playing it too much like a nerd or they were too broad or they weren't funny or they weren't charming. It was such a pivotal role, and we were getting very much concerned.

We were approaching this moment where we had to start rehearsals, and I remember saying to Joel, "It's over. We can't find our Miles Silverberg. We'll have to go with Actor X." And my husband said, "No, I think this is really wrong. We've got to hold out." Director Barnet Kellman and I said, "You don't understand, Joel; there are twenty-four hours left. We can't do this to ourselves. We're going to wind up with somebody *really* horrible." He insisted, "No, I just have a good feeling that tomorrow we're going to find this guy."

The next morning we went into the office and there was a new batch of tapes from New York. Suddenly there was an actor on the screen who was Miles Silverberg. He was brilliant, perfect. We rolled the tape back and looked at it again. Who is this guy? We looked at the little piece of paper that was our guide to names of the actors on the tape. "Grant Shaud." Miracle.

"In producing you have to learn a lesson, the one my husband taught me. You have to leave yourself open, it's never over till the fat lady sings. In the case of Miles, we had another day, and that day did it.

In writing, I know pretty much the history of each character before I start. I did that first on *My Sister Sam.* I didn't create that show, and I didn't feel I knew enough about the characters to come in and take the show over. So for myself, I wrote a biography of each character, and then I decided to share that with the actors, and they added their things. With *Murphy* I didn't write it down, because I felt that I knew them so well, having created them, that I felt I didn't need to put it on paper. Our actors, though, have all created lives for their characters, in addition to what I've told them.

Some of them have done this in incredible detail. In your book[1] Bobby Pastorelli [Eldin] and Charles Kimbrough [Jim Dial] share those biographies with you, which they had never done with me. I never wanted to know too much about Eldin, and I don't think we should; he's kind of mysterious and should be kept that way. I wouldn't want to go to his house, or meet his parents. But for Bobby, it's helpful. He knows exactly where he came from. I do think it's important, when you're writing characters, to know as much about them as you can, before you start to write. Then you'll always discover a lot more as you're going through the writing process.

How do your political views emerge in the show? Are you conscious that you are making statements concerning things you care about in society as you write the scripts?

English: Absolutely. We walk a fine line. We don't want to abuse the fact that we have access to the public airwaves. We respect and understand the fact that it's a country composed of people who have opinions that don't jibe with our own. We don't want to be a show that's an issue show, where every week you tune in and see what these particular writers think is the issue of the day. But we get a lot of requests every week from various special interest groups: "Can you do something about animal rights?" "Can you say something about migrant workers?" We resist it because we don't want to become vulnerable to outside pressures no matter how worthy the cause. The material has to be generated by us, internally, so we can remain independent. There are times when we feel there are things that affect everyone in a bipartisan way.

What we want to dramatize is that you can preach about the environment all you want, but it comes down to what the individual does and that's what's very hard. In the end, the episode should say to people, "Take responsibility for your own life. Don't expect the government to do it, don't expect legislation to do it. If this place is going to be fit for your children there's something you can do, in your own small way right now, that'll have a huge impact later. It's not easy but we don't have any choice." But the ultimate question is, can we get a good comedy show out of it? That's *our* first responsibility.

We also thought about doing a show in which advertisers pull ads from a very controversial edition of FYI. It would deal with censorship and pressure groups and so on. The easy road to take is to point a finger and say that the ad guys are weak, and that boycotting products is wrong. But we wanted to have at least one advertiser step forward and say, "I'm going to sponsor this thing. Sometimes you have to stand up for what you believe and put the dollars and cents aside." We wanted to represent these people fairly. They're not all weak, money-ruled individ-

uals, so we need to represent their strengths as well as the obvious weaknesses. Audiences have to hear, "We have companies, we have payrolls to meet, families to feed, we have to worry about whether our products are going to be boycotted or not, it affects our staff, our payroll." We also want to hear the side of the woman who proposed a boycott. Her actions came from a real concern: you don't want to turn on your television and see gratuitous sex and violence. We want the show to be as complex as possible. Otherwise, it's too easy and too predictable.

In the episode about Murphy's visit to the Men's Club ["Soul Man," 20 February 1989], somebody asks why she wears a man's outfit. That was a choice made by Candice, our wardrober, and us, and it's not a man's outfit: it's from Ralph Lauren's collection that year. It does have masculine overtones, especially the sort of smoking jacket. We thought it would be fun to have her declare by her dress that now that she's crashed her way in, she'll try to be part of the gang. Murphy stands for a lot of things, and I think if we ever did an episode that people would point to and say, "This is a feminist show" that would probably be the one, but the way we saw it was not so much a show about feminism as it was about exclusion in general. There was a scene in the FYI studio where it was being discussed and Carl the Cameraman said that it was wrong anytime you ever excluded someone. So we tried to broaden it beyond just focusing on a feminist issue—not that there would be anything wrong with that.

Is Murphy Brown *predicated on your own understandings of the feminist movement?*

English: I don't like labels in general, but if feminism means that my female characters or my friends or myself are respected, in all walks of life, then I'm a feminist. But I don't like to refer to myself as a *woman* writer. I think those kinds of labels are very limiting and I look forward to the day when no one refers to me as a woman writer anymore, because I'm just a writer. . . . I think the only way that will happen is if women stop listing themselves in the back of the Writers Guild of America Manual under "Minorities—Women" and stop associating themselves with groups that have an agenda of punishing men.

What is your first priority in producing and writing the television series?

English: We have a format that so suits the news of the day that we have to be very responsible. Our first priority is to be a comedy show and to be entertaining. But we are also making a lot of comment about the TV medium. We can't just bring up the issues and not comment. It's not possible.

We haven't gotten any complaints from the network at all. Ninety-nine percent of the letters we get are from people who applaud us for the quality of the show, and part of that reaction is that anytime we deal with an issue we try to deal with it fairly. Nothing is off the cuff or just there for a cheap laugh. We think about all of it a lot. We dealt with Murphy wanting to become a mother but not having a man in her life. When we pitched that episode to CBS, we crossed our fingers. We thought, this is where they are going to come down on us. But that wasn't the reaction. The audience loved the episode. We didn't get one negative piece of mail or phone call. I think that show set the tone of *Murphy Brown* early on. It was a risky subject that was handled in a tasteful and sophisticated way. And, bottom line, it was very funny and very real.

Women in Film is an organization out here that promotes excellence in filmmaking and television among women. I entered the episode about the Men's Club in their annual awards competition, which I did not only because I thought it had a chance of winning but because it was conceived and written by two men. One of the rules was that, in order to be eligible for entry, a woman had to be in a position of prominence on the show, so I had to list my name on the entry blank as producer. On the entry blank, there was a question, "Should your episode win the Lillian Gish award, who will be accepting it?" I answered "Tom Seeley and Norman Gunzenhauser" as creator-writers. The episode won; however, their names were excluded from the program and from the press release. Women in Film would only present the award to me. That was blatantly wrong, so I refused to accept it. And they mailed it to me, a beautiful crystal sculpture. So I gave it to Norm and Tom and wrote Women in Film a long letter in which I said they were practicing the same policies they had been protesting all these years—excluding men. I argued that if these two guys could write the episode so effectively that it won the award there was something very wrong if you don't recognize that achievement. And Marian Rees, as president of Women in Film, wrote back a very lengthy, gracious letter of apology. They've now changed their rules.

Are you offended by the current craze for showing women in jeopardy?

English: It depends on how it's done. At the moment it's very commercial, more so in television than in features. It depends, for me, on what happens to that woman when she's placed in jeopardy. How does she fight back? A lot of these shows are based on real life and that becomes a limiting factor in what you can do. What offends me is that the woman never has the good role. I have a lot of actress friends, and they're always complaining that they don't get the good roles—they're the victim, or the "girl," maybe the girlfriend, the sidekick, but she doesn't have the

funny lines. The big commercial blockbusters are like *Die Hard,* action/ adventure movies, and those are for male actors. Men tend to write those movies and men tend not to put women in the leading roles. We don't see or therefore accept women in a Bruce Willis type of role; but it's interesting what happened in *Alien,* which was written for a man. In the script the character's name is male, which I believe they changed when they cast Sigourney Weaver in the role. But they never changed a word of dialogue. I think that probably will occur more often as more women become involved in writing movies and doing what I'm doing. You'll see a broader spectrum of roles for women. But right now there are just not a lot of good female roles. My friends say they keep waiting for, say, the good comic role instead of the passive ones. But they take what's offered because they need to work.

What is your background?

English: I moved to New York after teaching theater arts for a year. I was born and raised in upstate New York, Buffalo. I was writing plays at the same time I was teaching. I decided I had to put full time into my first love, which was writing plays. My idea was to go to New York and be a playwright. So I put all my things in a truck and moved. But you don't just get a job as a playwright, you know. You've got to support yourself as you pound the pavements. It's a very expensive city to live in, and it was even in 1971. I wound up getting a job in Public Television as a secretary to support myself while I wrote my plays at home. The person I worked for was Jac Venza, who was executive director of a series called *Theatre in America.* And that's where I learned to write a script. There were people there under contract—people like William Goldman (who wrote great screenplays, like *One Flew Over the Cuckoo's Nest* and one of the drafts of the ill-fated *A Chorus Line,* and he's known as a successful script doctor). I learned a lot from him. That's where I first learned the difference between playwriting and screenwriting. I got more and more interested in television because it was so much more immediate than playwriting, which can take five years of your life trying to raise money. So I switched gears into television writing and wound up doing this—which is as close as you can get to doing live theater. We shoot our show on Friday night in a studio, in a theater, in front of an audience. It's the closest thing to summer stock.

I was pleased with my time slot. Monday is a good night for comedy, and we were fortunate in the combination of *Murphy* and *Designing Women.* It's one of the better nights and time slots that CBS had to offer. I was especially pleased that we were able to wangle a 9 o'clock time slot also, because *Murphy* is too sophisticated a show for 8 or 8:30. You have to study viewer behavior: people who watch our show tend to not be

able to sit down in front of the television until about 9 o'clock or 9:30. There's something called a "HUT Level," which is "Homes Using Television," and that level is higher at 9:30 than at 9:00. So when we began, *Designing Women* tended to do a little better than we did; we gave them a lead-in and they also got these additional people who are available to watch television. Our problem was that we were up against football on Monday night and no matter whom we had got on the show, the fans were going to watch football. So our ratings tended to stay rather depressed until January when the Super Bowl was over; then they started to go up again.

Writing comedy is my favorite kind, though not the only thing I've done. I wrote comedy as a child. They say that the one trait comedy writers have in common is a bad childhood. It's a defense mechanism, and I think I fall into that category. Mine wasn't the most pleasant childhood. You learn to protect yourself. People are surprised that that stuff comes out of me, because they look at me and say, "This is not a funny person." And I'm not, in person; I save it for the page. Some of the people on my staff have stand-up comedy acts; these are people who are funny. Sometimes they have a problem focusing it onto the page, shaping it. So we work together well as a group.

The whole process of writing a script is one of collaboration. What you see on the screen is the result of all of the group. We had seven on the writing staff, seven actors, and a director, and we all worked together to make this finished product. One person may have an idea for an episode. We would sit in a room and pitch that idea around. For instance, I said to my husband, "Is there any reason why a boy like Miles at the age of thirteen wouldn't have been bar mitzvah'd?" He said, "Sure, there might be a lot of reasons: a family disaster, or he really didn't want to do it, or he couldn't find a good male role model." I thought that would be a good episode. Miles didn't get bar mitzvah'd; he regrets it at age twenty-eight; he's going to have a bar mitzvah; and he's going to involve Murphy in this. That episode began with just a thought. We spend an entire day together doing scene-by-scene story beats until we've got something we feel has got a beginning, a middle, and an end. It's hard to find those and we work very, very hard on them. I think what makes us a little different from the way some people do it is that we don't just hear one or two lines of a story and say great, go write it. And then get into trouble later. We always asked what's at stake for Murphy. We never wanted her to be just peripherally involved in the story. She really needed something invested in the story, something must be at stake for her. So we always looked for that. And then we would just start throwing funny stuff around.

The person who's going to write the episode takes notes, transcribes it all and puts it in the form of an outline, which we all read and give notes

back (this works, this doesn't, maybe you should put this over here, here's a funnier idea). We try to work it all out up front before the show is written. Then once I approve a story for development the writer goes off and does a pretty extensive outline, which is a scene-by-scene narrative of what happens in that show. It includes a lot of character attitudes, not just the plot: each character has to have a specific take on what's happening in that scene. And an attitude that gets mined and that is part of the outline as well, so you know where each character is coming from at all times.

And then [the writer] goes off and writes the script. He or she does a draft, which is considered a work in progress; it's not nearly ready to put out on the stage. We all read it and work on it to fine-trim it; I usually do some rewrites on it, as does Korby Siamis.[2] And then we bring it to the actors, who read it aloud on a Monday morning, so we hear it—it's no longer voices in our heads, but real actors saying lines. Now you can tell what really works: some things that you thought would work, don't—no one laughed; some lines are too long, some seem too short; the ending might be too abrupt. Our table readings are generally great because the shows are practically finished and ready to shoot. The only thing wrong with them is that they are generally too long. They all are too long because it's hard to know what to cut until you rehearse and perform. You can cut some material after seeing the first run-through and knowing that some stuff definitely doesn't work. But I'm always glad that we at least gave it a chance. Or, on the other hand, something you were going to cut you're glad you didn't because that works better than the thing you thought was better.

How did you imagine the personality of Murphy when you created her?

English: Murphy was created to be much more outspoken than most female characters. You very rarely see a woman who has an opinion and is willing to stand up for it; and you rarely see a woman who can act like a jerk sometimes, and deserves a good kick in the butt. We were trying to create somebody as real as we could, like people we hung around with. We would watch television and not see anybody like us, so we tried for that. The network was afraid that she would be too tough (in addition to their fear about the alcoholism). "Tough" is an attribute that is sometimes acceptable in men, but even then somebody like Dabney Coleman's *Buffalo Bill* , where the lead character was totally irredeemable, was rejected by America. I thought he was hilarious, the character wonderful, and I loved that series. Anyway, it's not a quality that is embraced in women. There are a lot of people who fear the supposed castrating female. So it was my job to convince everyone that, with the right actress, and with the right moments in the show where she would be taken to task and be forced to show a softer side of herself, that we

could make this work for us. We weren't so successful in the opening episode: she would often come in and start zinging at people who didn't deserve it; and we realized that if you focus that at people who deserve it, then audiences will love it. But you don't want her to get off the elevator and go for a co-worker unjustifiably.

I didn't have too much discussion with Candice about the script. We often had a Sunday night phone call after she'd read the script. Ninety-nine percent of the time she would say, "I really love the script, I can't wait to do this, I love this, this is hilarious." Sometimes it's—"I'm concerned about this, what do you think is going to happen?"—it was very rare, though. If she felt uncomfortable about a script or the idea of the show she didn't usually express it to me. She was very sensitive to other people's feelings. She tried to shelter people from things, she didn't want me to know that she was concerned about something because she was afraid it would just add to my burden. She just took the leap with us.

It was kind of a miracle that we got Candice Bergen. We knew Murphy would be tough to cast. We needed somebody who would really take the stage, somebody who would just fit into this role and run with it, somebody with great comic instincts, a lot of fire and passion. So we all started making lists, and Candice Bergen was not on anybody's. There were two reasons: nobody thought that she, a big movie star, would want to do a television series; and nobody put her in the category of funny, fire, and passion. She was more cool, aloof, princess. Her agents and ours were with the same agency. They had just signed her; she was very unhappy with her representation at Creative Artists: she was only getting melodramatic television movies. She had had a baby and hadn't worked for three years but she was ready to come back to work and do something funny and of quality, and she didn't care what it was. She read my script and really liked it. She sent a message through her agent, saying that she would like to have us consider her for it. Joel and I got on the plane the next day to go to New York to meet with her. We weren't sure what to expect. Our immediate thought was, if we get her, what a coup this would be, but is she going to be able to make us laugh? Within five minutes of meeting her, there was no question. I can't tell you how much like this character Candice Bergen is in real life. She is really a very warm person, outspoken, a real prankster, willing to make a fool of herself. Her father, Edgar Bergen, was a master of comedy, with this little daughter who grew up in the shadow of his hilarious puppets. The interesting thing is that she gets to be Charley McCarthy in this show—the uncontrollable big mouth.

So we fell in love with her and went back to L.A. to tell the network this great news. Candice had made a commitment to us and we were thrilled. We called up the network and we said, "Guess what. Guess who we just booked? Are you ready? Are you sitting down? Candice Bergen."

There was silence and then, "Gee, I don't know, it's not the kind of image we had." We had forgotten an important factor. They were having the same reaction Joel and I had when we first heard her name. We had to go through a process, we got to know her, we looked at her work, and we heard her do a fantastic reading. We knew something they didn't. CBS was starting from scratch. They said, "We don't know. We don't think so. Let's do a screen test." I said, "Guys come on, Candice Bergen isn't going to do a screen test. I mean, please." There was a lot of back and forth and what we finally agreed to was that Candice would come out to L.A. and we would meet with them. We would pick out a couple of scenes that we would read together.

Candice really understood the baggage that she carried with her, that it wasn't easy for people to look at her and see Murphy Brown. So she wisely agreed to do this and we tried to make it as quiet and comfortable for her as possible.

She came in from the airport. She met our director, Barnet Kellman, for the first time. They worked on a couple of scenes together. It was just great. And then we drove over to CBS. Joel and Barnet went in one car and Candice and I were in my car. We wanted to spend a little time together driving over. We popped some Aretha Franklin into the cassette player and we turned it up real loud, got ourselves in the mood.

Once she walked into the building we were kept waiting for a long time, out in the anteroom. Then Kim LeMasters kind of mysteriously came out and said, "Diane, can I talk to you privately for a minute?" I followed him into his office. Essentially what Kim said was, "She hates me, doesn't she? She's really mad at me for making her do this."

He had met her before and adored her but he was afraid that she was angry with him. I said, "Well, I don't think it's helping that she's sitting out there. So why don't we just get on with it?" He said, "What should we do when the reading is over? How do we end it?" I said, "We'll play it by ear." Part of the nervousness was his great admiration for her and just a crush that he had on her, I think. The other part of his brain was working as an executive who had a hot project on his hands that could maybe be the breakout show CBS needed to pull itself out of last place. He wanted to make sure it was cast the right way.

Meanwhile the tension grew and I'm sure Candice was thinking, "What the hell am I doing here?" So we all filed into Kim's office. Lisa Freiberger was in the room as well. There was a lot of discomfort in that room. I wish there had been a videocamera there because it would be more interesting than viewing the Rob Lowe tape. A lot of uncomfortable people, very funny if you look at it as a fly on the wall. And then Candice and I read together. Well, it wasn't the best reading that Candice had ever done. She was very impacted by the whole business of waiting out there and having

just gotten off a plane, and not knowing any of these people. My mind was going a thousand miles per hour. I wanted her in this project so badly and I knew she was exactly right, but I could see what was going down. Kim was at a loss, so he stood up and said, "Well, OK. Well, listen. Thanks for coming in. Thanks for stopping in. I really appreciate that you have come all this way. Lisa and I are going to talk and we'll get back to you." Joel and I and Candice and Barnet stood up and everybody said their good-byes and everyone was walking out the door. And I don't know why or how I did it, but I just turned around, went back in and I shut the door. And I said to Kim and Lisa, "I have just got to tell you this project is more important to me and Joel personally, than it will ever be to CBS. And if we feel this is the right actress, you really need to think hard about that." Kim said, "Yes, but she didn't read well." I said, "I'm telling you we've seen it done brilliantly and if it can be done once, we can get it that way on the stage. Our director believes in it." Then I took out the list of possibles, actresses who were available, actresses who were interested in doing the role. I said, "If you see one person on this list who you think would be a bigger score than Candice Bergen, then we'll forget about this idea." I was sweating it out, because there were one or two big names on the list, but their ages were wrong. Kim looked at the list and he couldn't say there was anybody better. And I said, "Isn't it worth the risk of going with her than to go with one of these women who is competent, but (I didn't say this at the time, but it was the idea I was trying to convey) will never be on the cover of *Newsweek*." Kim said to Lisa, "It's your call." Long silence. Then Lisa said, "I think we should go with Candice. She didn't read that well but I think we should take the chance." Then Kim called Gregg Mayday, head of comedy development, who was in New York at the time. Kim said, "We just had Candice Bergen in the office." Gregg said, "How did she do?" They both said, "Not great but we want to hire her." And Gregg said, "Why?" And to Kim's credit he did something that maybe another network executive with that much to lose in his position at the time, would not have done. He gave the producers their head. He said, "We want to take the risk. We think it's worth it."

And that's when we went out and told Candice she had gotten the role. Actually, Kim told her because he wanted to. He walked up to her and said, "Hi, Murphy." It was the last thing she expected to hear. We all went out for a drink afterwards.

There are always a lot of battles, or skirmishes, or just tense discussions in negotiating a series. Speaking of *real* battles, we got very close to the point of separating me from the *Murphy Brown* project. We had a two-year contract with the studio, and all negotiations to bring us back had fallen through. It was very, very bleak. I was OK about that; I had put in two good years, and I would have liked to do it another two

because I felt I had more to say. Of course, I was also concerned about what would happen to the series if I left. I didn't know if any of our staff would stay without Joel and me, and if they did I was concerned about their ability to take over; so it almost looked as though *Murphy Brown* was ending; but literally at the eleventh hour the studio came back to us with an offer to come in and talk with them. It was a six-month-long grueling process all through our hiatus. Soon after we struck a deal, the lawyers had to write it up and when it came to us it was not anything like what we had agreed to. So we had to start all over again at one point. And we really didn't sign our deal in time to go back to work; we had to delay a week. But we got two years non-exclusive, which means that we didn't have to do just *Murphy Brown*; we could do another show as well, and it didn't have to be with Warner's. This was the most important thing to us and the thing that they fought the hardest. The reason why we don't want to do a show with a studio—and this is complicated— studios are like banks, and you need banks. Making a television show is a very expensive proposition. Very few people are in the position to go into their own pockets and take $850,000 a week out to make their own television shows—nor should they. And that's what the studio does; but they make a lot of demands in return, including a lot of creative ones, which we feel is not their strong suit. And they take a very large—we feel disproportionate—part of the profits. When you're first starting, with your first show, you know you have to live with this; but we figured it out and decided that the next time we'd do it another way. We would get our backing from people who don't need to have a creative hand and who will be more equal partners with us.

We've been very fortunate in having creative control. Neither the network nor the studio bothers us much any more. But the idea that you have a project you really want to do and having to go through all these layers of people who want to tell you what to do, "No, she can't be an alcoholic," and that kind of thing—I don't want to do that any more. I don't feel that I should have to do that any more. It's bad enough to have to deal with a skittish network, without having your bankers tell you what to do. So that's the reason for wanting to break free of the studio. It's for independence.

Once we finished our negotiations, then we began with the writers, through their agents. And then with the actors, renegotiating their contracts. The agents say about their clients' salary: that was then, this is now, we want more. It's a tightrope process, because contractually, they're obligated to show up for work and they're obligated to work for the negotiated amount, and yet you cannot force someone to come to work. It never actually came to that with any of our cast, but their agents certainly made our lives miserable from time to time.

My main concern is that no one actor, other than the star, is making significantly more than another. We feel it's an ensemble, that everyone contributes equally. That's very hard for some agents to swallow. They really feel that their client should be making more than such and such another person. As the mom and dad on the show, Joel and I feel very strongly about keeping it an ensemble; because once you begin to give people preferential treatment, it's the beginning of the end. We have a very, very happy set, and we want to keep it that way.

It's been tough. I approach things from a writer's point of view, a creative point of view; that is, I want everybody to have everything they ask for. Joel approaches things from the businessman's point of view: it's irresponsible to give everybody everything they ask for—and there's nothing that's going to stop these agents from coming back in the next year and doing it all over again, so you can't give everybody everything right now. I sit and worry about how so-and-so is feeling about this, and appreciate that they're probably feeling very depressed. We all do have to go back to work together after all the fuss. But it all works out: it's amazing how short memories are for this sort of thing. And they do have a very good job; for most of them, this really makes their career or turns them around. It's quite a wonderful situation.

But there are always new wrinkles. A lot of people are making deals directly with networks now, bypassing the studio. The network makes the deal and gives you straightaway the money to do the series, with no middleman. Normally, what they did was give the studio a license fee. On *Murphy Brown* it's about $500,000 an episode, but the show costs $850,000. So the studio goes into its own pocket and makes up the difference, hoping that it will go into syndication and make lots of money. So that's the gamble they take. In the new kind of deal, the network guarantees you a time slot and picks up the whole deficit—or at least most of it. So that's what we might be doing. Even if the network is paying more without that arrangement, it is to our benefit because the show is guaranteed from a producer they want. The networks have a lot of pilots in front of them; and this pilot by this producer is terrible, but the head of the studio says you have to put it on the air because if you don't you're not getting that other pilot that you want. That kind of thing goes on all the time, and the networks are getting tired of it.

~

Notes

1. Robert S. Alley and Irby B. Brown, *Murphy Brown: Anatomy of a Sitcom,* New York, 1990.
2. Siamis, a close associate of English, was de facto head writer.

BETH SULLIVAN

15

✦ BETH SULLIVAN ✦

He never would have pulled that stuff with a man

BETH SULLIVAN WAS THE CREATOR AND EXECUTIVE PRODUCER OF *DR. QUINN,*
Medicine Woman. It premiered in 1992 as a co-production of The Sulli-
van Company and CBS Entertainment Productions. The series received
a number of awards, prominently displayed on the walls and shelves in
Sullivan's office: they included an Emmy, Golden Globe and People's
Choice nominations, a Heroes Memorial Foundation of the United States
of America Founder's Award for honorable recognition of Native Amer-
icans, the Genesis Award for spotlighting animal issues, and the Envi-
ronmental Media Award Finalist Certificate for raising environmental
awareness. There was even one from the Romance Writers of America for
the most romantic program in 1993. An episode of *Dr. Quinn* on book-
burning resulted in a special commendation from the American Library
Association.

In 1995, we traveled to Ms. Sullivan's office, located on a ranch some
forty-five miles northwest of Hollywood, a countryside setting in gently
rolling hills in a park open to the public and hence protected from
development. The set and the sound stages are all in this location. Sul-
livan quickly came to the point of our visit.

~

Sullivan: After some years in the business, I now have the power to say
"No." To hire and fire. I can say "No, I don't want a certain person here
any longer." That's now entirely up to me. But I really reserve that
power very carefully. I don't run around chopping off people's heads. I
don't get any pleasure from that. I don't like power for its own sake. I

know a lot of people who do; and I know there are a lot of people who are in this business primarily to move the chess pieces around. I don't like moving the chess pieces around. I like the result. I feel good if the show gets on the air and I can be proud of it. My ego extends only that far: get it broadcast and be proud of it. I can always see the need for improvement in one of my completed shows; but when I can basically approve, my ego is satisfied.

I think that approach is female. At least, it's not as natural to men. They jockey with each other so much. I wouldn't want to be a man in this business. I think it must be very uncomfortable having to bump into all those other guys continuously, like a pack of dogs jostling for their position.

Of course, to some degree we all have to establish some power identification. But I've just chosen not to make that my center. I've chosen to make my principles my power base. Not to sound too lofty, but that's my way. I get hyper about content, but not about having my say.

I regret that there aren't that many people in my position to share specific problems or commiserate with. The only successful female executive producers I know of are in comedy, and they have husband teams or male partners. I'm not sure if there is a woman even in comedy who does it alone.

~

Dr. Quinn, Medicine Woman was Beth Sullivan's first credit as executive producer. Just prior to that, she created *The Trials of Rosie O'Neill* and was, in effect, the supervising producer; but Barney Rosenzweig, its executive producer and owner of the company, was opposed on principle to the proliferation of producer credits and therefore reserved this nomenclature for himself alone. Sullivan indicated that she believes otherwise and gives credit out "where I think it's due, to a co-executive producer, supervising producer, and so on."

~

Sullivan: I agree that the culture raises women to be more nurturing than men; but there are many men who are more helpful about giving a leg up than many women. For me it's been more the individual from whom I've received help, not the gender. If I had to make a generalization, I'd say that I would probably look to another woman for help, but it would be a woman who had roughly the same experience as mine. That's what's important. I would not expect help from a female executive, most of whom, like most men executives, are likely to be jealous, envying your position and your talent. Executives—men or women— tend to feel that you as a writer have a great job and have it easy, so

what's your problem? But secretly they wish they were doing something else, like writing, that they might have aspired to but didn't feel they could, or didn't dare to try. So there's a real frustration there.

In that regard, women are just as devious as men, and just as detrimental. I've run into this a lot. It's very rare that you find a great executive or a great non-creative producer who really understands what he or she is doing and is at peace with that, a person who feels the importance of his or her role and doesn't try to be anything other than that. I've gotten the best kind of notes from that kind of producer. Ironically, they end up being more creative than the ones who try to be something that they're not.

But women who've been doing the same thing that you do, who've been on the firing line, fellow writers or producers, are often helpful. I've run into them and had an instant rapport that I seldom have had with men in that position. Women seem to understand the predicament; they've been treated in a certain way and they understand your situation. That can be very helpful.

Were there mentors helpful to you?

Sullivan: Yes. People certainly gave me a break and were very supportive. Marian Brayton, when she was at CBS, gave me a real break. Deanne Barkley, when she was at NBC and at ComWorld, was very good to me. And Susan Baerwald, a wonderful producer, who was at NBC Productions until recently, when she took a fall for a project that went sour. It was very unfair; she's one of the finest producers in the business.

But men have also been helpful. When I was writing in film school and working on my M.F.A, I got a job at 20th Century Fox as a story analyst and then became a development executive there. That was long before the Fox Network. Sy Salkowitz was a fine mentor there and remained a close friend until he died of cancer a few years ago. And David Sontag was an immense help. He remains a friend with whom I stay in touch. I should also mention Chuck McLain and my first agent, Paul Yamamoto, who was a real champion of *me*! And, of course, Jeff Sagansky, who put himself on the line for me with *Dr. Quinn*. When we get to this show, there were several men who were instrumental in making it possible: Jeff Sagansky, David Poltrack, Andy Hill, Bob Gros.

In film school at UCLA in the early seventies, I considered myself a raging feminist, and that consciousness lasted through the decade and then gradually subsided into the background. There comes a point in your life when you know what you're facing but you also know that if you spend too much of your time being upset about it and not just moving through it, you're being wasteful. So I had come to grips with

the forces arrayed against women in our culture, or at least I thought I had, quite early in my career as a writer.

But the problem lay in the fact that I *was* a writer, and was safely ensconced for a decade working my way up the ladder writing for television movies, becoming an "A-list" writer (they tell you there aren't lists but of course there are). I was doing very well, consistently; but what I hadn't realized until I stuck my head out the door was that the bullets were still flying; in fact, they were flying harder. The backlash really had happened. Coming into the marketplace as a writer with producer credits, I found how intense it was.

This realization hit me as I started working on *The Trials of Rosie O'Neill.* Even though I had worked in a producing capacity on earlier shows, I hadn't been responsible for handling the use and distribution of funds until *Rosie,* and even then much less so than I would later on with *Dr. Quinn.* So I date my producing days from about 1990, and therefore my shock at the backlash against feminism.

～

We knew that Barney Rosenzweig, executive producer of *The Trials of Rosie O'Neill,* has long been considered one of the rare television executives knowledgeable about and friendly to the women's movement. Organizations like Women in Film and the National Commission on Working Women have publicly commended his *Cagney and Lacey,* which received many awards for its groundbreaking portrayal of the two policewomen. Betty Friedan has elaborated on his importance, as a more positive image of women has evolved. Georgia Jeffries was an important co-worker and a real force in this "breakthrough" show—to use Friedan's words. Rosenzweig, then, would obviously be a promising colleague for the new generation of women producers. Ironically, he (1996) announced his retirement from the pressures of television life, has moved to Florida, and declared rustication as his goal—carefully leaving the option for returning when something looks good and he's in the mood.

～

Sullivan: *Rosie* was close to ready-made, which made it a lot easier for me than for most people trying to break in. It's not often that someone gives you the opportunity to create something you didn't originate yourself. In this case Barney had sold a one-line idea and a star, Sharon Gless, for a pilot commitment, plus eight on-air episodes. He got the deal on the strength of his and Sharon's names. It was a wonderful idea, but not at all fleshed out: a woman gets dumped by her husband, who was her legal partner, and suddenly she's on her own in every single way; so she decides to turn her life around by going from being a rich Beverly Hills

lawyer to being a public defender. That was their concept. I knew it had lots of potential and they knew it, too, but not being writers, they had to turn to somebody else to create it. The person who writes the pilot is given the credit as creator.

So I hired my first staff person, Joe Cacaci, a playwright from New York, who had written a play about public defenders. I brought him in to help me write the pilot; at the same time I was hiring other staff and planning episodes. We did it, and I generously, against my agent's and everybody else's advice, relinquished half the "created by" credit, even though Joe had never written a movie script in his life. I was the one who sat at the computer and showed him how. But he had a lot of wonderful skills with the voices and the characters and had a lot of police department information, too; so it worked out fine.

∽

That was the 1990–91 season, after which she left that show to strike out more fully on her own.

∽

Sullivan: The *Rosie* experience confirmed my feeling that, for me, television was a wonderful business—it was exciting; you had immediate gratification and a tremendous ability to communicate to a wide audience. So I wanted to keep on working in it, but I didn't want to be under somebody else. I wanted to be the engine.

I went to CBS Productions, knowing that I had some stock there for having done *Rosie,* and sure enough, Jeff Sagansky said, "Yes, we should do something with Beth. She's earned her shot." So they let me pitch an idea, which almost happened; but they passed on it, cordially, telling me to come back with something else. At this point I didn't really understand how the one-hour thing worked; and I didn't really think it was my job to keep coming in and throwing things against the wall to see if they'd stick. So I said I didn't want to keep doing that and to please tell me what the heck they wanted or didn't want, so that I wasn't wasting my time.

I'm glad I did that, because it forced one of the people at CBS in-house, Mary Masur, to keep after Jeff. She was very kind to me; she told me, "I don't know how long it'll take me to get a few minutes with Jeff to talk about this; but I'll do it." I stopped thinking about it, and about six or eight weeks later she called me and said she had gotten to talk with Jeff. She told me that because *Sarah, Plain and Tall* [*Hallmark Hall of Fame*] had done so well, a forty share, he cast around for an idea, and off the top of his head said, "Well, how about something like *Sarah,* something of a period piece and with a woman in the lead?" And then his

second thought was a reminder to get a franchise, since it was going to be a series.

I thought, "Gee, that's a lot of leeway. I mean—period, woman—you got it!" So I just put myself to the task. I had been an anthropology major and history minor in college, before I went to film school. The post-Civil War was the historical period that interested me the most. It was a very volatile time and one that could be paralleled with today in many ways. It was progressive, even more so than today in terms of what people were exploring and thinking about and doing. Basically, I asked myself, What would I have done in 1867? I had always been interested in medicine, thinking that maybe I might have been a doctor then (since there were no screenwriters).

I didn't decide on a doctor at first, though. I thought of a lawyer, but that seemed arbitrary and I couldn't sense the possibilities; in fact, I thought the limitations of what you could do with a lawyer at that time were too great. Also, I had done my lawyer thing with *The Trials of Rosie O'Neill*. I knew I wanted my woman to be a fish out of water, but I didn't right away decide on her profession.

Then, all of a sudden, it came. More than anything else I've ever done, this concept sprang full-blown from my head. It was the culmination of a lot of different things that had interested me at various points along the way; and it all came together as soon as I started doing research. She was to be a doctor. It was clear to me that she had to be Bostonian, upper class, and very liberal and thrown into a situation where she'd be challenged by a lot of people. And they would be right to challenge her: I realized that not everybody is going to have my interests.

But Dr. Mike *is* me, as far as my concerns and attitudes. I won't say I was a virgin at thirty-seven, but that was a difference of the times and the history we created for her. And I couldn't have her be just a mouth-piece for my thoughts. I couldn't just have my Meathead; I had to have my Archie Bunkers, people in the show who would disagree with me or at least be different from me as Dr. Quinn.

So I began. Once I had gotten it to the script stage there was a lot of maneuvering to do. But fortunately there were people whose interests coincided with mine, for whom it was good to get this movie made. Andy Hill was brand new at CBS Productions, which he was heading. This was his first project and he was very much behind it. It was impor-tant for him to get something going. I felt good about working with him, because I had known him for a long time and knew him to be a good fellow for backing strong projects and giving their creators a lot of freedom.

But here's where the female theme comes in. In my original deal, the men at CBS couldn't conceive of me as the executive producer, even

though I had asked for it. I had a deal-memo that named me as co-executive producer [which in TV parlance is second-string, working under an executive producer]. I had been doing so much in preparing for the show, I said, "Look, I think I'm ready and able to do this. I have a lot of production credits, I was a production executive, I came from film school, I have made movies."

A man with half these credits wouldn't even have had to ask. They'd have assumed his right to the title. I went through channels with a request to be made executive producer, and it wasn't working. Finally, I went straight to Jeff Sagansky and said, "I don't blame you for thinking of me as a writer, because I've mostly functioned as one, but I have the credentials, and I feel I have the right and I'm the best person to do this." I asked him to think about it; he promised he would call me the next day. So twenty-four hours later he called and said, "All right, don't let me down."

I appreciate that now, as I did then. But taking a longer view, we can't be pleased with the idea of women having to be given prizes like that, of having to beg and plead and cajole and convince—that's not something a man would have to go through.

It wasn't that this was the last of all the struggles. After winning my credit, I was still challenged at every step along the way.

Having been told by the network to choose a director, I had gone after my first choice, Simon Wincer, who directed *Lonesome Dove*. He was in Czechoslovakia doing Steven Spielberg's *Young Indiana Jones.* He liked the project enough to stop in Los Angeles on his way home to Australia and talk it over with me. He was enthusiastic, but it turned out that CBS wouldn't make the money deal. So I realized they really meant what they said in the budget and therefore I couldn't get him or another director who was my second choice, because they usually get twice that amount.

My CBS partner, Andy Hill, and I turned elsewhere, eventually turning to features to find somebody, a person who might need this project [a pilot, with royalties] at a certain moment for some reason. And we found our man, a good director with fine credentials. We knew that he had had scheduling problems on a recent feature film, going past his forty-five day shoot to sixty; but we rationalized that it was a difficult job, it had dogs in it and a lot of difficult action stuff. After all, it was going to be my job to keep the controls out here in the middle of nowhere, forty-five miles from Hollywood, where I'd be boss.

Well, this director thought he could run the show. Among other things, he thought he could force us from our twenty-day shooting schedule to twenty-four days. I would look bad; but he would do what he wanted. I just wasn't going to stand for that. I knew that my ass was

on the line for this one, but also I was setting a precedent for my authority on the show: I had to control the production to be taken seriously as the producer.

He escalated this situation into warfare, basically challenging me to pull the plug on him. He made it into a question of my trying to fire him or going over budget. Understand, at this point, I would have to have network agreement to fire him, so I would have to find allies. It was hard for me. This was a big six-foot-six guy, who was not above screaming profanities at me and about me at the top of his lungs when I asked him, for example, if we couldn't please talk about speeding the afternoon schedule up because we had only done two pages before lunch on a six or seven-page day!

I finally had to resort to calling some men in from the network to arbitrate. It was just before we got to the half-way point in the production. I told them if we were going to keep him, we would have to get things straight. I let them know that if we ran out of time every single night, we were going to have a damn funny-looking movie at the end, with scenes missing. Or, he's going to have to do the movie, as he said he would. I said, "You guys are going to have to come out and deal with this, because if it were just me I'd fire him today, shut down for two days, and get somebody else who could be in here by Monday."

According to the deal for this pilot, I didn't have the authority to do that, and of course I didn't really want to. It's never good to interrupt the production, to change horses in midstream. But I told them that this guy was not going to make the schedule for Beth Sullivan.

I remember they came out late one muddy night. We had had a lot of rain during that pilot, actually causing us to shut down at one point when we were flooded out. So these network guys came out to see who was raising such hell about me. We had a meeting, during which I pointed out that I was reflecting our interests and theirs; and they made their position clear: they were behind me one hundred percent. At one point, my director turned to them and asked, "You mean, you agree with *her*?" He was absolutely incredulous. And they said, "Yes, of course we do." And then he turned to me and asked, "And you agree with *them*?" I said, "Yes, that's what all of this is about. That's why they drove forty-five miles out here in the mud."

So he jumped up and started screaming at me. It got so bad that two or three of the guys got up out of their chairs for some physical stuff. But I said, "No, no, no, go ahead and hit me. I dare you." He didn't, so I said, "You don't get it, do you? You work for me." That's what was required.

He never would have pulled that stuff with a man. He never would have done all that challenging and seeing how far he could push the

envelope. He was shocked that he couldn't win, that I was going to fight back. His attitude all the way along was based on the fact that he was dealing with a woman executive producer.

∽

We have included this segment of the interview, in all its original detail as it tumbled out from a producer who was obviously reliving the experience, not to allow her to vent some spleen in print but because we have come to realize that Sullivan's experience with this man is not atypical. This director remains unnamed primarily because he is generic.

The story continues.

∽

Sullivan: The interesting thing about this experience is that I've heard similar stories from a lot of women, mostly in features. These women— Dawn Steele comes to mind—tell how they were challenged by men who unfortunately seem to push us into a place where we have to fight them on their own turf. When my director was screaming at me, right in my face, I couldn't in the heat of that moment walk away. I don't like confrontation. But he thrived on it. He went home and slept well every night, I'm sure.

There are men, certainly not all men, who learn a very aggressive style of behavior. Some women do that; but most women are not taught aggression as a way to deal with situations. Fewer women than men are taught to negotiate in society that way. But at that moment, when everyone is watching to see whether you will meet him on his turf, you can't walk away and do this in your own way. You have to declare your will over his.

And that's what I've heard other women say, or read in interviews. We really resent being dragged into a very masculine mode of relating at certain moments of crisis.

I've worked very hard here to do it my way and I have a very happy crew, a happy set. I love all my people. I hug people. [This claim was borne out when we strolled with her down to the set and met the actors and crew.] A lot of them call me Mom. It's just a different way of doing things. While that director was at home sleeping fine, I was home not sleeping. Even though I could stand up and match his decibel level, I'd go home and feel terrible.

So my director was a perfect example of a man just being very indulgent and making me ride roughshod. He threw down the gauntlet and forced me to be a challenger rather than a colleague. And I really believe that the confrontation came about not because of me personally, but because he just saw "woman producer" and thought he'd get around

her. Then when that didn't work he thought he'd have to squash her, and then—when he couldn't do either of those things—decided it was time for a lot of tantrums.

～

One result of this rush to completion in the allotted twenty days was a first cut (the director's) about which Andy Hill at CBS said to Sullivan, "God, he really did ruin the movie." But Sullivan and the editors went into a two-week huddle and edited to make it work.

～

Sullivan: We stole shots. The director hadn't gotten a lot of coverage or a lot of variety. He specialized in what we call "ballet shots," complicated and very lovely ones, but without enough coverage. So we hoped that viewers wouldn't notice that in some of the reaction shots a collar or some other detail was from another sequence. It was desperation, but it worked: we got more emotion into it.

Do you find occasion for female networking?

Sullivan: I have a lot of women friends who are in the television or film business; but when we get together for lunch, we'll end up talking not about the next deal or power-brokering something together, but about our relationships, our babies, that sort of thing. I'll have entire conversations with women friends in New York about whether their fertility clinic is working out. I know their kids' names.

When I go down to the set, too, I know who's getting married and who's not, and why. Next week, I'm going to a wedding shower for one of my dressers. Women *do* network about business matters, of course, and a lot of them do it more often and better than I. I've never been a good social networker or business networker. I've always marveled that I've gotten as far as I have without having to play that game as much as people usually have to. I just sort of hunkered down and kept working, working, working. I know women who do business together, but it's much more social. It's more like sticking together than making the power thing happen. The context is more "I'll help you and you help me" than the power of business.

～

It seems to us the premise of a doctor on the frontier necessarily contains an educational element, coupled with a strong point of view. After all, each hour—while ostensibly just telling a story about life on the frontier—to some degree counteracts such conventional concepts as ad-

venturesome men and their steadfast women. Dr. Quinn was not the familiar wife, school teacher, or prostitute, but a professional woman and a heroine—the sort of heroine called for in the comments of Friedan, Carter, and Jeffries. And the form of each episode took shape around her as center, a fulcrum for the movements of others, a touchstone against whom others are measured.

One might claim Barbara Stanwyck's Victoria Barkley in *The Big Valley* (1965–69) as a predecessor to Dr. Mike. But there are at least two important differences. Certainly, the 1990s context of the feminist movement cast a whole new perspective on the thoughts and actions of the female protagonist. In addition, there was the fact that the person in control, the executive producer, was a woman—a strong presence in the building of every script. Sullivan told us, "I have a writing staff, but I'm involved at all the stages in each story."

These conditions suggest several concerns about realism and about ethics. We are interested to know whether Sullivan uses *Dr. Quinn* to any degree to teach some lessons, and if so whether that compromises the integrity of the show in any way. Are we dealing here with point of view? persuasion? propaganda? Are we learning history? Women's equality? Are we in the throes of "political correctness"?

~

Sullivan: Oh, I definitely send messages. I don't think the sending of messages is a bad thing. In a longstanding tradition of—I hope—good writing, I always start out with the question, What's the story about? I feel you have to have a premise, a root idea that's pretty solid, or you're not only going to lose your way in the story but lack any sufficient reason for telling it at all.

There are too many stories that are just out there for the yarn, and I'm not into just spinning yarns. There doesn't have to be a blatant message, and certainly not a political one; but we've toyed with some that are political, approached some, and come head-on with a few. Sometimes there is just some sort of personal interaction that teaches the "lesson" that we all need to keep learning over and over again. I always say that the best premise is the Golden Rule because even though all of us think that we follow it, we really don't—not any of us. "Do unto others as you would have them do unto you" is a premise that you could make a drama of every day and not have it fall on deaf ears or consciences.

So at the table when we start a story conference, I always ask what's it about. If they start to answer with the plot, I interrupt and ask, "No, what's it *about?*" And I also plot out the arc of the whole season, in terms of some theme. Call it a message if you like—it's a central idea.

This year [1995] it's "A New Life," and last year it was "For Better For Worse." That whole business last year about the train coming through the town, connecting it in a new way with the outside world: it *is* coming, it's progress, we're moving forward. But what price do we pay? Do we lose some good things as we gain some? There are obvious parallels with notions of progress today.

We introduced a new antagonist in the first episode of 1995. A banker, who comes in on the train from Boston. It's progress: new money to be loaned. Preston Lodge III is seemingly someone who would have a tremendous amount in common with our main character, who's also from Boston and upper class; but of course they have nothing in common at all. He's not a bad guy but his value system is totally contrary to hers and even to what's going on in the town. He expands the opportunities for people by lending them money and getting them in debt (you hear the positive and negative aspects of this?) He's got the rationale: this *is* progress. His spiel goes: "You deserve a new surrey, don't get your old one fixed, I'll lend you the money." And Horace falls for it, just as we fall for our new car ads. He buys it and proceeds in his pride to wreck it the first day. And now Preston Lodge III offers a loan to get it fixed. And the audience can see credit cards looming!

～

One question deriving from the show's acknowledged feminine point of view concerns historical accuracy. Here Sullivan has a lot to say. This is obviously important to her.

～

Sullivan: There's no real tension between the realities of the show and the realities of history. We back off when they conflict, although I'll admit to a few cheats. We have a medical historian on payroll as an advisor who reads all the scripts for accuracy. That's Dr. Michael Harris from the Smithsonian. Between him and our other advisors and researchers, we don't let ourselves get away with much. I have a principle about that, because I chose from the pilot on to weave real history into the show. I decided to stick real close to the possibilities afforded in 1867: we fudge no more than a few years, maybe three.

The thing that we stretched the most—and we made a point of doing so—was the show about mastectomy. People in the 1860s knew very little about breast cancer; but they did know de facto things: sometimes if you take the breast off, the person survives; sometimes she doesn't; and if you don't, she might die, but sometimes she doesn't. It was that lack of knowledge that we made a point about, Dr. Mike's frustration as she

pored over the books to find what was there and speculate about what wasn't.

In the first season we did an episode about blood transfusion. That might seem to be modern, but it was based on actuality. Surgeons had been doing all sorts of surgery, and using transfusions. The Egyptians had performed brain surgery. The reason that people died in droves was primarily ignorance of effective means of sterilization, along with the lack of antibiotics or other means of dealing with infection.

For one episode, I told the researchers I needed a disease that could be misdiagnosed because no one would assume a rich person had it. We would let Dr. Quinn diagnose it correctly and cure it. Dr. Harris came up with it. He said, "You know, if a person had been on the cutting edge of medicine and reading French medical journals, in French, she would know that they had just discovered that hepatitis was carried by shellfish. This was found in the mid-1860s. But this fact wasn't commonly known. You had to be a doctor who paid attention to the latest developments in medicine."

The disease would mimic other diseases, like liver cancer. Dr. Harris said that Dr. Quinn could figure it out, though. The reason that the patient's regular doctor would never suspect it was because at that time hepatitis was considered a disease of the poor and the filthy, and rich people didn't get it. On our show, the patient contracted hepatitis from expensive food at a good restaurant.

All sorts of medicines were known by the American Indians, and we try to reflect that as a reality on the frontier. In one episode Dr. Quinn reads a paper that introduces willow bark to the Medical Society in Boston. Native Americans had been using it for hundreds of years as a source of aspirin.

Ecology is another subject that might seem to be superimposed from the present onto the past; but there actually were people who were concerned then about the environment. In our bad water episode, for instance, they traced the bad water up to the mine. Our research revealed actual cases of water poisoning that they traced to these lead slag dumps that were used in the processing of ore.

Sometimes we find something like that in the history books, and we start getting a story from that historical fact.

Another example is our evolution case. Darwin's second book, *The Descent of Man*, came out in 1871. It was all the talk of intellectual circles, creating a furor. There was a case of a man who tried to protect a girl from a custody situation where she was being beaten and starved and overworked. There were no child protection laws in those days and he couldn't find a law to sue under. But there was one that had been enacted by the American Humane Society for animal protection, to pro-

tect against physical abuse. So he sued under that law, contending that this girl was part of the animal kingdom, and cited Darwin as his proof. Judges ruled in his favor, so he actually got her out of her abusive environment in this way. We mimicked that case, but we changed the emphasis to have Brian in love with this little girl and trying to protect her. We came at it from a human rather than a factually historical angle.

As far as cheats go, we have a few. In one episode Custer shows up at a wedding alone. He would never have done that: he would have had an escort or a guard, probably more than one. We talked about it and decided to go ahead with it, rationalizing that because of the emotional pull that the mother exerted over him when she invited him, he was determined not to miss that social event of the season. I hoped it would slip by. And in the story he gets knocked out. He had to be alone for that to happen.

From the beginning I planned a telescoping of time regarding the Indian experience. We'll probably telescope about a decade worth of stuff into a couple of years, to get the real feeling of what that was like in the beginning. In the next phase, Cloud Dancing is still running, still wanted, a bounty on his head. The arc of the first show [1994] is to convince him to go to the reservation. We'll show how the reservations at this time were conglomerations: they were government-established with government-issued teepees and clothing. There was almost nothing left to hunt: no buffalo for meat or hides. But the most painful thing is that they were thrown together with remnants of other tribes—Utes, Sioux, and a few Cheyennes, a lot of them natural enemies, or at least not culturally attuned to each other. We have Cloud Dancing as the only Southern Cheyenne who's thrown into this local reservation. He'll be able to get passes into town; but it's still a grim new phase of life for the Native Americans.

In this matter of historical accuracy, I have to tell you also that there are things we don't do because the reality is too preposterous for people to believe. Sometimes these are things that seem so contemporary that no one would believe it. In fact, sometimes people don't even believe the premise of the show. You would be surprised at the incredible arrogance among some reviewers when the show first came out. One guy, with absolute aplomb, stated that you could tell this show was fake from the get-go because everyone knows there were no women doctors in 1867. He said it with such authority; yet the truth is that the first woman doctor was Elizabeth Blackwell, who received her medical degree in 1849. [It was awarded by Geneva Medical College of Geneva College, now Hobart-William Smith College.] There were two medical schools for women by the 1860s when our show takes place. I have her graduating from a real one, then called The Women's Pennsylvania College of Medicine, now the Pennsylvania College of Medicine. They were thrilled

to have us put them on the television map. The New York Infirmary also had a women's medical school division. The Pennsylvania school was sponsored by the Quakers, a very progressive group at that time for women's rights—in fact, for human rights.

~

With mention of the actual existence of Elizabeth Blackwell, we come specifically to feminist history and the show's educational component.

~

Sullivan: Elizabeth Blackwell was in *my* history books when I was little, but perhaps girls paid more attention to her than boys did. She'd be there with a few other women, like Marie Curie, Susan B. Anthony, and Clara Barton. Not that women's history was being taught, but there were a few women who slipped through there. So I thought, well this reviewer just doesn't remember his history; but for him to go in the opposite direction and state with such assurance that such a person didn't exist, was wrong.

But *Dr. Quinn* is not a docudrama. We try to be historically accurate, but our stories are driven by our fictional characters. And it's not an autobiography, either. I've said that Dr. Quinn is, in many ways, myself, but she's in no way my mouthpiece. In other words, she's not an excuse to teach history or promote my personal agenda, even though there's some of each there.

Jane Seymour, who plays Dr. Quinn, suggested having a section at the end of certain shows which would tell people where to go to read more about the subject of the week. This would increase the feeling of authenticity and serve as a bridge to an actual history lesson. But the networks were too concerned about what they call "clutter" at the end of shows, preferring to lead their audiences directly into the next show. This ploy is known as "capturing the audience." They're not interested in anything thoughtful or intellectual happening in that spot at the end of the show.

So at the moment, the formal educational part of the show is relegated to answering certain inquiries from students who are writing a paper for history class, or women's studies, or psychology. Teachers write to let the producer know that they are using the show in their classroom.

Is there such a thing as a feminine perspective?

Sullivan: Definitely there is, in this show, because the character is a woman. Her point of view does drive every story. And the main plots center on her. Even if, some weeks, she's the hub of the wheel and not as active as others, she's still the focal point and it comes back to some

conflict that is central to her. What's always going on is how the conflict impacts her. So we're forced by definition—it's *Dr. Quinn, Medicine Woman*—to be coming from her perspective. But I've always had men on the writing staff and right now we have more men than women—only one more, though. We really could be said to have more a male than a female influence, but I really think it's more about whether a writer "gets" the show or not. If a person grasps the show then it doesn't really matter about the gender. I think the men write the show with just as great a sensitivity towards Dr. Mike's point of view as the women do.

But let me add that I believe that if this show had been put together by a man it would be different. Once it's originated and on track, and also with me here to say "You can't do that; it's too violent," we go along pretty smoothly. I'm the rudder steering the boat, a kind of conscience of the through-line of the show's content and of Dr. Mike's character. We're now producing our eighty-second hour, so there's such a body of work that everyone's pretty much on board with it and it's not very often that I have to say, "Oh, come on, now. . . ."

But I think if a man had drawn up the blueprint it would have been a very different show. I think the form and the content are both influenced by the gender of the creator.

But the thing that bothers me most about this proposition is the flip side, where it can be used against women. There's still a feeling among a lot of people that women are suited for writing certain shows and not others. For years the only male producer in this town who would voluntarily and eagerly hire me to write male leads was Chuck McLain. Others always put me to work writing female leads. Now, mind you, there were some wonderful women's films—stories featuring women—like *The Tracey Thurman Story* [Dick Clark/NBC, 1989], which I wrote. But the idea that it's a woman's story, get a woman to write it, is a pigeonholing that keeps women back. In a sense it's used against men: they aren't hired to write *Tracey Thurman,* but I would still like to take my chances in the free market, scrambling around with everybody equally, than to know that I have a comfortable safe niche where the guys aren't allowed in but I'm limited in space. I think women would rather be out there vying for the same projects and getting them on their merit.

~

Sullivan's idea of merit in a free market seems a fitting note upon which to end the interview; but we wish to include an epilogue, another anecdote featuring her struggle with another director. The story came in response to a question about power: she had told us she lacked the authority to fire her director on the Dr. Quinn pilot. Now, we asked, had she achieved that power?

~

Sullivan: Yes, I now have the power to get rid of a director if I choose. There was one, who's now back on the show, who was very surly. He treated people badly, sometimes even yelling at them. The final straw for me was when he raised his voice to my little boy, my little Shawn, who's an angel. He's the kid who plays Brian and he's just the sweetest, smartest, and most unspoiled child in the world. It's a miracle to have a kid like that in your life.

So when I heard that he had yelled at my boy, I went down to the set. It takes a lot to get me mad, but I was furious. In matters like this, I can usually put myself in somebody else's shoes: when you're in charge of three hundred people, you have to try to understand their problems and try to help everybody get together and work. But in this case I shorted out. I've always taken the side of the underdog, and Shawn was that. My mom says that when I was little I wouldn't swim until I had fished all the bugs out of the pool and saved them. I can understand tempers flaring and people having bad days, especially in this high-tension business; but I can't abide someone systematically mistreating others.

Even though he had done a lot of good work, and even though our star liked him very much, I said, "OK, that's it; he's not coming back." He treated Jane Seymour very well and worked with her nicely, but I couldn't have a director who was going to abuse others.

Well, it turned out that he felt very badly about it and wanted to continue to work with us. It wasn't a question of his needing the work or groveling or anything like that; he really felt bad that he was out of control and hadn't even realized what damage he was doing.

Our situation at this time was, I think, a very male/female kind of stand-off. He had been working with other men, and I don't think any of them had called him on his behavior. He'd been surly and abusive for a long time, whenever he felt cranky. But he understood my reaction, and asked me whether we could work it out. I replied that we could. It all depended on him: I had a certain set standard of behavior about how people are treated. That's how I live my life and I don't want to have people on the set doing anything else.

This seemed like a real surprising concept to him, but he was terrific in responding to it. And I'll tell you, he's happier now, doing the show. I see him smiling a lot and having a better time. He's not allowed to be a mean guy; so his attitude is much better. I think he's relieved to have the boundaries. Sometimes I think grown people, like kids, go out of control because they think they can, and they're looking for someone to give them some definition or at least say, "No, this is the line, you can't cross that." I actually see a man who is relieved, is having a better time doing his work, and doing it better than he ever did.

~

We have no doubt that Sullivan's two directors would have different accounts of these two situations. People differ, and there are always two sides in complex human arguments. But we have heard this story, with different women and different adversaries, so often as to present it as a basic truth about the experiences of the new breed of female television producers.

Sullivan's own concept of creating fictional characters is apropos here. "I do believe that there are no black hats in the world. I think even the worst people pet their dogs and love their children. The key to a bad guy is that everybody has a rationalization for what they do, even mass murderers. No one goes to sleep thinking, "I'm a bad person." Everyone's got to feel justified. And as long as you create the justification and the rationalization for the action, then suddenly the person becomes understandable. He or she becomes human, even if you don't like that human, or disagree with him, or are upset by him."

FREYDA ROTHSTEIN

16

✦ FREYDA ROTHSTEIN ✦

The tone should be positive, not angry

IN THE SPRING OF 1996 FREYDA ROTHSTEIN WAS PREPARING TO LEAVE THE country for a three-months' stay in Prague to produce a CBS movie based on Edith Wharton's novel *The Reef*, to be titled *Passion's Way*. It was broadcast in the Fall of 1997. In a lengthy conversation just prior to her departure she explored with us her career as a "sheltered" producer. The term is used to describe financial arrangements in which the monetary risk lies with the company. "I always had a company backing me which owned the movie. Typically I receive fifty percent of the profit but one almost never sees that money. I now receive a very generous advance against profit."

Still quite active after forty-four years in the business, Rothstein spans the entire period we have explored in this volume. She began her career in New York in 1953 working on the TV soap *Search for Tomorrow*. She recalls those early days as shadowed by the threat of blacklisting. She was asked to sign a loyalty oath, and after much agonizing she decided not to do so. The threat was real: Lee Grant was fired from that show because of pressure from a scurrilous organization, "Aware, Inc." Headed by a blacklisting fanatic, Vincent W. Hartnett, the group published lists of persons whom it accused of being pro-communist. During her days as an actor, Dorothea Petrie was harassed by the same crowd. And such a refusal almost cost young Joe Papp his position as stage manager. Ironically, as Rothstein notes, "Following my heroic decision not to sign, I was never asked to sign because my salary was paid by the ad agency rather than the network!" There were no repercussions for her career.

She attended Carnegie-Mellon University and graduated from New

York University. Upon leaving school, she got a job as production assistant on *Search for Tomorrow*. After taking six years off to have children she returned to television, again as production assistant, on *Love of Life* and then became associate producer.

~

Rothstein: That was as high as a woman could go at the time. The ratings on the show were slipping and I was invited to a meeting in a bar on 57th Street and told that the executive producer was being fired. They wanted me to take the job. I told them I'd take it on a temporary basis until they found the man they wanted. I went home, thought about what I had just done, and called to say I'd like the job. I got it.

The show was done by CBS in Studio 54. So I began to produce on a show where I had been the PA for the director, Larry Auerbach. It was a miserable six months because instead of going for coffee for him I was telling him, "We need to tighten the act or tell her not to cry." It was very hard for him, difficult to have his former PA as his executive producer. We finally developed a great collaboration and we are still good friends.

The show was live on tape. You could take out an act between commercials but no editing beyond that. You had to be very strong. In those days, with the exception of one woman director there were no other women role models for me. There were two ways to deal with the stage hands. If you were in the booth and opened the key in the control room and asked for a set to be moved, when you closed the key you knew that on the stage the men were saying, "OK, the bitch wants it moved." Or you could go to the floor and say, "Hey Steve, would you do me a favor? I'd love it if you'd move the set it to the left. Would you do that for me?" Steve would reply, "Sure, honey."

After three years I went to work at Paramount Television in New York as Director of Program Development for the East Coast. And of course there were no shows on the East Coast so I developed game shows and soaps. Then in 1976 I went with David Susskind as Director of Network Development on the East Coast for Talent Associates. David was a great genius and the biggest bully I ever knew. He taught me everything about production, and also how not to behave. He had a large number of women around him because we were grateful enough to accept his tactics. But I learned that if you call a bully's bluff he backs down.

~

Talent Associates was bought by Time-Life and Rothstein continued in her position with the title Vice-President of Network Development. In 1979 she came into possession of a diary by an assistant principal at

Central High School in Little Rock, Arkansas. Elizabeth Huckaby had been advisor to the girls at the school during the confrontation between segregationist Governor Orville Faubus and the Federal authorities seeking to implement the Supreme Court decision in "Brown v. Board of Education." She took that story to Richard Levinson and William Link, distinguished television writer-producers in Los Angeles, and they agreed to work with her on the project, *Crisis at Central High,* for which she was executive producer. With Joanne Woodward portraying Elizabeth Huckaby, the film won the Christopher Award and received an Emmy nomination. The story focused upon a woman of genuine integrity who probably had more to do with the successful first steps toward integration than anyone other than the nine black students. The film was a distinguished look at a strong and committed woman standing up against benighted local mores.

～

Rothstein: The CBS film was to be a three-hour movie, but after tightening we were ten minutes short. We thought that by eliminating the ten minutes we had a much stronger film. But it was too short for the network. I went to see Bill Self at CBS and after some conversation he agreed to let us take out twenty more minutes and gave approval to a rare exception at the network, a two-and-a-half hour movie. That could not happen today. It would probably be padded with a rape in the middle.

～

Moving to California, Rothstein continued her association with Time-Life Films and then moved to the position of Senior Vice President of Creative Affairs at New World Entertainment. Today, she heads Freyda Rothstein Productions and has made twelve films in association with Hearst Entertainment. Along the way she took time to produce a CBS drama series, *Emerald Point N. A. S.,* for a year.

Concerning her 1997 project, the Edith Wharton novel, she comments, "It's a period love story. I am shocked that it's being done." But while *Passion's Way,* starring Sela Ward, is a satisfying work for her to do, Rothstein makes it clear that she "will do any movie where I can do some good story telling. If it doesn't violate some emotional or moral premise, I will do it. I do not have to 'love' every film I do. And my heart is in the two-hour form. People who do only things they absolutely adore make only one movie every three years."

When Rothstein describes how she functions as a "sheltered" producer, it becomes obvious how her world is significantly different from that of most of the women discussed in this book. "Hearst takes care of all

the deficit financing. I find a property I care about and Hearst gets a first look. If they pass on it I am free to carry it to other companies to make and take a "suspend and extend" option that separates me from Hearst for perhaps three months. I pitch the movie ideas to the network. I have to sell it, develop the script through many drafts, and hope to get a network order to make it. I negotiate with lots of people, women and men. I'm not that gender conscious in the job.

"As for a feminine perspective, I don't think about that. There are sensitive men and very insensitive women, tough women, who only want to do hard male-oriented films. There are so many things that make up a point of view, not just being a woman. We are conditioned by our religion, our ethnic background, our parents, our friends. Now there are non-creative people, lawyers, and older men in the business who try to bully women. And I won't put up with that."

When asked about writing Rothstein states that she does a lot of rewriting because she "wants the story to be as good as it can be. I think of myself as an editor, strong on structure. That makes it possible for me to pitch an idea to a network. I am not good at filling a blank page, but I can do what a producer needs to do: fix it."

Rothstein has had numerous films on the Lifetime Network and in comparing it with the broadcast networks she notes that Lifetime will handle more controversial material and wants to be the woman's network. "HBO seems to believe it must show some blatant language and nudity in the beginning to separate it from the broadcast networks."

One such venture for Lifetime drew our attention in 1997. In June, Rothstein's film *Two Voices* was telecast by Lifetime. The story is focused on the subject of breast implants and is rooted in a conversation eight years earlier that she had had with a Beverly Hills woman who, following a double mastectomy, chose to have silicone breast implants. Rothstein states, "Sybil Goldrich is the city mouse in the fact-based story. The country mouse is Kathleen Anneken, a nurse from Kentucky who chose silicone implants for cosmetic purposes. This is the story of two real people who took on big business and the government (FDA) and made a difference. Neither was told about the possibility of leakage and when it occurred in both cases they were amazed to discover that the Food and Drug Administration for fifteen years had not tested the effects of the implants. Instead the agency had accepted the prevailing wisdom that silicone was inert and would do no harm. I sold the story to Lifetime as a drama centering on individuals making a difference in society by demanding the right to be informed and to know what had gone into their bodies. There is an analogy here with the tobacco companies, who have finally admitted that they knew all along that smoking caused cancer. The film received excellent reviews."

But there was a drama within the drama started by John Meroney in a column for *The Wall Street Journal* ("Hollywood on the Breast Implant Saga" 11 April 1997). Meroney, with callous disregard for the obvious, accuses the two women of creating the issue. He does not explain how such a fabricated story would result in the FDA banning silicone gel implant in 1992 and why Dow Corning agreed to a $4.5 billion legal settlement of a class action suit. As one correspondent to the *Wall Street Journal* noted in reply, Maroney appeared dismayed that "Dow Corning has been held accountable for its amoral attempts to boost its bottom line at the expense of women's health and well-being" (Karen Hazel Radenbaugh, Letter to the Editor, 7 May 1997). Further, Mr. Meroney's disdain for Rothstein's distinguished career in filmmaking, including *Crisis at Central High,* does not speak well for his analytic skills.

After the column appeared there was discussion about possible cancellation, but "Hearst stood strongly behind the film and it was aired on June 16."

Looking back on her long career of some forty films, Rothstein does recognize the existence of the "glass ceiling," noting, "there are no women at the very top in the networks." Jamie Tarses was appointed ABC Entertainment president shortly after our earlier conversation with Rothstein in 1996. However in July 1997, ABC appointed a man, Stu Bloomberg, as Chairman of ABC Entertainment, thereby demoting Tarses, making her no longer the number one programming executive. With the departure of Lucy Salhany as head of UPN and the Tarses demotion, women could well be losing even this limited control in network television.

In light of that development, Rothstein's further remarks are telling. "The 'ceiling' is reinforced by the old boys network and businessmen's clubs and not helped at all by the professional guilds. Yet if we had more women in those positions would it make a difference in what is done? I think that's wishful thinking. Things would be fairer, there would be more opportunity and it would be important for women to have that opportunity to do the work they want. Would it change the face of broadcasting? I doubt it."

In terms of hiring, Rothstein "feels an obligation to mentor young people—men and women. Occasionally I find a script that would provide an opportunity for a Black person or a woman, and I try to make that happen. I want sensitive persons, women and men."

Reflecting on her career, Rothstein notes, "It was a hard row. But I am thrilled to have been in on it early. I now have the authority to say what I need and have it done. Today the industry is far closer to representing the makeup of the population. Where there is work to be done what is needed is not complaints, but a recognition of the terrific opportunities taken by women who developed them into impressive careers. The tone should be positive, not angry. I have been lucky and blessed."

Part 3
The Symposium

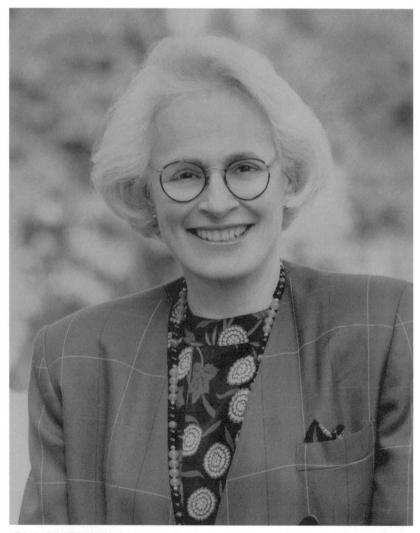

JEAN FIRSTENBERG

◆ A SYMPOSIUM ◆

Noble women remain the untapped resource in television

ON THE LAST SATURDAY IN APRIL 1996, TEN TELEVISION PRODUCERS GATHERED in Los Angeles to engage in a wide-ranging discussion of the history and current status of women in television production.

We have been tracking the contributions of women producers since 1975, engaging them in symposia, classrooms, and lectures. Some had begun their careers in the 1950s, others only within the past ten years. On this day we sat and listened as the participants engaged each other in three hours of intense, serious discussion, leavened frequently with humor natural in a gathering of old friends. In this chapter we offer the remarks of each, in her own words but woven together by us with careful attention to accuracy and context.

Our gracious host, Jean Firstenberg, director of the American Film Institute, set the stage and presided over an uninhibited conversation. The discussion was opened by Virginia Carter.

∽

Virginia Carter: I had no intention of getting into this profession, one that almost opposes creativity. Because of the way I got in I am confident that how people get into this business is spotty. In other professions, in other careers, training is a prerequisite. A physicist or a physician gets a degree and with the proper credentials goes and does the job. In this particular profession I have never been able to determine any appropriate credential or degree. I am the perfect proof of the pudding because I am trained not to do well in this business. I am a physicist by education. I was a woman physicist at a time when there were only 365 female

physicists in North America. I went from that to working at Norman Lear's right hand side in show business and I guess my ignorance made it all possible. I had no idea how difficult and tricky the business is, how fraught with interpersonal *stuff* it is. So in I waltzed and off I went and I had a grand time for fourteen years and then went home. So I have inferred from that that there is no appropriate training; but what is necessary and appropriate is a talent, skill, a special kind of brain. I can't define what kind of special brain you folks have, but I'm confident you've got it or you wouldn't be where you are because there isn't a credential you can hang on your wall that lets you go do what you are doing.

Barbara Corday: I didn't know that I was going to become a television executive or even particularly that I was going to be a producer, but I knew when I was a kid that I was going to be in the entertainment business somehow. As my parents and grandparents were quick to point out, since I couldn't sing and I couldn't dance they and I should be quite worried as to what I was going to do, how I was ever going to make a living. Writing sort of became my savior because I figured out that there was one other thing that I could do: for a lot of people writing is a fabulous entre into any part of the business, particularly producing. I don't think it was always that way, but in the last twenty-five years it has been. It's very appropriate that Marcy [Carsey] should walk in at this moment because she was really very responsible for me making the major turn I made in my career. After writing for a long time and mainly doing episodic television and working on staff for a few series, with one TV movie in my credit, my long time writing partner, Barbara Avedon, and I broke up. It occurred because I wanted to produce and she did not. She was what I always called a real writer, someone who would write whether she was getting paid for it or not. I always thought that I was sort of a fake writer because I hardly ever sat down at the typewriter unless I had an assignment. At that exact moment—this was 1979—I met Tony Themopolis at ABC who said I had to come in and meet Marcy and talk to her. He informed me that they needed somebody in comedy development and it would really be interesting to have a writer do that. "Why don't you talk to Marcy?" he said. And for unknown reasons that she could probably answer she hired me and I became a comedy development executive at ABC. That was an incredible turning point for me. It gave me everything that I needed at that moment to change my career. Having been a partner with someone for a long time you know how hard it is to get writing jobs. If you've been a partner and decide to strike out on your own, everybody wants to see something you've written by yourself. I had really no identity of my own. As a

matter of fact because my partner's name was Barbara we were always called "the Barbaras." My ex-husband once introduced me to someone with the words, "This is my wife, Barbara Avedon." [Laughter, and a murmur of "grounds for divorce" circled the room.] So Marcy was responsible for changing my entire life. Without that first job, that first step, I probably would have had an incredibly difficult time becoming either a producer or an executive. I certainly would have had to do a whole lot of writing stuff on my own. I might add, writing is a good training ground for the whole business.

Nancy Malone: When I produced my first movie of the week I think Lillian Gallo, Carolyn Raskin, and Jacalyn Babbitt were the only women television producers at work. I had been under contract at 20th Century Fox as an actress. Lillian Gallo had been secretary for Bill Self, the president of Fox television. She was absolutely wonderful to deal with and through her I became friendly with Bill Self. I would see him and complain about what actresses complain about. I never realized at the time how easy I had it with the makeup and the dressing room—acting has been very good to me and I don't want to knock it; but it certainly was a lot simpler to deal with than producing and now directing.

My career in production began in an interesting way. After I had finished one of the series at Fox, the president of ABC, Tom Moore, who was a very dear friend and great supporter, was putting together a company for General Electric. In my way of not holding back I was complaining to him one night at dinner about the fact that there were very few really good roles for women on television anymore [the late 1960s, early 1970s]. "Here's your coffee honey," was about the most intelligent line women were speaking in those years. He said a remarkable thing, "Why don't you do something about it?" That stopped me and I said, "What does that mean?" He said, "Create your own show." As Virginia [Carter] was saying, I had no idea of how to do that or what that meant exactly. It was only the gentlemen in the business who did that sort of thing and with the exception of some writers one saw very few women. There was never a woman writer on *Naked City* or for that matter *The Long Hot Summer*. I don't recall ever seeing a woman in production. When Moore put his company together he asked me to enter the other side of the business. I was doing a play in New York about the Catonsville Nine. He said "I'd start you off at $200 a week but you'd have to give up acting." Since I had started acting when I was five it was a very difficult consideration. Acting was something I knew and I did my craft very well. I thought about it for a while and said yes.

So I gave up the acting business and went to work for Tom. I think Marcy came in after that. I was the first one to be hired. [Carsey com-

mented: "You painted your office the most delicious color of blue and there was a matching lamp shade."] The office was so tiny that closing the door created something just this side of solitary confinement but it was a wonderful experience. I really learned that I had whatever that is that it takes to do the job. I did project after project. One got picked up. I tried to get a lot of things done in the company and a number of things went on to get made by other people. I felt I knew what I was doing. I understood literature, I understood what makes good movies, good drama. I had never graduated from high school, but I read voraciously. Shortly thereafter, when I left Tomorrow Entertainment I produced my first movie for NBC. It was again that strange thing that makes somebody a star or talent or whatever—perception and awareness. When I teach acting I make the kids do a drill by going into the store looking at products and then ask how many products they remember. It has to do with awareness, with what people need.

Marcy Carsey: Based on what Barbara and Nancy have said, each made a conscious decision. If Tom Moore had not been the agent of change, someone else would have been. It begins with a decision you make. You want to do something, you want to change something, you want to affect something, then you go do it. You find a way to do it and you find the person that's going to help you do it.

Malone: Tom Moore was the conduit, but it never would have occurred to me to take the step until I heard those words. I said yes because it was there to say yes to.

Carsey: I'm sure you had thousands of casual conversations that year, none of which were in your head. And that was it. It struck something in your gut. The decision was there to be made.

Carter: Marcy is crediting us with our own power. If we all sit down together we can do that for each other.

Lynn Roth: You are bringing back to me my father's words when he was visiting me. Observing my phone calls in an incredibly busy week, he commented, "You are doing exactly what you did when you were eleven years old." "What are you talking about," I asked? He said, "You're organizing the block and putting on a show." That is what I spent my childhood doing. I began my career as a writer and then 20th Century Fox simply gave me *The Paper Chase* to do literally because of my relationship with John Houseman. They called me and said, "Here's a series, would you like to produce it?" I said, "I'd love to." Then I called all my

friends and asked, "What does an executive producer do?" In a very short amount of time I realized it was organizing the block and putting on a show. It was an inherent quality or need I had when I was eleven and that was manifesting itself all over again. The responsibilities and the actions and the result weren't that different.

∼

Jean Firstenberg asked about the impact caused by applying the Equal Employment Opportunities Act to women in the early 1970s.

∼

Marian Rees: When I went to Tomorrow Entertainment I knew Tom Moore and Tony Themopolous. Shortly thereafter I remember Marcy saying, "Well I'm out of here and off to ABC. I will tell them they have to hire me." I love to tell that story because I think that's absolutely true. When the EEOC applied the law to women it provided economic opportunity. Shortly thereafter [1975] Tichi Wilkinson, editor of *The Hollywood Reporter*, started Women in Film, along with a few others, like Nancy Malone. She used her paper to provide direct support to women and help establish the organization. I remember she did profiles of women who were succeeding, were pioneering, and had substantive resumes that could fill a column. I don't know whether she ran out of women but there was a period in which it flourished. There was that window there.

But women also must recognize that it is imperative that we find a way to empower each other. Several years ago Jean Firstenberg inaugurated a women's directors institute at the American Film Institute to bring them together in an environment to explore the possibilities within this community. Those same women can find ways to change the system by using it wisely. This is not an isolationist position. I found that the system had the ability to provide an equity for me.

Carsey: I agree. I didn't know it at the time but looking back I think it had everything to do with it. I was hired by ABC in 1974.

Rees: I remember the day you left.

Carter: It is also true that the feminist movement, the second wave of feminism, was hitting its major stride right in there. They all sort of came together.

Carsey: Yes, I remember I was pregnant and everybody thought I was disgusting, insane. They asked, "What did you do to yourself?"

∼

As the discussion progressed, with the introduction of the subject of the family, it became obvious that most of the participants in the room had numerous common experiences.

~

Corday: I remember Marcy as the only one with a playpen in her office. It was a very, very shocking and wonderful thing to walk into that office with the playpen in it. I mean it just made us feel you could do anything.

Carsey: It was ignorance, sheer ignorance. I didn't know you couldn't do it. I just went in assuming you could.

Rees: Also, it was part of your own attitude toward children. And you have been sustained with your sense of family, your commitment, and that's how you integrated all of that.

Carsey: Yeah, but again I swear, Marian, I don't know, it was also simple-mindedness or single-mindedness. I just figured the guys had been having children and having jobs for centuries. It didn't make any sense not to do it. I was thirty when I got pregnant and Mike Eisner had hired me when I was pregnant, knowing I was pregnant. It never occurred to me that you wouldn't do both: life seemed to me to be both work and family. I don't know why I wasn't taught otherwise, but I wasn't.

Malone: The common thread with all of us here is that aspect of "Why not?"

Esther Shapiro: My experience was just a little different but very much the same. It started very early with me. I was not able to communicate to many of the people I lived with. My family was a kind of restricted European one and at the same time they were wildly exotic. I got a lot of mixed messages and I was always receptive to those messages, but no one seemed to want to hear me talk about it. So I began to write very early. Under an assumed name, as a young teenager, I sold stories to *Modern Romance*. I went to work doing greeting cards and began to write funny condolence cards. I had never done much comedy. I found that in trying to communicate with an audience, to a world, something I had always wanted to do, writing was the only relief I had. And I came to believe that drama could deal with more fantasy than comedy.

I have always loved Marcy's shows because they dealt with reality and the family and all of that. But there is a part of us that deals with dreams and fantasies, becoming spies, power fantasies, beauty fantasies, control. Even the movies I wrote in the early seventies were all about women

trying to gain control of their lives. Before that, in the sixties, I was writing features at Warner Brothers, teenage summer movies that weren't about anything. There was no control in features. I tried television and still no control. I did a movie with my husband, Richard, at Universal—*Portrait of a Teenage Alcoholic*. It was very well directed by Dick Donner. It was well cast, but it was not right. And I was frustrated. I had no control. Knowing I didn't have it sort of moved me toward production. I found that working with my husband helped because for women it was very hard in those days. We told NBC we wouldn't write anything unless we produced it. And they said OK. I remember the first day we were on a set and I don't even know what I wanted but the crew treated me like an editor of a high school paper. They had no experience with women producing. They just weren't around. In the early seventies there weren't any women producing.

A little later, after a trip to Europe, Brandon Stoddard offered me an office at ABC. And I said, "With the enemy?" I took the office and became sort of a script doctor. Sometime later Stoddard asked, "How would you like to take over this department?" I had done a stint as a story editor earlier. I told him all the reasons I couldn't do it. I had to be home for my kids by 3 p.m. He said, "You only live a mile and a half from here. When the children leave school they can come here." While Marcy had her playpen I had a little desk where my kids, a little older, could do their homework. Nobody ever said anything about that. I took the job and more or less started that department and did some incredible things.

Then after a certain number of years, after Marcy didn't become head of the network or I didn't become head of the network, I decided to go on my quest for control, because there wasn't a lot of control for women. I had been used for all kind of stuff by men who saw me as a no-paid producer. I left. Richard and I went into partnership with Aaron Spelling and the first thing we did was *Dynasty*. Marcy was running ABC Development and it was just a dream time. As I look back, all the movies I had written were about women, alcoholics getting control, women getting control of their lives. That emphasis began to fade in the eighties.

The producing thing which I did in the final two years of *Dynasty* and in several series since and in movies began to make me feel restless again. It was still somebody else's company. I started getting interested in social movements and I got a congressional appointment to be on a council on women's issues, three Republicans, three Democrats. We consulted with Presidents Bush and Clinton and I started to get a bigger world view and I saw we could produce for the world. Having been European and my shows going well in Europe, I started to get a different fix and began producing with European companies. It's very different there. Their

attitudes toward women are different: some of them are more macho and some are less.

It was interesting and always important to be independent but it took me a long time. Some of you got there real fast. I didn't. Drama wasn't really in favor and it was hard. Today I would take a job because there was something in it that said "More control."

Debbie Smith: Everyone has been speaking about what they did to get to this place. From the time I was twelve it was very obvious to me what I was going to be doing. I originally intended to be in publishing. I visited Los Angeles once when I was in college and I thought it was the most disgusting place I had ever been. I was a New Yorker going into publishing. But, as it turned out, my job in publishing ended and I began working as a literary agent. I asked a friend, "Where do I go from here?" He suggested I go to LA. I had no idea what the television business was about and I thought I'd be a script girl with no idea about that either. I would just get a job doing anything.

Somehow I got an interview at Lorimar with a woman who herself was just starting. She ran the business affairs department. She was kind enough to hire me. I decided to give it six months and see if I could do the job. I was there for two years and then I got into production. You do have to make choices constantly but they have to be there for you to make. The training ground is doing whatever job you are hired to do and do it the best of anyone.

When I started working it seemed it was always a surprise and an amazement to the person who hired you if you did your job well. For me it was just what I was hired to do. I looked around and realized that most people tried to get away with doing as little as possible. And I found out that if you just did what you were supposed to do, you were rewarded for it. That would lead to something else. That's what I try to tell anybody who works for me. Do the job, whatever it is. If it's getting lunches for writers, do it faster, more efficiently, and people will see you can do that and then they might add on to the job more responsibility. That's what it was, always adding on. It was one thing leading to another in very small ways. It was being interested and having people see you were interested in the whole process. As I went from a secretary to a production secretary the company knew I did one job well and said, "OK you can do this too." As I served as production secretary I looked around and thought post production was kind of interesting, so I asked, "How about being associate producer?" And they would say, "OK she's been on location and she can do this. So let's give her a shot." It works if they don't have to change your salary. It was building on.

I did work for Lorimar for a long time. They were a small company

and they knew who I was. The training ground is starting somewhere and doing each job well. Let people know that you are responsible and can handle the job you have and they will move you on to the next job.

I don't think you learn it in school. Taking film courses is not the way in. I think that they are probably a lot of fun and probably a creative thing in college, but I'm glad I didn't take them. Getting an education and learning how to organize yourself and learning history and literature and physics teaches your mind. Producing is organizing, putting things together from the very beginning to the very end. It begins with your first crew member and goes to the network at the very end. You have to be good at it and you keep raising your hand. At the production meeting in the morning they say, "Who's going to look into this?" You say, "I will." They say, "OK you can do it." Then do it and make sure you let them know who you are.

Firstenberg: Women in television, is it harder for a woman to be a producer today?

Carsey: I don't perceive it as being harder.

Anne Hopkins: The corporate culture has affected the situation. The sense of being a producer isn't honored anymore. One is not respected as being a contributing creative force. They—the financiers and the networks— would like to strip any sense of your voice and vision. I don't think gender is the issue in that sense. If its harder for a woman, I think it's in the sense that Marcy and Esther were saying before, that we don't separate our emotional, personal lives from the professional in the kind of projects that we want to do or the voice that we have to share. So when the market is as controlling as it is, those in charge are myopic about the kind of stories they want to tell. Women are the primary viewing audience. But there are a limited number of people you can go to to sell and they, mostly men, tell us their perception of what women want to see. We as women go in and say this is a theme or a story that an audience will respond to and they summarily say, "No it isn't." [This was one of the major points that Betty Friedan had made in 1987, as recorded in some detail earlier in this volume.]

Carter: I had that happen a lot. I love your succinct statement.

Hopkins: We've all been bemoaning the sex and violence in television and women as victims, but now women are perpetrators. We are informed that women have power because now they can kill and belittle men. That isn't any better a scenario than what it was years ago. But in terms of human emotion and stories that move us, that climate is extremely diffi-

cult and we all know it. They're the ones in charge, and it's men who are making those decisions. Advertising agencies are run and controlled by men. They're the ones who read the demographics and say what rules the numbers, and therefore what people are watching. It's harder to be a woman producer with the stories we want to tell. It's a harder climate.

Carter: You know, feminist theory would suggest that it should be a little easier for us as women in the industry now because there are a few more of us there and we might be sensitive to each other's needs in some ways that our brothers weren't. I don't know if that's true.

Carsey: I think there are a lot more women producers, and there have been over the last fifteen years a lot more women in middle management positions; but I think there are still very few women who can say "yes" to anything and I think that's where your statement about increased sensitivity, Virginia, sort of hits a wall. But I do think the situation is going to change over the next couple of years.

~

The obvious question comes from almost everyone at once. "WHY?"

~

Carsey: You can see it. You see women—well, Lucy Salhaney is now running Warner Brothers Television network. If that network does survive and comes into prominence that will matter. Jamie Tarses is about to become a president at ABC. There are a couple of smart women working right under Warren Littlefield. I'm sure he's responsible for bringing them in and promoting them. It could happen that three out of four or four out of five of the networks are run by women within two or three years. It could easily happen.

~

The discussion turned to focus on family and the work being done by several persons in the room.

~

Shapiro: I want to thank a lot of the women in this room for keeping the mother alive. I don't know if it's a psychological hangup with men. They are all so troubled by their mothers that invariably in an hour drama the mother is conveniently dead. It's a pleasure to see Roseanne or Grace or Cybill, to hear that voice. In the dramatic two hours it's often a story about a woman and I think that women bring that special sensitivity but until that happened we just didn't see the mother. There were gorgeous girls or power fantasies which were different, but the real mother was dead. I want to start

seeing the real mother as a role in drama and comedy. She may also work. I don't know that men are aware, but they have problems with their mothers. A lot of us do, but it seems to come down to that more completely with men.

Carsey: We saw such a lack of mothers and you might think we would have corrected that in our first couple of shows but we didn't. We found the divorcee. We kept putting them on and there kept being room for them.

Firstenberg: Will a break for women in top positions have any influence on content?

Carsey: You can't imagine the influence that would have on what people are receiving in their homes.

Roth: I feel so nostalgic being in this group . . .

Group: We're not dead yet!

Roth: This kind of atmosphere I haven't felt in a very long time. And I'm trying to analyze what is making this group different from the groups I've been in recently. A lot of the women in this room were the "first" in some area. (Tell me if this is delusional.) But there was room for other women, room to explore. I feel now there is a gripping of the job. "This is my job." And I have to worry about my job. The kind of feeling we used to have among each other is missing. I succeeded Nancy, we had those experiences with each other, but we helped each other. I don't know, I definitely don't feel that atmosphere today and I worry desperately about the content that you see emanating from women who are in the position of making decisions now. I wish it were otherwise but this is the way I see it. In other words, I'm not as optimistic as you, Marcy, about top positions improving content, or even changing it.

Dorothea Petrie: I feel there is a great deal of fear among women executives right now. You can see that in the takeovers. They won't say, "I'm afraid," but you feel that they're thinking "I don't know whether they will like this or not."

Carsey: Don't you think that when women are actually in those jobs of running the entertainment division and setting the agenda they will set a kind of vision and climate?

Petrie: I do; I believe it and I also think that when women are fired and make a change, that is an opening. If you look back—and I am a senior

person here—the change opened an opportunity for people like Marian to stop and say, "All right, I'm going to do it. I'm not going to depend on this person or that one, but I'm going to do it," and you do. And I think that's, in some way, what we've all done.

Carsey: In my case it was the only choice. You say, OK it's not what I planned, I don't know whether I'm going to be good at it but it's my only choice. At ABC I loved being a network person and I loved the people I was working with, although I didn't like the people I was working for. Except for them, it was fabulous. But management had changed and I was working for people with farmland for brains. And I told my husband, who has a very clear head about these things, that ABC wanted me to stay, they wanted me to re-up. The guy who was head of the company did say how uncomfortable he was with women, ha, ha, as if admitting it made it all better, but "We love what you're doing Marcy. Won't you re-up for another couple of years doing what you're doing in series television?" I asked him, "Why wouldn't you promote me to president of the entertainment division?" He said, "Well I'm uncomfortable . . ." And in my tactful way I said, "You have children too and I think they're home from school by now. You'd better get the hell out of here." It was not a smart thing to say. I went home and said to my husband, "They want me to re-up." I gave him the lay of the land and he said, "You have to get out. They want you dead. It doesn't matter how good a job you are doing. You have to get out." So that's why I formed my own company.

Shapiro: You know what I think we could do, too? There are a lot of the corporations that constitute another whole level we could interact with. For example, Rysher Entertainment is owned by the Cox sisters. They have the biggest communications organization. Why are they still doing all macho stuff on their first-run syndication? We're not interacting with them. There are at least two or three women on the Disney Board. I know when I went to Washington I found out that the largest growing segment in the country is women-owned businesses. There are organizations finding women and teaching them how to do that. This is reflective of what's going on around the country and I think we can get a lot of reception. Women also need to be brought out. They don't just have to invest their money, they could maybe tag something onto it. They could ask, "What kind of programs are these? How come women don't watch first-run syndication?" To look at it another way: they push you to be outspoken at the network, so I said on the *Donahue Show*, "My network would rather be third with a man than first with a woman." Tony Thomopolous called and was so heartbroken that I said that about the net-

work and I said, "Well it's true isn't it?" That's the kind of thing you are pushed to say. It wasn't polite but it was true from my point of view.

Firstenberg: If women do ascend to the top where they really are going to be making the choices, it is very important moment because I think we have this great creative community. We've all got to work to get better work done. Because the violence level is not acceptable, it really isn't, and maybe this is the way. There can be some changes, but there don't seem to be any changes on the horizon.

Shapiro: As Lynn alluded to earlier, women are often just imitation men. We don't have a lot of role models and men are not used to women showing their feelings, communicating openly, and we have to kind of develop a role model of how women can do it. Men have a strategy. We need to develop ours.

Smith: I'm a hired gun; I'm not a development producer, I'm a line producer. I have the opportunity to follow things through and do testing and things like that. And I find the network puts more credence in numbers and testing. A woman would say, "I really like this. This is really good. I'm going to put this out there and people will watch it. I just know it." Men won't do that. They have to have numbers and they have to listen to people and they think too much about something and they know they have to say something different in the process. So they change everything. They say you have to find another type who's stronger because they said they want a stronger woman. We say, "We wrote her stronger and you took that out because you thought she was too strong and she was a bitch." It's constantly back and forth. I think a woman would be more willing to go with what she feels is right and good and I think men are not. I think the whole system is built around their not actually going with something that they believe, which is a feeling about the right thing and the good thing. They feel, "Maybe this is too violent, but you can't ignore the numbers." They put a gauge in front of people and if the men laugh at vibrator jokes that's all they know, so then it's funny. But I think you should put things on that you believe in.

Carsey: I would not make it such a gender split. There are people who believe their job is everything and they need to keep that corporate job to rise in the corporation so they are going to do whatever they perceive the corporation is wanting and needing.

Smith: At this point there are more men running the corporations and they have set up the system. Maybe if you got more women involved, eventually there might be more of an approach where you are asked what

you think about this. Ask a man what he thinks, and what kind of response are you going to get in your daily life, let alone in their corporate life? Of course, there are men who are in touch with their feminine side, no doubt about it. There are Norman Lear and Grant Tinker, who really believed in something and in television itself. But I don't think you could get a *Mary Tyler Moore Show* on the air today.

Shapiro: If a male network executive loses his job he'll have twenty phone calls the next day offering him one. If a female loses her job months could go by. The perception of failure is different. Men lost their jobs because they just didn't get along or something, but women don't have that history of protecting and nurturing or caring about each other. We have a few—just a few—role models but we don't have structure or strength yet. Men are doing what they need to do to stay in power.

Firstenberg: Is Women in Film playing a valuable role for people coming into this community?

Corday: Over the past ten years my complaint is that it is much more there for newer people than it is for people already in the business. It is more focused on the entry level. There are a lot of workshops and networking aimed toward younger people coming in. Everybody in this room has taught a workshop or participated in a symposium or done something for them, but I haven't found that they offer a lot. I would like to do something like this meeting today once in a while and I haven't found they offer anything like this. Just sitting in a room with this group of women certainly would make me want to be part of the organization.

Firstenberg: Does FinSyn change things for independent women producers?

Rees: It creates a producers' hierarchy in an entrepreneurial sense. You just don't own your product anymore. It means a shift in how we all do our business. In the past there was more collaboration. The network was never the competitor, there was a very different climate in which that work was done. That's all gone because NBC was determined to change the way of doing business. ABC was not as aggressive, but it was all built on capping what they had to have in their budget so that there was always a deficit for every producer. The networks created the system.

Carsey: We knew the end was near. We are the only independent left.

Shapiro: Their true agenda is not just making a profit but getting their stock up so that they can either sell their company and get a whole bunch

of millions they don't have to work for or buy another company and get even bigger. Sometimes they will spend a lot of money to get the stock up. It is no longer the Nielsen, it's getting your stock up. They will do anything to do that. And that's increased in the eighties with the take-over fever and mergers. That's what it's about.

Rees: I think there is a different issue here. I think, Dorothea, you can speak to it better than anybody. And it comes out of the Producers' Guild and the Caucus. You are saying "producer" as if there is a single producer.

Petrie: The producer now, the title "producer," is redefined. So many people, including a driver I had in Atlanta, ask what do you do and when I tell them they say, "Oh, I'd like to do that." There is no conception of what a producer does. There may be nine people with producer credits on a film or episode. I've just finished a picture in Canada. A man contacted me from the network to do it. Let me explain the problem we face. There was a contract with an executive producer that said he would get an Emmy with us if we won. He was never around and I don't think he saw the picture. We had a writer who got credit and did not write one word. Bob Cooper called me yesterday and said, "Let me read you his credits, all lies." It's a problem. I took my credit at the end because I wasn't going to put my credit in front of the show with that man. The writer was called the associate producer. Hallmark was very generous about it. They said go and do the picture. Don't worry about it. But it was an injustice. I wish we had a producers' guild, a strong guild. The Academy has determined that only two producers would go get the Emmy no matter how many were listed. Every star says I want to be a producer. Managers and development people seek producer credits. Nobody is around producing.

We need more women producers and I think we ought to target women who we think will be terrific and support them and say to all of this upper echelon, "You should meet them, they would be great in your company." We should really push people we think are outstanding and then we will have precedents.

Malone: Excuse me for being cynical, but what makes them not conform to what's going on now? We can find the most marvelous women that we believe in and as soon as they get into that environment they become like it.

Shapiro: They would be so set on their career that they will conform.

Petrie: That's not the woman we are going to pick out.

Rees: Marcy's got the clout here.

Carsey: Yes, I do, for the next moment or two.

Petrie: There is a window in time when you have that clout.

Carter: There are no rules and so when you move into your position it is simply a measure of your basic character. There are no rules on how to develop character. You either have it or you do not. So if we are going to find somebody we must focus on this question of character and when you find her you can be perfectly comfortable. If she and other women like her, with character, have positions of authority they will do wonders for us.

Carsey: She's right, character is everything in executives and writers and producers, in life.

Carter: But this industry is so unlike any other place I've ever been in that your character gets to be presented to the world in the set of choices you make in popular media. It's not like going into the jewelry trade and making a ring or becoming a physicist and analyzing spectra. It's something that influences the entire world and what's so appalling to me is that we cannot quite identify this as the essential fact of our lives. We must find the character in the persons we support or we must find it in ourselves if we are to be comfortable with who we are.

Roth: Character is destiny.

Carsey: In fact, the last time I commented on a major event one of the companies that took over one of the networks happened to ask me what I thought of one of the executives they inherited. I said he doesn't have the character to have that job. That was the first thought that came into my mind and I thought I had to say it because I owed it to this person who asked.

Shapiro: More than that, I think people without character are not comfortable with someone with character. They don't like the truth in the room when you get to that certain level. There are women without character.

Firstenberg: Surely, just as many as men.

Carsey: The corporation has a character too. I believe in Mike Eisner's character, so I believe there is hope for ABC.

Carter: It's so interesting to me to note in hindsight. I felt that Norman Lear had enormous personal character, not knowing at that point your history of being summarily fired, Marian; and then I realized that he was able to have his character of outspoken support for women and pro-social causes in part because he hired Alan Horn and Jerry Cranshow to run the other side of the track.

Shapiro: They leave the lot when they have to fire somebody and then the hatchet men come in.

⌣

The conversation shifted quickly, at this point, to questions respecting politics and ethics.

⌣

Firstenberg: Respecting the subject of character, what relation does that debate have to the question of violence?

Carsey: Am I not looking at the same television shows that everybody else is? I don't see violence on network television. It's non-existent. It's on cable and feature films.

Firstenberg: I don't think that Washington thinks about four networks or five networks or six, or prime time; they look at the whole twenty-four hours, failing to distinguish between broadcast television and cable.

Roth: I think it's a political issue that's going to die down right after this election. I think it's religious

Corday: I think there are people who are not making violent programs. That's the point I really find important. I think that most of the violence is in theatrical features which are made for a different audience, a very young male audience, whereas television is not made for a young male audience. And I would venture to say that 98.5% of prime time television and daytime television has no violence in it at all.

Hopkins: There are the two-hour movies that are equating sex with violence—it's teachers having their students kill their husbands—and there is a horrible sense of passion that is about sex and satisfaction and they are using violence in a horrible way. The V-Chip,[1] I don't know, are they going to bleep out the entire two-hour movie?

Carsey: I think the movie ratings have worked very effectively in theater exhibitions.

Corday: For the most part the broadcast standards departments have been in existence for decades viewing it for the public.

Firstenberg: The networks have also been monitoring programs for the internal management. It's been an internal decision.

Corday: They have been rejecting anything you'd like to do.

Petrie: You get shot in the head in a war, you don't show any blood. We don't show the consequences. I agree about the violence. I don't think there's that much violence, I think the V-Chip is going to be headed for the wrong people. The wrong people are going to check the schedule. Those persons are responsible already. I think it's for a lot of parents who aren't going to have a chance to look and would love to have their children sitting in front of a television set because they are at work.

Hopkins: If the V-Chip happens the power will be vested in someone to pre-determine what is unsuitable for viewing by children, for whatever reason. Thus, if you already have a certain quotient of violence and sexuality which you as producer have approved and you know it will be targeted by the V-Chip, you may as well allow more, so that those who *are* watching are going to see a level that will be worse.

Shapiro: It doesn't make any sense. When it comes to sex it's all dumped in. A scene in our CBS movie depicts a fifteen-year-old girl's birthday. She was in her pajamas and her father came home and said happy birthday and he picked her up and sat her on his knee for a moment and told her what a perfect girl she was. CBS saw that as incestuous and made us take the scene out. What's going on with these people? They said if you don't take it out we'll take it out.

Carsey: Except for movies for television, the only thing that frightened my children when they were growing up was news. Yet the V-Chip is not to block out the local news. My son grew up being terribly afraid of kidnappers and robbers. When you're a kid and you watch that local news you think that you can't go out the door without being assaulted. It makes the world look like a very unsafe and horrible place. And by and large it isn't. There is no huge danger out there. Every year only four hundred kids are kidnaped by strangers. That is the most damaging part of network television, but it's not the business that any of us are in. It's a bandwagon that gives us strange bedfellows and dangerous bedfellows. I don't see network television as a problem except for the few movies.

Corday: I would like to think that the people who are putting themselves in the position of trying to regulate us could take a few hours to learn the difference between local news, theatrical movies, and prime-time television. It would be nice if the twelve people on that committee could spend just a little time figuring that out.

Carsey: I think you'll get permission from the networks to put on all sorts of shows they don't now put on. They will say the responsibility isn't ours anymore. The people at home can just activate their V-Chip.

Petrie: Marcia Brams, who I believe was the first woman manager of a news broadcast on KTLA, was told by her boss that he wanted nothing but headlines, ten seconds of this, ten seconds of that. She quit. I remember her anxiety about going in to do some primary news story that she'd been trained to do and wanted to set the background but they just wanted the headlines. She is now writing a book.

Firstenberg: How can we help each other? And how can we nurture and mentor and support the next generation? What we want for them is an easier road than all of you have had to blaze.

Petrie: It comes down to trust. And I notice that competitiveness now is coming from women. There is a great deal of jealousy and a great deal of mistrust about how helping someone else endangers one's own job. That's what I have been told, and Lynn said it earlier. So that's hard.

Smith: There is also the Me Generation coming in, the generation of entitlements. They all want to be producers or whatever title they can get before the age of thirty. If not, they say, "Just as we thought, we're not going to make as much money as our parents." I've heard that a lot and I see a lot of frustrated secretaries who have been in the business all of three years going from production assistants to writers' assistants asking for associate producer credits. They actually ask an executive to go in and try and get it for them. In my view it's not a title, it's a job. Also, it won't do any good when they leave here. Their new employers don't care. Secretaries are making a thousand bucks a week now. There is no working your way through and up and learning and failing and picking yourself up and getting another job and going to people and looking at yourself in the mirror and asking, "What am I going to do next? How do I do this?" They don't think they really have to and are very cynical.

Roth: We are not mentors because they are not allowing us to be mentors.

Smith: They don't want to hear us.

Carter: Are you not mentoring? I am really shocked to hear that. Are you really not mentors?

Roth: To the students, yes. But not the way Fay Kanin mentored Marian.

Carter: One of the greatest satisfactions I had in my show biz career was to have a few people who I thought had character and to whom I gave help.

Roth: Young people don't want that. They are not interested in that.

Shapiro: We have a few, and I kind of mother-earthed them.

Corday: My daughter is a young agent and all her friends seem to be very much helping each other and getting each other jobs and they are faxing all the time. My daughter sent me my last two assistants. She has this group that meets for dinner once a month. They are all young development executives and they share information and I think it's a very rash generalization to say that the Me Generation has no trust or doesn't want help. The young women whom I have seen who are my daughter's friends and contemporaries don't seem to me to be quite so crass as what you guys are saying.

Smith: I think people help people by recommending, but within their own framework when they are separated from their friends they see it as a game and kind of like to play it. They probably did have great character when they came out of college, very idealistic and wonderful, and then I think they came to see it as a game plan. How do I do this and where is my mark and where do I move? You see other people doing it and I think they think that is a part of what they need to do.

Shapiro: In our company we pay for any courses that young beginners want and for their books. Every week I find myself spending an hour or two saying the rolodex has to be done this way, the calendar has to be out before you leave for the day, and going over all those things and trying to show them you can't be a producer if you can't do detail. Some are men, some are women. They know they can take those classes. One of them is now taking a memory course. They go to screenings. They meet on Fridays and on Friday I want to know what they are doing over the weekend. All this helps them to see the relationship between the work they are doing now and where they want to go. I tell them never

mind about interrupting, just check so they'll understand what they're hearing. I like to mentor.

Firstenberg: We have been asked by several women if the American Film Institute would set up a program to train assistants. No one can find an assistant today. No one knows the basic office procedures. We would guarantee three interviews if you complete the course.

Group: Good idea!

Shapiro: We had one woman who didn't want to answer with the company name but just say hello.

Jean Firstenberg asked the group to address two other areas before adjourning. What is the nature of a feminine perspective and what would be your comment on the current status of the glass ceiling?

Carsey: At the basic level the feminine perspective affects content; that is, we are women and we bring experience that is different, wholly different from the male experience, into the product. So on the simplest level if we are doing a half hour comedy about a mother and we're using male writers and female writers, male producers and female producers, male directors and female directors, it always happens—almost always on every episode in the details of the dialogue, in the details of the story—that the female perspective corrects the male perspective. It always happens that one of us says, "It doesn't ring true, you just wouldn't do that, a parent wouldn't do that, a mother wouldn't do that, a wife wouldn't do that. You just wouldn't do that. It wouldn't happen." Or, "A woman wouldn't feel that way."

Just on the simplest level it really does affect content because we bring our experience into the work place, and it really is wholly different from the male experience. And then in the corporate culture, the way you run a company, the way you see business, the way you see the workplace and the way you see yourself in the workplace is often different from how a male sees himself in the work place. In fact, Peter Tortorese, whom we just recently hired and who used to be head of CBS Entertainment, said he got caught up in the idea that machismo defined your work ethic, that in this area of your work your manhood was defined to the extent that you were willing to sacrifice your home life for your work. It was a war mentality, a campaign mentality where everything had to be accentuated by the network job he was in. I said to him that I always define my womanhood in exactly the opposite terms, in how much courage I had to take time away from the workplace and attention away from the

workplace and put it at home. Just in those simple ways in which we define ourselves in the workplace—that's another level.

Corday: I've had the experience a number of times in the last few months when I have not been working where someone will say to me "What are you doing?" And I'd say, "Oh, nothing, I am just kind of home." And a number of men, I can't even tell you how many, said, "You really shouldn't say that. You should say that you're developing something or writing a book." I wondered, well why would one say that? I'm really not doing any of those things. If I said that aloud to them, they would reply, "Well it's not good for you to say that you're home." My point is I'm having a wonderful time being at home for a few months. I don't feel my personage is diminished by being home.

Shapiro: You know why. The reason I think is just basically genetic. When men see a problem, you can say to them that's a problem that has to be fixed. When a woman speaks and they can't fix the problem there is a lot of anxiety. We tend to want to vent, we'll process and sometimes we don't want anybody to fix it for us; we just want to be heard. And that's very difficult. Men can't stand the pain that the anxiety of a woman in trouble brings them. So they don't want to deal with it because they feel they have to solve it. If they could just get beyond that idea.

Carsey: The fuller your life is, the richer your life is, whether it's family or travel or dipping into art, that full life makes the product better that we are all working on. That richness of your experience you bring into the product and so it's better.

A couple of years ago I said to some people I work with, "You know what, we should all take sabbaticals of at least a couple of months, just get away and not call into the office or anything, just get out there and go to New York, see some plays, read some books that have nothing to do with the arts, just get out there and live and do and come back with the richness of that experience." And one man said, "Gee, what a wonderful idea, I'll see you in a couple of months." If you don't make time to get away, you suffocate yourself.

Carter: I think there is another enormous difference in the feminine perspective and that is I think women can see women in a much wider range of possibilities and attitudes and convictions than men can see women. Men see women in really quite a narrow set of options. The classic example is how we always have to show women with their vulnerable side so they can fix it. We can't sell women as the beings we are. We are on a normal distribution curve, some of us are wonderful, some of us

are just OK and some of us are crap. You don't get to see that on TV. I think we can see this and men cannot.

Petrie: I still believe in the feminine instinct. I think that in talking to somebody my husband will be snowed by a comment and I'll sit there and I'll say, "No." You just have that instinct. I also think that producing, we women have always done everything, getting coffee or whatever it is to do. I got the nicest letter after a production from a young man who said, "I've never seen a producer like you. You even picked up some trash." I did. It was there, why wouldn't you pick it up and put it where it belongs? I think that women will do that. It's just a natural thing to do to be able to do everything and not worry that your image is going to be harmed in any way.

Carsey: When I was an executive at ABC my daughter was little and in school and everyone was asked what their parents did for a living and she said, "She gets people coffee."

Smith: I don't meet with corporate heads but I am very often involved in meetings with department heads and the crew members on the set and the production manager and head of production and I have been involved in meeting where I was the "girl." One time they were wondering why I was there. I sat back and watched these boys discussing the problem they were having with a piece of equipment and almost getting into a fist fight because the department head invested so much money in that particular piece of equipment and the person on the crew who was using it really thought it was a piece of crap. And I sat and watched this thing happen because they felt threatened by this person criticizing the equipment which they had bought for the company. The head of production didn't get into it at all because he didn't want to get punched out somehow. I wondered, "Who is running this meeting?" And I finally asked, "Are we going to change the equipment or not? It's not working." They all stopped and looked at me. That was the issue. "The equipment is not working for us. I don't care what *your* problem is, we want to solve *this* one." They were dumbfounded. The meeting was ended. It was like little boys fighting on a field for their territory. Somebody was threatened and they felt it. I just had one little problem that should have been solved in a half hour. It is a difficult thing for women because we are not dealing with highly educated or politically correct people; these guys don't care about being politically correct and treating women in the modern way. But this is changing and eventually it will get better. Females have to win over crew members in different ways that are not necessary for male directors, for instance. It's an extra step that women

have to take when given a title and a job to do. It's partly the difference in how a male and a female handles a meeting. But it will change.

Carsey: I think the seventies were much better for women in corporations. In the eighties' backlash, there was an implied permission that it was OK to retain the boys' network.

Carter: The pressure from the feminist movement set the tone of the seventies that has diminished greatly in the eighties and nineties. Back in the seventies we were in the middle of the great debate.

Malone: I think now it's to the point, "Oh, you hired one of them and now let's get on with it." What you said, Debbie, about women directors is quite true. I was directing a *Central Park West* recently and the whole crew was from New York and it was unbelievable. It was a question of winning them over to get what I needed to get from them. At first, there was a lack of awareness of my even being there. At the end of the shooting they were hurrying so they could all take me out for a drink.

Roth: I have learned that when they attach the word "woman" to anything, I know we are in trouble. When I first started writing it was "Oh, I've never worked with a woman writer before." In producing it was a woman producer hiring a woman producer. And now having just directed my first film when I went on the set it was, "You are the first woman director that I have ever worked with." So until you drop the word "woman" you're still having problems.

Malone: The women directors coming up after me will be in a better position to be more favorably accepted if their experience with me was good. But it's like climbing a mountain all the time.

Shapiro: This group is the passionate protector of content. I think of the automobile industry as an analogy: in the thirties in America there were a thousand car companies, separate companies. All beautiful and creative and wonderful. And they shrank to three. What happened? When you go look at cars you often cannot tell one from the other. I always think about that when I consider content. In your mind, you see some great old Pierce-Arrow. And you wonder what happened to that? In television, the men don't want to be doing the same old thing over either; they'd rather be creative and distinctive, but the system forces otherwise.

Roth: What will be interesting to watch is how women and economics blend because that's what it's becoming a question of. Power is not a

matter of who's got the guns but who's got the money now. That is pervasive so as we strive to shatter the glass ceiling and we reach the incredible heights, it will be "How will the feminine spirit deal with the economic base of the business? How will that manifest itself?"

Malone: As a director I try to go for the emotional values in things. I'm not a good action-adventure director, I don't like it, it doesn't appeal to me. I'm somebody who likes to deal with stories with emotion. Hopefully there will be more women directors and also more nobility in the Movie of the Week business. In general, roles for women in the movies of the week are terrible. It's back to victims again. We've left behind *The Autobiography of Miss Jane Pittman* and other great movies. I want to see more movies where women are noble. That is my vision and the kind of thing I want to do. All of us can achieve this goal, if we can get the network executives and the women we are going to put in these positions to have the chance to do these kind of films rather than what is dictated to them.

Carter: Noble women remain the untapped resource in television. I went off to pitch some of their stories to the networks, to no avail. We went down that track and hit a wall with a splat.

Brown and Alley: This is the easiest book we have ever written because your words so clearly directed us.

Malone: Wait til you see our edit!

~

Note

1. The V-Chip was a highly touted means to control television fare for children. By the year 2000 little attention remained focused on that device.

EPILOGUE FROM A DEAR FRIEND

As a producer I exercise my own passion. Likewise, producers of *Jane Pittman* personalized the civil rights movement with an argument of persuasion to the heart, to the sense of who we are as people. It was a landmark television experience of the efficacy of television that doesn't exist in any other medium. Rape laws were changed because of programs that spoke to that same sensitivity, as did films about child abuse. Women are uniquely qualified to bring that sense of humanity to the home screen. But it requires that if you ever feel something really matters to you, do it.

In 1989 I recall a Women in Film Festival in which women from around the world displayed their work. They were dynamic, articulate, vital film makers, self-assured and self-confident. Most of those women benefitted from state subsidies which freed them from many pressures. In this country we have no such protection, but we have the talent and potential and freedom for the feminization of power, and we need only look around to know that talented women in our industry have succeeded and continue to challenge and change the male dominated industry.

—Marian Rees

Part 4
Biographical Sketches

✦ BRIEF BIOGRAPHICAL SKETCHES ✦

MARCY CARSEY

Marcy Carsey, along with her partner, Tom Werner, is by any standard one of the most successful producers in television for the past fifteen years, beginning with the *Cosby Show* in 1984. She had begun her career in television in the early 1970s as an NBC tour guide, followed by the position of production assistant for the New York based *Tonight Show*. Moving to Hollywood, for three years she was a story editor for the prestigious Tomorrow Entertainment Company. In 1974 she moved to a position at ABC as Vice President of Prime Time Comedy and Variety. She then became Senior Vice President of Prime Time Series. In that post she was responsible for the creation, development, and supervision of all prime-time series on ABC. Some of her notable successes in that position were *Mork and Mindy,* and *SOAP.* In 1980 Carsey left ABC to form her own production company, and, with Tom Werner, created The Carsey-Werner Company in 1981. Their first success was the casting of Bill Cosby in a new series which Grant Tinker, President of NBC, saw had great promise. Premiering in 1984, the comedy commanded huge audiences and brought financial health to NBC.

The credits for Carsey-Werner are impressive and include *A Different World, Roseanne, Davis Rules, Grace Under Fire, Cybill, Third Rock From the Sun,* and the new Cosby series that appeared in 1997. The Company has been awarded numerous Emmys, The Golden Globe Award, the NAACP Image Award, the Humanitas Prize and the Peabody Award. Even with the changing structure at the networks, Carsey's company remains a powerful alternative to network productions, albeit one of the few.

VIRGINIA CARTER

A Canadian by birth, physicist Virginia Carter moved to Los Angeles in the 1960s to work at the Aerospace Corporation. She soon became an active and vocal member of the California chapter of the National Organization for Women. It was in that capacity that she met Frances Lear. They became friends and Lear persuaded her husband, Norman, to hire Carter to work in his television production company, Embassy Television, which at that time was producing *All in the Family*. The evidence supports the conclusion that Lear terminated the position held by Marian Rees in order to make room for Carter, whom he hired in 1973 as Vice President for Drama at Embassy. In that capacity Carter was given an office next to Lear's with unrestricted access to him. She has credits as producer of *All in the Family, The Jeffersons, One Day at a Time, Facts of Life,* and *Who's the Boss.* Upon Lear's retirement in 1978, Carter began producing one- and two- hour dramas including *Eleanor, First Lady of the World.* In 1987 she left the ever-shifting fortunes of Embassy to enter private business.

We first met Virginia Carter in 1975 and it was obvious from personal observation that she was empowered to make high-level decisions at Embassy. She was trusted by Lear and constantly present when company productions were under review. Of all the women interviewed for this study Carter is, as far as we are aware, the only individual who was employed because of a particular point of view on social and political issues. It was, we would argue, an inspired choice.

BARBARA CORDAY

Barbara Corday began her career with a small theatrical agency in New York. In 1967, she moved to Los Angeles and joined Mann Scharf Associates.

In 1972 she and Barbara Avedon, who had been a television writer for several years, became partners and came up with a project that became their calling card. This led to their being hired as a writing team to do several projects. As free-lance writers they wrote numerous episodes for television series and a few pilots from 1972 to 1979.

During that period the two women developed the idea for *Cagney and Lacey.* The script was adapted to the television screen and produced by Barney Rosenzweig in 1981. CBS contracted for it as a series beginning in 1982.

That same year Corday accepted a position with Columbia Pictures where she started her own production company, Can't Sing Can't Dance Productions. In 1984 she was appointed president of

Columbia Pictures Television and in 1987 she took on the additional duties of overseeing another Coca-Cola television subsidiary, Embassy Communications, as president and chief operating officer of Columbia/Embassy Television.

In July of 1988 Corday was named Vice President of Prime-Time Programs at CBS. In the spring of 1992 Lorimar Television hired Corday to be co-executive producer of the CBS evening serial *Knots Landing*.

In the fall of 1993 she was appointed president of New World Television where she was to create first-run programming. Most recently she has been teaching at the University of Southern California in the School of Cinema-Television.

She is a member of the Board of Governors of the Academy of Television Arts & Sciences and a founding member of the Hollywood Womens' Political Committee.

SUZANNE DE PASSE

Suzanne dePasse is, as *Newsweek* describes her, "the little-known power behind some big show-business hits." Her career began in the late 1960s at Motown Records where she shaped the careers of the Jackson Five and the Commodores. In 1972 she was a screenwriter for *Lady Sings the Blues*, for which she was nominated for an Oscar. In the 1980s and early 1990s she collected numerous Emmys for a large number of Motown variety specials for television. Entering into a new venture with Berry Gordy in 1988, she obtained the rights to Larry McMurtry's novel *Lonesome Dove*, which appeared on CBS as an eight-hour mini-series in 1989. She has formed her own company, DePasse Entertainment, which currently produces *Sister, Sister* and *Smart Guy* on the WB network.

Her interest in the creative role in television production is reflected in her comment, "I'm rethinking how to be in the entertainment business. I have to find things that are creatively interesting but have a financial payoff." Speaking of her years with Gordy, she credits him with focusing upon "doing good work, ground-breaking and satisfying entertainment." She is currently at work on an autobiography, we are told by her publicist.

BONNY DORE

Bonny Dore began her career as a teacher after graduation from the University of Michigan. In 1973 she moved to New York City where she began working for the New York State Department of Education, during which time she created the multi-ethnic and multiracial series *Vegetable Soup* for PBS. She then created the children's program *Hot Fudge* for

ABC, shortly thereafter joining ABC Entertainment as an executive in charge first of children's programming and then of ABC Prime Time Variety Programming. Among the series she developed were *Donny and Marie* and *The Brady Bunch*. In 1977 she went to work for Krofft Entertainment as Vice President of Development and Production. There she functioned in several capacities—line producer, supervising producer, co-producer. In 1981 she moved to Centerpoint Productions as Vice President of Development and Production and in 1983 she founded, and served as president of, Bonny Dore Productions, where she produced *Glory! Glory!* in association with Orion Television. That show received two ACE Awards, the cable version of the Emmy. Her recent movies of the week include *Reason for Living: The Jill Ireland Story* (NBC) and *Captive* (ABC).

In the past decade Ms. Dore has been active in Women in Film and has served as co-chair of the Caucus of Producers, Writers and Directors, an organization which includes the most distinguished names in television. She is the executive producer of The Signature Series, an oral and video history of the outstanding pioneer women of show business sponsored by The Women in Film Foundation.

DIANE ENGLISH

Diane English, a native of Buffalo, credits her decision to become a writer to a professor, Warren Enters, who "taught me to write indirect dialogue, something I do to this day." In 1971 she went to New York as a story editor for WNET-TV. During her ten years in New York she was a story editor for "Theater in America" and associate director of the Television Laboratory. In 1980 she wrote *The Lathe of Heaven,* the first full-length motion picture for PBS.

While in New York, working at WNET, she met and later married Joel Shukovsky. They moved to Los Angeles in the early 1980s and her first major success there was the purchase by CBS of her half-hour comedy *Foley Square*. While it lasted for only fourteen episodes, it received some good reviews and that resulted in an offer to English to join a new series, *My Sister Sam,* already in production on the Warner Brothers lot. This show continued until the spring of 1988, by which time English had sold her own creation, *Murphy Brown,* to Warner Brothers and then, in turn, to CBS. That series lasted through the 1997–'98 season. In the third year of its production, English left the series and went on the create *Love and War* for CBS. She returned to *Murphy Brown* in its last season, as executive producer. In so doing she placed her touch on the final episodes of one of the most successful series in the history of television, joining a select dozen sitcoms to be on the air for ten years or more. It

garnered multiple Emmys for its creator, as well as an array of other awards.

SUSAN HARRIS

Susan Harris grew up in the 1950s in New York watching television. She concluded that "anybody could write this." By 1969 she sold a script to *Then Came Bronson,* a short-lived NBC series. In 1970 Garry Marshall brought her to *Love, American Style,* for which she wrote ten scripts. It was there that she met Norman Lear and she wrote scripts for *All In The Family,* taking her son with her to the story meetings. Following the Supreme Court's 1973 decision in *Roe v. Wade* Lear decided to address that issue. Susan Harris wrote the script for "Maude's Abortion" and received the Humanitas Award for it.

During those years she met Paul Junger Witt and Tony Thomas and in 1976 formed Witt/Thomas/Harris Productions with them. Harris created and wrote the series *Fay* starring Lee Grant. In 1977 she wrote the series *SOAP,* a show bitterly attacked by some religious groups. Harris then moved the character of Benson to a show by the same name. She went on to create and write *I'm A Big Girl Now, Hail to the Chief, Golden Girls, Empty Nest,* and *Good and Evil.*

By the time she received the Emmy award for *Golden Girls* in 1987 Harris had literally changed the face of television comedy. Working alone, she sparked a revolution as a woman writing about women while providing insight into male personalities as well.

In the past twenty years Witt/Thomas/Harris has grown to become the largest independent producer of television comedy in the United States. Married to her partner, Paul Witt, Susan Harris has retired from television. She is active in community projects and an avid art collector.

ANNE HOPKINS

As Anne Hopkins tells us in her interview, her "route has been circuitous." She began her career in theater with the Metropolitan Opera Company and moved from there to Broadway as a producer and director's assistant. In the late 1960s she was introduced to Norman Lear who suggested that she move to California and work with his company on the post-production of his film *The Night They Raided Minsky's.* In 1971 she joined the staff of *All in the Family.* She was an assistant to the producer; there she met Marian Rees. After leaving the Lear organization Rees went to Tomorrow Entertainment and Hopkins joined her staff as an assistant. The result of that relationship, now nearly twenty-five years together, has proved invaluable to both women. As we observed the

activities at Marian Rees Associates since its formation in 1981, the easy style in the office has always been complemented by an the exceptional working pattern between the two women. When Hopkins went to Richmond, Virginia to film *Miss Rose White,* Rees was there. As they roamed the streets of the city on a couple of weekends examining locations and plotting the week's work, one got no inkling of Hopkins working *for* Rees. It was and is a team that is impressive and augurs well for their current collaboration, begun in 1999, producing five dramas for Mobil-Masterpiece Theater.

GEORGIA JEFFRIES

In 1998 Georgia Jeffries wrote and produced a film for Showtime Television. She has arrived at a place in her career where her writing talent can be integrated with the authority she possesses as a producer. That move toward a dual career began when she became a writer on the staff of *Cagney and Lacey* in 1984. In that capacity she earned the National Commission for Working Women Award as well as The Humanitas Prize, both for distinguished scripts. The series was created by Barbara Corday and Barbara Avedon and its executive producer, Barney Rosenzweig, was married to Corday at the time. The company was zealous in hiring women for the production staff and the scripts were frequently focused upon issues of equity and fairness in the workplace. It unapologetically addressed controversial topics like abortion from a strong advocacy point of view.

In 1987 Jeffries joined the *China Beach* production company as Supervising Producer where she earned an Emmy nomination for writing the episode "How to Stay Alive in Vietnam." She brought her particular talent to the shaping of the female characters in the series. In the 1990s she served as Co-Executive Producer of the series *New York News.* All the while she continued her writing career, seeking to bring to the screen her talent and commitment. She is a strong advocate of better children's television programming. She has been very active in the organization Women in Film.

GAYLE SICKINGER MAFFEO

Gayle Maffeo began her career in the programming department for CBS, where she became an associate producer for the shows of Jack Benny and George Burns. She served as associate producer for the pilot of *It's Not Easy* in 1983. In 1985 she became the producer for the *Mary* series on NBC. While that show, starring Mary Tyler Moore, lasted only six months, it proved an excellent springboard to the new series *Head of the Class*

which came to ABC in 1986. She recalls with amusement that while visiting on the set in 1987, we noticed that on the bulletin board in the high school set the pictures were all of prominent men. The next time we saw the show in the fall, Eleanor Roosevelt had joined the group.

Before going to her present position Maffeo also produced *Buffalo Bill*. In 1988 she assumed, for a brief period, the production responsibilities on the series *Roseanne*. In 1991, by then a part of the Carsey-Werner company, Maffeo began handling producing responsibilities for *Home Improvement*.

Maffeo is currently Vice President of Production for Wind Dancer, responsible for all projects, television and motion pictures. Unlike most of the women interviewed for this study, her early career in production was as a "line" producer, that is, one concerned with the technical aspects of the series and the budget.

MARIAN REES

Marian Rees began her television career in 1952 as a secretary/receptionist for NBC in Los Angeles. That was a scant four years after NBC went on the air with a seven day schedule in 1948. She is a veteran of New York live television drama. She was an associate producer in the 1960s on the tributes to Ethel Barrymore and Fred Astaire. In the 1970s she held that same position with *All in the Family* and *Sanford and Son* at Tandem Productions where she spent seventeen years, ending her stay there as head of the company's new development division. After leaving Tandem, Rees spent a highly productive time with Tomorrow Entertainment. In 1981 she founded Marian Rees Associates. Since that time she has produced more than two dozen films, including several Hallmark Hall of Fame productions. Her credits include *The Shell Seekers, Resting Place, Foxfire, Between Friends, Little Girl Lost, Is There Life out There?, When the Vows Break,* and *Decoration Day*. Two of her films—*Love is Never Silent* and *Miss Rose White*—were honored with several Emmy awards. Her work has garnered eleven such awards as well as a Peabody Award, two Ace Awards, two Golden Globe Awards, and six Christopher Awards. We were able to watch closely her producing style when *Miss Rose White* was shot entirely in Richmond. She has worked with the best directing talent in the business and we observed the seemingly effortless vision she provided for the director and others during that production. In 1999 she remained at the top of her profession, recently signed to provide several American dramas for *Masterpiece Theatre*.

Rees has served three years as president of Women in Film, which she helped found with Nancy Malone and others, and she has been a powerful voice in the Caucus of Producers, Writers and Directors.

LYNN ROTH

Lynn Roth began her career in television in 1972 as a writer for television. Her first major assignment was to write an episode of *All in the Family*. She then went on to write for *Love, American Style*. She also wrote for *Chico and the Man*. In 1978 she was recruited to produce episodes of *The Paper Chase* after it left CBS and moved to cable on Showtime. Following that success she began to write and produce for her own company. She made several movies for television, including *Just My Imagination* and *The Portrait*. In 1996 she produced a miniseries, *Daughters of the New World*. She also was involved in the production of the Turner Network film *A Century of Women*.

FREYDA ROTHSTEIN

Freyda Rothstein is a graduate of New York University and Columbia University's graduate school in dramatic arts. Upon graduation she began her television career in New York with the daytime soap *Search for Tomorrow* and then moved to *Love of Life*. After three years she joined Paramount Television in New York developing programming on the east coast. She then moved to David Susskind's Talent Associates. In 1979 she bought the rights to a diary concerning the Little Rock Central High School integration dispute in 1958. She became the executive producer of the film *Crisis at Central High*, at which time she moved to Los Angeles. Since that time she has been executive producer of some thirty-five films for television, including *Passion's Way, And Then There Was One, Descending Angel, Something in Common, Blackout, Dial M for Murder, The Family Man*, and *Sex and the Single Parent*.

She had an early interest in American Folklore which led her, along with Margot Mayo, to record for the Library of Congress some two hundred interviews in the mountains of Kentucky and Tennessee.

ESTHER SHAPIRO

Esther Shapiro is a native of New York but was moved to Los Angeles as an infant. She attended the University of Southern California, where she met Richard Shapiro, whom she married four years later and with whom she has been in partnership for nearly four decades.

Shapiro began her career as a television freelance writer/ producer in 1959. In 1973 she joined Paramount Pictures as Executive Story Consultant. She moved to ABC Television in 1977, where she supervised the development of numerous films, including *Masada, Friendly Fire, East of Eden, Winds of War, The Women's Room*, and *Roots: The Next Generation*.

After a brief time with Aaron Spelling Productions, she and her husband, Richard, formed Richard and Esther Shapiro Production in 1988.

Shapiro created and was the executive producer of three series, including *Dynasty, Emerald Point,* and *The Colbys.* For her work on those "night time soaps" she received numerous awards, including the People's Choice Award, a Golden Globe Award, and an Emmy. She also received several awards for her writing for *Minstrel Man* and *Sarah T.: Portrait of a Teenage Alcoholic.*

Shapiro is involved in several important organizations, including the Writers Guild of America West and the Caucus for Producers, Writers and Directors. Her civic involvement includes the appointment by former Speaker of the House of Representatives Tom Foley as a member of the National Women's Business Council, a committee of nine citizens monitoring government and banking.

DEBORAH SMITH

The biographical data on Debbie Smith is more familiar to us than that of any other woman producer. Writing the book *Murphy Brown: Anatomy of a Sitcom,* we had the opportunity to watch her work from 1988 through 1998. Smith came to *Murphy Brown* with its creator Diane English after holding a production-assistant position with the series *My Sister Sam.* She was assigned the title of coordinating producer on the new show and then that of co-producer. As the series concluded she was listed as supervising producer. Her responsibilities were wide-ranging in the ten years with *Murphy Brown.* Smith was one of the few remaining members of the original production crew when the show ended in 1999.

A typical week would find her working out shooting dates in relation to air dates. But even as she took on more and more tasks during the years, her main focus was editing of the film shot each Friday evening. Yet her many-faceted job made her one of the primary persons on the set, as well as in the editing room. Like many of her peers, perhaps the best description for the layman would be floor manager.

Upon the conclusion of her work with *Murphy Brown,* Smith moved into the role of producer for a comedy at Warner Brothers for the WB Network, entitled *Katie Joplin.* She is working with the two writers who also started with *Murphy Brown* in 1988, Norm Gunzenhauser and Tom Seeley.

BETH SULLIVAN

Beth Sullivan's career began with the writing of a script for a feature film in 1980 produced by Anthony Quinn. In the next ten years she did the

rewriting on three more features. At the same time she entered the area of television movies, writing and/or producing some eighteen films, including *When He's Not A Stranger* (CBS) and *Who Will Save My Life* (NBC). In 1990, with Barney Rosenzweig, she co-created and co-wrote the series *The Trials of Rosie O'Neill*. Then in 1992 she produced *Sarah, Plain and Tall* for Hallmark under the label of her newly formed Sullivan Company. The next undertaking was as creator and executive producer of *Dr. Quinn, Medicine Woman*, which became a staple for the CBS Saturday night schedule from 1992 to 1998. Unlike most of the hour-long continuing dramas on television, this series was shot entirely on location in a public recreation area northwest of Los Angeles. The set, which included a functioning nineteenth-century locomotive, provided a believable period atmosphere.

In the Fall of 1998 the series was dropped by CBS and replaced by *First Edition*. A viewer protest failed to move the network, which opted for a series it owned over an independent production. Certainly the ratings were declining on *Dr. Quinn*, but the circumstances of its demise strongly suggest that CBS simply preferred to have a larger potential profit resulting from ownership.

PRINTED IN U.S.A.

GAYLORD